Sonia Delaunay

Sonia Delaunay

Artist of the Lost Generation

BY

AXEL MADSEN

McGRAW-HILL PUBLISHING COMPANY

New York St. Louis San Francisco
Hamburg Mexico Toronto

1 2 3 4 5 6 7 8 9 DOC DOC 8 9 2 1 0 9

ISBN 0-07-039457-1

Library of Congress Cataloging-in-Publication Data

Madsen, Axel.
 Sonia Delaunay : artist of the lost generation / by Axel Madsen.
 p. cm.
 Bibliography: p.
 Includes index.
 ISBN 0-07-039457-1
 1. Delaunay, Sonia. 2. Artists—France—Biography. I. Title.
N6853.D34M34 1989
709.2—dc20
 [B] 88-33147
 CIP

Book design by Eve L. Kirch

CONTENTS

Contents

ACKNOWLEDGMENTS

The author owes special gratitude to Charles Delaunay, Sonia's only child, who despite terminal illness gave of his time and energy, only to die before this book was finished. Unless otherwise reported in footnotes, conversations are transcribed from interviews with Mr. Delaunay.

I could not thank all the people who took time to help me prepare this book—and not all would want their names to appear. Let me thank at least:

In Paris: Jacques Damase, Philippe Labrousse, Dina Vierny, Georges Hoffman, and Florence Callu.

In Nice, Cannes, and Grasse: Marie-Louise and Svante Loefgren, Ferdinand and Irène Springer, and Céline Weiss.

In Munich: Peter Gehrig.

In Lisbon: The staff of the Gulbenkian Foundation.

In New York and Chicago: Edyth Klinow, Suzi Magnelli, Lisa Frost, Jane Jordan Browne, and René de Costa.

In Los Angeles: Ileana Alteresco.

In Wilmington, Delaware: Linda Winkler, Phil Winkler, and Hatsuhana.

And in New Hope, Pennsylvania: Ragna Hamilton and Dr. Edwin Carlin.

Carversville, Pennsylvania, June 1989

"One cannot live without champagne and gypsies."
Russian proverb

PART
ONE

1

July 9, 1944

The soldier left the motor running. The canvas flap at the back of the truck was flung open and six soldiers jumped down. Four others followed. A military car squealed to a halt. From where she was sitting she could see two black-uniformed officers get out.

"Gestapo," mumbled someone at the bar.

"They're getting nervous," one man sneered under his breath.

The two officers came straight toward their café. Behind them, soldiers fanned out toward the other cafés surrounding the railway station.

Men on the café terrace leaned forward to get identity cards out of back pockets. A woman fumbled with her purse. Behind the counter the owner kept wiping the same glass.

Mute like the rest of the customers, she held on to her traveling case. A prison van drove up and stopped in the middle of the square. The owner bit into his cigarette butt and squinted at the Germans. A tall man fumbled for his papers.

"*Allez, dépêchez!*" The soldier at the door made an impatient gesture with his machine gun, while a second, older Gestapo officer

eyed the customers at the counter. Silently, the tall man handed over his ID.

For her, it was the second surprise check since yesterday. Before boarding the train in Cannes, a Frenchman had pulled a militia badge on her and asked to see her *carte d' identité*. She hated people examining her papers, the several names that life's itinerary had given her.

The militiaman had scrutinized all six pages of the foldout document, taking his time.

"Religion?" he had asked.

"Russian Orthodox."

"Not Israelite?"

"Why do you ask, Monsieur?"

"Your maiden name."

She had stared him down and haughtily launched into her routine. He could call the *commissariat*, if he wanted. She had lived in Grasse for three years, ever since she had become a widow. Without a word the man had shoved her papers back at her and continued down the platform.

The Resistance kept blowing up railway track. It had taken her twenty-four hours to get from Marseille to Toulouse. At Nîmes, a German soldier had wanted her and six other civilians to give up their compartment. The way he pulled at her sleeve had been just too much, and when he shouted to his comrades to come and help him, she had spoken up—in German.

"You know how to talk as though you're one of us," one of them had answered suspiciously, "but in reality you're for the Allies."

In the end, she and the six other civilians had been kicked off the train. This morning's BBC broadcast said the Allies were advancing toward Rennes.

The older Gestapo officer began working his way down the counter. A couple standing between their suitcases had their IDs ready. The owner kept wiping the same glass.

Suddenly, she saw Willy, her former husband, standing at the far end of the counter next to a butcher in full smock and apron. He looked different with his gray hair, but it definitely was he! How could

he be in Toulouse? How could they have chosen the same café next to the Matabiau station?

Fear, instinct, and memories of an impassioned year long ago made her get up. Clutching her bag, she moved toward Willy.

The Gestapo officer gestured for the couple with the suitcases to show their papers. The husband mumbled that they were on their way home to Malause: "That's the station after Moissac."

She was fearful of even whispering Willy's name. To make him notice her, she held up a 100-franc note and asked the owner how much she owed.

Willy recognized her. Neither he nor she acknowledged the other. Their eyes met. He was reading her mind because a thin smile creased his lips.

The owner snapped the 100-franc note from her fingers.

The officer took the papers from the man next to the butcher.

She was not afraid of a perfunctory glance. Her *carte d'identité* gave her married name first, in big bold letters. But even if the Prefecture de Cannes stamp neatly smeared Gradizhsk, U.S.S.R., as the place of birth, close scrutiny would reveal the "née Stern, Sarah." She wondered whether Willy carried fake papers. So many people did. Surely his ID wouldn't say that he was born in Friedeberg in der Neumark.

The owner dropped her change in a porcelain saucer and shoved it in front of her. She might be on her way to Auschwitz or Buchenwald, but she dutifully calculated how much she should tip. Only the butcher stood between her and the Gestapo officer.

She sensed the German somehow knew that this exercise was futile, that the person they were looking for had probably slipped away. She couldn't help staring at the skull-and-bone emblem on the Gestapo lapel as the officer took the butcher's papers. She could smell the uniform. With his two-day beard, frayed uniform, and fat neck, the German looked like a Georg Grosz caricature. Why had she believed it would be safer here in the café than in the station waiting room?

It was her turn.

"Nationality?" the Gestapo man asked.

"Russian-born," she managed.

With a funny smile, he asked her if she knew Kiev and Kharkov. She wondered if he had seen the Ukraine as a combatant, when

suddenly an officer appeared in the doorway. From the street came shouts in German and French. Two Frenchmen were being dragged toward the prison van. One protested vociferously while the other, a stocky, bald-headed man, looked subdued, as if he knew he was condemned. The Gestapo officer turned and, with the rest of them, watched the two men being pushed into the van. Everybody knew what it meant.

The Gestapo officer drummed her folded ID against his fingers, watching her for a second before he handed the papers back and looked past her at Willy. It was a long, sharp squint, but a second later he wheeled around and walked out of the café.

The van left.

The Gestapo officers climbed into their car.

When she turned back again, the bistro owner spat out his cigarette butt in the direction of the street. The Germans took off.

"The bald one is Quevastre," someone said. Around them the small talk picked up again. She glanced up at Willy. He suddenly looked even older, she thought. He still had the pinched aristocratic mouth and high forehead that Picasso had captured so well in that portrait of him, but the eyes looked tired.

The bistro owner eyed them suspiciously, maybe sensing they were foreigners. During the other war, people had suspected her of being a German spy.

She was still clutching her change when Willy and she walked out into the noonday heat. They crossed the canal without a word, not knowing where to begin. The spire of the Saint-Sernin basilica cast its Romanesque shadow on the Old City. When had she seen him last? In 1938, she realized. In his gallery. She had found him old even then, but as passionate as ever about art.

They were halfway down a street called Rue Bayard when he said he had his bicycle over by the park.

"A bicycle?" she asked, as if to have one were something extraordinary.

"Belongs to Cassou, actually."

They spoke careful French. He asked about her life since Robert, about her son Charles. She asked where he was living.

"Cassou is running the entire Combat, Libération, and Franc-

Tireur network; I'm staying with him, Tzara, and Céline and Paul Dermée."

Cassou had been the first curator to bet on the name Delaunay. She had had no idea he was a resistance leader.

"And you?" Willy asked.

She told him she was planning to go south, down to St. Gaudens or maybe Tarbes. The closer to the Spanish border the better. "I mean, how long can it last?"

"The BBC said this morning . . ."

It felt odd being alone with him after all these years. She didn't care to remember how long ago it was that she had first walked into his little gallery in Rue de Notre Dame des Champs. Her life had turned out different from what she had imagined when the two of them had gone to London to get married.

She told him about Grasse, about Jean Arp, a widower now, and about Alberto and Suzi Magnelli, about the Springers and Céline Weiss, whose villa had been a refuge these last months. René Weiss was a Gaullist and a resistance leader, and the house was half-empty anyway.

Jean and Sophie Arp had invited her to come and stay with them after Robert died. For one happy year they had all formed a little colony of their own. "We refused to give in to the war's insanity, but when Sophie got sick she managed to use her Swiss nationality to get not only herself and Jean to Zurich, but Ferdinand and Irène Springer as well."

The hot July sun beat mercilessly on the near-empty Rue Bayard.

"The Gestapo confiscated the Springer paintings I bought from him eight years ago," Willy said.

"The Magnellis were the last to go into hiding," she continued, lowering her voice. "Alberto thinks they are safe, but Suzi was born Gersohn . . ."

Whether it was the emotions of having escaped the Gestapo sweep or feelings of pity for her, he suddenly turned to her and said, "Why don't you come and stay with us? Cassou has this abandoned château near Grisolles."

She had no idea where Grisolles was, but she had known Jean Cassou since before he became the curator of the National Museum of Modern Art, when he was a journalist. The way Willy explained it, Cassou was the nominal renter of this castle with its medieval tower and formal garden overlooking the Garonne River. There were more

rooms than any of them had bothered to count. Tzara had a whole wing to himself, Florent Fels and the Dermées occupied one floor.

"The last time I saw Cassou, Robert was still alive," she said. She could still see Le Corbusier and Fernand and Jeanne Léger on the podium, trying not to let the Communists write off surrealism and cubism and impose realist art as the only valid one. Robert had shouted, "So what the Party wants is that we all return to the un-inspired old crap!" Abstract painters had loved Robert, and in derision, chanted, "Rem-brandt!" "Ru-bens!" from the floor. On the way out she had run into Cassou, all flustered and embarrassed. He wanted everybody to pull together, now that socialists were in power. "It's silly to split when we should unite," she had told the curator. "But the free choice of colors is what counts. The liberation of colors is the new realism, not figurative art."

"And Fernand and Jeanne?" she asked Willy. Fernand's wife had a teasing, mocking quality, but she could be terribly funny.

"They're in America. Fernand is teaching at Yale University, if you can imagine."

They were at the bicycle, an old black contraption with a big metal rack behind the saddle.

"You'll be safer than at any hotel in St. Gaudens or Tarbes," Willy insisted. "The Germans are rounding up all the time."

"But do you have enough food?"

"We have everything. Even a greenhouse you can use as a studio."

It was a long and hot twenty-five kilometers on Willy's baggage rack. People smiled at the sight of a tall, lanky fellow in a summer jacket puffing and pedaling and a chunky woman in a print dress on the baggage rack hanging on to him. Each breezy downhill and panting uphill brought them deeper into the heart of a Gascony still strewn with half-abandoned castles from which the Three Musketeers had sallied forth and which now served as havens for a good number of people who, having little desire to be known to the Gestapo, led very discreet lives.

Instead of going on the *route nationale* where they might run into militia roadblocks, Willy took the old *départémentale* along the Garonne River. On the long Blagnac uphill, they both got off and walked. At

the top they rested in the shade of a huge oak. She remembered the summer they had spent in Chaville, on the western outskirts of Paris, and the Saturday evening he had taken her to meet Gertrude Stein and her friend Alice. The two American ladies were used to seeing Willy show up with tall, blond good-looking young men who clicked their heels and stood at attention all evening.

"Gertrude Stein thought I was conventional, I remember," she said.

Willy smiled. "She was sure I was marrying you for your money."

It all came back to her, her own rectitude, her youthful naïveté. For her, marrying this spiritual art lover had been an end-run around her adoptive parents' repeated arguments that a young woman could not live abroad, alone and free. And it had worked between them, in their own way. Her own sensuality had been sublimated, her fervor concentrated in tubes of color and stretches of canvas. She had believed he might learn to love her.

"The Magnellis told me Gertrude Stein and her friend are in hiding somewhere near Annemasse," she said.

"They never left, like us."

"The Guggenheim Foundation sponsored us to come to America."

He sat up. "So what happened?"

"By the time the papers were ready, Robert was too ill to travel."

The castle at the end of a poplar lane was even lovelier than Wilhelm Uhde's description, and the greetings of Jean Cassou, his wife, and the others brought tears to her eyes.

The stage operetta château with its medieval tower was perched on the bank of a fairyland tributary to the Garonne. It was surrounded by a French garden and by chestnut, pine, birch, and age-old walnut trees.

In the courtyard, dogs barked, and Tristan Tzara embraced her. Cassou came running. Instead of listening to Willy's story of how the two of them had met in the middle of a Gestapo raid, they swung her around as if appraising a fashion model, hugging her and shouting for the Dermées and Fels to come out.

"God, just to see you," Tzara repeated.

She had forgotten how small the neurotic inspirer of surrealism was. She had known him since his name was Sami Rosenstock, and she had illustrated his first Parisian poems. She still thought Robert's portrait of Tzara was one of his best paintings.

The Dermées came out. She had known Paul Dermée, the Belgian surrealist poet, and his book-editor wife, Céline Arnaud, since 1923. Céline had lost nothing of her dark beauty.

As they all escorted her in and offered her the entire Tudor wing, she could only marvel at her good fortune. The view from her room was of a landscape of abrupt slopes and hardwood forest, and on the other side of the stream, a red-tiled village and a tiny railway station.

The dinner that night in the enormous kitchen was as magnificent as it was unexpected. Cassou, who was some fifteen years her junior, was at the head of the table. They were in the land of foie gras, of goose cooked in a hundred ways, he said. In her honor they insisted on Armagnac wines.

The electricity went out in the middle of Cassou's *clafoutis*. Dermée found four huge church candles. They sat and listened to long, drawn-out rumblings, faint and muffled, and wondered whether it was distant artillery or *marquis* sabotage. She had always loved the way candles gave high relief to the human face.

Cassou regaled her with his picaresque tangles with the Vichy government during the first months of the German occupation. It was not sensible to name him director of the reopened Museum of Modern Art, he had told his superior, but the man convinced the Vichy leaders otherwise.

Cassou smiled over his glasses. "My boss told the government people that the fact I'd been a Popular Front socialist and agitator for Republican Spain, that my wife was Jewish, should not be an obstacle to my nomination. They even pretended that Marshal Pétain himself acquiesced; there should be no retaliation because of my prewar politics."

"How naive can you be?" Tzara asked with mock horror.

"I was told my nomination had been accepted," Cassou continued. "I went home, turned on the radio and heard a newscaster say 'the Spanish Jew and Free-Mason Jean Cassou has been named director of the Museum of Modern Art.' "

That was the end of the nomination.

The conversation was upbeat. The Allies were almost at Nantes and Orléans. Cassou announced he was already writing about the postwar era. Fels hoped that he could find finances to start a magazine again, and Willy that he would be able to recover most of his paintings. It was the second time he had lost all his paintings. In the first war, the French had considered him an enemy alien, and confiscated his entire gallery. This time the Germans had called him a traitor and seized everything. The Gestapo was still trying to arrest him for having signed the exiled Germans' anti-Nazi manifesto.

The distant explosions stopped, but the lights didn't come back on.

She watched Willy in the flattering candlelight. He had always looked distinguished, the scion of the Protestant jurist's family he really was. He had been the cultivated bachelor who had lived in Paris for seven years and knew everybody in the arts when they met. It occurred to her that it might have been *he* the Gestapo had been looking for this morning. As she listened to him talk about the gallery he would open—inevitably—after the war, she dismissed the thought. The Germans were losing the war; the Gestapo had arrested two men this morning. They were looking for saboteurs, resistance fighters, not art dealers who had signed an anti-Hitler declaration.

Cassou lifted his glass. "To victory," he smiled. "And to Sonia."

She could only thank them for taking her in.

The postwar era would be a period of renaissance, Cassou said, a time of exhilarating new perspectives. They agreed tomorrow should not be a return to the world before 1939. The question was not so much to hold on to obsolete dreams as to be effective without losing individuality.

Fels mentioned a series called *The Hostages* that Jean Fautrier had painted.

"Dubuffet is back doing figurative stuff." Willy emptied his glass.

"I love Dubuffet," Cassou said. "He's always had an instinct for farce."

She let them talk. If she had one wish it was that peace would bring a renewal of spirituality. No one could foresee war, revolution, and ruin. All anyone could do was try to adapt. She thought of Robert, of how forcefully he would have argued for the future. If she had been the last to leave Grasse it was because finding a place to protect the paintings from bombing raids had not been easy.

Tzara caught her daydreaming. "Another sip, *malinkaya sestrit-ska?*" he asked, holding up the bottle.

She smiled. She hadn't heard that affectionate Russian diminutive for "little sister" in years.

"The portrait Robert did of you is one of his best," she said.

"Did you ever sell it?"

She told him she still had it. Oil on cardboard. It was stored with Robert's and her own canvases and with several of Magnelli's, Arp's, and Springer's paintings, behind bags of plaster in a dry semi-underground garage.

"It was the year you did the costumes for my play." He smiled.

Tristan had come to the apartment and, with his superior sneer, shouted, "I bring you the world's handsomest swindle in three acts. Georges Auric is doing the music."

They were back in 1923, the dizziest year of surrealism. André Breton had helped them sell *The Snake Charmer*. And besides Tzara, Robert painted portraits of Breton and Louis Aragon, and of the newest Russian émigré—Iliaza Zdanevitch, a lean-faced Georgian who called himself Iliazd, and had helped stage the play.

"The audience, you remember?" Tristan asked.

"Cocteau, Stravinsky, the surrealists."

"The composers Darius Milhaud, Erik Satie."

"Not to talk about the poets."

"Don't tell me."

Paul Eluard and Aragon had jumped onto the stage and attacked Tristan. Her cardboard costumes hadn't been designed for fisticuffs. The theatrical evening ended back at the apartment with her applying compresses, soaked in toilet water, to members of the cast.

Her costumes had led to an offer to design fabrics. The textile industry was keeping a careful eye on the avant-garde, and she was only the second artist to be asked to create textile designs. She had followed Raoul Dufy, but her pure geometrics had sold better than his exotic imagery.

"It's been a long day," she said.

Her saying good-night broke up the conversation. Others thought of going to bed. Tzara shared out stumps of candles so they could all find their way and maybe read five minutes in bed.

She found her room without difficulty, and blew out her candle. Moonlight gave the room an eerie white sheen that reminded her of

the milky midsummer nights of her adolescence. Why had no St. Petersburg painter ever captured the opalescent beauty that natives of the city sailing home through the Gulf of Finland called "Kronstadtsky," for the pearly haze in which they first saw the island of Cronstadt. People from St. Petersburg who took milk in their tea asked for it "Kronstadtsky," with the merest dash of milk, only enough to cloud the tea.

She crossed to the French window and opened it. An elfin haze rose over the river. Her motto had been that love makes everything possible. She had given her total love to Robert. He had never doubted the shimmering significance of what they were doing, the prophecy of their art, the destined recognition. "You'll see," he used to say. So now *she* had to carry on. She had to make sure his vision of their art as images of light, structure, and dynamism would not be forgotten in any heady postwar era.

From Sarah to Sonia

Her earliest memories were of colors—the white dust of acacia flowers powdering her dirt road in spring, ruby-fleshed watermelons and sunflowers with black hearts in summer, endless yellow wheat fields against black September skies, and pristine snowbanks twice as tall as she when she brought her father's lunch pail to the factory on winter mornings. The houses were chalk-white and low-slung. They seemed set into the black earth like mushrooms. What she would retain from early childhood was a sense of the joyful balance of all things, of confidence in life and in the good black earth.

She was born Sarah Stern, the daughter of Hanna Terk and Elie Stern, during the third year of the reign of Czar Alexander III. The date was November 15, 1885; the place the village of Gradizhsk on the north shore of the Dnieper River, 160 miles southeast of Kiev in central Ukraine. It was the land of Gogol's *May Night*, of *Evenings on the Farm at Dikanka*, of tales of the humpbacked horse who brought his master good fortunes, and of the magical cat who sang verses when he circled to the left and told fairy tales when he went to the right.

For Jews like the Sterns it was the land of existential perplexity, of Sholem Aleichem, of the ingenious person who was always the *shli-malz*, the clownish victim of misfortune.

She would remember the buckboards and their nervous little horses, which in winter were harnessed to sleighs with joyous bells. She would remember the immensity of the sky, a friendly endlessness.

The Sterns already had a son when Hanna gave birth to Sarah. Elie was in the army. Later, in civilian life, he found work in Gradizhsk's only factory. To his wife's distress, however, three more children had followed Sarah.

Hanna was a woman who felt she had missed out on life. Her brother was a lawyer, a man of privilege and distinction in St. Petersburg. Gherman Terk had married a relative of the Zacks, who, with Baron Gunzberg and the Benensons, were perhaps the most prominent of Jewish families in the capital. Hanna dreamed of life in the city, of what her existence could have been had she not married an honest but poor man and brought five children into the world.

Born in Odessa, Elie was a warm, outgoing person with respect for new ideas. A man of frank, exacting views, he faced mean and unscrupulous behavior with steadfast principles. Elie read his fellow-Odessan Leon Pinsker's book about the two cures for antisemitism—complete assimilation of Jews wherever they lived or the recognition of Jews as a nation with a country of their own. He followed with interest the saga of the first Russian Jews to emigrate to Palestine in 1882—the year of the last Cossack pogrom in Gradizhsk. On the Biblical New Year's Day he raised his glass to the ritual "Next year in Jerusalem."

Hope and perseverance were deeply engraved in his psyche. His integrity and tenacity won him not only respect in Gradizhsk but advancement. At the nail factory where he had started as a laborer, he would finish as the head of the enterprise.

Little Sarah identified with her father. As an adult she would credit her strength of character to Elie's presence during the first years of her life. His generosity and optimism were absorbed into her personality. What she could never understand was her mother's unfulfilled dreams of romance, her sentimental yearnings for life in the capital. The self-pitying Hanna would leave her daughter with a lifelong horror of pessimism and complaints.

"That is the deep reason no doubt for my aversion to my mother," she would say late in life. "From the age of three, I reacted like my father. All my life, I clenched my teeth without complaining. I've always hated crybabies."

In the struggle over Sarah's future, it was nevertheless Hanna who won out. If convention and timidity kept Hanna in the provinces, the wife of a solid factory foreman, there was no reason why one of her children shouldn't come to know the refinements and glamor of St. Petersburg. Hanna's brother was in the capital. He was a man who had overcome all the barriers.

The Terks were a family of modest crafts people who had put all their bets on their eldest son. Once through *gymnasium* and law school, Gherman Terk had helped his younger brother become a doctor. There had been no money left to educate the daughters or to provide them with dowries. The Terk girls had remained spinsters or, like Hanna, had married men without money.

Gherman had made the handsomest marriage. His position as lawyer for the Banque Zack, his demeanor and eloquence, his facility with French, German, and English, plus his love of the arts had impressed Anna Zack, the banker's niece.

Like a Tolstoy heroine, Anna was effortlessly elegant and cultivated. Brought up by her banker uncle, she had received the choice education of a wealthy, emancipated family. She was cosmopolitan and multilingual—one of her sisters had married a physician in Heidelberg. Her singing voice was schooled, her abilities on the piano and at an easel accomplished. As a young girl, she had patronized circles where literature and social issues were discussed. She had even attended feminist meetings, although she had found the women who sponsored them uncared-for and unattractive.

Gherman, who had gallicized his first name to Henri, had all the qualities Anna appreciated. His surname was not obviously Jewish—not that Anna was ashamed of her roots, but in her milieu one just didn't dwell on one's origins. Henri believed in science and progress: He was in favor of reforms but found the idea of revolution irrational. Like Anna, he admired both the British constitutional monarchy and—despite the Dreyfus affair—the French Republic because it had no state religion. Before visiting her sister and brother-in-law in Heidelberg, Henri and Anna had spent their honeymoon in Venice sailing the canals and in Florence admiring the treasures of the Uffizi Museum.

If there was one dark cloud in the gifted young couple's life, it was that they remained childless.

Posterity would not record whether Henri and Anna thought of filling their townhouse with an adopted child's laughter or whether Hanna, in her sustained correspondence with her brother, planted the idea with them. Sarah Stern would come to believe that her uncle had wanted to adopt her and that her mother—perhaps pushed by her father—agreed only in order to let Henri and Anna Terk provide for her education.

There were to be two accounts of how Sarah came to live with the Terks. In one version, Hanna's letters complaining of too many children led Henri, while on a business trip to Odessa during the summer of 1890, to detour to Gradizhsk to see his sister and her family.

One must assume that Henri and Anna had already discussed the idea of adopting one of his favorite sister's sons. Were the Stern boys too boisterous, too coarse for the banker uncle? Was little Sarah an utterly captivating child? We will never know whether it was her sparkling eyes, her vitality, or the way she listened with a smile that captivated her uncle. In her diary, however, the eighteen-year-old Sonia Terk would describe herself as having been "an extraordinary child."

According to a second, perhaps more likely, version, the overwhelming summer of the five-year-old girl's life took place at the Baltic Sea. In this account, her mother and she were taken by buckboard to the nearest railroad station to travel to Kiev, where they changed trains for Moscow, St. Petersburg, and finally the Terks' summer residence in Finland. It was the first time Sarah saw the sea, and the memory of looking for amber among the pebbles in the shallow water lapping at her feet would remain with her for life. If the holiday was some sort of tryout or test of compatibility, Sarah passed it, because at the end of the summer Hanna returned to Gradizhsk alone.

Sarah would meet her father only once after that, and she never saw her mother again.

Having affluent relations educate a child of less fortunate kinfolk was far from unusual in turn-of-the-century Russian-Jewish families.

Anna herself had been adopted by a wealthy uncle. The Terks made it official. A writ signed by a deputy to the St. Petersburg governor established that "Sarah Stern, daughter of Elia Stern and his wife, Hanna, born November 15, 1885, and registered with the Odessa rabbinate, had requested to reside until her coming of age with Henri Terk, member of the St. Petersburg bar." An authorization, signed October 23, 1891, established her legal identity. She adopted her uncle's patronymic, and during the next seventeen years was known by the name of Sofia or, its Russian form, Sonia.

Life in the capital was a village girl's dream come true. Ignoring the traumas that such uprooting must have caused in the mind of a five-year-old, she would, late in life, put her childhood in an uncomplicated perspective: "My father left me a sense of honesty, and from the age of three a line of conduct was traced in me, a line from which I never strayed. My uncle opened my mind to the world of culture and tradition, the world where a person could develop feelings for beauty, and ambitions to spread his or her wings." In her teens, however, she would admit she had been something of a loner as a child, that she had confided in no one.

The townhouse was spacious, the uniformed servants numerous, and the Terk soirees fashionable and tony. Aunt Anna was passionately interested in music and in German philosophy, from Kant to Nietzsche. Uncle Henri loved paintings and collected the works of Isaak Levitan, the landscape artist whose sets graced the historic premiere of *The Sea Gull*, of St. Petersburg's most fashionable painter, Ilya Repin, and of Arnold Boecklin, the Swiss symbolist whose moody studies in nostalgia and melancholy were the height of *fin de siècle* fashion. Copper-plate engravings of museum originals filled Henri's library.

St. Petersburg was a Nordic city of pale colors and soft light, a quality of pastel that, as Somerset Maugham would note, its painters seldom managed to put on canvas. Fedor Alexiev painted luminous perspectives of the city in a meticulous Venetian manner, for which be was dubbed the Canaletto of the North. The city's silhouette was both severe and stately with its wide avenues, straight streets, and elegant squares. The smooth surface of the Neva River with its

branches and canals was framed by gray and pink granite embankments and over three-hundred bridges.

In the company of her aunt and uncle and governesses, Sonia discovered the czar's city that would be her home until young womanhood. They walked along the Court Quay, pygmy figures, Sonia thought, below the Winter Palace, where a staff of eleven-thousand tended to the imperial family. She would remember how once, when they sailed back from an excursion to Finland, the low silhouette of the city emerged from behind the Cronstadt—the bronze dome of St. Isaak's Cathedral, the spires of the Fortress of Peter and Paul, and the Admiralty.

Sonia's favorite childhood memory was Butter Week in early spring, when temporary wooden theaters, fairground booths, bearded storytellers, organ grinders, merry-go-rounds, and roller coasters appeared in the square of the Winter Palace. With Aunt Anna, Sonia watched, with fascination, the frenzied performance of Petrouchka, the puppet cursed with a human heart, who in some stories sat melancholy and alone in a dark room, crying out his despairing love for an unfeeling ballerina, but in other retellings beat his wife and killed people and was finally hauled off to hell by the devil. While the puppeteer behind his curtain worked the punch-and-judy show, the organ grinder provided music and dialogue. He would continually warn Petrouchka, "Look out! You're in hot water," and Petrouchka would merely give a shrieking laugh. Kitchen maids in the Terk household told Sonia stories of princes who rode through the darkness of the deepest forest and braved the cunning Baba Yaga, of the hunchback horse, and of the Firebird's gleaming feathers.

Summers were spent traveling abroad or at the family seaside residence in Novaya Kirka, Finland. Less than three hours by train from St. Petersburg, the summer home was nestled in a hollow surrounded by pine forest and sloping down to the Gulf of Finland. Henri had decorated the garden with several Italianate statues. Sonia loved the company of the marble men and women. Her favorite hiding place was in the bottom of the garden. A picture shows her there as an eight-year-old, a pretty round-faced girl with a page hairdo, looking straight at the camera with large beautiful eyes. Despite the pensive pose, the impression is one of mock severity, as if only a moment before the photographer ducked under his hood,

having demanded that she hold still, she had been a ball of impish energy.

Once or twice Henri and Anna invited one of Sonia's brothers to spend a vacation with them in St. Petersburg or at the summer house, but if she longed for her siblings or her parents she kept it to herself. In the diary she began writing when she was eighteen, she would note that she had been an "astonishingly uncommunicative" child. "Although I had friends, I talked to no one about my thoughts or my feelings."

With Aunt Anna, Sonia got to know the shops along the fashionable Nevsky Prospekt and took tea in opulent Biedermeier interiors along the curving Fontanka Canal. With her governesses she spent sunny afternoons in the Hermitage Park. She saw her first play at the Alexandrinsky Theater, attended her first concert at the Hall of Nobles, and thrilled to her first ballet at the Mariinsky Theater.

The Terks celebrated Christmas and Easter. On New Year's Eve Sonia scrupulously observed the tradition of writing her wish on a piece of paper, burning it, and ceremoniously eating the ashes. Seeing the onion domes of the Church of the Blood shimmer in frosty sunlight she wondered what would happen if she no longer believed in God.

"My childhood was one long permanence," she would remember. Henri and Anna were a lot like her natural parents: he an outgoing, affectionate, and excitable man who easily exploded and just as easily regained his sunny self; she a more reserved person rarely given to display of emotions. Early on, Sonia sought to emulate masculine latitudes, aspirations, and freedoms, and her role models remained her father and uncle rather than her mother and aunt. "One must not forget that in those days an enormous barrier separated children from grownups," she would say. She would have no recollections of Henri ever coming to her room. Anna brushed her long hair, apparently her only concession to maternal instinct. "For a child the way to escape was through daydreaming. If I've had a lovely life, it's because I daydreamed."

More tomboy than wallflower, Sonia's life was governed according to the rules of Edwardian propriety. Until her late teens,

she was not allowed to leave the house unchaperoned. She carried no money and never traveled by streetcar or visited a restaurant by herself.

Aunt Anna's days were fully mapped out with social rounds—visits to Madame Berthe, her dressmaker, obligations toward her charities, and preparations for her "Wednesdays." She sang romantic lieder, and a cousin who lived on the mezzanine played operas on the piano. If there was one thing that Petersburg society enjoyed it was French and Italian opera. Henri and Anna were in their loge the February night in 1891 when the Australian Nellie Melba came to sing at the Mariinsky.

To help her appreciate Goethe, Voltaire, and Shakespeare in the original, Sonia had, until the age of fourteen, live-in *Fräuleins, mademoiselles*, and misses. To have an English nanny in a nursery was the height of Petersburgian snobbery. The English governess left little impression, however, and Sonia didn't like Mademoiselle Turvoire because one day the Frenchwoman tried to entice her to lie to Aunt Anna. Fräulein Piltz was Sonia's youngest and favorite governess. Together they played cowboys and Indians in German, making a wigwam to hide under by hanging blankets over the long dining room table. In the fall, they took brisk walks along the Moika, watching the barges, and on winter afternoons they skated on the pond in Mariinsky Park.

On the Nevsky Prospekt it was fashionable to speak foreign languages. Anna hired a tutor to improve Sonia's command of Russian. Playfully, she also planned the girl's future.

"For you, Sonia, we'll find a prince." Anna smiled.

"There aren't any Jewish princes."

"No? The Gunzburgs are barons, aren't they?" Anna was referring to the pride of Russian Jewry. The Gunzburgs were at the top of the social scale, and it was said they were friendly with the Romanovs. But men of business and finance were becoming prominent. Gregori Benenson had a townhouse on the Moika, and the Beckers, who were making money in the oil fields of Baku on the Caspian Sea, were the talk of Jewish Petersburg. In Baku, the Beckers had met Calouste Gulbenkian, the young Armenian who first grasped the immense future of oil. Henri knew him from London, where, in the

face of the Turkish massacres of Armenians, Gulbenkian had fled with his family.

The Terks were at home in many languages and cultures and would talk to Sonia as an adult about Plato, Mozart, *Peter Schlemiel*, and the Golem, about the aristocrat who spoke only in verse and forced his entire household to reply in kind, and of the Guards officer who used to walk about St. Petersburg exercising his pet wolf.

3

A Brave Little Person

Russia in the 1890s was a land of contradictions—of economic progress, repression, and a government that seemed to walk backward toward the dawning century. Sects dissenting from the Russian Orthodox—the Catholic Eastern Rite churches, the Lutherans, and the Jews—suffered systematic persecution. Henri and Anna Terk—and their adopted daughter—however, experienced nothing of ghetto life or of the dreaded pogroms which tormented the existence of Jews in the great stretch of territory known for administrative purposes as the Pale of Settlement, a swath of dense Jewish population from the Baltic to the Ukraine, and which drove the best and the brightest to emigrate. An imperial edict allowed a Jew to reside with his family outside the Pale if he qualified through a learned profession, if he was a merchant belonging to one of the influential guilds, or if he had undergone the maximum period of military service.

Russian laws were meant for bending, and, like Anna's family, the Terks were a half-assimilated family whose Jewish values had lost their content and whose preoccupation with themselves and their bourgeois status made them scorn Yiddish culture. They belonged to

the minority of deft, sophisticated Jews who had broken with tradition and whose drive, ambition, and restlessness moved them toward power and riches in the capital.

The accession to the throne of Nicholas II in 1894 accelerated the rise of entrepreneurs. The new sovereign was, despite his reactionary politics and basic insecurities, the first czar to evince personal interest in Asia, and it was beyond the Ural that such men as Grigori Benenson made their fortunes building railways and joining in the oil discoveries in Baku in faraway Caucasus.

Henri and Anna Terk were not as famous as the Gunzburgs and were not as rich as Benenson, but together with the Zacks, Henri was closely associated with the most profitable area of commerce—international banking.

Anna's uncle had become rich by raising capital for gold and platinum explorations in Siberia, railroad building in the Ural, and the construction of paper mills along the Dnieper. Banks in Zurich and Hamburg had been the traditional underwriters of capital ventures in Russia, but a state visit by Nicholas to his Uncle Bertie—the name by which every Russian who followed royalty knew King Edward VII—had led to the inflow of fresh capital from the City of London. A specialist in international law, Henri spent his days in an office on Admiralty Quay, attired in black jacket, winged collar and striped pants, drawing up the contracts that prudent London financiers demanded.

Sonia grew up without any intense curiosity about Jewish life and without knowledge of the Yiddish language, Yiddish theater, Hasidim, zionism, or of events in the Pale. No one talked to her about God— the Terks' celebration of Christmas and Easter was less a bow toward religion than an attempt at being fashionable.

To deny one's heritage was spineless, of course, but to advertise one's origins was equally inelegant. The faux pas was what one avoided at all costs, and this was what Anna and Fraulein Piltz instilled in Sonia. Russia's "men of God" were bearded patriarchs that Henri took Sonia to see at the Butter Week fair. They were men of Russia's cruder past that no one of Henri's progressive views would think of inviting to his home. The guests Henri and Anna entertained were a tony mix of individuals who quickened the pulse of the modern era. All kinds

of people, Christians and Jews, had fled their backwater origins for the capital, where life and opportunities coursed richly along the *prospekts* and the canals. This was a heady and flamboyant era that the French so eloquently called *La Belle Epoque*.

Sonia would remember dinner parties at their home that began at 6 p.m. in the grand salon and ended long past her bedtime, grownups who seemed to spend their waking hours eating. "Before the dinner guests sat down, they nibbled at caviar, sausage, ham and cheese at a 12-foot-long serving table," she would say. "Once they were seated, stewards and maids served borscht and *pirozhkis*, followed by smoked fish and vegetable salad, followed by poultry or game with preserves and, finally, desserts. Wines from France or Hungary were served. Around midnight, guests were offered tea and pastries or chocolate cake. People were killed with food. Our cuisine was famous in town, the second after the czar's."

Dinner guests included such men of business and art as Savva Mamontov, the most remarkable of the new railroad magnates, and his energetic wife Elizaveta, who had enormous influence on all artistic activities. Savva loved music, and after dinner Anna sometimes accompanied him on the piano while he sang. He had spent several years in Italy developing his baritone voice, and was also a playwright and gifted stage manager. His latest discovery was Konstantin Korovin, a young graduate in painting, sculpture, and architecture who was designing the sets for the railway baron's private theater. Mamontov had been the first to support Mikhail Vrubel, a precursor of Russian cubism whose tragic life had all the haunting glamor of Paul Gauguin and Vincent van Gogh.

The Terks liked an urbane mix of Jews and gentiles at their soirees. The Kourlands, whose granddaughter was a friend of Sonia, lent a note of aristocracy. High finance was represented by Sergei Lamansky, an attractive bachelor, and by Sergei Slobodshikov. The Genns were Anna's intimate friends.

When Sonia was allowed to leave the table, she liked to go to her uncle's studio. Here, she had permission to leaf through his albums of engravings: pictures of heroic battles, pastoral landscapes, mysterious forests, ships on stormy seas, people in placid interiors, and gypsies. "Since the adults' conversations interested me very little, I looked at these albums every night."

Between three imposing stoves in the 100-foot-long formal dining

room, the walls were decorated with paintings. One was a portrait of a Moroccan, another a view of a rainy street in Amsterdam. In Henri's study hung other paintings and print reproductions of Italian and Dutch masters. The picture that fascinated her the most showed a rowboat with a figure swathed in white and a coffin arriving at an isle of death. It was so sad. Across from it hung a painting of a woman draped in translucent veils. Sonia had never seen a woman more beautiful.

Her own room was big and uncomplicated. A dresser in aquamarine colors was complemented by an oval table and a Turkish sofa. On winter nights, an enormous white-tiled stove threw an eerie light. On misty midsummer nights she sometimes stood by the lace curtains and waited for the birds to start singing.

Sonia never let anyone suspect that she had an inner self. An only child surrounded by distracted adults, she grew up lively and seemingly invulnerable, a brave little person with big black eyes who never complained but rather smiled at fate.

Years later, when she became a mother and bounced Charles, her only child, on her knees, she would tell him very little of her own childhood. The boy would grow up without Russian lullabies and Russian proverbs; he would be denied the tales of the fire serpent and of Petrouchka. But Sonia would teach him her own sense of the horror of telling lies. Anna demanded absolute truth from Sonia and, with Fraulein Piltz, instilled a total respect for honesty. Mademoiselle Turvoire was less scrupulous when it came to creative fantasizing and occasionally indulged in impulsive embellishment. Sonia would say she had always believed in her own innate happiness. "Ah, Russian women," she told Charles once, "how strange, how sweet. What softness, what abnegation." The adult son wondered whether she was being sarcastic and self-deprecating. She would always be sensitive about people examining her papers. For, beneath the person of Sonia Terk lurked the name of Sarah Stern, indelible reminder of her adoption, of the distant father and mother that had given her up—to give her a better life, as she had always been told.

* * *

Sonia was twelve years old before she knew any girls of her own age. To give her a chance to escape her tutors, Henri and Anna enrolled her in St. Petersburg's best *pensionnat*. Chela Friedlandskaya became Sonia's first friend, Maria Oskarovna her first confidante. Maria, who was a few years older than Sonia, was the granddaughter of Oscar Kourland, a Frenchman who had emigrated to Russia to escape the French Revolution. Maria—"M.O." in eighteen-year-old Sonia's diary—would remember Sonia as something of a gossip, "always ready to say nasty things so as not to be considered a Miss goody-goody."

Sonia entered the *lycée* at thirteen and, without losing all of her spontaneity, began to imitate her best friends, Chela, Katia, Tania, Olga, Wanda, and Masha. At fourteen, she attended her first costume ball, wearing a "Turkish" costume of her own confection. A picture was taken of her in her outfit: a graceful, mature girl watching the camera with an inquisitive gaze and an air of poised assurance.

Returning from a business trip to Stockholm, Henri brought her a book about Swedish folklore. The illustrations reminded her of Ukraine. She liked to draw, and Mademoiselle Turvoire suggested that a pretty sketch or perhaps a watercolor painting might be an appropriate gift for the Terks on the occasion of their twentieth anniversary. Sonia applied herself and at the anniversary celebration presented Anna and Henri with a painting of a bouquet of flowers, dutifully signed Sophie Terk. "To my beloved parents, two people I can only admire," read her accompanying card. It was the first time she called them "parents."

4

The Pleasure of Your Company

Sonia would not credit Mademoiselle Turvoire with making her discover the pleasures of sketching. Henri had opened her senses to the arts, buying and discussing the works of Repin and Levitan and showing her the treasures of the Hermitage. She would also speak with gratitude about two of her teachers, one a Hellenist who gave her a taste for Greek culture, the other a Miss Bernstein, who recognized talent in Sonia's drawings.

At fifteen, Sonia received a year-end medal as runner-up in her class. She attended a costume ball dressed as an Egyptian princess and borrowed a string of real pearls from Anna. Henri's graduation gift a year later was a hefty history of philosophy. Spinoza was her favorite. Henri pointed out that Spinoza's lively intellect, logical vigor, and pantheist arguments caused him to be expelled from his synagogue with all the curses in the Book. Sonia began to read voraciously. When one of her brothers came for a visit, he borrowed Spinoza's *Ethics*. She would never forgive him for not returning the book.

Henri and Anna were profoundly uncertain in their attitudes toward their faith and toward Russia, and their ambivalence would

influence their adopted daughter. Unlike less fortunate Jews of the Pale, the Terks never had to choose between helplessness and revolution, between destitution and a new life in distant lands. Henri was too successful to opt for the notion of a Yiddish state on Russian soil as proposed by the Bund, the Jewish socialist organization. More to his liking was the idea of weaning Jews away from orthodoxy, Zionism, and devotion to the Hebrew language that Lenin's new Social-Democratic party envisaged.

Like Henri and Anna, Sonia would applaud Jewish innovations in the arts and politics, but steer clear of any commitments to "Jewish life." She never experienced the cycles of repression and relaxation that created and re-created Jewish ambivalence toward the Russian homeland. Images of ravaged homes, burned synagogues, and smoldering Torah scrolls—the notorious Easter 1900 pogrom in Kishinev happened less than 250 miles from Gradizhsk—were never seared into her consciousness.

For the summer of 1900, the Terks went abroad. With their fifteen-year-old adopted daughter, they traveled through Germany, Switzerland, and Italy. Munich was remembered for the Pinakothek Museum and its strawberry tarts, Zurich for its bridges and chocolates. Coming to Italy's alpine Lake Maggiore from the leaden landscapes of industrial Germany, Henri rented a yacht and had the captain head for the Borromean Island. As they approached, Sonia recognized with a chill the melancholy mood of *The Isle of Death* painting that hung in Henri's study at home. The painter was Arnold Boecklin, Henri explained, a Swiss artist who now lived near Florence.

"Are we going to see him?" she asked.

Her uncle smiled and said Boecklin was now a famous old man.

Sonia fell in love with the sunny beauty of Florence. Anna and Henri took her to the Palazzo degli Uffizi. The museum of their honeymoon contained the world's most famous paintings, from Michelangelo and Titian to Raphael and Caravaggio, Rembrandt and Holbein. Sonia thought the clear, light colors of Veronese's paintings were the prettiest she had ever seen.

Henri did not take Anna and Sonia to Fiesole, where Boecklin lived, because another great painter was waiting to see them in Berlin.

Max Liebermann was a fifty-three-year-old painter of cosmopol-

itan reach who had lived in Paris and studied with Millet and other masters. He was president of the new *sezession* movement. "Resistance to change comes from two sources—the vested interests of academies and schools, and the unwillingness of a vast public to adopt to new ways of seeing," he said, showing his Russian visitors into his studio. "So we have seceded, founded our own association so we can organize our own shows."

Sonia had never been in an artist's studio, but Liebermann's was breathtaking. The windows reached to the rafters, and the view was of the entire Pariser Platz, with hansom cabs and lines of streetcars. Liebermann was a Berliner full of puns and sensual guile. He entertained the Terks with stories of unappreciative sitters, brewers, and the nobility. He told one about a swooning spinster who told him it must be wonderful to sit in this room and paint until the sun threw its last rays on the city. "God no, Fraulein," he answered. "At 5, I do the cash register!"

Leaning nonchalantly against the wall, Sonia surveyed Liebermann's pictures. He liked to paint women—laundresses, shepherdesses. On his easel he had a painting of fisherwomen mending a net. She wondered what he meant when he said people weren't ready to see things in new ways.

"If I'm teaching anybody anything, it's to adopt the impressionists' love of light, color and spontaneity," he said. When the Terks were ready to leave, he gave the young girl a box of colors. Sonia would never forget.

The summer residence in Finland was not the largest, but its location was the prettiest, and Sonia loved it. Like bleachers, pine forest on both sides of an immense lawn gave it privacy. Sonia strung a sheet between two tall trees at one end of the garden and, behind it, took off her clothes. Sunbathing had not yet become fashionable, but every morning when the sun was shining, she slipped behind her sheet and, from 9 to 12, exposed her body. Dressed in a proper turn-of-the-century bathing suit, she also went for invigorating dips. Swimming was not good for her heart, however, doctors told Aunt Anna.

On rainy days Sonia brought out her sketch pad. A drawing of a Finnish maid would survive along with a sketch of a nude woman on a seashore, dated 1901. The sketches reveal that she knew the

technique of chiaroscuro and how to balance contours. A photograph of her that year shows her with a Gibson girl hairdo and a lacy dress. Her direct look is both severe and challenging.

Like the nobility, Russian landowners, and members of the new industrial class, the Terks returned to the capital in September. The Imperial Theater opened, and the university term began. Sonia attended balls where hawk-eyed mothers, aunts, and sisters surveyed the year's crop of debutantes. At one such dance a boy cornered her in a corridor and kissed her. At another ball, she had fun turning the head of the boy who claimed to be in love with Masha but kissed her under the Boecklin in Henri's study.

In 1902, Sonia began her last year before matriculation. She was serious about art and felt she was lucky to have an arts instructor who understood and encouraged her. In a note to the Terks, Miss Bernstein, who after the revolution would become the founder of Leningrad's museum of popular art, counseled that Sonia be allowed to study art after her graduation. Noting that Sonia "must be allowed to breathe, and at her own pace," Bernstein suggested that Sonia study abroad.

The teacher's conviction both flattered and alarmed the Terks. It was a compliment to the breadth of their culture and to their upbringing that Sonia had the drive to explore her own talent, yet disturbing that she might be endowed with more than minor drawing room accomplishments.

Art lover and collector, aesthete, and a man of cosmopolitan views, Henri was not averse to Sonia's spending a semester or two in a fine arts school abroad. Anna, however, was more cautious. She couldn't quite see Sonia on her own. The girl was certainly orderly, but also impulsive. The discussions continued deep into the summer nights. Both Anna and Henri agreed that Paris was too worldly for their seventeen-year-old. If Sonia was as serious about her passion as she said she was, surely they could find an arts academy closer to home.

Florence was her next choice, but Italian was not one of her foreign languages. The fine arts schools of Wilhelmine Germany enjoyed a solid reputation in St. Petersburg. Henri announced he would consult his German acquaintances.

Katherine Krapivkova was a classmate of Sonia's who imagined herself an artist. Together, Sonia and Katia decided they could double

their chances of being allowed to go abroad if they told their respective families they would study together. Neither family approved outright—the Terks found Katia terribly knowing and mature—but allowed that if the two girls were properly chaperoned, they could spend the summer looking over arts academies.

As the girls laid plans, a young man fell in love with Sonia. He was Nicholas Genn, the son of Anna and Henri's gentile friends. She called him Koka. Their kisses were chaste, but when Sonia told Anna that Koka had whispered that he might not always be able to respect her virginity, Anna thought it was time for a talk about the facts of life. Sonia blushed and refused. Anna suggested a compromise: Why didn't Sonia *read* about it? Sonia gave in. To learn about the facts of life in a book was less painful. Once she "knew," her first response was to smile at her own innocence. Her second was to realize the dangers that lurked. To her diary she confided that she was happy Koka hadn't "abused my naïveté." The scouting trip to Berlin, Munich, and Heidelberg was set for the late spring of 1903. Before all the details were arranged, Sonia fell in love—safely—by correspondence.

The young man was an acquaintance from St. Petersburg who was finishing his studies in Madrid. Fears that friends might discover who he was prompted Sonia to identify him in her diary as Sergei only, and in her letters to caution him about keeping everything a secret. She, too, was learning Spanish that summer, but their increasingly fervent correspondence was in French.

They gave themselves mythical names. He signed his letters Peleus, the Argonaut king for whom Antigone killed herself. Where did she find her heroine, Rica? In her letters, she reproached him for being faithless, and in one missive assured him that if he returned she would smother him with caresses. "My arms hold you tight, tight, your Rica, your Sophie."

She tried to make Sergei jealous. A certain Mikhail who liked to take photographs of her was someone "I can tell everything to." Anticipating Sergei's return to St. Petersburg and the resulting gossip if friends found out about their long-distance passion, she told him that if anyone asked about her, he should merely say he had received a few postcards from her. "People are so indiscreet. You know I don't want people to know what is happening between us."

Dutifully escorted by one of Henri's spinster sisters, Sonia and

Katia traveled to familiar Berlin and Munich, Sonia furiously writing letters to Sergei in trains and hotel rooms.

Katia knew that Schwabing was the Montparnasse of Munich, that it was here, in fleeting encounters in cabarets, lofts, and beer halls, that they would meet Bohemian dandies. The aunt knew that Schwabing was full of seditious artists and, despite the girls' tearful pleas, refused to take them to any *künstler kneipe*. She also failed to find boarding arrangements suitable for her young charges and, with spiteful glee, discovered that the official art academies in Munich and Düsseldorf did not accept women as students.

The trio returned to St. Petersburg. The sudden marriage of Maria Oskarovna to Henri's younger brother made Sonia momentarily forget about foreign studies. To marry Maria and to assume a post as a government physician, Dr. Terk had abandoned his Jewish faith and embraced the Orthodox Church.

Sonia spent the summer at Novaya Kirka. She sunbathed behind her suspended sheets, discovered Nietzsche and psychology, and, with Anna, played hostess at lawn parties that lasted as long as the midsummer night's sun.

Moody clashes between Sonia and her adoptive parents sometimes dispersed the ennui of these Chekhovian stays in the country. When Henri complained one day that he couldn't read a list of art supplies Sonia wanted him to bring back from the city, she retorted that if he couldn't read her handwriting somebody would just have to copy her list.

"Am I supposed to copy you?" Anna cried out.

Henri threw down the list. "If I can't read it, I simply won't bring *anything* back."

"I don't care," snapped Sonia.

"What do you mean, you don't care," Anna said calmly. "You're less than honest."

"Nobody talks to me like that!" Sonia bolted from the veranda, ran up to her room, and in tears threw herself on the bed. Anna came to Sonia's door, summoning her to come down for tea immediately. But she refused.

Masha, the maid who had been with the household forever, knew

how to handle Mademoiselle. "Come downstairs. Your aunt is crying also."

"Why's *she* crying?" Sonia sniffled. "It's ridiculous. She takes everything so tragically."

There were days when Sonia and Anna took long walks along the shore, confidantes, the best of friends. They talked about people they knew, about mixed marriages. Sonia told of a girl she knew whose father was born of a Jewish father and a Russian mother, and "yet told incredibly vulgar stories about Jews."

Koka came out with his parents. He had the nerve to tell Sonia that a friend of his, Alexander Smirnoff, wanted to meet her. She consented, of course, and at the appropriate afternoon tea saw a grave young man come toward her and solemnly kiss her hand.

She thought of Smirnoff as an older person, someone from Anna's entourage. He was, in fact, the son of a lady friend of the Zacks, an intellectual who, despite his upturned nose and somewhat squat physique, was said to have a brilliant career ahead of him. By the end of the tea, Sonia had been told that Alexander was only two years her senior.

Sonia turned eighteen that November, and felt herself destined for a grand future.

5

The Silver Age

The first decade of the century was a period of such glittering accomplishments for St. Petersburg that it was to become known as the Silver Age and the Russian Renaissance. The ferment of activity extended to politics and science, but it was in the performing arts that the city equaled any other in brilliance, audacity, and vision. Russian artists traveled frequently, freely, and widely, and the influence of their music, literature, ballet, and theater would, before the decade was over, set audiences on fire throughout Europe and the Americas.

Painting was the exception. Despite the outstanding art treasures at the Hermitage and three-hundred private collections, where even the works of Henri Matisse, Pablo Picasso, and Amedeo Modigliani could be seen, Russian painters seemed incapable of rising above academic provincialism, hesitating between realistic historical painting, a forced archaism, and playful imitations of rococo. As Max Liebermann had said in Berlin, resistance to change came from the academies and schools, and from people unwilling to see things in new ways.

The most famous Russian artist was Ilya Repin, a Ukrainian who

had started as an icon painter and whose works graced the Terks' parlor. A man now in his late fifties, Repin had twenty years earlier helped form the influential association of young painters called the *peredvizhniki*, or "itinerants," for the roving exhibitions they organized in an attempt to bring art to the masses. Because the Imperial Academy of Arts had refused to hang paintings treating mythological subjects, the *peredvizhniki* opposed the mawkish prettiness of official art and instead decided to make the fears and conflicts, the hungers and barely formulated yearnings of the huge country's people the themes of their art. They painted scenes denouncing abuse and inequality, images that depicted popular ignorance and misery. Czar Alexander III, who rather gloried in the idea of being of the same rough texture as the great majority of his subjects, had been a supporter of the movement. Repin's *Volga Boatmen*, exhibited in Vienna in 1873, had made the artist internationally renowned. Advised by Leo Tolstoy, who saw in the painter a perfect illustrator of his own reformist ideas, Repin chose subjects of epic sweep and followed up with *Cossacks Defying the Sultan* and a painting that expressed a deeply felt social unease, *They Did Not Expect Him*, showing the unanticipated return of a political exile from Siberia.

There is a measure of irony in the fact that the summer Sonia asked her aunt and uncle's permission to attend an art school in a western university, the vitality of the Silver Age was about to invigorate painting.

It would be two years before Sonia met Sergei Diaghilev and sixteen years before she would design sets and costumes for his ballet company, but in 1903 the future impresario and animator of modern ballet was electrifying the St. Petersburg art scene as publisher of an art magazine and as organizer of seminal exhibitions of western art.

At thirty, Diaghilev was a monocled nobleman of unusual appearance. He had a large head that seemed too large even for his massive body, dark, impressive eyes, a small, neat mustache, and a streak of white through his dark hair that earned him the nickname "Chinchilla." His hands were full of rings, his tie held in place with a huge black pearl. Fond of boys, showy ideas, and exquisite cuisine, he had spent the modest fortune he had inherited at twenty-one on paintings and trips abroad, and was living beyond his means with his old wet nurse in an apartment on the Fontanka. Without being pro-

ficient in any of the arts, he had a creative appreciation for them all. His greatest gift was the ability to charm the nouveaux riches and princesses hankering for the social spotlight into bankrolling his nervy taste for the avant-garde. He could kiss a lady's hand in such a way that she felt *she* was curtsying a monarch.

Around Diaghilev and the lavishly printed *Mir Iskustva* (World of Art) magazine gravitated cultivated amateurs, students, and artists joined by a mutual opposition to what they saw as the stale, over-realistic tendencies of the itinerants. Alexander Benois, the descendant of a distinguished family of Venetian and French artists who had emigrated to Russia a hundred years earlier, was the center of the group. Benois' father was architect of the Imperial Court; his uncle Alberto Cavos had designed two opera houses in St. Petersburg, as well as the Bolshoi Theater in Moscow; and his nephew Evgenei Lancerey specialized in painting theater sets. The Benois household was always full of painters, sculptors, and architects.

A friend of the Terks and a charter member of the *Mir Iskustva* group was Leon Rosenberg, the prim, redheaded son of a respected Jewish merchant family. After marrying the daughter of the *peredvizhnikis'* financial backer in 1905, Rosenberg had changed his name to Leon Bakst and distinguished himself as a portrait painter. Valentin Serov was a former student of Repin who painted impressionist landscapes; he had just been commissioned to paint a portrait of Czar Nicholas II. Within a few years, Diaghilev would have Benois, Bakst, and Serov design the sets and costumes that would enthrall Ballets Russes audiences.

The patrons of *Mir Iskustva* had been Savva and Elizaveta Mamontov and Princess Maria Tenisheva, the wife of a millionaire who had the monopoly of all passenger steamers on Russian rivers. It was in Tenisheva's "conspiratorial" apartment that, in 1899, the magazine had been hatched at a meeting where Diaghilev brought her and Mamontov together with Serov, Benois, Bakst, Vrubel, and Henri Terk's favorite painter, Levitan. The fortnightly magazine had been in existence less than two years, however, when business losses caused the Mamontovs to pull out, and Tenisheva, alarmed at the notoriety of the people surrounding Diaghilev, withdrew her support. Undaunted, Diaghilev asked Serov to approach the czar and ask for a subsidy. At Czarina Alexandra's insistence, Nicholas agreed. His

annuity of 10,000 rubles was spent introducing Paul Cézanne, Claude Monet, Edgar Degas, Alfred Sisley, and Henri de Toulouse-Lautrec to *Mir Iskustva*'s readers.

If Russia lacked outstanding painters, it had fearless collectors. Surpassing Mamontov in enthusiasm and daring were a trio of Muscovites. Pavel Tretiakov, Bakst's father-in-law, had amassed the first private collection of foreign paintings, and Ivan Morozov had bought the works of Monet, Cézanne, Gauguin, and Matisse, and for 10,000 francs, Renoir's *The Actress Samary*, which had fetched 1,500 francs in 1875. But it was Sergei Shchukin whose passion for French impressionists and postimpressionists resulted in the largest and most important collection in Russia.

A small man with piercing black eyes, Shchukin filled his Moscow mansion with art at the rate of one major canvas a month. On Saturday afternoons he opened his house to the public. No one was quite sure where Shchukin's money came from, but it was known he was in the business of buying and selling things that were much in demand, from the best tea to the most sumptuous textiles. Presumably he bought them cheap and sold them dear, for his fortune appeared to have no limit. Muscovites flocked to stare at his amazing hoard, which by 1910 included thirty-seven Matisses, fifty-four Picassos, twenty-nine Gauguins, twenty-six Cézannes, and nineteen Monets.

During this same period, young ladies were winning their independence. Studying abroad was what every budding artist, male or female, aspired to. Marie Bashkirtseff had moved to Paris when she was twenty and, inspired by Manet, painted intense, appealing portraits and sentimental genre scenes—only to die of tuberculosis at twenty-four. Her canvases were now being collected in St. Petersburg, Paris, and Nice. Sonia had read Marie's diary, published posthumously after the French government had acquired one of her paintings.

Natalia Goncharova, three years older than Sonia, was in Paris studying Cézanne and Matisse. Marianne von Werefkin, a Muscovite who had studied with Repin, was living a Bohemian existence in Munich with Alexei von Jawlensky, a nobleman who had renounced his military career to become an artist. Together Werefkin and Jawlensky had already been to Paris and discovered Vincent van Gogh and Cézanne. Munich was also the city their friend Vasily Kandinsky

had chosen. It was rumored that he, too, lived with a woman painter, a student of his, Gabriele Munter.

Whether Anna believed the commanding artist colonies of Berlin and Munich might prove too beguiling for her eighteen-year-old daughter or she knew of the Bohemian lives young women like von Werefkin and Munter were leading, she decided Karlsruhe was more suitable. Karlsruhe had a renowned fine arts academy, and besides, it was only an hour by train from Heidelberg and Anna's sister and brother-in-law. Katherine Krapivkova would not be going. Katia had decided to abandon painting and to marry her bad-boy officer. Sonia didn't see how she could say no to Karlsruhe.

In the meantime, Alexander Smirnoff sent his visiting card to Anna requesting her permission to take her daughter out. Sonia was less than enthusiastic, but Anna pointed out that besides being a scholar who had already attracted attention in university circles, Alexei was a gentleman.

Alexei and Sonia's first date took them to the offices of *Mir Iskustva* to glance through back issues for reproductions of the painters that Henri Terk admired—Levitan, Boecklin, Korovin, and Ivan Shishkin, who had just died. They had tea a week later on the Nevsky Prospekt. Behind Alexei's flushed countenance and diffident language, Sonia soon discovered that she was the object of burgeoning, if timorous, affection. Perhaps it was just as well that she was leaving in September.

Alexei pledged his devotion and, with Anna and Henri, came to the railway station. To his chagrin—and Sonia's amusement— Koka showed up on the platform with a bouquet of flowers just before the departure. Impulsively, Sonia kissed her admirers on the cheek and promised everybody she would write. Traveling alone for the first time in her life, she set out for Karlsruhe, making a stopover in Berlin to buy an entire new wardrobe.

Fluent in German since the age of seven, Sonia registered for the 1903–1904 school year and enrolled in a class taught by Ludwig Schmitt-Reuter. To mark the occasion of her emancipation, she decided to begin a new diary. "I begin to breathe," she wrote in Russian on the first blank page.

Built around a citadel with streets fanning out from the castle

tower, Karlsruhe was, like nearby Heidelberg, devoted to higher learn-ing. Besides the academy of fine arts, the capital of Baden-Württem-berg possessed a music college and the Fredericiana technical college, the oldest of its kind in Germany.

In the arts the city on the edge of the Black Forest looked naturally toward Paris. French discernment had guided the taste of the princely houses of Baden and Zahringen, including the passions of Caroline Louise of Hesse that had richly endowed the state museum. Besides works by Rembrandt, Ruisdael, and Jordaens and Cranach's graceful *Virgin Mary*, the *Kunsthalle* contained rococo portraits by two of Mme. de Pompadour's protégés, Boucher and Chardin, as well as the minute delicacies of the Italian baroque masters Albani, Batoni, and Dolci.

Immediately, Sonia made friends with a graduate music student and his wife. Arnold Schoenberg was a twenty-nine-year-old Viennese composer who had married Mathilde von Zemlinsky, his teacher's sister. In his music he was a revolutionary.

Karlsruhe was an escape from in-laws for Schoenberg. In Vienna, Mathilde and he had lived with brother-in-law Alexander von Zem-linsky, a conductor who pounded away at the piano all day.

"Arnold cannot compose when other music is going on around him," Mathilde explained.

Sonia liked the Schoenbergs. Like herself, they were nonprac-ticing Jews. She wasn't sure she liked the spare strands of his string sextet or his symphonic poem *Pelleas und Melisande*, but he was a patient explainer. The Frenchman Claude Debussy, Sonia's compa-triot Igor Stravinsky, and Schoenberg were trying to accomplish in music what the new painters were attempting in the plastic arts: to break down and remold new and often-mystifying forms.

Transfiguring the concepts of the plastic arts was not what was taught in Schmitt-Reuter's class.

The teacher was a heavy-set man with a rebellious lock of hair on his forehead who believed that drawing formed the basis of all the arts—architecture, sculpture, painting, and many of the crafts.

"Since classical antiquity," he thundered in class, "only three things have happened. First, Leonardo da Vinci happened. The most varied and accomplished artist of the Renaissance taught us to draw like no other man had done before. His incomparable drawings can

only humble a modern artist. Michelangelo, whose crosshatching tech-
nique recalls the chisel, was said by Varesi to have destroyed most of
his first ideas because he didn't want posterity to know the extent of
his labors. Still, it was Michelangelo's fame that hastened the rec-
ognition of the drawing as an independent means of expression."

When students asked what the third "happening" was, Schmitt-
Reuter answered, "Raphael." If someone dared ask why, the teacher
would say that Raphael was merely the greatest natural drafter of all
time.

Sonia loved it. To master human anatomy, she followed medical
school lessons and didn't hesitate to join interns at the city morgue
so she could draw the musculature of cadavers. "Schmitt-Reuter was
a great teacher," she would remember. "He gave me solid notions,
and his attitude toward art had nothing to do with academism. He
hated what is haphazard, facile and vague." Out of class, da Vinci,
Michelangelo, and Raphael reverberated in her sketches. She devoted
herself almost exclusively to portraits and self-portraits, the latter
executed with a mirror.

George Tappert and Adolf Erbsloh were fellow students with
whom she became friends. Five years older than she, Tappert was a
Berliner who was in his senior year and couldn't wait to get away.
Important things were happening in Berlin and in Worpswede, an
artists colony near Bremen, he said.

Because there were women artists in Worpswede, Sonia wanted
to know more. The painter Paula Becker and the sculptor Clara Wes-
thoff had settled there after traveling separately and together to Paris
and London. To mollify her parents in Bremen, Becker had completed
a teacher's training program, but painting was the only thing that
interested her. Marrying Otto Modersohn, a Worpswede artist, had
allowed her to do just that.

Westhoff had been a student and a lover of Auguste Rodin in
Paris two years earlier when the Austrian poet Rainer Maria Rilke
came to Paris to do a short book on the famous sculptor. Westhoff
and Rilke had fallen in love and married.

"Not much of a marriage," Tappert said with a grin.

Sonia wasn't sure she wanted to know more, but George contin-
ued. Clara Westhoff had given birth to a little girl, but Rilke was too
fitful to settle down, and was living in Paris, still interviewing Rodin
for his book.

"What kind of art are the two women doing?" Sonia asked.

George didn't know, but promised to find out the next time he went to Worpswede. Sonia was happy simply to know that other women were getting on with their work.

Adolf Erbsloh was born in New York of German parents who had returned to the homeland when he was seven. Like Tappert, he couldn't wait to get away, and in the meantime he made fun of their teacher's classicism. He wouldn't be going to Berlin or Worspwede, but to Munich where he'd join the *sezession* painters. "I know Liebermann; he gave me my first box of colors," she said.

Erbsloh pretended not to be impressed.

"I visited him in his studio in Berlin, on Pariser Platz." She didn't bother to mention that she had been with Henri and Anna.

To get back at her, Adolf howled in derision when she happened to mention that her father owned a painting by Boecklin.

"But that's kitsch!" he cried.

The twenty-three-year-old Erbsloh said *real* art demanded a view from the edge. Real art questioned assumptions. It was full of conflicts, fears, and spiritual yearnings. And it was seditious—so subversive, in fact, that it had caused Kaiser Wilhelm to deliver a speech on "the art of the gutter," a phrase every intellectual now used as a badge of honor.

"Liebermann was one of the oldtimers who, after finding tradition-bound organizations unwilling to show their works, had helped found the breakaway association."

"I know." To her it sounded like a combination of the *peredvizhniki* and the *Mir Iskustva* back home.

Sundays were sometimes spent hiking with other students, boys and girls together. Germans loved to walk in nature and the *Wandervogel* movement was part of a wider self-assertion of the young, a reaction against society's moral stiffness and repressive politics. Sonia met young Russians who were not all the sons and daughters of St. Petersburg's best families. Several were Ukrainians, ardent and outgoing, who on tramping up a hill would break into enthusiastic if off-key renditions of revolutionary songs. They challenged Sonia to smoke a cigarette. Bravely, she took three puffs. At a shooting range, they had her try out a rifle. She was good at it. One of the young men kept her company on a visit to Heidelberg.

She took some of her new friends to meet the Schoenbergs, and

in listening to the arguments realized that composers, too, were rebelling against traditional and familiar forms.

In the spring of 1904, Sonia found a note in her mailbox from Erbsloh with an address in Munich. He had decided he couldn't be bothered with graduating.

When she returned home for the summer, there was no *Mir Iskustva*. There was war.

6

A Young Lady of Independent Means

The forward thrust of the czar's interests in the Far East in general and his private financial interests in Korea in particular were partly responsible for the war that had started in February with Admiral Togo's sneak attack on Port Arthur.

Since then the government's policy had been somewhat confused. While the Japanese fleet was lying off Port Arthur unchallenged, the Japanese army had landed and cut off the garrison from the main forces in Manchuria. There were rumors that the czar was about to order the Baltic fleet to sail around the world to the Far East.

Everywhere Sonia went, the war was the subject of passionate discussion. Reform-minded people of the Terks' circle almost wished for a Russian defeat or at least for a nonvictory that would force the czar to listen to progressive voices. If Jews were divided between various forms of socialism and the new international zionist movement, Henri was a fervent believer in challenges, even for the czar, and in revolution originating in the urban professional classes. Henri enthusiastically backed the *zemstvo* movement, the most vital and creative force

44

in Russian society and the focus of all genuine liberalism. Like D. N. Shipov, the chairman of the Moscow district *zemstvo*, Henri dreamed of a prosperous Russia at peace with herself and worked quietly to help achieve representative government.

"It's always difficult to be reasonable," Henri liked to say. To the radicals of various stripes, men like Shipov and Terk seemed to be a brake on the revolutionary transformation of society; to the czar and his ministers, the *zemstvo* movement seemed a brake to modernization from above, modernization by imperial fiat. Henri also knew that Czar Nicholas considered all who opposed him, regardless of their views, as malicious conspirators.

Sonia's two suitors, Koka and Alexei, were in the army. Several of her old classmates had joined up to become nurses. For a moment she wondered whether she shouldn't follow their example, whether frontline nursing wasn't a way for her to be active, "to live physically," as she noted in her diary. In a sentence that showed she was aware both of the discrimination Jews faced in government service and of her own position as someone for whom exceptions would be made, she added, "I know they will take me, even though I'm Jewish."

Koka and Alexei wrote her letters, Alexei progressing from the formal "Dear Sonia *Illitchna*," to the very personal "Sonia darling." She answered, but neither Koka's easy familiarity nor Alexei's highbrow musings colored her cheeks as had the inflamed missives from Sergei the year before. Koka's letters were lessons in moral behavior for home-front women. Alexei might have been the first to tell her that her eyes were not black but sparkled with deep emerald reflection, but his expressions of sentiments were nevertheless bashful and hesitant. It gladdened him, he wrote in one of his epistles, that her "kelly eyes and marble traits had also known clouds."

Sonia spent the summer months in Novaya Kirka exchanging letters with a German her diary identified only as Hoffmann, but whose photo, she assured him, she carried near her bosom. Her new admirer had a gift for parody. He wrote pages lampooning himself. Other letters evoked a ride in a hackney cab, hands that touched, and he begged for urgent replies. There was a letter from him every day.

To forget about war and distant admirers, she concentrated on

her art. She made a lovely charcoal drawing of Anna, capturing the mother's patrician nose, clear eyes, and reserved grace.

Sonia sketched herself in three-quarter profile in sepia ink. The drawing portrayed her as a comely young woman rounded in the cheeks and with her hair thrown up in a tight bun as if to contradict the wistful gaze she cast at her mirrored self. She drew nudes on a beach in pencil, and in gouache painted four figures at a table, a quick study of barely discernible faces above a kerosene lamp. She drew Philomena, the Finnish maid, farmers, little girls, anyone who would sit for her. The drawings were full of crosshatching à la Michelangelo and shadings reminiscent of Schmitt-Reuter. When she showed her work to Miss Bernstein, her old teacher told her there was no doubt Sonia had discovered her vocation.

Sonia was happy to return to Karlsruhe for a second year, and noted in her diary that she was beginning to understand what people meant by *joie de vivre*. The Schoenbergs, Tappert, and Erbsloh were gone, but she soon had a new painter friend. Alexander Kanoldt was a native, the twenty-three-year-old son of a Karlsruhe painter. Like Tappert and Erbsloh, he couldn't wait to get away. He, too, insisted the only place to be was Munich. Painters in the Bavarian capital didn't give a damn about "respectable" tastes. They wanted to explore the connection between life and conscience.

Tappert had spent a month at Worpswede and gave Sonia a five-page account of Paula Modersohn-Becker. Influenced by Cézanne's simplicity and by Van Gogh and Gauguin's chromatic intensity, the painter simplified her forms, strengthened her drawings, flattened out her space and began to use bold areas of brilliant color. She wasn't interested in what was happening in Munich, but preferred to struggle alone and make her own discoveries.

Letters from home were gloomy. In roundabout ways, Sonia learned that her elder brother, the first of the Stern children she had barely known, had died in the war. Genn and Smirnoff were all right—Alexei back in St. Petersburg—but both intimated that they were less than optimistic about a final Russian victory.

In January 1905, headlines in the local German newspapers told of 1,000 Russian workers killed when police opened fire on a peaceful

demonstration in front of the Winter Palace. The next letter from Alexei described the scene, the panic, the blood in the snow, the wounded and the dead. The demonstrators had come to appeal to Czar Nicholas, more in loyalty than in revolt. A priest had walked at the head of the procession, and everybody wanted to know whether Father Gapon was an unsuspecting innocent or a provocateur. It was no secret that Czarina Alexandra and maybe Nicholas himself had fallen under the spell of a debauched monk named Rasputin.

Kanoldt also talked about revolution, revolution in the arts. In a former butcher shop in Dresden where work and talk went on all night, a painter named Ernst Ludwig Kirchner had formed a group called *Die Brücke*, meaning the bridge to the future. Across this bridge, the group's manifesto read, "all the revolutionary and surging elements" of German art would find a path. These were artists who took their inspiration from Van Gogh and from native African and Polynesian art. They preferred the Gothic to the classical that Schmitt-Reuter taught. They wanted painters to communicate with jolts of color and shapes that shook people up instead of flattering their sense of cultural conformity. Their portraits showed people in awkward, half-dressed poses that made the onlooker feel like an intruder. Their colors were high and strong, as aggressive as their subject matter. Because Kirchner and his friends identified personal truth with candor of expression, some people called their work "expressionist."

Kanoldt showed Sonia reproductions of Cézanne and Georges Seurat and Seurat's friend and chief theorist, Paul Signac.

Cézanne was an old man now, but he still sat for hours in the sunshine before landscapes in southern France in order to build up a world of planes and volumes on his canvases. When he was lucky, he found the red and yellow, the blue or violet, that would define each object and clarify its relations to all other objects, whatever the actual color in nature. He found the edge of a hill continued in the bend of a tree branch, the horizon of an aqueduct repeated in the edge of a pasture. Artists should keep the cube, the cone, and the cylinder in mind when they worked, he said.

Seurat and Signac were painters who pleased Sonia's sense of neatness and order. Seurat studied volumes and light, and was trying

to discover an inner logic in lines and colors. He didn't mix pigments of color on a palette or combine them with a brush on the canvas. He believed that small dots, all the same size, laid precisely side by side, would combine themselves to recreate the full range of natural colors in the viewer's eye. Signac, who was wealthy enough to sail the Mediterranean in season and had introduced Matisse to the bright light of the Riviera, believed brilliance of colors and abstraction were more important than being able to copy the exact appearance of things.

* * *

It was not the long talks with Kanoldt, however, but the reading of a book about Edouard Manet and his circle of painter friends that made Sonia decide that she, too, would have to leave. *Manet und Sein Kreis* was written by the noted Berlin critic Julius Meier-Graefe. "Art is a celebration of life," was the repeated catch phrase of this author who had the gift for striking images and described Manet's canvases as "jubilant dances, joyous in their colors." It was the discovery of French painters during an 1889 visit to Paris that had decided Meier-Graefe's career, and a return to "the capital of modernity" in 1901 that had made him realize the magnitude of what the impressionists had wrought.

Sonia closed the book, convinced that for her the place to make her commitment to art was Paris.

She returned home as Russia suffered its worst setback in the war. After a voyage lasting seven months, Admiral Zinovi Rozhestvensky's Baltic fleet rounded the south coast of Korea on the final leg to Vladivostok, when the Japanese Navy, superior in speed and armament, attacked. Two-thirds of the Russian fleet was sunk, shattering all Russian hopes of regaining mastery of the sea.

The defeat made people on the homefront question the czar and his conduct of the war. The *zemstvo* constitutionalists were becoming more outspoken in their political demands. Strikes were on the increase and there were farm riots in several provinces. In St. Petersburg there was now talk of the czar's accepting the proffered mediation of President Theodore Roosevelt.

* * *

Henri and Anna were less than persuaded when Sonia announced that Paris was next. Art was essential to her, she said. Besides, she added quickly, she would be twenty in November.

They told her she should think of marriage.

"I'm not in love with anyone, let alone engaged," she said.

"Perhaps if you were home more often," Anna suggested.

"All the young men are in the army."

The argument turned to money. Sonia said she would find a modest *pension* in Paris. They reminded her who had paid for her education. As a dutiful daughter she thanked them and managed to insinuate that it would be silly to waste that education.

They made her understand that until she was married, she was in their custody. To put it more plainly, Henri said, she would not come into any real money until then. His will was simple. Besides a legacy to Marie Kourland Terk, his sister-in-law, Sonia was their only heir.

"On your wedding day, you will come into a substantial estate," Henri said in his most lawyerly voice. If she remained a spinster, she would eventually inherit everything, but only after Anna and he passed away.

With a nod toward Anna to acknowledge that what he was about to say was his wife's idea, he added that they had of course taken into consideration the fact that Sonia would be come of age next year. "To give you an income until you find a husband, I have—we have bought apartment houses in your name here in St. Petersburg."

When she asked where the houses were in the city, he replied that they consisted of new apartment blocks in an area she had probably never seen. "Suffice it to say this real estate will give you a monthly stipend."

She thanked them both, but a deeper swell of gratitude was directed at Anna. Sonia had never been close to her stepmother, but emotionally they were both composed, deliberate, and reticent when it came to divulging their innermost thoughts. Perhaps Anna had suggested to her husband that they make Sonia self-sufficient because of the realization that her daughter was, despite her lovely eyes and spirited character, less than beautiful and that her destiny therefore was an interior one—a life of her own.

Perhaps Sonia sensed it herself. Her adolescence had been a subtle withdrawal from the formalities of the parlor toward an inner life of fantasies and reflections. Late in life, she would write that she had never let anyone suspect her emotional depth. "I was an extremely energetic character, invulnerable, almost unreal, someone with an innate sense of happiness."

Boulevard du Montparnasse

"We all went to Paris." Not only Americans, as Stephen Longstreet would write, formed a "steady, mounting migration of geniuses, fools, and drunkards, Wesleyans, cultists and jazz musicians." The summer Sonia managed to convince Anna and Henri that two years in Germany surely had matured her enough to let her go to the capital of modernity for one year, the trickle of artists who had always gone to Paris was turning into a torrent.

Picasso may have made his first visit in 1898 and Jacob Epstein came from New York in 1902. It was in 1905 that Constantin Brancusi settled down in Paris after walking across most of Europe from his native Romania, that Julius Pinkus, who changed his name to Pascin, arrived from Bulgaria, and that Amadeu de Suza Cardoso and Eduardo Vianna came in from Portugal. From Bialystok, Poland, via New York, came Max Weber, to be followed a few months into 1906 by Amedeo Modigliani and Gino Severini from Italy, Ludwig Meidner from Germany, Juan Gris from Spain, Stanton MacDonald-Wright and Marguerite Zorach from California, and Fujishima Takeji from Japan.

Sonia stood with her luggage outside the Gare de l'Est, watching the bustle on Boulevard de Strasbourg with the startled eyes of a foreigner. The quick, chattering nasal French dissonances around her were not quite what Mademoiselle Turvoire had taught her. Sonia felt tongue-tied, but managed to get a cab to take her to Madame de Bouvet's *pension* at 64, Boulevard Port-Royal, where, at Anna's insistence, she would board with three other Russian young ladies.

The landmarks were both strangely unreal and postcard-familiar as the taxi crossed the Seine with the Louvre on the right and Notre Dame behind the Préfecture de Police on the left, and continued up Boulevard Saint-Michel to the Jardins de Luxembourg and on to the quiet residential prolongation of Boulevard Montparnasse. Years later, when Sonia became a Parisian, she would wistfully forget her first steps in the big city, Mme de Bouvet and even the names of one of her four compatriots. What she would never forget was the first evening's excursion to the Closerie des Lilas café with its pretty little garden where one of her new friends pointed toward a handsome man kissing a skinny young woman. In whispers Sonia was told he was the Russian anarchist and author Kilbachich and the girl Rirette Maître-jean, also a dangerous revolutionary.

Henri had been generous with the money he allowed her from her real estate holdings. The account he set up with a corresponding bank gave her a monthly stipend of 1,000 francs (nearly $2,000 in 1989 money).

Sonia spent money freely. "By temperament, I was thriftless, and I lent money to my friends, right and left," she would remember in *Nous Irons jusqu'au Soleil*, her slim, "as told-to" autobiography.[1]

With two of her fellow Russians, Marie Vassilyeva and Elisabeth Epstein, Sonia enrolled in the Académie de la Palette, one of four art schools on Rue de la Grande Chaumière, a stump of a street running from Boulevard du Montparnasse and Boulevard Raspail with its Dome and Select cafés, to Rue Notre Dame des Champs with its tiny art galleries. A quartet of forty-year-old classicists and a Russian woman taught at the Palette. Alexandra Exter, the third roommate at Mme de Bouvet's, decided to study at the Académie

de la Grande Chaumière. Alexandra was three years older than Sonia.

Georges Desvallières, a former student of Gustave Moreau, began his classes by telling his students there were only two subjects that a man's intelligence can dwell upon—art and women. Edmond Aman-Jean was an intimist painter who specialized in murals in official buildings; he was a friend of Seurat, the master of the postimpressionist movement and of symbolist poets. Jacques-Emile Blanche was the mundane portrait painter of Paris and London intellectuals who told his classes that an artist's supreme goal should be to penetrate the psychology of his or her sitter. André Simon loved what was left unfinished and had his class concentrate on sketching and painting nudes and portraits.

Desvallières was one of the founders of the Salon d'Automne. This annual fall show was newer than the Salon des Indépendants, but its criteria for inclusion were tough. The exhibition this coming October was particularly important, Desvallières announced in class, because he and the rest of the jury had chosen a group of young artists who all used distorted perspectives and strident, dazzling colors.

Mornings were spent in class, students all in white frocks sketching from models. After lunch, a period of review followed when Desvallières, Aman-Jean, Blanche, and Simon critiqued the students' work, often at cross-purposes. Like Schmitt-Reuter in Karlsruhe, Desvallières stressed the mastery of drawings. Anan-Jean was fond of aesthetic speculation and the theories of color, but demanded compositions that were both evocative and realistic. Blanche, the cultivated dandy, and Simon, the frumpy Bohemian, didn't mind if a student's sketch was slight as long as it captured mood and sensations. All things told, Sonia was not impressed.

Elizaveta Kruglikova was different. A woman twice Sonia's age, Kruglikova invited the Palette Academy's three Russian girls to her studio across Boulevard Montparnasse to meet various compatriots passing through Paris. Vassilyeva, who quickly "masculinized" her name to Vassilieff, was fascinated by famous people, and when one night Kruglikova announced Sergei Diaghilev would be stopping by her studio, Marie made sure she got to meet the great man.

Sonia was too shy to allow anyone to introduce her. Instead, she watched and listened, bewitched. The big man never took off his

pelisse, a singular mantle made of Siberian furs and belted with frogs and loops, and while he spoke he picked up a chocolate from a box put out by Kruglikova. Then he surrendered, emptied the box, made himself sick, and stayed all night to talk.

His goal was to show the wonders of Russian art in the West. "That is, pending a change in government," he said in his silken voice. When Kruglikova pressed him for details, he hinted that a peace treaty with Japan would curb the powers of the czar. This, in turn would lead to a western-style cabinet government. There were people—he couldn't name names—who would want a Department of the Arts in which, you guessed it, he would be Secretary of the Arts.

"In the meantime, yes, I am planning a vast exhibition of Russian painting and music at next year's Salon d'Automne."

"Past and present?" Kruglikova wanted to know.

Diaghilev sighed. There would be icons from the fifteenth to seventeenth centuries, portraits and landscapes of the eighteenth and early nineteenth centuries, Levitan, Serov, Vrubel. "But I cannot bring myself to exhibit the *peredvizhniki*—except Repin, that is."

Kruglikova took the girls to the circus and had them sketch clowns and trapeze artists, and to a *bal musette* in one of the tenderloin districts. Marie Vassilieff soon found herself dancing with a gigolo, enjoying the tawdry atmosphere and the strange argot of her demimonde partner. Sonia wasn't brave enough to let herself be invited to the dance floor. She also did not have the courage to imitate her teacher and take out a sketching pad. One of the apaches called Elizaveta a "voyeuse." The term had to be explained to Sonia.

At an excursion to a Montmartre *boîte* on Place Blanche, Sonia got her sketch book out. The result was a quick pencil drawing called *Chez Maurice*, the study of a bar interior with a dancer in a sombrero performing solo for an audience of seated and standing figures.

Art engulfed Sonia's waking hours, from classes at the Académie de la Palette to visits to galleries and public shows. Exhibitions like the upcoming Salon d'Automne were places where reputations were made, as Desvallières put it—places to keep in touch with the whims of public taste. The famous Dome and Rotonde cafés on Boulevard

Montparnasse resounded with noisy arguments about neoimpressionism, intimism, futurism, and cubism. Van Gogh had been dead for fifteen years, but Desvallières reminded the class that forty-five of his paintings would be at the salon.

The salon opened October 10. Scandal, public clamor, scorn and critical sneers surrounded the new works in the special *salle 7*. What Sonia saw there took her breath away.

An Italianate torso by the sculptor Marque, a small, conventional cupid done in the quasi-Renaissance style of Donatello, the greatest Florentine sculptor before Michelangelo, stood at the center of the room, surrounded by flaming landscapes and portraits. The pictures on the walls were a riot of colors. The skies were sometimes cream-colored; shadows were green, tree trunks red, and the paint laid on so thick on portraits that you could see the knife marks. Color shapes were related, rather than contained, by flowing lines. Each separate element was used to intensify the expressiveness of the whole.

Woman with a Hat illuminated one wall, one of four paintings by Matisse. The canvas was the standard bourgeois portrait, a three-quarter profile of the painter's wife under a spectacular hat. What shocked and exasperated the onlookers were the arbitrary hues of the face. A broad green stripe ran across the forehead and another down the bridge of the nose. One cheek was highlighted in yellow, the other was pinkish-red. The neck was red, and the flowers in the hat a bouquet of persimmon, violet, black, and maroon.

On another wall were portraits signed Georges Rouault, subdued in colors but grotesque renditions of circus folk and the demimonde. The other painters in the room were Charles Camoin, Jules Flandrin, and Albert Marquet, all friends of Matisse and students of Gustave Moreau. In the next room hung lean geometric paintings by André Derain, crude, stormy landscapes by Maurice Vlaminck, and quick, audacious nudes by Cornelius, or Kees, van Dongen. There was also a huge canvas of a lion signed H. Rousseau. The strangely naive and exotic picture was entitled *The Lion Being Hungry Throws Himself on the Antelope.*

The focus of the opening-day visitors' scorn and sarcasm was *Woman with a Hat.* The picture was not simply bad, they said, it was an insult; it violated not only the sitter's demeanor but the audience's concept of women. In the October 17 issue of *Gil Blas*,

the critic Louis Vauxcelles coined a name for the painters whose work seemed so offensively irrational. In a bemused allusion to the Italianate cupid by Marque at the center of room 7, he wrote that the effect was of *"Donatelli parmi les fauves"* (Donatelli among the wild beasts).

Matisse was deeply offended by the public outcry and swore he would not exhibit at the salon again. The other *"Fauves,"* however, were pleased to be called wild beasts. Their paintings might be condemned as meaningless daubs of a kind a retarded five-year-old might turn out, but they saw themselves as bold innovators, not tame academic sheep. Vlaminck, who shared a studio with Derain, was a racing cyclist who loved speed and crowds and also played the violin. The best thing society could do, he shouted, was to burn down all museums, "those refuse heaps of the past filled with dead images that stink like rotten fish."

Gertrude Stein was a wealthy young woman from San Francisco who also came away puzzled. The future poet, novelist, and critic who was to be the leading American expatriate in Paris and the subject of wide literary controversy thought the pictures were so strange that she quite instinctively looked at anything rather than *at* them at first. The short, solid-featured woman, who was already aware that emotionally and physically men had no attraction for her, was an inquisitive person and defiantly arty. She had a knack for saying things that mattered in a very few words. She had followed her brother Leo to Paris two years earlier, and together they started collecting modern art in their vast inner-courtyard studio in the Rue de Fleurus. The year before they had bought Cézanne's *Portrait of Mme Cézanne*. When the 1905 Salon d'Automne closed, they purchased Matisse's *Woman with a Hat*, reportedly for $100.

Sonia left the exhibition with a new sense of urgency—aroused, energized, and assailed by a thousand fresh ideas. She, too, was ready to turn visible reality into imagination, to make things express the inner world of her own feelings. The challenge was to express her own passion, not, as in the past, by illustrating a "subject," but by the eloquence of form alone.

She wanted to learn new techniques. One of her teachers introduced her to Rudolf Grossmann, a red-haired German who could

communicate his enthusiasm for etching, wood carving, and print-making. Sonia was an attentive student. Soon she knew how to do etchings, half-tone work, and dry point. Grossmann thought she was particularly good on copper plates, that she knew exactly how much ink to roll on.

The days weren't long enough. To paint was no longer a matter of looking to the motif, but of looking inward to an emotion that translated into paint. Sonia felt close to the *Fauves*, but in discussions with Vassilieff, Epstein, and Exter surprised herself by suggesting that the "wild beasts" weren't going far enough.

"We criticized Matisse; I found him too bourgeois, with the exception of his big still lifes," she would write in one of the last entries in her journal.

Two weeks before her twenty-first birthday, the diary became a casualty of her new vigor. She would continue her multiple correspondence—and meticulously classify and keep all letters—but decided she no longer had time for a journal.

Marie was a tiny, eccentric girl who kept saying Paris was the place she wanted to stay. "Russia, aristocratic St. Petersburg, and commercial Moscow, that's the boonies," she would scoff. Elisabeth was more reserved, less bowled over by Paris. She had already spent time in Munich and knew Kandinsky, Jawlensky, and Marianne von Werefkin; she spoke of going back to the Bavarian capital to study again.

Paul Gauguin had died in faraway Tahiti two years earlier, but friends at the academy spread the word that some of his Tahiti paintings, evoking the simplicity of life among primitive and unspoiled people, were to be seen at Ambroise Vollard's gallery in Rue Laffitte near the Boulevard des Italians. Vollard was the discoverer of Cézanne and the only art dealer who had supported Gauguin during his difficult last years. Sonia would never forget her first encounter with Gauguin's emotional paintings in Vollard's small gallery. Gauguin, she decided, could teach her one thing—to do away with details. At the other end of the boulevard she discovered the works of Pierre Bonnard and Edouard Vuillard, a pair of intimist painters much discussed in class.

Her classmates included Amadée Ozenfant, a native Parisian who

was to become famous in New York, and a pair of inseparable friends who were particularly interested in the quiet revolution of Bonnard and Vuillard. André Dunoyer de Segonzac and Jean-Louis Boussignault talked incessantly about Bonnard and Vuillard's use of glue, or plaster, paint that gave canvases the flat luminosity of fresco painting. When they weren't painting or talking about getting their own studio and submitting their work to the Salon d'Automne, Dunoyer and Boussignault were young men about town.

Alexei Smirnoff came to Paris. Sonia was not in love with him, but was happy to see him, to have him escort her, and to hear the details of the war's humiliating ending. Russia had surrendered its lease on Kwantung province and Port Arthur, evacuated Manchuria, ceded half the Sakhalin peninsula, and recognized Korea as being within Japan's sphere of interest. And the silliest thing was that the Japanese had taken the initiative in proposing peace negotiations through President Roosevelt. Exhausted financially and fearing a long drawn-out war, the Japanese had hoped the acute unrest in Russia would compel the czar to discuss terms, and their hope had proved right.

Nobody was happy with the political situation. The czar had agreed to an elected legislature, but granting a few political and civil liberties was too little too late for the liberals and too much for the landed classes.

Sonia introduced Sergei to Vassilieff, Epstein, and their teacher, and the group of young Russians soon included the poet Chuiko. Kruglikova dragged them all to fairs in suburban Neuilly and dared them to try the ferris wheel at the Trocadéro amusement park across from the Eiffel Tower. Parisians called the Eiffel Tower a leftover monument from the 1889 Universal Exhibition and said it marred the beauty of the city.

One night the group found themselves at the studio of baroness Hélène d'Oettingen, a pale beauty of Polish-Russian aristocracy who used masculine pseudonyms for her artistic activities—"Edouard Angibout" to sign her books and "Rich Guy" for her canvases—and lived with her painter cousin Sergei Jastrebzoff in a townhouse on Boulevard Berthier in the chic 17th *arrondissement*. "What French-

man can pronounce my surname?" he would shout, telling the Russians he had shortened it to Serge Ferat. His newest discovery was Cézanne.

Ahead of Dunoyer and Boussignault, Sonia rented her own studio. The place was in an artists' warren across the Boulevard Montparnasse at 9, rue Campagne-Première. Water and toilets were in the inner courtyard. To be close to the workplace, she left Mme de Bouvet and boarded with a Madame de Jeanne at 123 Boulevard Montparnasse.

Rudolf Grossmann lived behind the Notre Dame cathedral, at 11, Quai aux Fleurs. From his window, he had a charming view of Île St. Louis with its noble seventeenth-century houses and little streets. For her first try at copper etching, Sonia did the view from Grossmann's third-story widow, a wintry study of the tip of Île St. Louis with barren tree limbs, the Seine, and the first arch of the Pont St. Louis.

One day in February 1906, when she was climbing the stairs to Grossmann's apartment, a neighbor one floor below had left his door open. She could hear Grossmann speaking in German to a man one flight above, and to let them finish their conversation she allowed herself to peek into the apartment. What she glimpsed made her take a step into the hallway. Paintings exploding in colors and brisk, raw perspectives illuminated the living room walls.

"Won't you come in?" someone said behind her.

She wheeled around and saw a tall man in the doorway. "You must be Mademoiselle Terk. Hello, I'm Wilhelm Uhde."

For a second she didn't know whether to retreat or satisfy her curiosity. Monsieur Uhde—he pronounced his name *Ooh-day* in a genteel east German accent—had heavenly gray eyes, a patrician profile under a receding hairline, and an impish smile. A manservant appeared. "This is Constant," her host said.

Uhde was more than happy to show his treasures. "Yes, that's a Derain, and over there you have a Vlaminck. That's a Dufy, and that's my favorite, Braque."

Over Turkish coffee served by Constant, Udhe admitted he was not a painter. "Just a passionate collector." They established that he

had been living in Paris a year longer than she. Before she left, he disclosed that he had a gallery at 73, rue Notre Dame des Champs. Sonia realized she must have passed it a hundred times.

Spring came early that year. Wilhelm Uhde invited Sonia to dinner at the Ambassadeurs on the Champs Elysées, and for the occasion she bought a pale dress, white gloves, and a hat with a *gros point* veil. He ordered Moët et Chandon '94, "the year of my twentieth birthday." She calculated that he was eleven years older than she. Many years later, he would recall the evening at the Ambassadeurs, the scarlet carpet in the dining room, people strolling outside under the blooming chestnut trees. She would remember a droll story he told her about German bumpkins in Paris. A friend had sent a trio of young painters to see him. He invited them to meet him for lunch at a restaurant and saw them show up in rented tuxedos.

Uhde's latest discovery was a little old man, a second-time widower who was an amateur, or "Sunday," painter with a direct, simply and hauntingly naive vision. Henri Rousseau—everybody called him *Le Douanier Rousseau* because he was a retired customs agent—painted large and complicated pictures of elaborately fanciful subjects with a matter-of-fact, almost childlike technique and strong color. "I got him a commission from a wealthy divorcée, who chose the theme of the painting herself. He was admitted to the Salon d'Automne this year."

The commission Uhde had managed to get for Rousseau was a huge painting called *The Snake Charmer*. The picture depicted a nude playing the flute in a mysterious, fairy-tale jungle. "When I saw the painting on his easel for the first time," Uhde said, "I realized the legend of his artistic 'naïveté' was unjustified. He was concerned with the general harmony and balance of the large competition and asked my advice whether to make a tone darker or lighter, whether to suppress something here or add something there."

When Sonia asked if Rousseau hadn't had a huge picture of a lion at the show, her host's face lit up with gratitude.

Uhde was fascinated by Rousseau. The sixty-three-year-old widower meant his pictures to be totally real, each figure, leaf, flower, and tree measured in patient earnestness. The result was a kind of enchanted stylization. Despite his childlike naïveté, the sweet little man had total confidence in his ability as a painter. But he was afraid

60

of his pictures at times. "He tells me his hand is being guided by the spirit of his dead wife," Uhde sighed.

Rousseau lived behind the Montparnasse cemetery and, after two marriages, was courting a fifty-year-old laundress named Léonie, politely asking her parents for her hand. To his sorrow, Léonie's parents had said no, finding his paintings ridiculous. His modesty and the naive stories he told left people wondering. The account of his taking part in the 1864–1867 Mexican campaign on behalf of Emperor Maximilian was unverifiable and tended to diminish his other stories to the level of silly jokes. No one would take seriously the apparently truthful tale of how the gallant Sergeant Rousseau had saved a village during the 1870 Franco-Prussian War.

Uhde had tried to sell some of Rousseau's paintings. The artist wanted to get between 20 and 40 francs for each of them. Uhde bought advertising. *Le Figaro* published an insidious notice to the effect that a German art dealer was taking this clown Rousseau seriously. Nobody showed up.

"I'd forgot to put the address of my gallery in the ads," he said wryly.

Wilhelm Udhe was the son of a respectable Protestant family. Born in Friedeberg in der Neumark, in Prussia, he had been destined to follow his superior judge father with a law career of his own. He had started law school in Dresden, but felt listless. Then, during a stay in Florence, he discovered his taste for the arts and a need to write and to react to the stuffiness of Wilhelmine Germany.

"Three things have destroyed Germany," he smiled, "Luther, Goethe and Bismarck." His mother was from Posen, the former Polish city of Poznan, and he had a sister who couldn't wait to come to Paris.

Sonia found Willy—they switched easily to first names—to be both amusing and sincere, and candid enough to tell her there were lean intervals in his life. His family might possess castles in Thüringen, but financially he was on his own. There were also fat periods, of course, which were entirely due to his flair for recognizing trends in art. One day he was going through a junk dealer's collection of canvases when he came upon a picture of a nude in a tub. It looked like a Toulouse-Lautrec imitation with a pinch of Cézanne thrown in. He

paid 10 francs for it, and friends at the Dome laughed hysterically when he showed it. "You've been had again," they grinned. One night when he was at the Lapin à Gil, the Montmartre cabaret, and mentioned this picture, a short dark man with fiery black eyes and the build of a bullfighter asked him to describe the bather in detail.

"It's mine, from two years ago," he said, "I sold it to settle a bar bill. My name is Pablo Picasso."

8

Les Demoiselles
d'Avignon

Henri Terk was caught up in the political crisis when Sonia returned to St. Petersburg for the summer.

The left-leaning majority of the *Duma*, or elected legislature, had wished to pass a full agenda of progressive laws—to divide up large estates and to ensure equal civil rights for dissenters and for Jews and other religious and ethnic minorities. The czar would consider no such thing and in July dissolved the *Duma*. Ruthless measures restored order, but just when everybody complained of a new dark age, the czar and his prime minister P. A. Stolypin decided to hold elections for a second legislative assembly.

Sonia was determined to wrest a second year in Paris from Anna and Henri. Distracted as he was, Henri complained that a girl of twenty-one who was not yet married was condemned to spinsterhood. Anna asked about Alexei.

Henri was adamant. As a financial entity, a single *young* woman was inherently unstable, and one would hope her position was transitory. He wouldn't mind increasing her allowance, if that was what she needed, but his basic decision remained unchanged. She would

have a substantial dowry the day she married. Until then she was his ward.

"Meaning that you don't mind my going back to Paris for a last year," Sonia smiled.

Henri sighed. "How will you find a husband when you're never home?"

Sonia mentioned Willy and managed to be sufficiently ambivalent to suggest the hopeful beginning of a relationship.

The Terks gave in.

Sonia rushed back to Paris early, to get to work, to see Willy, and to be ready for the 1906 Fall Show. For her and for all Russians, the Salon d' Automne promised to be even more exciting than the last year's. L'Exposition de l'Art Russe, put together by Diaghilev and Benois, would include nearly three-hundred works: one-hundred-fifty classical paintings and icons, and a hundred-forty canvases, and a dozen sculptures by *new* artists. None of the painters and sculptors were household names in St. Petersburg or Moscow, and all of them were ecstatic to find their work presented in Paris.

And that wasn't all. Twenty-seven Gauguins were scheduled for the show, and Willy's discovery "Douanier" Rousseau would be there, too. Matisse might have sworn he'd never exhibit at the salon again, but he was nevertheless rumored to have finished a very large canvas for the show.

Willy showed Sonia his new acquisitions, canvases by Henri Cross (who, with Desvallières, had been one of the founders of the salon), Signac, Rousseau, and Picasso's young friend Georges Braque.

"I also have a lady painter." He smiled.

Marie Laurencin was a friend of Braque's. A storky, tall Parisian of Sonia's age, Laurencin was the illegitimate daughter of a Creole seamstress. She lived with her mother near the Bois de Boulogne and painted a lot. Willy thought her work gawky and spare, but in her nymphs and young society girls, with their huge flowered hats, bare shoulders, and impersonal doe eyes, he believed he saw a strange blending of innocence and depravity.

Willy took Sonia to meet several of his friends. The German painters forgathered at the Dome café, usually with Hans Purrmann and Rudolf Levy as the center of gravity. Both Purrmann and Levy had met Matisse through Gertrude Stein, and had fallen under his spell. Purrmann came from the Berlin *sezession* and, following Matisse

to the south of France, painted joyous, bright canvases that contrasted sharply with the tormented expressionist works of the Munich painters. Levy had been in Paris since 1903 and was a friend of Matisse's. He sketched his motifs in tones of such exquisite delicacy that the poetry was transformed into a color harmony.

Sonia was eager to resume her own work, to try new techniques and styles. She decided not to spend another year at the Académie de la Palette, but to work on her own in her little studio in the Rue Campagne-Première.

From her earliest childhood in Gradizhsk, colors had been her inspiration, colors as the Fauves used them to paint dynamic, vibrating canvas surfaces with large bold areas of color applied in a spontaneous, even violent, manner. She wanted her colors to be intense and pure. She wanted to use colors arbitrarily to evoke an emotional effect and sometimes, as Cézanne had used them, to mold space.

She questioned the painters she met—and those Willy had her meet.

Uhde made frequent trips to a dirty, noisy, but bright tenement in Rue Ravignan high up on the Montmartre hill. There the twenty-four-year-old Picasso, for the first time in his life, had settled down. Surrounded by painters, poets, and other would-be artists in similar one-room studios, he lived with the pretty Fernande Olivier and their big yellow dog, Fricka. Picasso and Fernande called Willy by the Gallic version of his name—Guillaume.

The trio were linked by more than admiration for Picasso's latest series of pictures of harlequins, acrobats, and mountebanks gleaned from the Medrano Circus just off Place Pigalle. Together with Oskar Weighels, a young German painter who also lived in the Rue Ravignan tenement, they had experimented with drugs. Oskar didn't know when to stop, and his potent mixtures of ether, hashish, and opium had made him lose his mind. He had not managed to come out of it, and, a few days later, he hanged himself. The 1908 suicide had so traumatized Picasso that he and Fernande had fled to the countryside, renting a house near Creil, northwest of Paris. "Pablo suffered a nervous breakdown," Fernande would write in her memoirs. "He couldn't work and wouldn't let me leave him alone."[1]

Willy brought Henri Rousseau to visit Picasso and Fernande at

Creil. It was quite a meeting. The former customs agent told Picasso he was not overawed by most of the young painters. Fernande would remember the white-haired little man saying, "In different styles, you and I are the two greatest living painters—you in the Egyptian manner, I in the modern."

Uhde had found clients for the two painters. Berthe Félicie Delaunay, the Countess de la Rose, was the wealthy divorcée who had commissioned Rousseau's *The Snake Charmer*. Another lady of means, the American expatriate Gertrude Stein, had bought her first Laurencin from Uhde. In *The Autobiography of Alice B. Toklas*, which purported to be Stein's life story as told by her secretary and companion, Stein described Uhde as "a tallish thin dark man with a high forehead and an excellent quick wit."

"When he first came to Paris he went to every antiquity shop and bric-a-brac shop in the town in order to see what he could find," she wrote. "He did not find much, he found what purported to be an Ingres, he found a few very early Picassos, but perhaps he found other things."[2]

"Uhde used often to come Saturday evening accompanied by very tall blond good-looking young men who clicked their heels and bowed and then all evening stood solemnly at attention. They made a very effective background to the rest of the crowd. I remember one evening when the son of the great scholar [Michel] Bréal and his very amusing clever wife brought a spanish guitarist who wanted to come and play. Uhde and his bodyguard were the background and it came on to be [sic] a lively evening, the guitarist played and Manolo was there. It was the only time I ever saw Manolo the sculptor, by that time a legendary figure in Paris. Picasso very lively undertook to dance a southern spanish dance not too respectable."

Willy arrived too late on the Paris art scene to be Picasso's dealer—the famous Vollard had given Picasso a one-man show in his Rue Laffitte gallery in 1901—but Picasso was fond of Willy, and, with Braque, visited the Rue Notre Dame des Champs gallery. "It was here that Braque and Picasso went to see him in their newest and roughest clothes and in their best Medrano Circus fashion kept up a constant fire of introducing each other to him and asking each other to introduce each other," Stein wrote.

Sonia knew Picasso's blue period. The circus pictures were now referred to as his rose period, and unlike Matisse and the *Fauves*, these

paintings gained immediate favor. The Steins introduced American collectors to Picasso. One day Vollard went to the studio and bought thirty canvases for the sum of 2,000 francs. The relative affluence that this created made Picasso decide he would go to Spain, to the Catalan mountains, to recharge his batteries.

Alexei Smirnoff, not Wilhelm Uhde, accompanied Sonia to the Salon d'Automne, billed as the biggest-ever show of Russian art. The best pictures by the most distinguished living, or recently dead, Russian artists filled twelve rooms.

The czar's eldest uncle, Grand Duke Vladimir Alexandrovich, was the president of the exhibition, and the Russian ambassador and the most powerful society hostess, Countess Elisabeth Greffulhe, were *présidents d'honneur*. The decoration of the rooms was by Bakst and the catalog introduction written by Benois. Sonia hurried to the moderns. Somov headed the St. Petersburg representation with thirty pictures, two book covers, and a porcelain figure. There were eighteen paintings and ballet projects by Bakst, twenty-three Benois, and eight Lancereys. "Ours is sometimes a rather literary art," wrote Benois, "for we are in love with the refinements of days gone by, lost in dreams of the past and pledged to the cult of all that is intimate precious and rare." The Moscow contingent surrounded twenty-two pictures and seven pottery sculptures by Vrubel.

Sonia and Alexei were introduced to a painter couple Sonia had already heard about — Mikhail Larionov and Natalia Goncharova. Both had come to Paris for the show, both were exhibiting pictures based on the colors and shapes of Russian folk art. "Our inspiration is as much Siberian embroidery, peasant pastry forms, toys and woodcuts, and icon paintings as it is fauvist," Larionov proclaimed. Both said they worshipped Diaghilev.

Larionov was the son of a chemist from Ukraine; Goncharova, the daughter of an architect, came from an old noble family and was the grand-niece of Pushkin's wife and, on her mother's side, of the Belyav family, prominent patrons of Russian music. Larionov and Goncharova had met as students at the Moscow Institute of Painting, Sculpture and Architecture. They had fallen in love, but had refused to get married, and they were now exhibiting together, both for the first time.

"Sculpture cannot translate the emotions that come from land-scape, the moving fragility of a flower, the sweetness of a spring sky," Goncharova said in explaining why she had found sculpture too limiting and switched to painting.

Sonia was jealous.

Goncharova was tiny with a round face and a penetrating gaze. She had a flair for novelty and was already being imitated by other artists. She and Larionov were less than four years older than Sonia and yet had accomplished so much. They had rebelled together, gone through successive stages of experiments together and apart. They talked so freely about religious mysticism, revolutionary politics, symbolist ideas, educational reform, and sexual emancipation that Sonia and Alexei felt as though *they* were provincial and the two visitors from Moscow possessed visionary attitudes that owed little or nothing to the Parisian thrust that set them on their way.

Many art lovers would later confuse the origins and careers of Natalia and Sonia, especially after both created sets and costumes for the Ballets Russes and each considered the other a rival for Diaghilev's attention. Sonia would come to resent Natalia when Goncharova and Larionov settled in Paris at the outbreak of the Russian Revolution, and the two women's rivalry would remain repressed but fierce for fifty years.

More than satisfied with the success of the Russian show, Diaghilev made up his mind to present several concerts of Russian music in Paris the following year. As usual, he began by captivating a society lady who had money and connections. The beautiful and elegant Countess Greffulhe, who was the original for Marcel Proust's Princesse de Guermantes in *Remembrance of Things Past*, was the president of the Société des Concerts Français, but her impression of Diaghilev was less than devastating.

She took him to be either a young snob or a shady adventurer, but when he sat down at her piano and began playing Russian composers, she began to understand him. "His playing was excellent, and the music was so fresh, so altogether wonderful and lovely, that when he explained he was intending to organize a festival of Russian music in the coming year, I immediately promised to do everything in my power to help make it successful," she would remember. It was agreed

that the concerts would take place at the Opéra and that Gabriel Astruc, a French-Jewish music publisher receptive to new ideas and a popular, witty Parisian personality, would act as agent and intermediary.

If Van Gogh had been the bombshell of the previous year's Salon d'Automne, Gauguin, who had died three years earlier, was the revelation of 1906.

The Gauguin paintings traced the evolution of this successful stockbroker who in his late thirties left his wife and five children and, over the next twenty years, used flat patterns of color and writhing outlines to make symbolic statements about human fate and emotion.

"A *red* dog," sneered one viewer next to Sonia as she pointed to the disturbing canine image on a canvas.

Gauguin, who had made two voyages to Tahiti and had fallen in love with the tropical luxuriance, had come to think of Polynesia as a defiled Eden full of cultural phantoms, and his paintings of pagan myths, superstitious terrors, and mysterious symbolism bestowed an incandescence that proved he used colors not so much to describe as to express. Sonia walked from canvas to canvas, in awe of dusky peaches and ochers, creamy browns, metallic blues, and their risky contrasts. The colors were neither silk nor velvet nor gold but saturated, infinitely subtle material, oil and pigment, luminosity and space, surface and tone, made rich by the artist. She hurried back to her studio to test her own emotions on a canvas.

Two of the century's great paintings were created that fall and winter. Sonia was as stunned as everybody else when she saw Matisse's willfully original *Joy of Life* at the Salon des Indépendents, and she became painfully aware of how far ahead Picasso's *Les Demoiselles d'Avignon* was even of Willy's discerning judgment.

Both paintings assaulted the senses. Both were huge canvases of nudes: on Matisse's canvas, women identifiably undressed in the open air; on Picasso's, five angular whores stare back at the onlooker with aloof indifference. Matisse's big painting was the culmination of a year's efforts in composition—the sum total of his artistic instinct and acquired knowledge. In a distant homage to the bacchanals of a long succession of classical painters from Titian to Watteau, Matisse treated trees as if they were stage props, and the carefree people in his

landscape—dancing, playing the pipes, making love—not as erotic provocation but in a style of painting to be accepted on its own terms.

In March 1907, Uhde received an urgent message to come to Picasso's Montmartre digs immediately. Stumbling up the stairs at Rue Ravignan, Uhde was greeted on the landing by a coldly furious Picasso.

"Yesterday, Vollard and Felix Fénéon were here," Picasso snarled.

Uhde was exhausted from the climb. "So?"

Picasso led him into the studio. "So, the most enlightened dealer and the most perspicacious critic who is supposed to be able to describe anything in three lines come in, like you do. And they shake their heads, declare themselves perplexed and leave."

Picasso told Uhde to stand back and judge for himself.

The huge canvas, surrounded by smaller ones of women and fruit, Picasso would recall, was a picture of five ugly women with monstrous faces making themselves available. One of them sitting with her back to the viewer had a face that looked like an African mask, and the tribal features were repeated in the face of the woman standing above her. The other women stood like a caricature of that favorite Renaissance image the Three Graces, staring coldly with huge weird eyes. They looked like figures from Picasso's pink period, cut out with an ax. Faces, breasts, arms, and shoulders seemed detached. The overall impression was one of discontinuity and shock, of sexual danger, and violence that had nothing to do with the logic and coherence of the painting.

Fernande stood at the door, awaiting Willy's reaction. Before Vollard and Fénéon, Braque had been horrified by the painting's ugliness and intensity—Picasso, his friend said, had been "drinking turpentine and spitting fire." Derain had thought the undertaking an act of desperation. Fernande knew how the canvas—originally called *The Avignon Brothel*, after a whorehouse on the Carrer d'Avinyo in Barcelona that Picasso had visited in his youth—was the result of relentless concentration, solitude and isolation. She also knew it was so new and so important to him that he made its acceptance a test of his friends.

As Willy told Sonia that evening and, years later, would write in his memoirs, he found the huge work repulsive. He felt it would take him weeks to "enter" Picasso's new style.

But Uhde's hesitation had been enough to condemn him, like Vollard and the critic. Picasso not only demanded instant admiration

but a devotion for which he set the rules. "I tried to accompany Picasso on this new direction, and that at a time when others who would later worship him, laughed at him," Uhde would write.

A few weeks later, Uhde talked to fellow art dealer Daniel-Henry Kahnweiler about the painting.

"It's a strange composition," Willy said, "Assyrian, somehow."

Kahnweiler's curiosity was aroused. "I wouldn't mind seeing that."

The son of an old Jewish banking family from Mannheim, Kahnweiler had lived several years in London learning high finance. He had only recently given up banking and, with his French wife, moved to Paris to open a small gallery at 28, rue Vignon. Kahnweiler didn't know Picasso but was familiar with his reputation.

After Picasso's fallout with Vollard over *Les Demoiselles d'Avignon* and Uhde's fatal moment of hesitation, Kahnweiler's reaction to the painting was also one of distress. He liked—and bought—several other paintings, however, and, to the end of Picasso's life, would remain one of his dealers. Late in life, Kahnweiler would say of Willy: "I was very fond of Wilhelm Uhde. He played a very important part in the evolution of modern art. And he has not been given the place he deserves."[3]

Uhde invited Mademoiselle Terk out on several occasions, but he never took her to see Picasso. She felt that the art dealer found her too prim for the Bohemian anarchy and subversive living in Rue Ravignan. It was not until a year later that she got to see the Picasso painting that was to be the origin of cubism.

9

Sonia Terk, Painter

During the fall of 1907 and the first half of 1908, Sonia Terk created the most powerful and expressive paintings of her long career.

The focus of her interest was the power of Gauguin's Tahitian period. Together with Gauguin and the *Fauves*, she believed colors were direct emotions. Colors could heighten our sense of ourselves, of our union with the universe. Colors could work independently of the object with which they were associated.

Talks with Willy Uhde and his friends, and the kind of work she had been doing, convinced her that to paint was no longer a matter of looking to the "motif," but of looking inward to an emotion that translates into a painting. From Van Gogh and Gauguin she learned a visual shorthand that allowed her to summarize the character of the people she portrayed, people she increasingly chose for their expressive ugliness. Gauguin taught her to do away with detail, to select colors that represented feelings. From Matisse, she learned to fill in backgrounds, to flesh out her canvases with more than decorative elements.

She had Picasso question Vollard, who knew Van Gogh's art supplier, and learned that Van Gogh had used hemp canvases. She

noted that he avoided diluting his colors with turpentine, but reworked his oils when they were half-dry, and that he used lacquered vermillion, cadmium yellows, and lead paints for whites. In the manner of Gauguin, she superimposed different opaque colors and painted outlines directly onto herring-boned canvases.

Her half-dozen figurative works in the style of Van Gogh, Gauguin, and the *Fauves* were as genuine as Matisse's eruption of creativity. Sonia's portraits, a nude and a few landscapes might still be said to owe a great deal to others, but for the first time she ventured out on her own. For the first time she produced works that managed to bring out the personality of her models. For the first time she dared to edit reality, to underline and to suppress details, to use colors for their intensity, not their florid pigmentation. The design was primitive, clumsy or mocking, but eloquently hers.

The paintings evoked her consciousness, her sense of imagery, her vision. She knew she would never be quite the same.

Young Finnish Girl depicts a flat-chested girl in a riot of colors, from a face in a jigsaw puzzle of primary yellows, reds, and greens, and a blue eye repeated under the mouth, to an aquamarine-and-yellow chest, red arms, and folded hands. *Yellow Nude* shows a pubescent girl with a yellow-and-green body, a schematized face, flat chest, and black stockings. The girl is reclining on an embroidered pillow, her head resting on one hand. She seems to radiate with an inner spirit. *Landscape at the Water's Edge* presents two blue-black figures in a dark landscape under a riotous red, blue, green, and black sky.

Three haunting portraits glow with the same paroxysm of color and thinly traced contours. *Young Girl Asleep* shows the perfect oval face of a girl with full lips and tender features.

The poet Chuiko and the Terks' maid Philomena sat for several portraits. One painting of the poet showed him in a pensive, quiet mood, his head with its shadowed eyes leaning on his expressive hands, his lips sensuous below his bulbous nose. In another, he stares back at the onlooker with a severe gaze.

"He was really ugly," she would remember, "but there were dreams in his eyes."

Her portraits of Philomena were the result of numerous sketches. With brush strokes that were both harsh and loose, Philomena was caught in several oils, one a full-length study in red against a back-

ground of red-flowered wallpaper, another a portrait in dark earth tones.

Philomena was painted in St. Petersburg during the summer of 1908, a painful time for the Terks and their adopted daughter. Sonia was determined to be a painter and to live in Paris, but her courage to speak of her dream failed her when she came face to face with Henri and Anna. Not daring to proclaim her emancipation, she fell back on the fiction that she was merely studying in Paris. They saw it as their duty to bring her to her senses, to make her realize that at twenty-two it was time to come home and get married.

A photograph shows Sonia with her dog at Novaya Kirka that summer. Her features are full and her gaze direct. She is very much in command of herself, aware of her shortcomings and of her strengths and demanding no apologies from the camera.

She couldn't say she was short of suitors, Henri and Anna insisted. Alexei Smirnoff had finished his year in Paris and was destined for a brilliant academic career. Or was there someone else? Anna certainly knew several young men who would like to meet Miss Terk.

"I'll stay an old maid," Sonia said defiantly.

Anna tried to understand when Sonia told her that she found men boring after a while, that her consuming passion was art. But why couldn't she paint in St. Petersburg? The house was big enough. They'd have a studio with a skylight built for her upstairs. Sonia repeated that her former roommate Alexandra Exter was still in Paris, still studying at the Académie de la Grande Chaumière. The discussions usually ended with Henri storming out of the room and Anna and Sonia in tears.

"I'm sorry I'm so complicated," Sonia said after a while.

Anna sniffled and asked about Sonia's German friend, the art gallery owner.

Sonia liked to talk about Willy, his unerring taste in painting, his friends and quick repartee, and the way he encouraged her. He had told her of feeling lonesome on occasion and of how different it would be to return home to someone after scouting for new paintings and share one's enthusiasm. Anna was perspicacious enough to sense that her stepdaughter's relationship with the gallery owner was a spiritual one, that Sonia was probably still a virgin, both attracted to men and fleeing them.

To calm herself after scenes with Anna and Henri, Sonia painted.

She painted Philomena one more time. There was something restful in concentrating on the maid's features. Sonia painted Philomena against a backdrop of busy wallpaper, to see if the jarring background would change the effect, the serenity.

Sonia was not a man. She was no Gauguin, defiantly leaving wife and children and a livelihood to "find himself." She was no Wilhelm Uhde, turning his back on his family but with the wits to earn a living on his own. Intuitively, she knew that she needed the vitality of the atmosphere in Paris. What she understood, deeply, was that art was a total commitment.

Henri and Anna gave in, as usual, but also as usual, only halfway. Sonia could have just one more winter in Paris. "It will be the last," Henri repeated sternly.

When she returned to Paris, Willy told her Picasso and Fernande had broken up in August. Nobody knew why. Fernande was in contact with Gertrude Stein, and the American author seemed to believe Picasso needed to be alone. They had been together three years.

They were in Willy's gallery, on their way to dinner, when Sonia asked him, point-blank, if he had ever shared his life with anybody.

"I have never been assailed by sufficiently strong feeling to risk myself in a liaison, if that is what you mean."

She blushed and turned away. Then she noticed a new portrait of him. The likeness was striking: the receding hairline, the mustache, the dreamy blue eyes. As in a Seurat or Signac painting, the background and Willy's jacket were painted in elongated dots.

"Who is this?" she asked.

The painter, Willy told her, was Robert Delaunay, a young man with a dazzling vocabulary and sparkling with ideas. He was the son of the much-traveled countess who had commissioned Rousseau's *The Snake Charmer*. Robert had brought his mother and Willy together, and the three of them had trooped to the retired customs agent's studio.

Rousseau had been more than happy to be given a commission and listened, fascinated, to Berthe de la Rose's travel stories. "India," she told him, "sometimes feels like a venomous paradise." Immediately, the painter imagined a twilight scene of a lake with banks covered with plants in opposing greens, and a brown Eve standing naked in the foliage.

"But you have snake charmers in India," Berthe interrupted,

"men who played flutes and made rattlesnakes dance." Rousseau would paint a snake around Eve's neck, a snake she would charm by playing a panpipe.

In October, Willy gave Sonia her first exhibition. Three of her paintings shared the walls of the Notre Dame des Champs gallery with five Braques, three Picassos, three Derains, three Dufys, two paintings by Jean Metzinger, and ten drawings by Pascin.

10

Willy

When Sonia was ninety-three, she told a television audience that her marriage to Wilhelm Uhde had been her idea.

Patrick Raynaud, the director of the televised homage, was apprehensive. Homosexuality was a much-discussed subject in France in 1978, but in 1908? Would the old woman peering under the studio lights toward camera 2 understand? Would she be offended by the question? Would she refuse to answer, try to leave the studio?

"It was I who proposed the game," she said. "And, in fact, it worked out all right."

But in his memoirs, Willy would not say who had proposed the idea but talked of "appearances." "I knew a young Russian woman who had become a friend. She was intelligent, generous, open-hearted. She knew about pictures and was herself a gifted painter. She, too, wished to have a harmonious and orderly existence and a serious relationship of the mind. We therefore agreed to give our camaraderie the exterior appearances of marriage."[1]

He would not mention what his family's reaction was back home.

Friedeberg was small-town Prussia, a station on the Schneidemuhl to Koeningsberg railway and a county seat noted for its textile and leather industry. Willy had already thwarted his father by dropping out of law school. Whatever the superior court judge might think of his son's marrying a St. Petersburg Jewess, Willy had overcome the guilt of having abandoned his role as a bourgeois. As for Sonia, it had been a stay in Florence that awakened him to visions of beauty and sunny aspirations, to a life in reaction to Nordic rectitude and reticence. He lived with faith in his own capacity to achieve if not a poetic existence, at least a life in harmony with his intuitive understanding of himself and the art of the time.

Sonia and Willy knew they were good for each other. For the thirty-three-year-old Parisianized Prussian, she was a sister soul, a person in rebellion against family and fatherland, a free-thinking, cosmopolitan expatriate in love with the daunting possibilities of the new art. Marrying her was not only marrying a financially independent young woman who shared his ideas and love of art, it was a means of concealing the deep, dark secret—the homosexuality that was no less admissible in Wilhelmine Germany than in Edwardian England. It was only twelve years earlier that Oscar Wilde had been sentenced to two years of hard labor for pederasty, and in the Kaiserreich, the *Unzucht* (indecency) laws branded homosexuality a "decadent vice," punishable by prison and loss of "honorable" civil rights. For Sonia, marriage to this spiritual art lover was an end-run around the edict of Anna and Henri that this was to be her last year abroad.

Both Sonia and Willy were foreigners. To avoid a too-close scrutiny of their papers by French authorities, they decide to get married in London. He might have been in trouble with fiscal authorities; her passport, made out to "Sarah Stern, private teacher"—the label 'student' apparently was not considered suitable—made no mention of her living in Paris since 1905.

Dominique Desanti, Sonia's French biographer, would speculate that Wilhelm Uhde's origins flattered the Terks' snobbism—"the family castles, whether lost, sold, or in ruins, the eminent position of the magistrate father; no doubt the delicate finances of this art dealer were concealed."[2]

Anna came to Paris. Willy called her "Mother," and the way he later described a luncheon he and Constant, his live-in butler, con-

fected for Madame Terk suggests Sonia never told him about her real parents in Gradizhsk or of her adoption. "The mother of my future wife had no suspicion of the conspiracy that two young people, independent in their own eyes, had dreamed up," he would write. "To maintain her confidence, I invited her, together with her daughter, to my apartment for a real engagement luncheon. Since my kitchen wasn't exactly in working order, Constant and I bought all sorts of delicatessen tidbit, cold cuts, lobster in mayonnaise, foie gras, etc. My future wife and I were in the best of moods, my mother-in-law rather moved. She slipped rings onto our fingers, and demanded that we embrace. Constant stood in the doorway, in butler's garb and white gloves, and looked on with big bewildered eyes."

One Saturday before boarding the boat train for London, Willy took Sonia to meet Gertrude Stein. The thirty-five-year-old expatriate novelist and poet who understood the importance of modernity, would remember the occasion. "Uhde's morals were not all that they should be and as his fiancée seemed a very well to do and very conventional young woman we were all surprised," she would write in The Autobiography of Alice B. Toklas.[3] "But it turned out to be an arranged marriage. Uhde wished to respectabilise himself and she wanted to come into possession of her inheritance, which she could only do upon marriage."

Anna and Henri came to London. Everybody stayed at the Buckers Hotel in Finsbury Square. Willy and Sonia had time for the Tate and the National galleries. The December 5, 1908, marriage took place at the Holborn registrar's office and united Wilhelm Uhde, journalist, 35, bachelor, son of Johannes Uhde, and Sarah Stern, 23, spinster, daughter of Elie Stern, factory owner (sic).

The Terks approved. Sonia continued to receive her monthly income from St. Petersburg.

Back from London, the newlyweds took an apartment at 21 Quai de la Tournelle with a view of the Seine and Île St. Louis. Sonia would have to suffer the presence of Constant, apparently more her husband's live-in lover than his butler.

At seventeen, she had been so afraid of "the things of the flesh" that she had refused to hear about it, and Anna had been forced to

have her read about the birds and the bees. Sonia had been on her own since she was eighteen; she had seen and gone out with whomever she wanted, lived in avant-garde milieus, surrounded herself with friends, tried to please, provoked love letters, but always pulled back from the primal act. Her sensuality was sublimated, her fervor concentrated in tubes of color and stretches of canvas.

Willy might not desire her flesh, but he also did not want to dominate her, to make her conform to a role as the traditional echo and shadow of masculine respectability. She wanted to be admired for more than her femininity. Perhaps he would learn to love her.

It was a turning point, but there had been others. At five she had been transplanted. At eighteen, she had broken free and discovered emancipation in Germany. At twenty, she had embraced Paris and its cosmopolitan ferment. Each time she had adjusted.

A photo was taken of Sonia and Willy in their art-filled living room. She is on a chair, a round-faced young woman in a short fashionable coiffure, eagerly leaning forward; he is by the fireplace, a slender, mustachioed man with a receding hairline and a severe, direct gaze. On the wall behind them is their passion—"magical *Fauves*," as she was to call the paintings by Picasso, Derain, Braque, Vlaminck, and Rousseau. In a photo taken a few months later she has put on weight and looks older. He looks at her with crossed arms, as if puzzled.

To be able to give dinner parties, Sonia engaged Constant's mother, a perfect cook. Picasso came to dinner. So did Gertrude Stein and Alice Toklas, the cocky Kees van Dongen and his wife Augusta ("Gus" to everybody), the big, athletic Vlaminck, Derain who was also returning from a trip to England, and Braque (Willy had bought his first Braque at the previous year's Salon d'Automne for 100 francs).[4] The difference between Picasso and Braque was especially striking, Sonia decided. Picasso was forceful, restless; the blond Braque, who collected instruments and was not yet living with Marcelle Lapré, was reserved, almost shy. Yet both painted cubist pictures that were sometimes so similar, their friends had a hard time distinguishing one from the other.

One Saturday Berthe Delaunay came with her painter son. A

tall, vigorous redhead with piercing blue eyes and a gift for loquacity, Robert Delaunay immediately began quarreling with Rudolf Levy.

Willy's painter friend was telling a pleasant story about the inconsistency of art dealers. Willy had wanted to buy Picasso's portrait of Vollard and, knowing Vollard would never sell this portrait of himself to another dealer, Willy had sent Levy instead with an important cash offer. Nobly, Vollard had refused to sell. Two weeks later, however, Vollard sold the painting to the Moscow collector Ivan Morozov.

The story made everybody smile politely. Suddenly, young Delaunay's high-pitched voice said, "I find it disgusting when a painter becomes a middleman between dealers."

Levy said he had merely acted as a friend.

Delaunay abandoned the subject of painters' being helpful to dealers for an attack on Levy's work. "How can you as an artist ignore the transportation revolution, the automobile, the airplane? The velocity of movement, the dynamics of acceleration deforms and transforms the forms we're painting into pure colors."

The twenty-three-year-old painter grabbed the thirty-four-year-old painter by the lapels. Friends separated them. The hostess liked the young man's anger. He was someone who was ready to defend his ideas.

Madame Delaunay was convinced her son was a genius, and the fiery young painter thought of himself as a visionary. When mother and son attended one of Gertrude Stein's parties, the hostess found Mme Delaunay to be a lively little woman entirely out of place, and Robert inordinately ambitious. "He was always asking how old Picasso had been when he had painted a certain picture," Stein would write. "When he was told, he always said, 'Oh I am not as old as that yet, I will do as much when I am that age.'"[5]

In May, it became fashionable to be Russian. On the 19th, Diaghilev's Ballets Russes exploded on the Théâtre du Châtelet stage with Borodin's *Prince Igor*. Diaghilev had done it again—managed to raise the production budget among rich Parisians, as he had found underwriters for *Mir Iskustkva*. His muse this time was Misia Edwards, the Polish-born and scandalously rich and influential wife of press lord Alfred Edwards and mistress of the Spanish painter José Sert. Much painted by Toulouse-Lautrec, Bonnard, Vuillard, and Renoir, Misia

was in the first row, with the poet Jean Cocteau, the Countess de Noailles, and the society lion Marcel Proust. Willy and Sonia were several rows back, but they, too, were swept off their feet by the choreography by Mikhail Fokine, the exotic score, and the agile grace of the dancers. The legendary savagery and surging dreams of the Slavic soul had Parisians in ecstacy.

At the last curtain, spectators dashed into the wings to catch a glimpse of their new idols, Vaslav Nijinsky and Tamara Karsavina. The next night, Parisians saw their first Bakst decor when the company presented *Cleopatra*. Choreographed by Fokine to a medley of music by Glinka, Rimsky-Korsakov, Mussorgsky, and Glazunov and featuring Nijinsky, Karsavina, Anna Pavlova, and Ida Rubinstein, the erotic melodrama was an even greater success than *Prince Igor*.

To the classical tale of the Queen of Egypt committing suicide, the ballet added Cleopatra's desire for a lover for her last night before applying a poisonous asp to her breast. La Rubinstein, whose cold, sadistic beauty gave the French a new frisson, was Cleopatra, Nijinsky her slave, Pavlova a temple attendant, and Fokine the nobleman who is told he may spend one night with Cleopatra if he drinks poison in the morning. In an entrance of stunning theater, Rubinstein was brought onto the stage in a sarcophagus, wrapped like a mummy in twelve veils of different colors which were ceremoniously unwound one by one, with the queen imperiously throwing off the last one, revealing herself to Paris. Cleopatra and Fokine's lovemaking was hidden by the undulating draperies of her slave girls who conveyed in a variety of ways the languors and ecstacies of the bed. But what enthralled Sonia were the sets and the costumes, the glimpse of the Nile between huge pink gods, the ritual unraveling of Cleopatra's many-colored veils until Rubinstein imperiously threw off the last scarf to reveal her pale features, framed by gold, jewels, and a blue wig.

Sonia was remembering herself at fifteen as an Egyptian princess at a costume ball.

The Ballets Russes was the rage of Paris. The dancers were feted; Karsavina's dressing room was filled with white roses by admirers every day; after one dinner Marcel Proust insisted on taking her home. Cartier copied the jeweled choker Nijinsky wore in *Le Pavillon d'Armide*. Looking back on those first evenings, Benois would write that every member of the company felt he or she was bringing to the entire

world all that was Russian, "the inimitable features of Russian art, its great sense of conviction, its freshness and spontaneity, its wild force and at the same time, its extraordinary refinement."[6]

The cunning of Diaghilev was to show Parisians a fantasy Russia; it would be ten years before St. Petersburg got to see *Petrouchka* and *Scheherazade*, his future bankroller Gabrielle ("Coco") Chanel would say. "If he had imported the Imperial Theater Ballet as is, his success would have been due to the sympathy of his friends," she would tell the author-diplomat Paul Morand. "But he did one better; he invented a Russia for foreign usage, and of course foreigners were taken in. Since everything is deception and illusion in the theater, you need fake perspectives. The Russia of the Ballets Russes succeeded precisely because its fundamental idea was fictitious."[7]

The year 1909 was a heady one for Willy, a frustrating one for Sonia. The book he wrote on Henri Rousseau established him as a talent scout with an unerring eye. But she was still seeking her way. Since her arrival in Paris nearly four years earlier, she had learned to question, to reject the teachings of Desvallières and the others at the Académie de la Palette. Her husband of convenience made her meet audacious painters who had already discovered *their* style. Willy's friendship with Braque, Dufy, Vlaminck, Levy, and Rousseau and his admiration for Picasso's continuing exploits sharpened her ambition.

Willy took Sonia to Rue Perrel to meet Rousseau. Critics had pronounced his *Hungry Lion* painting "ridiculous" at the 1905 Salon d'Automne, but the young painters in Willy's entourage—Picasso, Marie Laurencin, Vlaminck, Delaunay, and writers such as Apollinaire and André Salmon began to be fascinated by the retired customs agent. In Rousseau's personality, the young artists pretended to discover the virtues of the "primitive soul," which Gauguin had traveled to the other end of the world to find, and best of all these virtues could be experienced right here in Paris.

Sonia found Rousseau to be refreshingly himself, unsullied by the sophistication of the avant-garde. "Even now I remember him as he was, and not like today's slobs, all dressed like pigs," she would say in her autobiography. "On Sundays he was nicely dressed, for walks in the suburbs. No one ever found out whether he had really been to Mexico or whether his was a Mexico of the mind, like the India of *The Snake Charmer*."[8]

Picasso had picked up a huge Rousseau portrait of a couple for a few francs in a junk shop, and this became the excuse for a party for Rousseau at Picasso's Rue Ravignan studio. Fernande Olivier was back with Picasso, Uhde had married—two added excuses for a Montmartre celebration.

The evening was animated, with solemnity and wit, by Guillaume Apollinaire. A legend in his lifetime, the man born Guillaume de Kostrowitsky was the quintessential inquisitive spirit, scholar and vagabond, aesthete and pornographer, atheist writer, art critic, poet, and impresario of the avant-garde. He was also Marie Laurencin's long-suffering lover, and as the guests gathered in a bistro for apéritifs before the dinner at Picasso's studio, Marie was already tipsy. After they all climbed the Rue Ravignan, it took all of Gertrude Stein's persuasive powers to convince Fernande to allow the inebriated Marie to come in. But first Apollinaire had to take his girlfriend for a walk, and after they came back, Marie passably sober, the events got under way.

The studio was decorated for the occasion with Chinese lanterns. Apollinaire read a poem in honor of Rousseau, who was seated at the head of the table. Fernande served her *riz à la valencienne*, Rousseau got up and played his violin. The poet André Salmon drank too much, Marie sang in her thin voice, and Apollinaire asked Mademoiselle Gertrude to think of an American Indian song, a request she regretfully declined.

To thank Apollinaire and Marie Laurencin, Rousseau invited them to pose for portraits by him. He took precise measurements— girth, shoulders, distance from nose to lips, head length.

Bohemian life was shifting from Montmartre to the Left Bank and Montparnasse, and Willy was among the first to make several tables at the Dome the crossroads of onrushing Germans, central and east European painters who would be grouped with so many others in the all-encompassing École de Paris. Louis Marcoussis (né Ludwig Markus) was the spiritual and mundane godfather, a native of Warsaw and friend of Apollinaire who brought in his wake Chaim Soutine, Moise Kisling, Modigliani, and the increasingly addicted Pascin, who at dawn sketched the junkies who crashed every night in his apartment.

At the tables at the Dome, where drawings and sketches on paper napkins were abandoned by hacks and future geniuses, sat German millionaires who became Willy's clients, unapplied talents and true artists not yet aware of their potential, people killing time and looking for familiar faces to erase hours of struggle with canvas and colors, and models looking for work or a man to live with. The girls could cook and speak to the tradesmen, and they helped the foreigners to learn French. André, a waiter, lent money to some of the women and treated many as a father would. When they moved in with a painter they demanded to be called "Madame."

Francis Picabia, a Frenchman of Spanish heritage, and Gabrielle Buffet were an extravagant twosome, a pair of wealthy if eccentric artists who, together with Marcel Duchamp and Frantisek Kupka, formed an inner circle. Kupka came from eastern Bohemia and, to pay for the Prague Fine Arts School, had earned a living as a medium. Mecislas Goldberg was one of the geniuses of the Dome, a Polish Jew who left behind him a legend. The philosopher Henri Bergson liked Goldberg's work, Antoine Bourdelle did a bust of him, and Apollinaire collaborated with him on a project. Painters were enthralled listening to his theories, but he left no evidence of his gifts.

For the summer months, the Uhdes took a villa in Chaville, a resort near the Meudon Forest and Ville d'Avray on the western outskirts of Paris. Sonia painted a still life that echoed her and Willy's discussions about Rousseau. She also tried embroidery. To break the carefully designed contours she used in canvas painting, she discovered embroidery allowed her greater immediacy. Angles of stitching could be changed completely without recognizable patterns or rhythm, and forms developed with a new independence. You couldn't "stitch over" in embroidery; each stitch had to be integrated with its neighbor in sequence. She made several satin-stitched wool embroideries in which she used small shapes of color that suggested the rhythmic undulation of leaves.

Georges and Marcelle Braque were nearby in La Roche-Guyon and came over for long evenings. Robert Delaunay, who had relatives in Chaville, came visiting in the evening, holding forth on cubist theories behind a series of variations he was painting of the Saint-Severin church. He was enlarging on the cubist themes, he said. He

didn't stop at analyzing figures, still lifes, and landscapes, but had become interested in the rhythm and architecture of cities. The makeup, the bend of the piers, and the vault of what many considered the most interesting of all Paris churches fascinated him. He started painting shortly after dawn every day.

Sonia and Robert took long walks together in the Meudon Forest. He loved birds, flowers, and plants and taught her the French names for all of them. She told him of her adolescent passion for the sun, her sunbathing behind suspended sheets at her parents' summer house. The people he knew in Chaville were his Aunt Marie and her husband Charles, a couple who had brought him up to some extent—a little like her, she realized.

There were differences, too. She had graduated with a second-prize gold medal; he had been thrown out of one school after another. He used to sit in class and do watercolors under his raised desk top. One day the saucer he used for mixing colors crashed to the floor, causing a scene with the teacher and the mandatory punishment of staying after school. "What I learned was to use dry pastel colors instead of watercolors," he said, grinning.

He didn't like foreigners. Many of the École de Paris painters came from somewhere else. To him, they were all wops and halfbreeds with "impossible" names.

"At least Fernand Léger, Braque, Dufy, Metzinger, le Fauconnier are French, like the big old painters. What's more French than Cézanne or the impressionists? Matisse, getting to be too bourgeois, too French even, like Bonnard and Vuillard."

"And Van Gogh?" she tried.

"Okay, an exception."

Robert had been invited to Picasso's dinner in honor of Rousseau, but had refused to go. "They were doing it to make fun of the old guy," he maintained. "I admire the man. I'm going to write a book about him."

Robert wanted to change people's vision of the world, and he talked endlessly about a seventy-year-old book with a forbidding title.

"When two objects of different colors are placed side by side, neither keeps its own color and each acquires a new tint due to the influence of the colors of the other objects," he quoted from Michel-Eugene Chevreuil's *Of the Laws of Simultaneous Color Contrasts*.[9] "Red hits your eye differently if it is seen next to green or next to violet.

Imagine, Chevreuil wrote that in 1839 and modern painters don't even *know* that!"

Robert had a way with truth when he was excited. The theories of Chevreuil had exercised a decisive influence on the impressionists and on pointillists such as Seurat and Signac.

By the end of summer, Sonia was in love—hopelessly, gloriously in love.

11

Robert

Back in Paris, Sonia Uhde and Robert Delaunay wrote notes to each other, agreed to meet. His bachelor garret on the eighth floor at 24 Quai du Louvre was only a ten-minute walk from Quai de la Tournelle.

They met at the Louvre-Versailles tramway stop and spent hours in museums—the Mesopotamian antiquities were their favorite rooms at the Louvre. Sonia left home in the morning, sometimes before Willy and Constant got up, and fled to Robert's mansard overlooking the Pont Neuf and the Seine. The place was a mess. She stepped over canvases on the floor, avoided vases of multicolored begonias that were supposed to lend "simultaneity" to the room, sat on paint-smeared chairs or on the bed. Outside the window Robert had metal trays with feed for the birds of Paris. He titled the first painting he did of her *Future Eve*. Between the canvases and the begonias they became lovers.

Social position and upbringing should have conspired to make Robert Delaunay his mother's wastrel son, a Parisian dandy, a Proustian caricature of the high-born dabbler in art and novelty. An only child, he certainly was spoiled. Yet for him art was no pleasure or

enjoyment, but a search for absolutes. What was not color, light, and structure had no place in his life. "And not colors as you see them on museum walls, muted and yellowed, but pure colors, bursting, sparkling hues, primary and complementary, warm and cold pigments, colors that come from the contrast with other colors."

Sonia held her own. She didn't immediately fall for his flashy cubism, the sensation of vertigo of his urban landscapes. Like Willy confronting Picasso's *Les Demoiselles d'Avignon* for the first time, she sensed she was facing something totally new, something she would have to learn to like. Nevertheless, she felt Robert was a precursor if not a genius, and while adjusting she kept her distance. What she didn't like was that he was fitful and mercurial and always in such a hurry that he never finished his paintings or any of his other projects. The book on Rousseau was never written, but Willy Uhde's came out.[1] They would have to learn to share their disagreements.

His mama was not pleased.

Countess Berthe de la Rose's marriage had been little more than a means of formalizing a delicate situation. Georges Delaunay's only appearance in Robert's life was on his birth certificate. Berthe had little talent for motherhood and brought up her son with distracted forbearance, peppered with guilty devotion. On her side, she told Robert, he descended from knights who had taken part in the Crusades. On his father's side, he was also of noble blood. A Marquis De Launay had been the governor of the Bastille during the years the Marquis de Sade had been an inmate in the infamous fortress prison.

Berthe and her family had been wealthy. Robert liked to say that it was the absence of paternal authority that had given him a keen, if early, sense of independence. For a while Berthe had entrusted her son to her elder sister Marie and her husband Charles Damour. The aunt and uncle had soon felt compelled to send the boy to a boarding school, limiting his time with them to vacations at their Chaville summer residence.

Berthe was a tiny, vivacious woman who confected her own hats and traveled the world—Russia, India, Africa. She had a way with ribbons and lace, brims and bands. She could add chic and charm to the simplest boaters, and she wasn't above selling her creations to famous milliners. Berthe's apartment was on the Avenue de l'Alma,

and when she felt flush she gave divine soirees. She wore jewels in the afternoon, and gave herself airs of mystery. She was rumored to have been the mistress of an eminent political figure who died mad. She was always on the lookout for money, while at the same time treating her creditors with disdain.

When the countess traveled, Robert was left with Marie and Charles Damour. If he hated being dressed like a doll by his mother, he hated even more the choking atmosphere of the Damour household. Since they were practicing Catholics, he showed off his atheism. Since they and their circle of friends criticized the new painting, he defended Cézanne at the dinner table until, at least once, Charles threw a dessert plate at him.

Robert was a less-than-brilliant student, and if Marie and Charles had nourished hope that compulsory military service would straighten him out, they were disappointed. Berthe had used her influence to have her son promoted to the post of regimental librarian, followed by early discharge.

As Robert had told Sonia, he loved to draw and paint. To everybody's surprise, he accepted, at eighteen, an apprenticeship at Ronsin & Company, a Parisian establishment specializing in theater decor and stage sets. Apprenticeship at Ronsin's in the working class Belleville district was a throwback to the Renaissance. Before Robert got to paint the simplest backdrop, he learned to coat canvas and to prepare and mix his own colors. It was at Ronsin, he would say, that he got the taste for painting vast surfaces.

After Berthe's meanderings and her lovers, she discovered a lasting passion—her son. Robert had painted since he was seventeen, exhibited since he was nineteen, and never worried about money. Berthe gave him a generous allowance and, as Gertrude Stein noted, set out to make him famous. Apollinaire would remember a dinner served on Limoges china under the eyes of Rousseau's nude *Snake Charmer*. For her artist son, the countess put together a library of art books, and she demanded that he spend Sundays with her.

Robert was both precocious and gifted. In four years, he ran the gamut of movements, from impressionism—"Gauguinism," he called it—and the Nabis painters like Bonnard and Vuillard—to Japanese Orientalism, neoimpressonism, and fauvism. With amazing insight, the youthful Delaunay realized that the representation of the world, and perhaps the artistic perception of it as well, had changed radically.

"I came to cubism the usual way, via Cézanne," he told Sonia, "but now I'm ahead of Picasso and Braque. I'm not just analyzing geometric forms; I'm trying to come to grips with the rhythm of modern life, trying to break down lines and architecture."

He would always be insanely jealous of Picasso. For now, he was telling Sonia that if Braque and Picasso were applying cubist principles to guitars and fruit dishes, he was doing it to the world's tallest, most aggressively modern symbol, the Eiffel Tower.

Although already twenty years old, the tower, which had created a sensation at the time of its construction, appealed to him as provocative geometric design and as symbol of daring modernism. During the winter 1909–1910, when Sonia and Robert saw each other every day, he was in the midst of his most inventive period, creating the only group of his paintings that achieved popularity with the public.

After the variations on the interior of the Saint-Severin church, he was doing a series of paintings of the Eiffel Tower, breaking the famous landmark into lines on his canvas and reassembling the splintered steel into more spectacular forms.

Guitars and fruit dishes could be understood by touch. The Eiffel Tower could not be grasped by hand. It could only be perceived visually. Yet it was impossible to take it in at a single glance. There was no overview. Its form was distorted by the onlooker's point of view—seeing it in the traditional perspective from the Trocadéro across the Seine, for example, standing at one of the legs and looking up, riding up among the steel girders, or standing on the top platform and looking down. To Robert, the Eiffel Tower was a challenge to artistic judgment, and over the next three years he would do some thirty versions of the tower. He gave one of the first to Sonia, penciling a dedication at the bottom that only they were to understand: "Franco-Russian in-depth movement, 1909."

Sonia was not enamored of the towers, but she sensed that he was onto something important. "Before I took a physical pleasure in seeing his paintings, I understood and supported him. I learned to love his colors, while remaining truthful to my self and my difference."

In the historical perspective, the Delaunay towers would be seen as an extremely original form of cubism. Robert's idea was not merely to "deconstruct" (it was *his* word) the traditional composition of a

painting, but by exploding the descriptive image on his canvas with different, even opposing, perspectives to create a kind of synthesis. The point was no longer to place on the canvas a harmonious assembly of elements, but to make the parts sufficiently independent of one another to give the whole a totally new sense of mobility.

"*The Red Tower* (1911–1912) shows how fully Delaunay could realize the sensation of vertigo," Robert Hughes would write seventy years later. "The tower is seen, almost literally, as a prophet of the future—its red figure, so reminiscent of a man, ramping among the silvery lead roofs of Paris and the distant puffballs of cloud. That vast grid rising over Paris with the sky reeling through it became his fundamental image of modernity: light seen through structure."[2]

Or, as Robert insisted himself, in his postcoital talks in the garret, his goal was to express movement through color.

In June 1910, Sonia realized she was pregnant. The early part of the summer separated the lovers. While Willy was busy in his gallery and sitting for a portrait that Picasso was doing of him, Sonia was in Italy, obliged to accompany an aunt to Peglia, near Genoa. Robert was in the foothills of the French Alps. In August, however, they were both in Chaville.

Sonia decided to act. She would have to divorce Willy and marry the father of her child. To her lasting gratitude, Willy was the perfect gentleman. He was willing to lend himself to the legal farce that contemporary French law imposed on divorcing couples and feigned his own liaison. In his memoirs, Willy told of the end of his marriage in elegant prose. "A friend of mine assumed he would be more skilled than I at making my wife happy, and it didn't occur to me to be an obstacle to their splendid future."[3]

Marie and Charles Damour accepted "the situation," and Robert and Sonia spent the dog days of August at the aunt and uncle's new summer residence in Saint-Rémy les Chevreuse, the village much painted by the impressionists on the Yvette River, a mere twenty miles south of Paris. A stream marked the border between the Damour property and an old churchhouse, and Sonia fell in love with the shaded garden. Robert was working on *The City; No 2*, a cubist cityscape that had been accepted for the upcoming Salon des Indépendants.

On September 4, a telegram from Willy told them Rousseau had

died two days earlier. They rushed back to town, where Willy told them how, only six weeks earlier, he and the painter had celebrated Bastille Day together.

Willy told them, "He asked me, 'Do you love peace?' and when I said 'Yes,' he added a German flag to the *tricolore* he was painting." In August, an apparently insignificant wound had turned into a general infection, and now the sixty-six-year-old, the greatest of the untaught modern primitives, was dead.

To cover the burial expenses, Rousseau's daughter asked Willy to organize an auction of what was left in her father's studio. The Countess de la Rose and her son contributed largely. Willy bought Rousseau's portrait of his wife for 200 francs.

There were no legal obstacles to Robert's getting married. The countess, however, was not amused.

Her son had knocked up another man's wife, she told her sister. Was that a reason to marry the woman?

"They are in love," Marie interceded.

"What is society coming to?"

Marie, who had had her share in bringing up the impossible son, managed to calm her down. Nothing could be better for the willful Robert than this Russian girl, charming, cultivated, and from a wealthy family.

"Robert tells me her family will continue to support her," Marie added, provoking Berthe's pride. If that was the case, she would match the St. Petersburg money.

Marie suggested Berthe invite the girl to dinner.

"You see, we trace ourselves back to the Crusades," Berthe purred when they all sat down under *The Snake Charmer* and a butler, hired for the occasion, served the entree.

Sonia suspected the countess no longer had a fortune, so she emphasized that Henri and Anna Terk were grand bourgeois who had money. In retrospect, she managed to be as catty as her hostess. "She concealed the fact that she no longer had any money," Sonia would remember. "She had been obliged to sell her emeralds, which had been gorgeous, and her furniture."

Money was a pretext. Sonia had little patience for mothers. She

had never liked Hanna Stern, and her relationship with Anna had never matched her affection for Henri. She was in love for the first time and sensed a rival in Robert's mother.

With the divorce proceedings under way, Sonia's lawyer suggested she leave Paris. Spring was coming and Robert decided they should visit the Nantua Lake region of the Jura Mountains near the Swiss border, where the valley was reported to be one huge carpet of flowers and a place where hundreds of species of birds nested. Sonia followed Robert through the fields of snowdrops in the beginning but after a few days felt oddly delicate. A local doctor diagnosed scarlet fever.

Shaking in bed, racked with fever, Sonia discovered a new trait in her lover. He hated disease, and every morning was off on a rented bicycle. He would come back cuddling several tiny songbirds, and in the evening he built clever little cages. The next morning he was off again, telling her to ignore her scarlet fever long enough to feed the birds, according to his written instructions.

Letters submitted to the divorce court by Willy read like a Feydeau farce of straying husband, fiery mistress, and scorned wife. In letters coyly addressed to B. E., the woman he lusts after, he spoke of his married life as a martyrdom, and of his "growing aversion to the ample woman that a ridiculous chance-meeting made mine." Only a fragment would remain of a return missive from B. E. "I am yours, Guillaume, and I kiss you, madly, stupid as I am for loving you."

Sonia's lawyer made her write a good-bye note to the faithless Willy. "I am leaving the house, ashamed and distressed, never to return, now that the mystery behind our perpetual confrontations stands revealed. Your behavior is even more contemptible than I had thought. You have a mistress, don't deny it! I have proof. One doesn't leave letters addressed 'general delivery' on the dining room table. Innocently, I opened the letters and read it all."

Sonia's pregnancy was difficult. It is not known whether her state of health made her miss the court date or whether her lawyer found it prudent not to have his client, seven months pregnant by another man, on the witness stand. The absence of the aggrieved wife was excused.

The judgment was brief. "The adultery of Mr. Uhde, who has not appeared before the court," the judge ruled, "is sufficiently estab-lished with love letters written by him to B. E., care of general delivery,

post office No 7., and the fragment of a return letter signed Berthe, to grant Madame Uhde's request for a divorce."

Robert and Sonia were married in a civil ceremony, November 10.

The rent at Quai de la Tournelle was too stiff for Willy alone, so from the City of Paris he rented a former cloister at 33, Boulevard des Invalides, using it as living quarters and gallery. As the movers were ordered, he wrote a letter to Sonia, giving the inventory of the furniture they had agreed was his. He took his business with him.

"As for pictures," he noted, "I carry with me nine Picasso paintings and two drawings; four Braque paintings, twenty [Auguste] Herbin oils, two Rousseaus, three by Puvis de Chavanne, three by Odilon Redon, three canvases by [Jules] Flandrin and two by [Henri] Friesz." A follow-up letter specified he was leaving "a little Rousseau and two or three small paintings that are in your room."

12

Fireworks

Robert made it abundantly clear that he was not meant to fulfill paternal or family obligations, let alone earn a living. He was on this earth to give pictorial speech to the new century.

At 3, rue des Grands Augustins, a narrow Left Bank street where Picasso would also find a lasting workplace, Robert rented a studio, actually a vast inner-courtyard hangar that he intended to use for work only. Sonia paid a plumber to install a bathroom. They would live in an apartment like real people, Robert said.

It was nevertheless in the big and humid hangar that, on January 18, 1911, two months after they were married, Sonia went into labor. A midwife was called. Robert, who hated the sight of blood, sweat, and iodine, ran to the nearest bistro. When he returned he had a son. The boy was named after his uncle Charles. One of the first visitors was Alexei Smirnoff, the man who had once wanted to marry Sonia.

Robert had not given up on the idea of a normal existence in a real apartment, and while he went looking, Sonia and the baby stayed either with Russian relatives of hers in the other end of Paris or in a

rented villa in the suburbs. When it became obvious to her that their budget could not support both an apartment and a studio, she had workmen install a modicum of living space in the Rue des Grands Augustins studio and moved back in.

It didn't take Sonia long to realize she was in charge of more than a newborn baby. Her husband was devoid of any practical sense: He had only contempt for the business of art, and, when it came to selling himself, he was his own worst enemy. Despite his gift for loquacity—how could he talk!—it was hard to consider him a responsible adult. From the beginning Sonia was in charge of their money.

His mother's promise to match the Terks' monthly check quickly evaporated. The countess habitually overspent, and the 1,000 francs were never forwarded with much punctuality.

"In fact, once Robert and I were married, we saw little of his mother," Sonia would recall.

And even less of her own family, she might have added. Anna Terk died in 1911, but Sonia made no hurried trip to her aunt's bedside. She and Robert didn't even go to St. Petersburg for the funeral.

Who said no? Sonia, no doubt. Her French biographer would speculate that if the reason was not the swirl of emotions aroused by the death of the woman who had brought her up, it was probably Sonia's fear of how Robert would take an immersion in Russia. "In Paris, she was a dose of exoticism to him."[1] He liked to speak lyrically about the warmth, the mysticism, that she brought with her, which he believed the contact with the West had somehow shattered.

As we know, she was always very careful not to show her papers, to be pinned down on her origins. She might have feared that her husband would discover her deepest roots, although paradoxically she knew everything about his lineage, beginnings, influences, and revolts.

In any case, no hard evidence of how Sonia took the death of Anna Terk reached posterity. Even Charles, when he grew up, could remember no references to a grandmother. Over the years, Sonia would exhibit an unconcern toward events in Russia, an indifference she might have overcome had she felt her art was indebted to the land of her birth. Neither the icons that she loved—she would have one

over her bed all her life—nor such classics as Feodor Bruni or Repin nor the social realism of the triumphant Soviet revolution would influence her.

Still, the monthly checks from Henri Terk continued.

Robert's emotional demands on his wife often exceeded those of little Charles. The slightest provocation could set off his explosive anger. Sonia—and later Charles—learned that the best defense was a stubborn silence. There were moments when she missed Willy's quiet attention to such daily banalities as paying the bills, moments when she wondered what her life would have been if she and Charles had shared Willy's cozy existence.

But were her two husbands that different? She had married Willy because of his dedication, his taste in art, but also because she had imagined she could recast his sexual preference. Robert was the eternal *enfant terrible*. Had he been less irresponsible, less the bold, outspoken, fiery prodigy, she might have felt herself less "fated" to share her life with him.

From the beginning, she knew she represented order and equilibrium in the marriage. Their common destiny, which from the first day overflowed with ideas and projects, was pledged to art. "We breathed painting like others lived in alcohol or crime," she would say in her willfully disjointed memoirs. She also knew that if there was one partner who would have to deal with everyday life—hire a maid, pay the bills, earn a living, fill out papers—it was she. Robert painted when he wanted to; she had to find time.

Unfulfilled dreams and self-pity had been Hanna Stern's weakness, traits that Sonia had always loathed in her mother. Hope and perseverance were deeply ingrained in Sonia, and as she settled into marriage and motherhood, she energetically screwed on a smile that Alexei Smirnoff, perhaps more perspicacious than Robert, said resembled Mona Lisa's.

Fortunately, Charles was a quiet baby. Neither Robert nor she were given to child care. Sonia found a young woman to come and look after the baby.

Robert believed painting was complementary to architecture and should, ideally, be grandiose, monumental. In his search for absolutes

he rejected everything that was not color—subject, drawing, light and shade, and other academic notions. His work method was cyclical, not continuous. His need to paint came in waves like fever bouts that attacked him unawares. He disappeared into his studio at dawn and came back out, dead-tired, in the evening. This sometimes went on for days. "At the time of the first Eiffel towers," Sonia would remember, "he spent days without even washing himself. It made me raving mad."

Between painting spells, Robert could go weeks without touching a brush. He could spend hours walking, taking care of plants, or chatting in cafés.

He was no house tyrant, asserting himself by diminishing his wife. He was just exasperatingly, zestily himself. He needed an audience, so every night the Delaunays went out or entertained at home. They ate in little local restaurants and once a week entertained painters at a Quai Voltaire bistro.

Sundays were open house at 3, rue des Grands Augustins. Sonia's Russian friends mixed freely with Robert's chums from the Salon des Indépendants. Chuiko, her poet admirer whose portrait she painted twice, and Elisabeth Epstein, now living in Munich and very much au courant about Kandinsky and the new *Blaue Reiter* group, mingled with Fernand Léger, Juan Gris, and Jean Metzinger, and their friends.

Two years older than Robert, Metzinger had abandoned medical school for painting. He had painted neoimpressionist portraits of Robert and of Apollinaire, and after seeing the work of Picasso and Braque, was focused on orthodox cubism. On occasion he brought with him a hunchback student of his; Maria Blanchard was a young Spanish painter whose constant struggle with her infirmity drew admiration from Sonia.

Elisabeth had news from several of Sonia's old friends. Arnold Schoenberg was living in Berlin. Kandinsky was corresponding with the composer, who was something of a Sunday painter. In fact, Kandinsky was including a Schoenberg canvas in the *Blaue Reiter* roadshow to Budapest and Cologne.[2] More gratifying was the news that in Moscow Mikhail Larionov, if not Natalia Goncharova, had been sufficiently inspired by Robert to construct works out of sheaves of colored rays.

* * *

The best minds were awed. Apollinaire and the poet Blaise Cendrars, who was to play an important role in Sonia's reassertion after motherhood, wrote not only about cubism, but about Robert Delaunay.

Orphic cubism—the reference to Orpheus the mythical singer was intended to evoke a primal source "close to the heart of creation"—was soon shortened to orphism, a short-lived attempt to introduce an element of lyricism into the austere intellectualism of Picasso, Braque, and Gris. Its dictionary definition had Robert in its stellar center. It stood for attempts at transforming what artists see into a kind of visual music. The example of the *Fauves* encouraged boldness, and Robert's great formal undertaking was to fit the whole range of colors and their tensions into the construction of new painting.

After the sensations of vertigo and visual shuttling of the Eiffel Tower paintings, Robert reached near-abstraction with a series of *Windows*—the sky seen through another kind of grid, an ordinary casement, with glimpses of the Tower appearing briefly to locate the scene in Paris. Like a Renaissance master, he used on his palette real lapis lazuli, the deep-blue mineral pigment first brought back to Europe from Afghanistan by Marco Polo. "I got the idea of doing a painting that, technically, was held up by color, contrasts of colors, developed in a time lapse but seen simultaneously, in one flash," he would say. The adjective *simultané*, which would remain Sonia's favorite word, meant seeing several things at once, seeing several aspects of one thing, or seeing a new creation from the sharp juxtaposition of previously diverse elements.

No artist in France, not even the fauvists, had yet made color the sole object of painting.

Picasso, Braque, and Gris had deliberately foregone richly orchestrated colors so as to bring out form—cubism—more clearly. Robert, on the other hand, replaced all other pictorial means—drawing, volume, perspective, shading—with brilliant colors. His goal was not to abolish form, perspective, and composition, but to make color give form, perspective, and composition to objects. Haughtily, he said, "Before me, color was only coloring." The *Windows* series were the first paintings in which space was rendered not with a linear or aerial perspective but with color contrasts.

Robert was in love with the new age—industry and science, automobiles and airplanes. He had been delirious in 1909 when a Frenchman, Louis Blériot, became the first person to cross the Channel in a flying machine. And he loved Paris as the modernist capital. He was not alone.

The 1911 the Salon des Indépendants was the first comprehensive cubist show. Reminiscent of the *Fauves'* explosive debut in 1905, the newest, richest, and most lyrical paintings were exhibited in room 41. Across from one of Robert's Eiffel Towers hung Léger's *Nudes in the Forest*. No idyllic pastoral scene here, but human bodies reduced to machinelike tubular shapes. In February 1912, Italian futurists caused a sensation in Paris with their first exhibition. Five young artists, led by Umberto Boccioni, wanted their paintings to express speed, violence, dynamic movement, and the passage of time. In search of a pictorial language, they had turned to Paris and discovered first the neoimpressionism of Seurat and Signac, then the cubism of Picasso and Braque, then Delaunay's Eiffel Towers. Boccioni's *The Street Enters the House* showed the artist's mother standing at the balcony of her apartment, looking down at the street below. By such devices as shifting viewpoints and a fragmentation of forms to represent the light and noise of the street, all the bustle and activity of the city street rise up to meet her.

Among painters, Robert was the forerunner of the three Duchamp brothers—Gaston, better known by his pseudonym Jacques Villon, the sculptor Raymond Duchamp-Villon, and Marcel, who was to be one of the founders of dadaism and become famous in America. Also influenced were Léger, the wealthy Francis Picabia, and the quiet André Lhôte. Word of the melting melodic images reached Munich, Berlin, and Moscow, and Kandinsky invited Robert to exhibit at the *Blaue Reiter* show. Named after a painting of a blue rider by Kandinsky, this Munich exhibition featured Kandinsky, Gabrielle Munter, Franz Marc, August Macke, David and Vladimir Burliuk—all of whom would find their way to 3, rue des Grands Augustins.

What Elisabeth Epstein told Robert and Sonia about Kandinsky also made them sit up and listen. Kandinsky was also hovering on the edge of abstraction, on that outer limit of objectless art where all that was left on a canvas was form and color. It was only in the last few months that Kandinsky had been ready to jettison subjects for color, line, tone, composition, and rhythm.

He had painted a picture of a house outside Munich and returned to his studio in 1909, when, on opening the studio door, he suddenly saw a painting of incandescent beauty. "Bewildered, I stopped, staring at it," he would write. "The painting lacked all subjects, depicted no recognizable object and was entirely composed of bright patches of color. Finally, I went closer, and only then recognized it for what it was—my own painting, standing on its side on the easel."

Since then the now-forty-five-year-old Russian had come to believe that objects had no place in his paintings, that indeed objects were harmful to his compositions. A new painting of his, simply called *Study for Composition IV*, had him halfway there. Every shape in the picture still had some recognizable source. The subject was a battle between Russian warriors, but Kandinsky had done away with the horizon line, and the mountain scenery had given him an excuse to break it up into diagonals.

A different kind of Russian showed up at the Rue des Grands Augustins, a painter who drew his inspiration from the *shtetl* and put his Jewishness on his canvases. A fiddler on the roof, a bird in flight, a bride and groom floating in the air, rabbis, wooden houses in the snow or by moonlight, those were the fanciful, dreamlike images of Marc Chagall's art. Sonia, Modigliani, Gertrude Stein, and Natan Altman—the only sculptor Vladimir Lenin ever posed for—were assimilated, nonpracticing, or agnostic Jews. Chagall was closer to his heritage and would sense the virulent antisemitism and xenophobia of prewar France, and would remember Braque at the Rotonde making remarks about dirty foreigners taking over.

Apollinaire brought the handsome dark painter to one of Robert and Sonia's "Sundays." Chagall had come from Berlin and was more than a little overwhelmed by new impressions and stimuli. He called Paris "my second Vitebsk" after his birthplace, and, he told Sonia, he found himself in harmony with the prodigious lyricism of the tumultuous art scene. Robert immediately adopted Chagall, but Sonia was a little distant.

"He was nice when he needed people," she would recall. "When he began to paint in order to make money, Robert blamed him for it."

Robert himself had no dealer and never thought of selling his work. Brought up in the atmosphere of haute bourgeoisie insouciance,

he had only scorn for the "awful bourgeois" mentality that he felt was responsible for all society's ills. His chip on the shoulder defiance had to do with his constant desire to provoke, his pleasure in shocking people—what had made his Uncle Charles hurl porcelain at him. The breadth of his esthetic and his scientific, ethical, and technical interests, however, impressed not only Sonia but a host of friends and hangers-on he brought to the studio for improvised luncheons.

Paul Klee arrived in April 1912, sent by Kandinsky. But the shy Swiss somehow didn't click with the boisterous Delaunay. Four months later, Willy Uhde made an appointment to introduce Robert's greatest German admirers. Sonia prepared tea and a gorgeous Russian cake to greet August Macke, his wife, and Franz Marc. The visitors were intimidated at first, but Robert—with Sonia providing a running translation—soon had them knocking over tea cups in their enthusiasm.

Marc recovered his school French and in turn aroused the Delaunays. "Pictures," he said, "should not be full of wires and tension, but of wonderful effects of modern light." In 1907, Marc had run away from a disastrous marriage and in Paris had sought inspiration in Van Gogh. Marc knew the woman painter Sonia had admired from afar, Paula Modersohn, and told how both she and Paul Klee tried to see things in simple, bold shapes.

On this trip, the Germans had discovered the late Henri Rousseau. From behind a curtain, Robert pulled Rousseau canvases they had never seen. Robert's sonorous laughter and talk of the "dynamics of space" had everybody in a trance. Macke, who was from the Rhineland and loved joyful colors, promised an in-depth study of Robert's work in the magazine *Der Blaue Reiter*. Before they left, Sonia had set up appointments with other painters for them.

Back in Munich, the cheerful Macke painted pure, crystalline pictures full of energetic "orphic" colors and wrote to the spiritual Marc that Kandinsky was in eclipse and Delaunay streaking ahead. In thank-you notes to Robert and Sonia, both men wrote that they would be back.

The Delaunays spent the summer months at Uncle Charles' Saint-Remy les Chevreuse residence. Alexei Smirnoff visited for a time and recast his feelings for Sonia to include her husband. Alexei was also swept up in Robert's theorizing, and when he returned to St. Petersburg in July 1913, he arranged a Delaunay evening at The Stray Dog, an

artists' cabaret. The interior of the club was decorated with posters by Sonia.

But that was two years in the future. In 1911, Sonia had the baby, the household, and her demanding husband to take care of. All she managed that year was a patchwork quilt made of scraps of fabric and fur for her son. Made before the collage experiments of Picasso and Braque, the baby blanket would be seen, in retrospect, as a breakthrough for both Robert and her. The varied geometric shapes possess an inherent tension. Friends claimed she had made a cubist quilt; she felt she was simply following the tradition of Russian peasants. The quilt would end up at the National Museum of Modern Art in Paris.

The theft of the *Mona Lisa* took everybody's mind off contemporary painting for a dizzy month. The robbery from the Louvre brought the spotlight of suspicion on Apollinaire and drove Picasso hysterical. A humiliated Apollinaire slept on a couch in Robert's studio for a month.

Apollinaire had just published *L'Hérésiarque & Cié*,[3] a collection of fables full of otherworldly extravagance, confusing erudition, and latent eroticism. The book included a rascal character named Baron Ignace d'Ormesan, who was none other than Apollinaire's young Belgian secretary. Gery Pieret, a former boxer, was a self-styled eccentric and a genial mix of juvenile delinquent and stylish fantasy. Apollinaire had given the youth a chance to make a living by letter dictations and digging up gossip items for the poet's daily column in *L'Intransigeant*. Pieret apparently also furnished the thirty-year-old Apollinaire with the hashish he sometimes used to attain his "artificial paradise."

Back in 1907, Pieret had one day asked Marie Laurencin if he could bring her anything from the Louvre. She assumed he meant to shop for her at the Magasin du Louvre department store, but when he came back, he had two primitive stone heads. He had stolen the Iberian sculptures from the Louvre museum, not the department store. Marie wanted no part of them. Picasso, however, was in the midst of the seminal *Demoiselles d'Avignon* and was interested in the barbaric stone heads. He bought Pieret's sculptures. Since then, Apollinaire had tried to persuade Picasso that it was perfectly safe to return the sculptures, but the painter had kept them.

The discovery on August 21 that Leonardo's masterpiece had been stolen from the Louvre knocked Kaiser Wilhelm's alleged threats against French interests in Morocco off the headlines. Immediately, both Apollinaire and Picasso knew whom to suspect.

Picasso panicked and made a clumsy restitution of the stone heads that soon had police suspect Pieret and his boss. On September 7, Apollinaire was arrested. Whipped into a frenzy, "L'Affaire Mona Lisa" took on xenophobic overtones, as the press headlined the arrest "Pole Kostrowitzky, a.k.a Guillaume Apollinaire, Leader of Gang of International Thieves Specializing in Museum Plunders, in Sante Prison." Hours of police questioning made Apollinaire admit he had bought Pieret a railway ticket to Marseilles and given him 160 francs. From Frankfurt, the Belgian tried to come to his boss's aid, sending a letter to a Paris newspaper in which he deplored the arrest of "a kindly, scrupulous and honest man." He signed it Baron d'Ormesan. Police—and newspaper reporters—read *L'Hérésiarque & Cié* and added perverse and bizarre authorship to the "dirty-foreigner" portrait.

With Apollinaire's release five days later, the theory that Pieret was the thief and the poet his accomplice fell apart. The affair shattered the poet. Marie refused to see him, Picasso had denied even knowing him, and the xenophobic hysteria—it was only five years earlier that Captain Dreyfus had finally been rehabilitated—deeply shocked this most French of poets, born out of wedlock to a Polish nobleman's daughter and a Swiss officer, and brought up in Monaco. During the fall, Marie tortured him. She was a painter, and she needed him to be poetic, full of Florentine intrigue and honeyed perversity. For a while, he stayed in Baroness d'Oettingen's empty townhouse, but the solitude was too much for him.

"Come and stay with us," Robert said.

They put up a makeshift bed under a new version of *Windows*. "All the Delaunays talk about is his painting," Apollinaire said, after being subjected to Robert's early morning discourse on the vibration of colors. Sonia liked the sweet manners of their house guest, so different from his sometimes coarse poetry. She felt Marie had an evil tongue, and never forgave Picasso.

Friends were caught in the middle.

Gertrude Stein wrote, "We haven't seen the Delaunays much lately. Something in the wind. [Robert] wanted that Apollinaire and I stop loving Picasso and there are all kinds of funny intrigues going

on. Guillaume Apollinaire was marvelous. He was about to move and found it handy to stay with the Delaunays. He paid for his room and board with an article on cubism, in which he spoke marvelously about Delaunay as 'having silently created something like pure color.' Right now Delaunay sees himself as the grand solitary figure when in reality he's an endless chatterbox who will tell anybody about himself and his significance anytime day or night."[4]

Other headlines took people's minds off the *Mona Lisa* theft. Italy was at war with Turkey, thousands drowned in the Yangtze River flood in China, and the *Titanic* sank on her maiden voyage.

To get away from it all, Robert and Sonia spent the winter with little Charles in Lyon. In the spring of 1912, they rented, with two other couples, a huge house in Louveciennes on the Seine west of Paris. Robert lured Sonia to stare right into the noonday sun until its rays burn the retinas. "When you close your eyes afterwards you see color spots, whirlwinds of color."

In a few weeks, Robert finished a painting that he called *La Ville de Paris*. Both a variation of the classic *Three Graces* and a repeat of his previous themes, the enormous canvas featured three elongated, geometric nudes with a cubist cityscape that somehow combined everybody's idea of the leading edge in 1912.

A letter arrived at 3, rue des Grands Augustins from Kandinsky. Returning to Munich, Elisabeth Epstein had talked to Kandinsky, and Robert was to join the 1913 edition of *Der Blaue Reiter*. Sonia sent photos of Robert's *Saint-Severin*, of two of his *City* paintings, and of the Eiffel Tower in drawing and painting. By return mail, Kandinsky asked that everything be forwarded together with a price list. Robert had no idea what to ask, so Sonia decided the *Saint-Severin* should cost 700 francs, the 1910 *City* 500 francs and the 1911 Eiffel Tower oil 1,000 francs. Kandinsky promised "simple frames, like in Moscow," and three days after the show's opening in December 1912 wrote back that three paintings had been sold.

Robert suggested that someone, perhaps Apollinaire, write a piece about him. Kandinsky answered in French that he would prefer if Delaunay wrote it himself. "In general, we take no stock in articles by critics, since in general when artists discuss art, even unskillfully, the things they say are alive. Writers, on the other hand, speak of things already frozen; that is, they do not see things as moving, but in a state of immobility, of death."[5]

Sonia's old fellow student from Karlsruhe, Adolf Erbsloh, had bought *Saint Severin* and Alexei von Jawlensky *The City*, while *The Tower* became the property of a Berlin industrialist and father-in-law of Macke. Kandinsky wrote he had received Wilhelm Uhde's book on Henri Rousseau, and wondered how much Rousseaus were going for. "Ah! If, for example, I could only obtain the landscape with the large cow and the little woman on the left."

The correspondence continued, and as Kandinsky became more and more familiar with the Delaunay work, his enthusiasm and interest increased. Robert should exhibit in Germany and Russia, he insisted.

13

La Vie de Bohème

"Nineteen twelve, thirteen, and fourteen, what rich and explosive years for Robert and me!" Sonia would remember. "Robert is prophesying and could not be stopped. Before the outbreak of the war Robert was shooting off rockets in all directions. Back on earth I gathered the falling sparks. I tended the more intimate and transient fires of everyday life."

These were pivotal years for the arts overall, years of passage when the currents of tradition locked arms with forces of renewal that would not burst through until after the war. Revolutions and crises of values and humanism were rumbling just over the horizon, and although nationalism was tearing at the European fabric, the avant-garde was still without borders. The brief, culturally explosive period, which would end with the guns of August, was still focused on shared aspirations.

The Paris of Picasso, Braque, Ravel, Stravinsky, and Apollinaire was being jostled by negro art, jazz, architecture, and the movies. If painters had a predilection for the banks of the Seine, it was not in Paris that modern architecture (Frank Lloyd Wright, Gropius, Le

Corbusier) was born, and it was not atonal music (Schoenberg), or stagecraft (Craig, Appia), or filmmaking (Griffith, Stiller and Dreyer). From Paris to Moscow, from Florence to London, Prague to New York, theories of form and content, of art and society, and of present and past clashed and united, argued and cross-pollinated in *futurismo*, orphism, vorticism, *Blaue Reiter*, *Lacerba*, and Ashcan.

The Delaunays cut a tony swath across effervescent avant-garde Paris. They were the first Russo-French couple—Picasso and Léger would also marry Russians—and their appearances at the Dome and Rotonde cafés on Boulevard du Montparnasse and at their "Wednesdays" at the Closerie des Lilas at the Port Royal intersection were greeted with enthusiasm. By the summer of 1913, they showed up in "simultaneous" getups, Sonia in purple dresses of her own confection, Robert in matching, albeit tailor-made, suits. Giacomo Bella, co-founder with Umberto Boccioni of the Italian *futurismo* movement, called the Delaunays' wardrobe futuristic.

Robert, as Sonia said, was shooting off rockets, but after a year of motherhood and domesticity she was getting ready herself to be part of the agitation, of the prophetic and utopian movements that seemed to pave the way for the promised "revolution."

As an avant-garde movement, futurism was theoretical and messianic. Bella, Boccioni, and Gino Severini glorified change and thrived on the hostility of the public. Robert incurred their wrath, at least temporarily, when he laughingly told them their polemical bravado was bigger than their artistic achievements.

Americans found their way to the Delaunay studio-residence, some to veer off into their own "-ism," others to become short-lived students of Robert—short-lived because Robert's testy quicksilver temper was less than conducive to sustain teacher-pupil relationships.

Sam Halpert, who had met Robert while in Britanny to look for Gauguin perspectives, was the closest student. He was a New Yorker with whom the Delaunays were to share their Portuguese exile during World War I. Patrick Bruce was a Virginian, expatriate, and former student of Matisse who, under Robert's influence, developed a distinctive form of geometric pattern. Because he destroyed his work before committing suicide in New York in 1937, he was to remain a footnote to American painting. Arthur Frost was the son of the il-

lustrator A. B. Frost. Arthur also came from Matisse and wanted to be a conventional artist so as to earn fame and money.

More challenging were Stanton MacDonald-Wright and Morgan Russell, expatriates in Paris since 1907 and 1909, respectively. MacDonald-Wright came to Rue des Grands Augustins via Santa Monica, California; Russell by way of Leo and Gertrude Stein. In 1911 when they met they began studying the theory of color together and soon painted abstracted figurative subjects in pure color.

MacDonald-Wright, who was five years younger than Robert and Sonia and whose real name was Van Vranken, was born in Charlottesville, Virginia, of Dutch parents. Like Sonia he had enrolled in a Left Bank academy upon his arrival in Paris only to learn everything from the annual Salon d'Autumne and Salon des Indépendants. When he met the Delaunays, he was moving from figurative abstractions to paintings in which disks and fanlike passages of spectral colors were organized into diagonal and spiraling sequences. Russell, a native New Yorker and a year younger than the Delaunays, felt that Robert was not carrying color experimentation far enough, while he himself aimed to "do a piece of expression solely by means of color and the way it is put down, in showers and broad patches . . . with force and clearness and large geometric patterns, the effect of the whole as being constructed with volumes of color." The word *synchromy* ("with color") was coined by Russell on analogy with the word symphony, and he and MacDonald-Wright exhibited nonfigurative "synchromistic" paintings to the 1912 Salon des Indépendants, where they were noticed by Apollinaire.

The sensation at the show, however, was Robert's *La Ville de Paris*. And the article in which Apollinaire spoke so "marvelously about Delaunay" focused on that painting, the largest at the exhibition. In his review of the salon, Apollinaire called *The City of Paris* the most important at the show,[1] and other critics chimed in. Roger Allard wrote that "the Eiffel Tower, the city, the river and the allegorical three Graces form the motifs of a veritable symphony of colors, whose pyrotechnic effect would not have been diminished by a more disciplined order, a more finished competition."[2] Andre Warnod called it "the blossoming of a new school—orphism."[3]

Next, *The City of Paris* went to New York for the famous Armory

show that became a brutal revelation for a vast and unprepared public and put an end to American insularity. Arthur Davies and Walt Kuhn had come to Europe in 1912 and, scurrying around Munich, Berlin, Paris, and London, selected an extraordinarily full and discerning representation of the modern movement for what was officially billed as the International Exhibition of Modern Art at New York's 69th Regiment Armory at Lexington Avenue and 25th Street.

New Yorkers first exposed their optic nerves to the new art February 17, 1913, and a wave of praise and protest swept through the press and the lines of people that formed to see it. Close to 70,000 people paid admission, and for the "compact" version in Chicago where the Law and Order League campaigned against its "obscenities," 190,000 turned out.

Everything possible had been done to ease the shock. In the entrance corridor exhibition-goers were greeted by Emile Bernard's classical *Prodigal Son*, followed by polite impressionists. From here, visitors progressed from the austerity of Seurat to Renoir's vibrant *Boating Party*, through thirteen Matisse paintings and Gauguin's tawny Tahitian nudes to the ultimate shock of the Cubist Room. There they saw Picabia's *Dance at the Spring*, which shattered the identity of two figures, Picasso's *Woman with a Mustard Pot*, the marble ovoid of Brancusi's *Mlle Pogany* sculpture, canvases by Kandinsky, Gleizes, Delaunay, Villon, Kokoshka, Boccione, and Balla, MacDonald-Wright and Russell's synchromisms, and the flashing shapes and lines of Marcel Duchamp's scandalous *Nude Descending a Staircase*.

Back home in Paris, it was the audacity of Apollinaire's thinking, his keen intuition and sensitivity to new forms, that put the cubists over the top. He called a small book he published *Méditations Esthétiques: Les Peintres Cubistes*—adding the subtitle in the last moment —and in it explained and analyzed the new painters' attempt at expanding the presentation of objects to include a full account of their structure and position in space. Cubism had been originated by Picasso and Braque, enlarged by Gris, and joined by Léger, Delaunay, Duchamp, Metzinger, Gleizes, Picabia and his wife Gabrielle Buffet, Kupka, and to a degree the sculptors Archipenko and Brancusi.

Apollinaire was also writing his most remarkable poem, his first truly modern piece of writing. *Zone* is a sort of versified autobiography in which childhood, adolescence, the scents of southern France, the Paris sky, and the bridges of Paris blend with disillusionment, shameful

pain, the grotesque calamity of venal love, the anguish of true love, loss of faith, and despair to form a lyrical, if melancholy, commentary on his life.[4] In the text, he consciously rejected the past by juxtaposing revered images of antiquity and Christianity with airplanes, cars, advertising, posters, and the Eiffel Tower.

Ironically, as he reached the height of his powers, a younger poet illuminated the Parisian sky with a burst of Roman candles to trouble not only Apollinaire but Sonia. Like them he was a foreigner with a made-up name.

The Delaunays met Blaise Cendrars on New Year's Day, 1913. The French-Swiss writer and vagabond, who called himself "one of the greatest liars of all time," was a slim, blond author of impressionistic and formless but evocative prose. Seven years younger than Apollinaire, he was a likable eccentric who revolutionized the verse form, and yet was highly suspicious of literature. Even more than his breathless writing, his personality was spellbinding.

Born Frederic Sauser near Neuchâtel, of a Swiss father and Scottish mother, he left home when he was fifteen, traveled through Russia, China, and Persia, and returned home dressed like a muzhik. He had behind him several adventurous failures—as businessman, medical student, and horticulturist—when, in 1908, he started to write seriously. With Felizia Poznanska, a Polish fellow student whom he dubbed "Fela," Freddy Sauser—as he called himself—lived in Brussels. He then followed Fela to the United States, where he could not find work. It was in New York, however, that his gift for innovative language asserted itself. His radical defiance of poetic norms exploded in *Pâques à New York*, an uneven and brutal evocation of modern life that John Dos Passos would translate into English in 1931. The new combination of the visual and the verbal resulted in locating the words on the page in a way that had to do with their force, either as image or as sound, which, in turn, motivated a typography spilling down the page. The poem led him to invent the name Blaise Cendrars: "Blaise" not after Pascal, but because it sounded like *braise*, or glowing embers, and "Cendrars" for its euphonic resemblance to *cendres*, or ashes.

After he returned to Paris, Fela was supposed to join him there. In the meantime, he lived totally destitute in an unheated garret,

while finishing what was to be his masterpiece, *La Prose du Transsibérien et de la Petite Jeanne de France.*[5] At the Café Flore, where he cadged drinks and meals, Blaise played the enfant terrible and was known as a whorehouse habitué who could hold his liquor and who never shied away from a street brawl. He grandly dissociated himself from all poetic "schools" and proclaimed that poetry demanded violence and energy, that it was a kind of fever. Just the kind of person Robert would pick up.

In fact, Robert and Sonia were introduced to him at Apollinaire's table at the Café Flore. Immediately, Blaise started speaking Russian to Sonia, and within a week, he was having lunch at 3, rue des Grands Augustins every day.

Blaise talked with Robert, or rather Robert verbalized, endlessly, about his revolt against cubism, "cubism as surgical analysis," he grinned, enjoying his new friend as a sounding board.

Blaise's life was poetry, not paint. When Robert went out or, in the clutches of a new inspiration, shut himself up in the studio, Blaise and Sonia talked, and what he said—and wrote—touched her acutely and passionately. He knew how to tell stories, and his adventures, true or false, were mesmerizing. He made fun of art, considered it a mere by-product of life, and although he liked painters and respected his friends Léger and Chagall, his admiration of their work was, he explained, the kind of reverence you had for a pretty woman—without affection or restraint. His cynicism shocked Sonia. She sensed that he loved to live on the edge, that he was vain, that he liked to shock, but also that people—women, especially—forgave him everything because of the marvelous originality of his poetry. He was a soul mate who understood what Robert did not, the deepest stirring of her being. He was the kind of man women fell for or, if they were otherwise engaged, would be grateful they didn't have to be his victim.

"How could I not love this big baby who lived from hand to mouth in the greatest possible disorder?" she would write about the poet who was only two years her junior. "His genius was self-evident. All you had to do was to listen to him."[6]

When Sonia, Robert, and Apollinaire convinced Blaise to read *Easter in New York* aloud to them, the trio listened in silence to the long poem that was a kind of conversation with God, inspired by Cendrars' hungry wanderings in the streets of Manhattan and by a poster on a church door, announcing an Easter concert of Haydn's

The Creation, and written at one go in a hotel room at three in the morning.

It began:

> Lord, when you died, the curtain was rent
> But what is behind it, nobody has told me.
> The street at night is like a wound
> Full of gold and blood, fire and
> > potato peelings.

When Cendrars finished, Apollinaire was as white as a sheet. Sonia would remember that Apollinaire then asked to read the text, which had been privately printed to accommodate an unusual typography. He read in silence.

Handing back the notebook-thin text, Apollinaire said, "I'd never! What's the book I'm preparing next to this?"

The conversation continued, but Apollinaire was in a deep funk for the rest of the evening.

Robert and Sonia kept the poem overnight to have a chance to read it again in quiet. When Blaise returned for lunch the next day, Sonia handed him an illustrated hardcover booklet. She had bought cardboard and binding material at her art supply store and had created a cover. On suede she had glued triangles of paper and fabric. The papers ranged from bright red and yellow to deep-blue, silver-blue, and metallic gold.

The cover for *Pâques à New York* began Sonia's career as a designer of book covers, which were to include all her favorite poets—Mallarme, Rimbaud, Laforgue, Romain, Minsky, Canudo, and, of course, Apollinaire.

Before Sonia could read *La Prose du Transsibérien*, Robert and Apollinaire went to Berlin together, Robert for his first one-man show, Apollinaire to give a conference on the new art in general and orphism in particular. At the last moment, Blaise Cendrars decided to go along.

Robert was ecstatic about the trip. To be wanted in Berlin compensated for being ignored in Paris, and having been the object of Parisian jealousies had been quickly amplified in his fertile mind to a general indifference toward him by the public. Robert was ready to

go totally abstract, and it was his hope that Apollinaire would speak about that.

The exhibition was the idea of Robert's two biggest German fans, August Macke and Franz Marc, and of an owlish Berlin Jew with a pale, nervously twitching face, nearsighted eyes peering out behind thick glasses, and hair falling down over his neck à la Franz Liszt. Herwarth Walden was an intensely curious intellectual, married to a true eccentric original, the expressionist poet Else Lasker-Schueler, who would spend the last eight years of her life in Jerusalem and be regarded as an Israeli national poet. In 1910, Walden had founded *Der Sturm*, a magazine crucial in the development of art. Unlike Diaghilev's resplendent *Mir Iskustvo*, Walden's magazine was printed in newspaper format and sold for pennies. The result was a large circulation.

Aggressive and polemical, it opened its columns to everything that was new and unusual. After meeting young Oskar Kokoschka in Vienna, Walden persuaded the painter to move to Berlin and to supply *Der Sturm* with a regular feature, a "Portrait of the Week." Soon both the *Brücke* and the *Blaue Reiter* painters were contributing—Marc woodcuts, Kandinsky his first abstract drawings, and Klee his first magazine cover. Since March 1912 when Walden associated a gallery with the magazine, a glorious series of exhibitions had spread the gospel of the new painting in the German capital. With an amazing deftness of touch, Walden assembled in quick succession nearly all the leading figures—although many of them were not to achieve fame until years later.

Kokoschka and the Munich *Blaue Reiter* painters were the lead-off show. This was followed by the Italian futurists; engravings and lithographs by new artists in Paris, with special emphasis on Picasso; German expressionists—Kandinsky, Marc Jawlensky, and others; and French expressionism—Braque, Derain, Vlaminck, Friez, Laurencin. And now Delaunay, to be followed in the fall with a first *Herbstsalon*, a fall exhibition that would include such artists from eastern Europe as Elisabeth Epstein, Chagall, Archipenko, Brancusi, and Larionov and Goncharova. Cubo-futurism, as it was practiced in Moscow, often had a decorative, folk-art quality to it. The colors were bold, almost crude.

Yet it was the Russians who, beginning in 1913, carried abstraction to new limits. The most far-reaching experimentation was ray-

onism. Larionov had begun speculating on the physics of light after seeing a Turner exhibition in London. In 1910, he and Goncharova tried to paint canvases that appeared to float outside time and space in some fourth dimension. They and others tried to achieve this by projecting lines or rays of parallel or contrasting colors into space, representing lines of force and attraction. Two sets of brothers David and Vladimir Burliuk, and Naum Gabo and his brother Antoine Pevsner, formed a group called the Joker of Diamonds.

In February 1913 *Der Sturm* carried a long article on modern painting by Apollinaire, in which the poet-critic asserted that there were only two new trends in painting: "on the one hand Picasso's cubism; on the other orphism and Delaunay."[7] The claim showed insight even if in retrospect it sounds exaggerated. Less fortunately, however, Apollinaire proceeded to list all the painters influenced by the two promethean trendsetters. While the names under the Picasso heading were perfectly defensible—Braque, Metzinger, Gleizes, Gris, and Marie Laurencin (with whom Apollinaire had just broken up), the Delaunay catalog was creatively playful, as it included Léger, Picabia, Laurencin (again), Marcel Duchamp, and, for Germany, Kandinsky, Macke, Marc, Jawlensky, and Gabrielle Muenter, as well as the Italian futurists who were consigned to disciples of a painter they vigorously challenged. That Macke and Marc were deeply influenced by Delaunay was a fact, and it might have been tempting to arrange in Robert's column the colorists Léger and Picabia, although both followed quite different and personal directions, but to put Kandinsky, Duchamp and the Italians under the Delaunay banner was overstating it.

Walden was at the railway station to greet the trio and take them to the three backrooms on Potsdammerstrasse, that were at once editorial office, studio, and gallery. Robert was already homesick and spoke of little besides Sonia. Guillaume charmed everybody while Blaise lost his gift for conversation. Still, both the one-man Delaunay show and the Apollinaire conference, delivered in French although the poet had some familiarity with German, were a success, and the trio returned home loaded with gifts from Herwarth and Else Walden.

Two months later, the Waldens were in Paris, spending most of their time with Sonia and Robert. Robert persuaded the Berliners to

include in the fall exhibition Amadeu Souza-Cardoso, the romantically handsome and wealthy Portugese architect and painter, who had also participated in the Armory Show. Souza-Cardoso was a friend of Gertrude Stein and of Modigliani and had just married a beautiful Frenchwoman. If ever there was a golden couple among the Delaunays' cosmopolitan friends it was Amadeu and Lucie.

The Waldens fell in love with Sonia and, to Robert's twenty-one paintings for the upcoming show, added twenty of her new works.

Sonia was painting again, and her audacity matched her husband's. Her first oils since the birth of Charles were joyous abstractions with sunlike disks and hints of the Eiffel Tower called *Simultaneous Contrasts*. Matching his *Disks: Sun and Moon*, her geometry was less disciplined than Robert's, her interest less concentrated on the problems of spatial illusions and more on the dynamics of the surface. Electric streetlight was replacing gaslight in Paris and inspired her to do variations of perspectives of long boulevards with the newest craze, luminous signboards, in the evening rain.

"Robert, our friends and I met at the St. Michel fountain at the bottom of Boulevard Saint-Michel," she would remember. "The halos of the new electric lights made colors and shades turn and vibrate, as if as yet unidentified objects fell out of the sky around us." She called her paintings inspired by the Boulevard Saint-Michel *Electric Prisms*.

For Sonia, the reading of Cendrars' *Prose Transsibérien* rang bells of recognition, bells that her own childhood should perhaps have chimed.

> I was sixteen and I no longer remember
> my childhood.
> I was sixteen thousand leagues from my birthplace
> I was in Moscow, city of one thousand and
> three bell towers and seven railway stations.
> And the seven stations and one thousand and
> three bell towers weren't enough because my youth
> then was so fervent and so insane.

> *The cannon thundered. The war was on*
> *Hunger cold pestilence cholera.*

The war was the 1904–1905 Russo-Japanese conflict in which Sonia had almost wanted to be a nurse.

> *I saw*
> *I saw the silent trains, black trains*
> *returning*
> *from the Far East and passing like*
> *phantoms*
> *And my eye, like a real signal light, is still*
> *running after the trains.*
> *At Talga, 100,000 wounded dying for*
> *lack of*
> *medical attention.*

During the Winter Palace massacre, Blaise had been in St. Petersburg, in love with an anarchist, but spending the Bloody Sunday behind the iron shutters of a distant parent's Swiss clock shop. Yet his poem blazed with an intensity that was totally lacking from Alexei Smirnoff's eyewitness letters to Sonia in Karlsruhe.

The *Transsibérian* of the title was the railway line that since 1905 linked Moscow with the Pacific. Together with such lines as the Capetown-to-Cairo link and the Trans-Andean railway (Buenos Aires, Argentina, to Valparaiso, Chile), the Transsiberian was an engineering feat that helped make it possible for a 1910 Philias Fogg to go around the world, not in Jules Verne's eighty days but forty.

The verse extols the "intense and tumultuous life" of the new century, action in the shape of the rebel—soldier, pioneer, gambler—who defends the right to be different from both established order and creeping joviality. The lyrical reportage contrasts past and present, anger and love, Russia and Paris, and various exotic locations in a form of writing that is neither traditional poetry nor normal prose but constantly veers between "journalese" and inspired expression. Sexual energy and appetite are expressed in images of war, and the whole is held together by the train's rhythmic forward thrust and the experi-

ences of the "I" fragmented and viewed from different perspectives. Almost cinematically, the poem "cuts" between verse and prose, between Siberia and Paris, between the little "Jeanne de France"—a prostitute on Montmartre as the modern counterpart to Joan of Arc —and the ever-rolling Transsiberian express.

The prose poem was totally new in French literature. It elevated the lyricism, eroticism, sweetness, exotic knowledge and passionate feelings of Apollinaire's poetry to a planetary scale. It modernized the taste for exoticism by stressing collective emotions and had a way of making humankind's new prospects exciting.

"Why don't we make a book that folds out?" Sonia asked Blaise. "I don't want to decorate your poem. I'd love to transcribe it into colors, make it vibrate, poetry and painting together."

Fela arrived from New York. Sonia found Blaise's girlfriend pleasant, but inconsequential and provincial. Sonia helped her get a new wardrobe, but the young Pole didn't appreciate the current Left Bank fashion and thought she looked gawky "in a dress made of mattress fabric."

With Blaise, however, Fela had lunch every day at Rue des Grands Augustins. She soon found more congenial companions at "La Ruche" in the Rue Danzig, the most original of the Montparnasse housing projects, where refugees from one diaspora or another—Lipchitz, Zadkine, Soutine, Chagall—sought cheap living space and the reassuring company of fellow artists of predominantly eastern European origin. The Russian was decidedly Russian, the samovar a focal point of social life ("Tea," said Stravinsky, "is the center of all our nostalgia").

Cendrars would claim that a sudden inheritance allowed him to have *The Transsiberian Prose* printed. In fact, Fela brought the money that permitted the publication, and made both Blaise Cendrars and Sonia Delaunay-Terck (sic) famous.

Blaise, but not Sonia, was among the artists, students, and "fans" to whom Diaghilev had sent free tickets for the Thursday May 13, 1913, Ballets Russes premiere of Stravinsky's *Sacre du Printemps*. The date had been chosen by the superstitious Diaghilev and the free tickets given out in the hope that the recipients' enthusiasm for anything new would countervail the anticipated shock of the bejewled public in the stalls and boxes, who were coming to admire the artistry of Nijinsky, the grace of Karsavina, and the color of Bakst.

The dynamic and powerful rhythms, Dionysian dancing and bar-

baric splendor provoked the expected riot between the smart audience in tails and tulle, diamonds and ospreys, and the suits and head-banded ladies in the aesthetic crowd. As Blaise told the story, he defended the *Rite of Spring* so heatedly that a hostile neighbor pushed him through his orchestra seat, a seat he wore around his neck like a collar for the rest of the evening. The incident caused the poet to dedicate the *Transsibérian* to musicians.

As they had the year before, Robert, Sonia, and little Charles spent the summer months in Louveciennes. Else Walden wanted Sonia included in the upcoming *Herbstsalon*, and both Sonia and Robert were busy painting. Their common interest in modernity led them to advertising and publicity, but the way they expressed it was totally different. Robert painted a hymn to rugby football, *The Cardiff Team*, inspired by Henri Rousseau. In this return to presentational art after his revolutionary disks and suns, he integrated several brightly colored advertising posters. "That the photo disappoints you I can understand," he wrote to Marc, "but it's my most beautiful and most mature painting in which I exceed myself. For five years I have tried to *show* by means of color alone, to try to reach purity in painting."

Sonia, on the other hand, flirted on the edge of abstraction with what was to become her most famous painting, the huge *Le Bal Bullier*.

14

Syntheses

Robert and Sonia liked to show up late at the Bullier, where, on Thursdays, students, painters, and *midinettes* waltzed and—the newest craze—tangoed. The Delaunays and their friends also liked to make an entrance.

Blaise Cendrars would remember Robert and the Parisian Englishman Arthur Cravan—an enormous "boxer-poet" and magazine editor who claimed he was Oscar Wilde's cousin—getting dressed at Rue des Grands Augustins for an evening at the Bal Bullier. It might not seem unusual to an end-of-the century audience accustomed to seeing men dressed in all the colors of the rainbow, but in 1913, anything but black and gray on a man was unheard of. They slipped on three or four pairs of mismatched violet and green socks so they could tango without shoes. Robert was wearing a scarlet tuxedo and, when Arthur stood still, painted scarlet tattoos on his friend's starched shirt front.

One evening, to give his posterior a dash of "simultaneity," Arthur sat down on Robert's palette. For five minutes the painter was furious. Did Cravan know what lapis lazuli cost?

Blaise tied "Chicago neckties, gaudier than parrots' feathers," around his own neck, calling the result a "mixture for Orphic Harlequin" to outrage the Italian futurists who might show up at the dance, while Arthur got into an immense black nightshirt cut in formal tails. Robert went dancing in a violet jacket and pink vest, or would don a red overcoat with blue collar, red socks, red and yellow socks, black pants, green jacket, sky-blue vest and tiny red necktie.

If the men dressed like undergraduates going to a fraternity dance, Sonia's getups were a fashion sensation. This was a period when the hourglass figure was firmly held in place with corsets, when hemlines had not yet cleared the ankle, when all colors were permitted as long as they were insipid nuances of pastels, when society women were still innocent of makeup, and when the designer Paul Poiret was daringly ahead of his time with emulations of Diaghilev's stage fashion, using bead and silk embroidery, velvets and furs, boots, cockades, and storms of feathers.

Poiret was the couturier and eccentric who made—and lost—a fortune creating the richest period of fashion. He was the sartorial genius of the 1910s, a megalomaniac and a dazzling designer of theatrical costumes, an inconsistent fashion dictator and a native Parisian who, with the exception of this one delirious decade, was always magnificently out of step. He was currently dressing *le tout Paris* in the vivid colors of van Dongen, Matisse, Derain, and Dufy. His illustrator was Romain de Tirtov, the son of the exclusive Kronstadt aristocracy, who went under the name Erté. Like Sonia, he had come to Paris to study at one of the academies, and, like her, he had quickly dropped out to pursue his own studies.

Sonia showed up in "simultaneous" dresses that had photographers clicking. Her most famous and most photographed was a creation in sheet fabric, flannel, silk, and lace in a riot of colors that ranged from English rose to blue, scarlet to tangerine yellow.

Robert's loud tuxedos were ordered from a tailor; Sonia's outfits were self-made, assembled in collage as her book covers were. She wasn't trying to innovate fashion, she said, merely to entertain. To hide, too. Twenty years later she would say, "I was timid, actually, but as soon as I was disguised, wrapped in my scarves, I felt secure. I could project myself; I was more who I was."

Apollinaire described the eye-catching Sonia for his *Mercure de France* readers, telling them that the way she dressed could only "transform fantasy into elegance." She wore "a purple dress, wide purple and green belt, and under the jacket, a bodice divided into brightly colored zones, delicate or faded where the following colors are mixed—antique rose, yellow-orange, blue, scarlet, etc., appearing on different materials, so that woolen cloth, taffeta tulle, flannelet, watered silk, and peau de soie are juxtaposed."[1]

Gino Severini, who had come to Paris the same year as Sonia and fused elegance and vigorous construction in his futurist paintings, sent a telegram to Milan, describing in detail Sonia's Bullier dance dresses. With some hyperbole, Blaise would say that Milan spread Severini's news throughout the world, particularly the avant-garde, which wanted to be up with the latest Paris fashion. "Our extravaganzas especially influenced the Moscow futurists who modeled themselves after us." Blaise wrote an erotic poem about the fashionable Sonia that became famous:

> Colors whose contrasts undress,
> On the gown she wears her body.
> The belly, a circle that moves.
> The double vessels of the breasts,
> pass under the rainbow bridge.
> Tummy, disks, sun,
> And the colors, shouting, vertical,
> fall to the thighs . . .

Were they lovers? Jacques Damase, Sonia's art dealer and friend during the last sixteen years of her life, was sure she was in love with Cendrars and that the question of an actual liaison was immaterial. She was a woman always in control of herself, someone who channeled the concupiscent ambience into sensual paintings. When Cendrars died in 1961, she would say she had "lived a luminous moment" with him. But she would also contend she always "kept" herself.

Since childhood, since her years in the Terk household, Sonia had liked to live in a masculine world. She considered herself the equal—better, the friend—of men. She knew how to maintain intense, if short-lived, spiritual relationships with men.

The musky scent of earthy carnality hung over the Delaunays' nights on the town. Robert had an impertinent way of approaching and charming women. Whether he carried his flirtations as far as love affairs and Sonia, in turn, found release in the arms of the troubling Blaise is a matter of conjecture. When she became a widow, she would say that she had told Robert, "You do what you want as long as you don't make a fool of me. I don't want to know."

Sonia would admit she was curious about vice, and at least one evening with Blaise and Fela ended up at the Sphinx, a bordello where half-naked whores tried joyless obscenities on them. Fela hated it, and Blaise would describe the evening as "appallingly" depressing:

"There we were, the Delaunays and the two of us, behind never-empty beer mugs, assailed by the girls and looked over by men who had come to soothe their fever. The perverse songs gave our women fits."

Not a dancer herself, Sonia liked to sit near the orchestra, absorbed by the music, the reflections of the electric lights. The sinuous rhythms of the tango induced the colors to move.

She painted the first version of *Le Bal Bullier* on a wide stretch of mattress canvas 3.90 by 0.97 meters (approximately 4 by 1 yards), depicting the entire dance floor and the electric floodlights. In the embrace of a tango, elongated shapes of faceless yellow, red, green, and black-and-white couples melt into a riot of color forms, prism reflections of the projectors. She called the painting her answer to the *Moulin de la Galette*, as Degas, Renoir, and Lautrec had painted the Montmartre cabaret. But she wasn't happy with her result. Dancers were always depicted in poses of rest—Degas' famous ballerinas caught in striking postures. She wanted hers to move.

But how do you make figures move in a fixed medium? By expressing the mood of dance, instead of the exact posture of the dancing figures, and by making the colors dynamic and blurring the figures. Almost all the painters who tried abstraction were confronted with the dilemma of seeing the subject all but disappear into the texture of the painting. Sonia's solution was to favor atmospherics and patterns. She boldly cut out most of her dancers, literally, by reducing the length of the picture. In its final form, the right and left thirds of the canvas are trimmed away, to leave a 1.3-by-0.97-meter painting.

What is left is a vast near-abstraction of color splotches and three barely distinguishable embracing couples.

If *Le Bal Bullier* was an exercise in color dynamics, publishing Cendrars' *Prose du Transsibérien* became a passionate experiment in synthesizing poetry and paint.

The *édition de luxe* was becoming an extension of art gallery ownership rather than publishing. Willy Uhde was busy with his newest discovery, Séraphine Louis, a clockmaker's daughter and former cowherd he called Séraphine de Senlis, and whose naive, devotional painting he believed made her a new Henri Rousseau. But his dealer friend Daniel-Henry Kahnweiler was particularly successful in coaxing his painters to supplement their income by illustrating limited editions of notable modern authors. Max Jacob was a legendary personality—a slightly older friend of Picasso and Apollinaire, a poet, visionary, painter, homosexual, recluse, astrologer, and humorist—whose work Kahnweiler had just published, illustrated with etchings by Picasso and André Derain.

The limited edition Blaise and Sonia had in mind with Fela's 3,000 francs was something totally new. Instead of having the text interrupted now and then with Delaunay-Terck [sic] illustrations, they decided his text, arranged like a movie sound track, should run down the page "in sync" with her images to make the effect *simultaneous* instead of sequential. This meant that the format of the book had to be changed. Instead of pages, *La Prose du Transsibérien* would run down a vertical paper panel two meters long, folded in half lengthwise and then accordion style into twenty connected sections. In this way it could be carried like a book, and unfold to be experienced as a six-and-a-half-foot layout.

Without illustrating Blaise's narrative, Sonia's color field would complement it. She began to paint the top panel, a not totally non-figurative display of blue and violet disks and a vertical white tower shape, a kind of abstract Moscow of a thousand and three bell towers and the "great almonds of the cathedrals all in white." Patches of yellow and red suggested the sun over Moscow or, as the text said:

> the Kremlin like an immense Tartar cake
> frosted in gold.

As the eye runs down, it travels over whirling suns, clouds, and wheels, the Transsiberian journey as seen not from a moving train but from an airplane.

To help pay for the expensive printing, Sonia got the idea of launching a publicity campaign. A flurry of leaflets, subscription forms, and prospectuses announcing the September publication of "the first simultaneous book" went out.

Sonia's posters were homemade silk screens, or *pochoirs*. Inspired by the Japanese stencil print technique, *pochoir* stencils had been used in elegant fashion publications and in book illustrations. After learning embroidery on her own and engraving from Grossmann, she now added silk screen processing and bookbinding to her "applied arts" skills.

Apollinaire weighed in with a puff piece: "Blaise Cendrars and Mme Delaunay-Terk have carried out a unique experiment in simultaneity, written in contrasting colors in order to train the eye to read with one glance the whole poem, even as an orchestra conductor reads with a single glance the plastic elements painted on a poster."[2]

The proposed press run was 150, with Sonia "bleeding" the silk-screen colors to the edge of each so as to make each copy unique. Standing 2 meters each, if unfolded, the 150 copies would, put end to end, rival the 300 meters of the Eiffel Tower, the supreme simultaneous monument. Sixty-two copies were actually made. The most beautiful copies were printed on vellum and sold for 500 francs; copies on Japanese vellum were 100 francs.

In September, Robert and Sonia and three-year-old Charles were in Berlin. The first *Herbstsalon* was the most ambitious show Walden had ever undertaken. Nearly four-hundred paintings and sculptures were on display, with abstraction and naive art the main themes. The late Henri Rousseau was represented with twenty-two pictures.

Blaise and the very pregnant Fela had preceded the Delaunays and were at the station with Macke and Marc to welcome them. So was someone out of Sonia's past—her aunt by marriage, Maria Oskarovna Terk.

Maria, the M. O. in the eighteen-year-old Sonia's diary, her first confidante, had not aged well. In fact, the Germans at the exhibition where the Delaunays spent most of their time, thought Frau Terk, who took care of little Charles, was Sonia's mother.

Maria talked about home, about the Delaunay evening Alexei Smirnoff had organized two months earlier, the gorgeous posters Sonia had made for the occasion. Why didn't she and Robert come for a visit?

"Alexei so much wanted you to come," Maria said, smiling.

Apparently, Maria, Alexei, and a few other early friends were all Sonia wanted to reveal of her Russian past.

Robert had thirteen paintings at the exhibition. Sonia made him promise not to get into arguments with fellow painters. Macke's wife found Robert to be as arrogant as ever and mentioned that he was always with Sonia and his "mother-in-law."

The Berliners fell in love with his *Cardiff Team* and his *Eiffel Tower* variations, but it was his abstractions *Circular Forms, Simultaneous Contrasts: Sun, Moon* that captivated the painters. Sonia's display copy of *La Prose du Transsibérien* was appreciated as well as her paintings, book covers, lampshades, cushions, goblets, and posters. Of the two of them, however, the show belonged to Robert. *Sun* and *Moon* were seen to suggest some cosmic symbolism, essentially paintings of light—light as the source of all life and energy, as of colors, to be on the cusp of a transition from symbolism to abstraction.

He was savoring his achievement—with a trace of jealousy. While he was in Berlin, Kahnweiler was preparing a major show for Picasso at the Tannhaeuser Gallery in Munich, to be followed by an exhibition of the American synchromists MacDonald-Wright, Russell, Pat Bruce, and Frost.

Returning to Paris, Robert and Sonia found a lot of their friends were increasingly anti-German. Luncheons at Rue des Grands Augustins had a way of turning heated when the conversation turned to politics. Austria could not tolerate the rise of strengthened Slavic states on her borders. Russia, on the other hand, did not want to see Slavic gains repressed. England and France could not sit still if Austria, with Germany behind her, moved into the Balkans.

Sonia hated politics, and Robert cut the arguments short by

reminding everybody that the German Social-Democrats, the biggest party, were for peace and that here at home, Jean Jaures was calling for all socialists to unite. "I [can] feel my soul go[ing] socialist," said Robert.

La Prose du Transsibérien came out in October. In early December, Apollinaire and his long-since-vanished secretary Gery Pieret were vindicated. Among the letters the Florentine art dealer Alfredo Geri opened one day in early December was one dated Paris, November 29. The writer described himself as an Italian; twenty-seven months ago, he had suddenly been seized with the desire to restore to his homeland at least one of the many treasures that the French, especially during the Napoleonic era, had stolen from Italy. He had snatched *Mona Lisa*, and the da Vinci was currently in his possession. He would not ask a price for the painting but intimated that he was a poor man. The letter was signed "Leonard."

Geri showed the letter to Giovanni Poggi, the director of the Uffizi Gallery, and together they decided the art dealer should answer. In less than two weeks, "Leonard" agreed to come to Florence and to bring the painting with him. On December 21, Geri and Poggi accompanied a modestly dressed thin young man to his hotel room who, to all their questions, said he wanted 500,000 lire.[3] From behind shoes, a pair of pliers and a mandolin, he pulled out *La Gioconda*. The Louvre catalog number and stamp were on the back.

Geri and Poggi assured Leonard that they would defend and respect his right to a generous reward but that Poggi would have to take the painting to the Uffizi to verify it. They all trotted to the museum, Leonard with the painting under his arm. An hour later, Vincenzo Perugia, a house painter who had worked for a contractor restoring the Louvre, was under arrest.

It was not the first time that the finding of *Mona Lisa* had been announced. One curator at the Louvre refused to believe it. When it sank in that it was true, Italy's King Victor Emmanuel III was among the first to be informed. In jest, the Chamber of Deputies debated the theft of the theft. Napoleon's theft was too ancient to constitute grounds for a feud with France. Italy would quarrel with the whole world since so many countries had stolen masterpieces from her. On

New Year's Day, 1914, the painting crossed into France in a special railway car.

Sonia couldn't forget Picasso's betrayal when Apollinaire had been the prime suspect. "I've never forgotten his jilting of a friend," she would say. "In his affection for demolishing people, Picasso never spared his friends."[4]

15

Distant Drums

The fateful year of the outbreak of World War I began on a happy note for Robert and Sonia. Her *Electric Prism* was exhibited at the Salon des Indépendants, along with his tribute to France's aviator hero Louis Blériot.

Even though airplanes and aviators were very much in the public view at the time, painters were curiously uninterested. Despite their search for novel perspectives, the majority of even the most innovative artists were irrevocably bound to tradition in their choice of subjects.

After the Delaunays' return from Berlin, Robert began to haunt the St. Cloud airstrip near Louveciennes. Despite his desire for a new vision, however, he apparently never invited himself for a ride in a flying machine—Charles would say the closest his father ever came to flying was when Lindbergh crossed the Atlantic in 1927. *Hommage à Blériot* is neither an aerial view of the world nor a realistic representation of Blériot's crossing of the English Channel five years earlier. It is an ambitious allegory of the new age, a large square painting in which a box-kite biplane floats over a rudimentary Eiffel

Tower next to a Blériot-type monoplane, while below a propeller, radial engines, and spoke wire wheels are caught in a cascade of swirling disks.

Sonia was sure they were onto something new. Her *Electric Prism*, she felt, inaugurated a new pictorial structure that set the colors free to become their own subject. For her there were no such things as "minor" or "applied" arts, and she didn't hesitate to apply the simultaneous technique to everyday objects—fabrics, embroidery, book covers, and clothes.

Fernand and Nadia Léger were regular guests at the Delaunay "Sundays" along with the leading critics and literary lights, from Apollinaire to Henri-Martin Barzun (a poet who claimed *he*, not Cendrars, had invented simultaneous poetry) and Jules Romain, holding forth on pacifism and humanity's need to transcend nationalism. Like Sonia, Fernand was experimenting with the depiction of movement on a canvas and, like Robert, with devising a pictorial equivalent of the machine.

Léger, who brought along a tall, skinny Dutchman named Piet Mondrian, pushed the already machinelike forms of his paintings, derived from human bodies, limbs, trees, clouds, smoke, etc., into still less recognizable shapes, calling the results *Contrasts of Forms* or, like the Delaunays, *Geometric Elements*. Mondrian, for one, was impressed by Léger's use of primary colors, black linear structure, and simple contrasting shapes. The artist, Fernand said, had only to reassemble a collection of given objects. "I have no imagination," he asserted.

Little Charles was the only child at these energetic talkfests, a somewhat neglected child who was brought along wherever his parents went. Parenting was not a dominant trait in either Robert or Sonia, and they paid only distracted attention to the boy. What Charles would remember of his early childhood was sitting under bistro tables while his parents talked and, at home, shuffling off to bed when he had had enough of the adult discussions.

They still dressed up for the Bal Bullier Thursdays, but the "gang" was falling apart. Fela had never liked the far-out posturing, the money sunk into *La Prose du Transsibérien* was not coming back in sales, and she was eight months pregnant. When she demanded a change, Blaise

obliged and found a farmhouse in Forges-par-Barbizon southeast of Paris. Fela gave birth to a boy they named Odilon after the still-living impressionist painter Odilon Redon. Apollinaire was angry at Blaise for inventing, or transmitting from what he had heard in New York, a false account of Walt Whitman's 1892 funeral. This had led Apollinaire to write a seriocomic piece in *Mercure de France* that led to public protests and trouble for him with the editor-in-chief. Marie Laurencin had finally dumped him and married Otto von Waetjen, a young German painter everybody on Montmartre, including Apollinaire, knew. And in May, Robert had a fistfight with Arthur Cravan smack in the middle of the Bal Bullier ballroom.

Though Apollinaire and Cendrars had written perceptive and flattering articles about the Delaunays, in general Robert was touchy about criticism, and some of the comments on the literary fringe, including those of the burly Arthur, were less than obliging. Writing in his magazine *Maintenant*, Cravan had said that until Robert had met his cerebral Russian wife, Robert had been an ass. "It is she who filled her husband's head with eccentric and extravagant ideas." *Fantasio*, another marginal periodical, announced, tongue in cheek, that Paris would soon have its orphic gallery. "The director will be the wife of an important Orphic who, so far, has not been able to find an art dealer."

In any case, the Delaunays were at their table with a bearded Italian painter named Ricciotto Canudo when, at the nearby bar, Cravan began to make snide remarks intended to be overheard by Robert. When Robert had had enough, he jumped up and shouted at Arthur. At one point, the 220-pound Englishman landed a punch at Robert. He slumped down, Arthur on top of him.

Sonia went to her husband's rescue, valiantly hammering her fists at Arthur, who got up, insulting his female attacker. Canudo grabbed Sonia from behind and lifted her out of harm's way.

The Delaunays went to the police station with a complaint and got themselves a lawyer. To prove malice aforethought, they gave their lawyer clippings from *Maintenant* of Cravan's printed jibes. The tiff at a bar turned serious, and in the end Cravan was found guilty and in a summary judgment was sentenced to one week in prison.

Friends were not amused. From his farmhouse, Blaise wrote to thank Robert and Sonia for toys sent to little Odilon ("he's too little to play with such big things so in the meantime I'm the one having

fun") and to wonder about the "tone of insolent triumph" with which Sonia had related their day in court. "I don't admire (Cravan's) 110 kilos and I'm not afraid of him," Blaise wrote.

On May 28, le tout Paris applauded the opening of the Ballets Russes' newest triumph, Rimsky-Korsakoff's last opera, *Le Coq d'Or*. The choreography was by Mikhail Fokine, and the sets and costumes by the only Russian painter of whom Sonia had ever been jealous—Natalia Goncharova. Over Benois' objections, Diaghilev had decided to risk letting a cubo-futurist do the sets and costumes, and the result was spectacular. The greatest sensation was the appearance of the king's silver steed on wheels. Diaghilev now called her "the most famous" of the radical painters, claiming that artists copied her work, while fashionable Moscow and St. Petersburg imitated her lifestyle. "She paints flowers on her face. And soon nobility and bohemia were going out sketched and painted in rainbow colors on their cheeks."

Sonia and Robert's American friend Sam Halpert suggested they spent the summer in Fuentearrabia, a Basque oceanside village just inside Spain from Biarritz and the French Atlantic coast. "The sunlight is so intense, you'll love it," said Sam, who had spent the previous summer in Spain.

They decided to go. The beach was muddy in places, but from their resort hotel they could see across the Bidassoa River into France, and behind the town the Pyrenees rose to majestic heights. They even found a young Spanish maid to play with Charles and to take him to the beach.

To Sonia's distress, Robert stopped painting. It was the first time it had happened, and he had no ready explanation himself.

"I'm just not in the mood," he sighed.

As Halpert had said, the brilliant sunlight was very different from the filtered light of Paris, and if anyone should have been inspired by luminosity, it should have been Robert. Sonia didn't know what to think when Charles suddenly fell sick. A doctor diagnosed typhoid fever and suggested the boy might have caught it on the swampy beach. Sonia was sure the little maid, who had also fallen ill, was the source of the contamination.

Sonia nursed both Charles and the maid, since Robert hated

disease. But the process of healing was soon not their only concern, for the guns of August surprised them there.

Robert was not caught up in the patriotic fever that surged in nearly all Frenchmen with the declaration of war. So utterly French in thought and temperament—he would never learn another tongue and relied on quadrilingual Sonia (Spanish soon became a fourth language) to get through to non-French speakers—Robert was married to a cosmopolitan with few tribal attachments, he was recognized in Germany, and he was part of a bohemia that, all things told, paid little attention to nationality. He believed contact between people, between small rural communities, cities, and countries could only narrow differences, that more and faster ships, railways, telegraph, and the newest of marvels, aviation, were accelerating the melting of the nations.

Robert was also lucky. He had just turned twenty-nine, and so was classified, at least for the time being, as removed from active service in the French army. Spain declared its neutrality. Everybody, of course, expected it to be a short war—just autumn maneuvers with live ammunition.

Most of their friends were on vacation August 1 when Germany declared war on Russia. Fernand and Nadia Léger were in the countryside west of Paris, Blaise and Fela at their farmhouse, and Marie Laurencin and Otto von Waetjen on their honeymoon in Deauville. Marcel Duchamp was in New York, the darling of American intelligentsia. Picasso, Braque, and Derain were painting in the south of France. Chagall was back in Russia, Mondrian in Holland, and Amadeu Souza-Cardosa in Madrid, while the solitary Apollinaire, mourning Marie's betrayal, alone was in Paris. Prudently, Mondrian stayed home in neutral Holland while Cardoso took Lucie with him to the family estate in Manhufe, in northern Portugal.

On August 3 when Germany declared war on France, President Raymond Poincaré announced the general mobilization to a cheering Chamber of Deputies and called for the *union sacrée* of all Frenchmen. The next day, when England declared war on Germany, Cendrars and Canudo enrolled in the Foreign Legion. Before Blaise marched off to war, he quickly married Fela. Kupka also joined the Foreign Legion, as did Marcoussis and Kisling. The tubercular Modigliani was excused.

Apollinaire didn't know what to do. At thirty-four he was beyond

the age of the first call-up, but the *Mona Lisa* affair and the "dirty foreigner" taunts were seared in his conscience. On August 10, when he went to a recruiting office to volunteer, he was told to be patient. For a month he waited, apparently the object of a more than routine background check. In the meantime, no one cared about art and literary columns. Military communiqués and ever-lengthening lists of frontline casualties took up all the space in the newspapers and magazines he worked for, and what was left was given over to proclamations and incendiary patriotism.

By the third week of August, the main force of the German army was sweeping over the Franco-Belgian border. Between its advancing columns and Paris there was very little to stop it. Under intense pressure, the French and British forces retreated. The German advance wavered before Paris, and on August 30 General Alexander von Kluck turned his army southeast, passing to the east of Paris instead of enveloping the city. The Allies rallied, and fresh forces, transported to the front in six-hundred taxicabs, struck the flank of von Kluck's army on the Marne River. In mid-September, however, the Germans dug in and a French assault was checked. The front was not to move much during the next four murderous years.

In the war psychosis, to be foreign was to be a spy. Posters were splattered on Parisian walls saying, "Hold Your Tongue: Enemy Ears Are Listening." Not all foreigners wanted to fight for France. Picasso might have lived in France since 1898, but as a Spaniard he didn't think the war was any of his business. When the mobilization call-up reached Braque and Derain, Picasso accompanied them to the train station in Avignon. As the war took its toll, neutral positions were considered treasonable, and Picasso's attitude and concentration on his art in the middle of the war-torn country required considerable courage.

Of all the friends, Uhde and Kahnweiler were in the worst situation. As "enemy aliens," the only alternative the two dealers had to internment camps was to flee the country. Kahnweiler's collection of paintings was quietly dispersed among friends while he managed to slip into Switzerland. Willy was not so lucky. After he left, his collection was seized as enemy property by the government.

Cubism became unpatriotic. Since the cubists had been lumped together at the 1911 Salon des Indépendants, the tension between them and those attached to tradition had never abated. The outbreak of

the war made traditionalists into patriots, and their scorn for the cosmopolitanism of the supporters of the new art, its success in Germany, and the German nationality of its early defenders—Uhde and Kahnweiler—reached hysterical heights. Jean-Louis Breton, a socialist member of the Chamber of Deputies, asked parliament to forbid "that our national palace should be the scene of manifestations of such an antiartistic and antinational character." Marcel Sembat, a defender of the new art, shouted, "If you think a picture is bad, you have a perfect right not to look at it and to look at others instead. But you don't call police!"[1]

The Delaunays found it prudent to put distance between Robert and any possible theater of operations. Sam Halpert came to Spain, as did Marie and Otto, and in September Robert and Sonia moved with little Charles and the Spanish maid to Madrid.

The Spanish capital was far from the war but also far from the Delaunays' sustaining habitat. Like St. Petersburg at the time of Ilya Repin, the art practiced in the land of El Greco, Zurbarán, and Goya was an academic mixture of folklore and regionalism. Spain's best talents had been drawn to Paris, and less than a handful of painters, mainly Basques, were cubists. Sonia and Robert met Maria Blanchard, who after studying with Metzinger and van Dongen had returned from Paris. She was not encouraging.

First things first—money. Postal communications with St. Petersburg were possible—in fact, you could write both to Paris and Berlin and be reasonably sure your letter would reach its addressee— and Henri Terk agreed to redirect the monthly payments to Sonia. In the meantime, the Delaunays shared an apartment with the wife of the director of the French State Railways. The apartment was within the residence of Alvaro de Figueroa y Torres, Conde de Romanones, a courteous grandee of the royal court with grown daughters who, until October 1913, had been prime minister.

The situation at the outbreak of the war had been determined by a 1907 agreement between Spain, France, and Britain and confirmed in conversations between Poincaré and Romanones stipulating that "should new circumstances arise tending to alter the territorial status quo" in the Mediterranean or the Atlantic coasts of Europe, the three powers would "enter into communication." The war was

obviously such a circumstance. France and England, however, had made no sign, and Romanones' successor had declared absolute neutrality, Spain having no stake in the conflict.

People's sympathies were divided in Spain, as Robert and Sonia found out. The working classes, the intellectuals, the trading communities, and the liberals—including their host Romanones—were mostly pro-Ally. The clergy, most of the army, and the bureaucracy were pro-German. But there was agreement on the one essential of staying out of the conflict, and on October 30 the *Cortes* unanimously endorsed the government's decision.

The railway executive's wife—and a circular studio within the Romanones' residence set at Robert's disposal—inspired him to pick up palette and brushes again. The woman, whom Sonia would never identify, became the model for Robert's most sensual nude. Variously called *Nude Reading* and *Nude at Her Dressing Table*, the picture was a joyous, Matisse-like three-quarter rear view of a blonde woman. Cheerful background circles in the style of his *Sun* and *Moon* are repeated in the woman's breast and buttocks, and in the tablecloth on her left.

To those who found it odd that Sonia would allow her husband to lock himself in the studio with his naked model, she replied, "He was so far removed from those little weaknesses, so absorbed by his research." Sonia never said whether she had total confidence in Robert or really didn't care, but perversely she noted that his model had left France with three children but went back with five.

Letters began to arrive—from both sides of the murderous trenches. From the Waldens, Robert and Sonia learned that a few days into the war August Macke had been killed near Parthes on the Marne front. In a letter dated January 8, 1915, Blaise wrote from the front that he was as happy as a beast can possible be, "a brute who can't think, unless it's the entire body that thinks, which adds up to the same." Less than two months later, Franz Marc fell at Verdun. A sketchbook full of abstract forms was found in his tunic.

Apollinaire wrote from Nice, where he was awaiting the army's decision on whether to enlist him. He was penniless. Friends and acquaintances arrived from Paris, writers and painters also without means. The art business was practically dead, he wrote. "Dealers are reticent—after all, paintings are easily damaged, difficult to transport and, in times of war, not the best investment." His next letters talked

of Louise de Coligny-Chatillon, a much-courted, beautiful aristocrat whose mocking smile inflamed the poet. The liaison was torrid but short. On December 5, he was advised to join the 38th Artillery Regiment in Nîmes for basic training.

Others found *la planque*, the army argot for an "easy commission," a "cozy assignment." After basic training, Picabia was sent on a mission to Cuba, but his stopover in New York lasted a year. Together with Alfred Stieglitz and Marcel Duchamp he had time to start the art magazine *291* (after the Fifth Avenue address of the Stieglitz Photo Secession Gallery). Picabia was a confirmed nihilist. He used machines not to glamorize a new humanity but to express his complete lack of faith in humankind. His work in New York came to consist largely of crude mechanical diagrams with heavy sexual connotations, mock blueprints, and amorous couplings of piston rod and cylinder. Not to be left behind, Duchamp created the most famous mechanosexual art work, *The Bride Stripped Bare by Her Bachelors, Even.*

Metzinger had been called up but returned to civilian life without seeing combat. In Russia, Chagall's brother-in-law managed to get Marc posted as a clerk to the St. Petersburg war office, where his job was to examine inspection rolls.

There was no news from Willy. They heard that their writer friend Romain Rolland and the German authors Stefan Zweig and Hermann Hesse had exiled themselves in Switzerland to protest the war. Robert raged against the war, but refused to sign pacifist petitions. He would have nothing to do with it, but he wasn't a "defeatist."

Sonia tried to work. She began a big painting that she called *The Flamenco Singers*. More expressive than *Le Bal Bullier*, the painting was all disks and circles except for the faces of a woman and a guitarist. A novelty in her vibrant palette was her use of black.

When they learned that Franz Marc had been killed at Verdun, they got all his letters out of their trunk. "You remember how you hollered at Marc when he didn't understand your theories?" Sonia recalled. Just before the war, Marc had done a painting that looked as if it had been painted by Sonia. He had been a brother.

Robert had stopped painting again, and spent days dragging little

Charles around the Prado Museum to show him the works of Velázquez and Goya.

"What you need is the countryside, flowers and birds," countered Sonia. "You remember Nantua Lake, the carpet of flowers, the bird you caught and told me to feed."

"What I need is someone to talk to."

It was hard to maintain the belief that art was the only thing that mattered, that it was possible to live beyond the pale of world events. Despite his testy airs, Robert was torn between his scorn for the follies of mass psychosis and his guilt for being spared. He railed against politicians. *They* had voted the armament budgets; *they* had plunged Europe into a savagery everybody had believed had died with the Middle Ages. To ninety-nine percent of his compatriots, Robert was a coward. There are also indications that he and Sonia were hiding from his mother, that despite his perfectly legal exemption from military service, the Countess de la Rose was urging him to come back and do his part.

Sonia would speak of Robert's and her time-out from a war that would claim nine million of her "generation" with a flippancy that, sixty years after the end of World War I, would still offend. In her memoirs, the voluntary exile became "the big holiday."

"The most beautiful period of my life, the big holiday, because I managed to work in the best conditions that any painter can wish —the violent luminosity of this country, the bustle in the streets which reminded me of my childhood's Russia, the fiestas, the markets, the singing, the folk dances. Life was not expensive, we were relieved of all problems, helped by the local women full of kindness and devotion."[2]

Inactivity, contrition, exasperation, the heat and torpor of the Castilian summer, plus a friendly postcard from Cardoso drew Robert to Lisbon, taking four-year-old Charles with him. At the last minute, Sam Halpert went along. And soon, without waiting to see if things worked out, Sonia followed with their belongings, including their treasured trunk of letters.

16

To Be Thirty

Ah, to be known at the Brazileira café, where the names of all the young who unnerved the arts fluttered from the "moderate" to the "avant-garde" tables. Ah, to hold forth to a respectful audience of cultivated, eager provincials who spoke French, to be able to use trenchant apostrophes, stunning metaphor, and verbal spark, to talk about orphism and simultaneity! Portugal was different, but Amadeu and Lucie Souza-Cardoso's welcome was sincere, and the joshing reverence of Amadeu's artist friends was just what Robert needed.

They loved it, until Robert mentioned the death of Macke and shouted that the war was one immense stupidity.

"The war. I'm for it," Cardoso snapped.

Cardoso was not the only Portuguese painter who knew the Delaunays. Eduardo Vianna and José Pacheco had followed Cardoso to Paris and had come under Robert's influence. Vianna was a frail aristocrat, Pacheco an unhappy Bohemian. The trio quickly introduced Robert and Sonia to José de Almada-Negreiros, the youngest of the "four musketeers" of the Portuguese avant-garde, who had stayed

home and who was also a poet, a cartoonist, a playwright, and a novelist.

Located at the Chiado, a small square in the center of Lisbon, the Brazileira was the local equivalent of the Dome and the Rotonde on Boulevard du Montparnasse. Journalists, poets, writers, musicians, doctors, lawyers, and the rest of the Portuguese intelligentsia met at the Brazileira to trade ideas, invent practical jokes, sign manifestos, and discuss the events of the day.

The arrival at the café of a hero of one of its *habitués* was greeted with accolades, exclamations, and comments. Anyone returning from Paris was surrounded, celebrated, and riddled with questions. When Cardoso came back in 1914, he was summoned to tell whether he classified himself as belonging to the cubist or to the futurist school. "To neither. The schools are dead," he answered. "The young are looking for originality. I'm an impressionist, a futurist, an abstractionist. Nothing is absolute in painting. What was the truth for yesterday's painters is a falsehood to today's artists."

An aroma of subversion mixed with the coffee that was ceaselessly consumed, often with a tumbler of *bagaço* white brandy. The waiters were caught in the heady air of invention and created new words to detail the various coffee mixtures and dosages demanded by their regular customers. Robert would remember the Brazileira, Sonia the warm welcome of the new Portuguese friends, and Charles the cable cars running up and down Lisbon's hills.

Portugal was different because it was drifting into the war. At the outbreak of hostilities, it had proclaimed its adhesion to the Allied alliance, and before the end of 1914 it committed itself to military operations against Germany. An expedition was under way to reinforce the African colonies, and there was fighting in northern Mozambique and in southern Angola, on the frontier of German Southwest Africa.

Still, the Delaunays decided not to rush back to neutral Spain. Pacheco managed to have their return railway tickets to Madrid reimbursed. At the suggestion of Vianna, they and Halpert visited Vila do Conde, a fishing village near Porto in northern Portugal. The market town's main attraction was an aqueduct, built in the eighteenth century to bring spring water from the hills above. The five-kilometer aqueduct had exactly 999 arches.

This corner of rural Portugal enchanted them with its atmosphere of dreamy torpor. "The indifferent rhythms of oxen with huge horns, harnessed to an ancient yoke, and guided by a tiny girl draped in multicolored fabrics," Robert wrote in a letter. "Savage and strange along with other visions of clashing colors, the women's clothes, shawls full of flavorful metallic greens, watermelon reds. Forms and colors, women disappearing behind mountains of pumpkins, vegetables in a fairytale market, full of sun, intersected by a tall figure carrying on her head a vase, pure and irregular like an antique vessel. Local dresses of a rarely seen richness of color, all kinds of bursting of shapes dissected by deep blacks and gleaming whites of the male costumes which give gravity and angles to the moving ocean of disseminated colors."

Together with Vianna and Halpert they looked over a fisherman's house that was for rent. Situated in the ancient Rua dos Banhos, a street ending in the sand dunes, the house had a garden, vast rooms ideal for big-scale painting and enough bedrooms to accommodate all five of them.

"Let's take it," Sonia said.

They decided they could all fit in—Robert, Sonia and little Charles on the main floor, Eduardo and Sam upstairs. Life was dirt-cheap and peaceful in this southwest corner of Europe. "We could work from morning to night," Sonia would say. "The house was perched on the sand dunes, facing the sea, with cacti blooming in the garden. I thought I was living a fairytale. As soon as we arrived, I fell in love with the village." A photograph shows her in the garden in a long skirt and a dapper little hat and with both hands in an oversized jacket, jauntily smiling toward the camera.

What would remain in Charles' memory of Vila do Conde was fruits and vegetables that, in hindsight, seemed enormous, the displays of locally manufactured terra-cotta dishes at the market, and his father going swimming. "He disappeared into waves that were as tall as he, waves that crumbled as if someone tripped them, instead of sagging onto the beach in a carpet of foam. I seem to remember waiting an eternity before his head popped up again, so far away from where he had plunged in."[1]

The Delaunays continued their far-flung correspondence. They learned of Tsuguhara Foujita's huge success, and of Larionov and

Goncharova's leaving Russia to work for the Ballets Russes, now stranded in Italy. Arturo Ciacelli, one of the Montmartre Italians, had married a Swede and was living in Stockholm where he and his wife were planning to open a gallery. From neutral Sweden, the Ciacellis were in contact with Harwarth Walden in Berlin. In this roundabout way, Sonia and Robert learned that Jawlensky was living in great seclusion in that other neutral haven, Switzerland, and that Kandinsky had returned to Moscow.

The news from Petrograd (as the capital had been renamed in place of the old German-sounding St. Petersburg) was that the campaigns in east Prussia had brought terrible casualties and that the majority of the center and the moderate right—cherished for so long by Henri Terk—had formed a progressive party and had proposed a national coalition government, an idea the czar rejected on September 15, 1915.

Blaise Cendrars was the most faithful of the frontline correspondents. When he wrote to Sonia from the front on September 15, he alluded to censorship: "Nor can I say everything I want. We are nevertheless close you and I, that's all that matters. I love you. Why don't you send me photos of your last work so that I'll have a bit of sun. . . . I don't regret anything, but it sure isn't the time to lose one's life." A few days after receiving the letter, Sonia dreamt that Corporal Sauser lost his arm. She woke up Robert and told him about it. On September 28, Blaise's right arm was shot to pieces and amputated at a field hospital.

The news prompted a note from Cardoso. "I am happy to hear that, despite everything, Cendrars has been saved. It would have been painful if this terrible war had robbed us of such a splendid mind. If you write to him, don't forget to mention me."[2]

The sunlight in Vila do Conde and the luxuriant nature of the surrounding Minho region overwhelmed the Delaunays just as the discovery of Provence had dazzled Van Gogh, and both Robert and Sonia were seized by an intense urge to paint. Fishermen and farmers in traditional garb, the white-chalked houses, the local brown pottery, and peasant culture combined with the surrounding landscape and the sea inspired Robert and Sonia to paint a series of figure studies and still lifes, but it was Sonia who made her breakthrough here.

What for her had been theoretical experiments in Paris now became daring combinations of observations and paint. She executed

oils, experimented with a wax-and-glue technique, decorated pottery, and painted book covers, housewares, umbrella stands and toys. Beatris Moraes, a local girl, joined the household to manage the kitchen and look after "Charlot," as parents and friends began to call Charles, after the French nickname for Charlie Chaplin.

With Beatris' trusted help, Sonia worked continuously. She created simultaneous necklaces and jewelry boxes, painted a near-abstract self-portrait and her first major Portuguese work—*The Market at Minho*. It was her most lyrical picture, a poem to the goodness of life close to nature. A swirl of colors, the painting gives full rein to the roundness and continuity of color contrasts. Concentric circles are repeated in a bulky ox seen full-face, in marketwomen's faces, and in the colored arches of Vila do Conde's famous aqueduct.

The Ciacellis invited Sonia to exhibit in their Nya Konstgalleriet in Stockholm. For the catalog she did a self-portrait and, with some trepidation, sent everything off. Quietly, unobtrusively, her art sailed past the war zones, the sea mines, and the U-boats and arrived unscathed. A series of still lifes made up the bulk of the exhibition, but *The Market at Minho* was the showpiece.

Robert and Sonia turned thirty; he April 12; she November 14. Cardoso sent them a case of twenty-four bottles from his estate, but their correspondence made no mention of their "coming of age." A photo shows them, with Charles, in their garden. Charlot sits on his mother's knees, in shorts and a jacket. With a kerchief on her head, Sonia's face has filled out. Behind them sits Robert, very much the bourgeois *artiste* in tie and jacket but with a plaid shirt. In a picture taken with Beatris standing behind them, the family sits as if ready for a trip, in hats and, in Sonia's case, a coat. Robert's sharper features makes him look younger than Sonia. Charles sits between them, a white beret thrust down on his head, and he looks as if he is wondering what will happen next.

Sharing the house with Sam and Eduardo demanded all the tact Sonia possessed. Robert was loud and testy, Vianna high-strung and vehement, but together the foursome explored new techniques. One was the wax-and-glue process, mentioned earlier, which resembled batik that Sonia had first seen in Paris and which Eduardo now perfected.

Art supplies were becoming scarce and a lot of the letters between the Villa Simultanée (as they called the fisherman's house) and Car-

doso concerned oil, gouache, canvas, and, increasingly critical, paper supplies. With Lucie expecting their first child at the ancestral Cardoso estate, Amadeu played the rich and ever-helpful, if distracted, friend. "Before going South, you must come and see me, stay overnight and leave the next day," Cardoso wrote December 7, 1915. "Give me your time of arrival so I can send a car to the station. And come all of you. I'm bored with the country, the winter is sinister. I'm going to Paris in January. I've got news from Sola and Picasso. He's working, despite what he says. I'm working, too, but I've had enough of country life."

Sonia wanted to involve Vianna, Cardoso, and Almada-Negreiros in silk-screen work, and together the four of them made plans to form a group called Corporation Nouvelle. The purpose of the unofficial business association was to pursue the work she had started with Cendrars and to publish collaborative albums of poetry and art. Cardoso rapidly lost interest in the project—on his estate in Manhufe, he saw himself as a gentleman painter, not a silk-screen operator. The handsome and fashionable Almada-Negreiros, who spent more time at the Brazileira than at his easel or his writing desk, was more enthusiastic, if not for *pochoir* printing at least for collaborating with Sonia on something artistically important. Eight years her junior, José was another Blaise, writing poems to her. She liked to be admired, at a distance, chastely, by talented younger men.

José had started doing political cartoons and, besides his painting, had written several plays and was one of the cofounders of *Orpheu*, a short-lived but important magazine. He suggested that Sonia and he do a ballet together.

Robert got into the Corporation Nouvelle proposal and, with his restless affection for large gestures and gift for showy ideas, suggested a permanent road-show exhibition that would travel the world. In a feverish burst of energy, he figured it all out, down to the price of reprint albums. Vianna desperately wanted to believe. To him, the Corporation Nouvelle and Robert's ideas might be a way out of isolation and provincialism. When Robert and Sonia left, he felt hurt and pursued them with insulting letters.

Halpert was the first to find either the provincial winter or the proximity in the Villa Simultanée a bit overwhelming, and by the first week of January 1916 he returned to Lisbon, soon to go back to the United States. He carried with him several paintings by Robert

and Sonia that he was supposed to try and sell in New York. If he was successful, Robert was thinking of moving the family to Barcelona or Madrid.

Almada-Negreiros kept telling Sonia not to forget the ballet project, which they decided should be called *A Blue Ballet, à la Véronese*. What he had in mind, he wrote from Lisbon, was a sort of erotic fantasy, where the music turned the staffs of her advertising alphabets into randy maleness and her dripping disks into sweaty femininity. "I can imagine stark naked disks made rigid by the obscenity of being beautiful, in which the roundness of bellies slide in love sweat," he wrote. "There will also be the whole internationalism of mountain music, the shudder of oratory, and the fondling caresses of the feminine genius."[3]

In the manner of her self-portrait for the Stockholm catalog, Sonia produced the two biggest canvases of her Iberian period—a pair of pictures called *The Flamenco Singers*. Both canvases were an orgy of circles of various sizes, attempts at expressionist music in paint. In one, only the singer's face and parts of back wall advertising ground are recognizable. She worked a long time on the two successive pictures, telling Robert and Eduardo she wanted to end up with something as beautiful as a Veronese painting.

Sonia continued to experiment with total abstraction. Working outdoors when the weather was good, she executed a series of paintings that she variously called *Disks* and *Circles*. Vaguely resembling the various Allied aircraft markings, the circles—and circles within circles—contrasted with the rectangularity of the canvases. All were painted in vivid colors.

Three months later, the war came a little closer. Portugal seized German ships in Portuguese harbors and, on March 9, 1916, Germany declared war on Portugal. The war jitters had scarcely reached Vila do Conde when Robert was ordered to present himself at the French consulate in Vigo, just over the Spanish border, to be examined by the army medical board.

With Charlot and Beatris, Robert and Sonia traveled the 100 kilometers north to the Spanish Atlantic port. As if anticipating bureaucratic delays, Sonia brought along their trunk of letters. If nothing else, they could write letters. When Robert presented himself at the consulate, his passport and *livret militaire*, the draft-card booklet

all able-bodied Frenchmen were told to carry, were taken from him. New papers would be issued after the medical exam. He protested.

"This is wartime," he was told.

The medical examination was thorough, but the army board was less than speedy with its verdict; in April the Delaunays were still waiting. Writing letters—and receiving them—were their only distraction. Postcards to Vianna back in Vila de Conde directed Vianna to forward their mail to general delivery, Vigo post office, and a week later, to redirect their mail to the Hotel de Francia. Pending the medical verdict, Robert was told to stay in Vigo.

Sonia could still travel, however. Taking Beatris and the trunk of correspondence with her, she set out April 8 on a quick trip to Vila do Conde. At the Portuguese border, she was arrested. The trunk of letters that Beatris was carrying was also seized, but the maid was allowed to continue.

"What for?" Sonia asked.

"Accusations of espionage," she was told.

17

Disks and Circles

Papers again. And she hated it. Date of birth, place of birth, nationality, and which was her real one? The counterintelligence people said they had all the time in the world.

Sonia was taken to Porto, the big northern port city, and the Portuguese counterintelligence service began to interrogate her. Coming exactly one month after Portugal entered the war, the spy charges were no laughing matter.

But why?

Didn't she paint abnormally big circles of various sizes and colors, they asked.

What did they mean?

Could one say these circles might form some sort of alphabet? A colorist alphabet, perhaps?

She was dumbfounded.

If set up on the Vila do Conde beach in a row, her big disks might spell out something. Perhaps her colorist alphabet had been made with a purpose.

What purpose?

Madame lived on the coast, in a rented house with a view of the ocean, visible *from* the ocean? Madame was, what, a Russian citizen? Perhaps her colorist alphabet was used to signal to enemy submarines—to German U-boats?

Absurd! She was married to a Frenchman.

Serving in which regiment?

He was exempt from military service.

She explained the trip to Vigo. It could all be verified. The French consul there, a Monsieur Vachez, was a friend of her husband's.

Madame was an artist.

Her husband, too, quite well known.

And what did they live on, as artists?

She could see on their faces that saying her adoptive father, actually her uncle on her mother's side, sent money from St. Petersburg every month didn't satisfy them. It could all be checked out. In the meantime, she had friends, influential Portuguese friends. She wanted to speak to them, to alert at least Amadeu Souza-Cardoso.

Madame spoke German, didn't she? She had lived in Germany, had traveled to Berlin only months before the war broke out.

She was determined not to volunteer the name of her first husband. Had she ever told Beatris, she wondered? Was the girl alerting Robert and Vianna?

Sonia was allowed to communicate with Consul Vachez in Vigo, who, apparently without giving any details, got in touch with Robert. He in turn alerted Cardoso, who came to Porto. In a quick note to Robert, Cardoso said, "Your wife is being detained here because of some business with the consulate which is making difficulties with her papers. She is in good health and hopes to have settled the complications they're giving her, so don't worry."

Cardoso was quickly on top of things and established that the villain was the French consulate in Porto. "The French consulate tricked police into this," he wrote to Robert on March 14. "As for the trunk, which the French consul and police seized from your wife, that is another disgraceful ignominy, because for the last three days, they have ransacked and read everything without your wife's presence. It's illegal, an abuse, a crime. They can't do that without her presence, or at least the presence of an impartial witness."

The same day, a Porto newspaper picked up the story and ran the multiple headline:

A TANGLED AFFAIR
Investigation continues

Arrests in Vila do Conde

The paper told its readers that the "judiciary police of the second section, at the request of the French consul in Porto, is trying to shed light on a case in which, according to our sources, Mme Delonnay (sic), of Russian nationality, and wife of Robert Delonnay, French painter who lived eight months in Vila do Conde and is currently in Vigo, is accused of acts of espionage.[1]

"During the last two days authorities made a meticulous inspection of all the documents in the trunk that was confiscated in Valanca from the hands of Mme Delonnay's maid, Beatris Moraes, arrested Sunday."

Also arrested in Vila do Conde was Vianna. He was transferred to Porto along with documents seized from him.

Robert expressed his antiwar sentiments freely and wrote of his sympathy for Macke and Marc in his letters. And what could the French consul make of Sonia's flirtatious correspondence with Cendrars, of the poet's denunciation of the cruelty of life on the front, the letters from Stockholm relaying news from Walden in Berlin? It took another week of investigation—and assiduous reading of the Delaunays' far-flung correspondence—first to liberate Beatris and Vianna, and finally, with the pressure of a lawyer Cardoso retained, to clear Sonia. On the 20th, Cardoso was allowed to take Sonia home with him to Manhufe.

Sonia was soon back at the French Consulate to obtain the necessary papers to join Robert in Vigo. The consulate wasn't ready to back down, and employees talked of clearance to come from Lisbon.

The army medical board was finally through with Robert. He had been found to have an abnormally large heart and a collapsed right lung, and so he was given a permanent discharge and new papers. No doubt afraid that a flareup by Robert would blow everything sky high, Cardoso, perhaps with Sonia's encouragement, told Robert not to come to Porto.

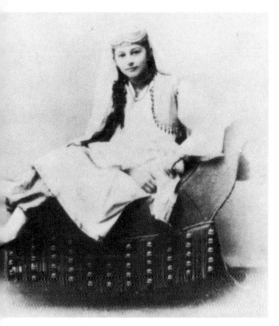

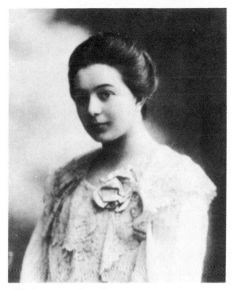

Sonia Terk at the age of twelve, already showing a delight in dressing up. Here she is in Russian costume in 1897. *(Jacques Damase collection)*

"Colors can heighten our sense of ourselves, of our union with the universe," said Sonia after her first heady year of studying art in Paris. *(Jacques Damase collection)*

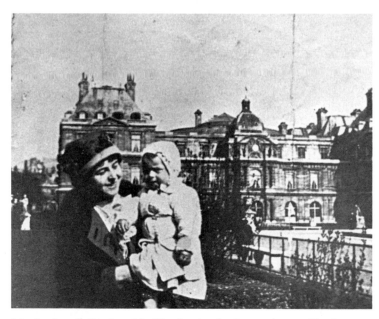

Motherhood: Sonia with Charles in the Luxembourg Gardens, 1912. *(Charles Delaunay collection)*

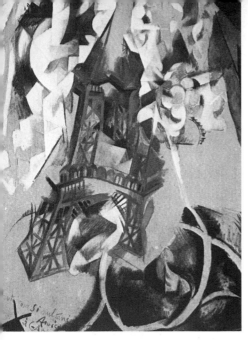

"Melting lyrical images," said Apollinaire of Robert's *Eiffel Tower* paintings. This is a 1910–1911 version of the subject. *(Museum Folkwang, Essen)*

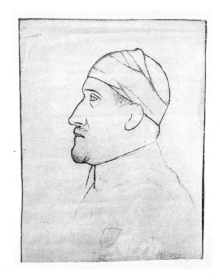

World War I drama: Apollinaire, home from the front and wearing head-wound bandages, sketched by Picasso in 1917. *(Roger-Viollet)*

Ballerina Lubov Tchernicheva, wearing the costume Sonia designed for Diaghilev's *Cleopatra*, London, 1918. *(Charles Delaunay collection)*

The Delaunays' defender and promoter in postwar Berlin, Herwarth Walden, painted by Robert in 1923. *(Galerie Gmurzynska)*

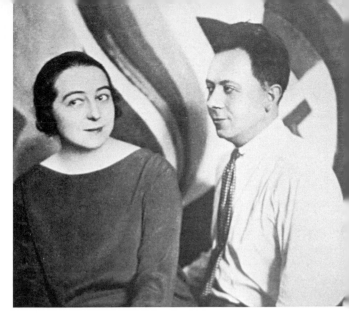

Sonia, making an en-
trance in her self-made
"simultaneous" dress for a
soirée at the Bal Bullier
in 1913. (Charles
Delaunay collection)

An artistic couple with cultural savvy: Sonia
and Robert, back in Paris after the war years
in Spain and Portugal. The picture was taken
in front of Robert's Helix, 1923. (Charles
Delaunay collection)

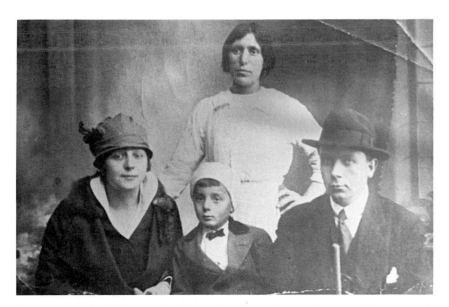

Artists in exile. Left to right: Sonia, Charles, the maid Beatris Moreas, and
Robert in Vila do Conde, Portugal, 1915. (Charles Delaunay collection)

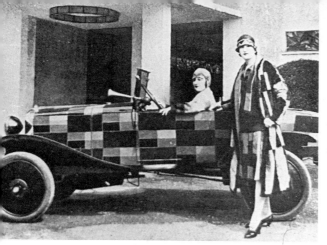

Models wearing Sonia Delaunay designs, with a Delaunay-customized Citroen in 1925. (Maison de la Mode)

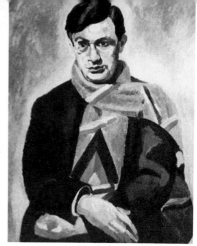

Surrealist founding father Tristan Tzara, painted by Robert in 1923. (Fundacao Calouste Gulbenkian, Lisbon)

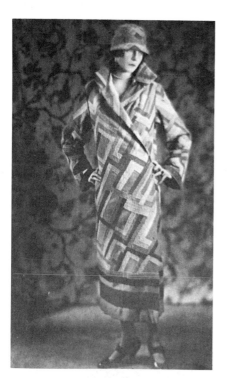

To be seen in a Delaunay design was de rigueur at the 1925 Exposition des arts decoratifs. Here, socialite Nancy Cunard models one of Sonia's creations. (Charles Delaunay collection)

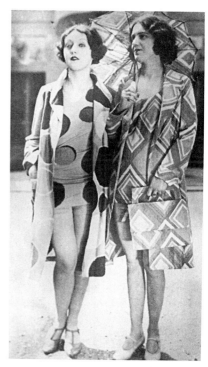

"Poetry Fashion": models showing off Sonia Delaunay beachwear, 1928. (Maision de la Mode)

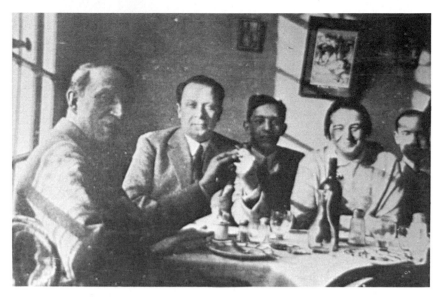

Luncheon at Boulevard Malesherbes. *Left to right:* Arturo Ciacelli, Robert, Charles, Sonia, and Joseph Delteil. *(Charles Delaunay collection)*

Robert, already sliding into obscurity in 1930. *(Charles Delaunay collection)*

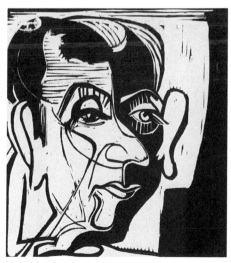

Best friend of Robert's later years: Jean Arp, in a woodcut by Ernst Kirchner, 1933. *(Museum Folkwang, Essen)*

Robert's soaring decoration for the Air Pavilion at the 1937 Paris Exposition. The task was enormous, but one that Robert and Sonia accepted with enthusiasm. *(Charles Delaunay collection)*

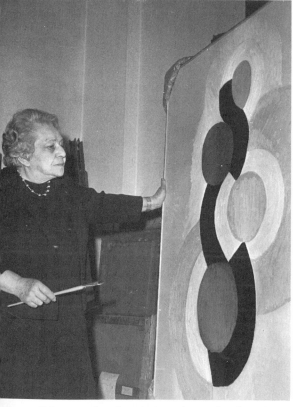

"Artistic freedom is just that—freedom from whatever constraints might detour an artist from his or her goal," said Sonia as she turned eighty. *(Keystone)*

Jazz great Louis Armstrong in a linoleum cut by Charles Delaunay. *(Charles Delaunay collection)*

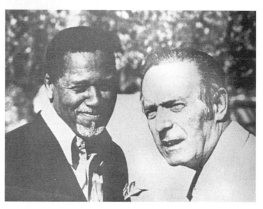

Charles Delaunay with jazz pianist and
composer, John Lewis, Nice, 1982.
(Charles Delaunay collection)

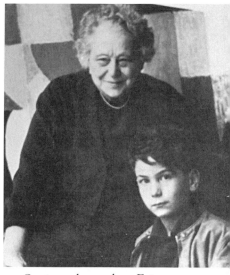

Sonia and grandson Eric.
(Charles Delaunay collection)

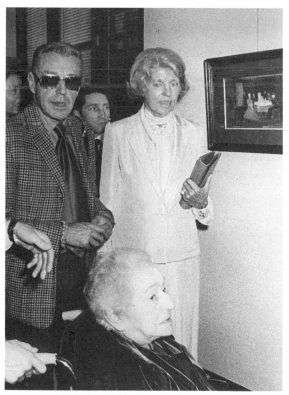

Sonia, shortly before her death,
with Jacques Damase and French
First Lady Claude Pompidou.
(Jacques Damase collection)

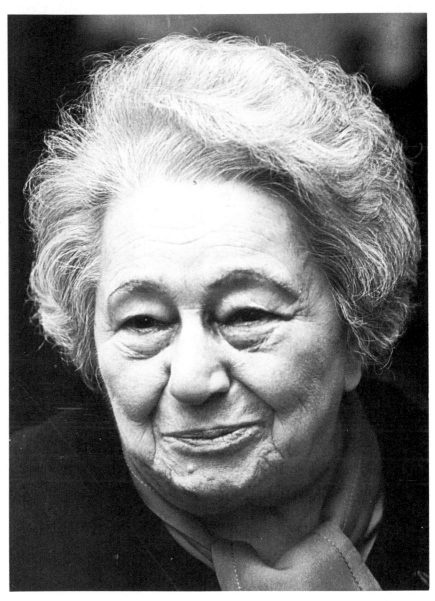

"The sun rises at midnight." Sonia at ninety-four. *(Keystone)*

As the wife of a French citizen permanently excused from military service, Sonia was given the necessary travel documents by the French consulate and, nearly a month after her arrest, crossed the border into Spain once more.

Robert couldn't help but hold forth on the obvious evocative powers of her disks and circles. Whoever it was who had denounced her—and his finger pointed to a French consulate employee vying for a reward offered to spy catchers—must have seen her paintings facing seaward in the garden.

Sonia and Cardoso weren't so sure someone from the consulate had happened down Rua dos Banhos when the disks and circles were out in the garden to dry.

"So if not the consulate employee, then who?" Robert asked.

They never found out. They agreed, however, that it might be prudent to get away from the coast. After the refusal of the Allies to consider Germany's proffered peace terms in 1916, the German high command believed Germany's fate was sealed unless its navy could somehow break the Allies' sea power. Submarine warfare was getting increasingly ruthless.

Spain, of course, was still neutral, and Sonia and Robert decided they would straddle the fence. They moved to Valança, the border town where Sonia had been arrested.

The choice proved propitious for Sonia. The mayor's father-in-law took a liking to the painter-refugee and arranged for her to design the tile decoration for the facade of the local chapel. The building, which belonged to a Jesuit monastery, became her and Robert's workplace.

The commission gave Sonia her first opportunity to work on a large scale, and to adapt her art to sculpture. In her preliminary wax-on-canvas designs, she imitated Renaissance frescoes and came up with her first and only religious pictures. The main picture portrayed the landscape of Valença, the people from the surrounding countryside, the donor of the chapel, and, at the top, an apparition of the Virgin. The sky, the people, and the iridescent vision—a swirl of color for a face—of the Virgin was contrasted by the Jesuit friars.

Christmas brought a surprise visit from Robert's mother. Charlot would remember his parents' astonishment at seeing Berthe de la Rose, loaded with parcels, get off the local train. "Despite the ef-

fusive greetings, the wonder of being together again never lasted," he would recall. "Invariably, my grandmother's stay was shortened because of futile misunderstandings that degenerated into painful confrontations."

The Delaunays celebrated New Year's 1917 with the hope that they would be going to Barcelona to take part in an exhibition, their first since the *Herbstsalon* in Berlin. The year was the grimmest of the war.

Berthe told them of a Paris without food and coal. Letters from Cendrars confirmed the rumors of defeatism's being rife in both the French and British armies, in government, in the press, and especially among workers. Treason in fairly high places was spreading. Georges Clemenceau, the "old Tiger," was brought back to power as French premier to restore confidence in ultimate victory.

On the eastern front, Russia was on the verge of collapse. Czar Nicholas and Czarina Alexandra were totally under the influence of the adventurer and self-styled "holy man" G.E. Rasputin, whose hold over them was due to his ability to arrest the bleeding of the hemophiliac czarevich, Alexis. To the massive casualties at the front, the retreat of the armies, and the growing economic hardship was added the knowledge, widespread in Petrograd, that the government was in the hands of incompetents. On New Year's Eve, Rasputin was murdered.

On February 1, the German navy proclaimed that its submarines would sink all merchant ships on sight and without warning. This ruthless campaign was followed by the severance of diplomatic relations between the United States and Germany, and on April 6 the United States entered the war against the Central Powers.

Henri Terk died that year without knowing that the progressive constitutional monarchy he believed in was following him to the grave.

Sonia and Robert were in Barcelona in October, taking a walk at the famous Ramblas, when newspapers boys shouted "Extra! Extra! Bolsheviks storm Winter Palace in Petrograd!"

They both embraced Vladimir Lenin's ideal of power to the people, but the confiscation of private property by the new order stopped the rental income the Terks had faithfully forwarded through war and peace every month.

"We're ruined," Sonia wrote. "Before we reacted to the repercussions of the Terk family's bankruptcy, the hopes of the Russian people made us cry with joy."

She and Robert were both thirty-two. For the first time they were faced with the necessity of earning a living.

PART TWO

18

Diaghilev

More than three years into what was now called the Great War, Spain was a refuge for many artists. Among the stranded were the entire Ballets Russes troupe.

The company had dispersed for an August vacation and was due to assemble October 1 in Berlin for the beginning of the 1914–1915 season. Sergei Diaghilev was in Florence to show his new choreographer and lover, Léonide Massine, the Renaissance treasures and was moving on to Rome with plans for a ballet with a religious subject. Diaghilev had signed a contract to present Nijinsky in the United States, but the war caught the dancer in Vienna—as a Russian citizen and enemy alien. Europe was in flames, and Diaghilev had no company and no money, yet he fired off letters to Stravinsky in Switzerland telling the composer not to worry but to finish the score for their next ballet.

Italy stayed out of the war until 1915, when a chance to nibble at the Austrian empire in Trieste made it join the Allied side. While Diaghilev had recruiters combing Europe for new dancers, he lived off the Roman aristocracy and managed to stage the world premiere

of Sergei Prokofiev's Second Piano Concerto. He also went to Switzerland, to get Nijinsky released from Austrian custody. To accomplish this, he not only prevailed on the Russian legation in Bern, the Hungarian ambassador to Berlin, and the American consul in Budapest, he got Countess Greffulhe, the dowager empress of Russia, the king of Spain, the Austrian emperor, and the Pope to intervene.

Meanwhile, his scouts found an English dancer, Hilda Munnings—Diaghilev changed her name to Lydia Sokolova—and by the end of 1915, Diaghilev had reconstituted his Ballets Russes. Randolfo Barocchi, the Italian owner of a marble statuary business and an amateur of music and the theater, became Diaghilev's latest financial backer, advancing the money to buy steamship tickets to New York for the entire troupe. On New Year's Day 1916, the troupe— and Barocchi—sailed to New York, and a month later, Nijinsky was sprung from Austrian custody and, via Switzerland, was allowed to join the ballet in America. But Diaghilev could pay neither the $80,000 be owed the dancer in back pay nor a salary. The American impresarios, desperate for the stars Diaghilev had promised, patched up the differences, and on April 12 Nijinsky made his American debut, dancing *Le Spectre de la Rose* and *Petrouchka*.

King Alfonso invited Diaghilev to present his ballet in Madrid. Nijinsky stayed in America, but the rest of the company crossed the ocean aboard an Italian liner. No submarines attacked the ship, and when they arrived at Cadiz, Diaghilev knelt down to kiss the soil of Spain. Dockworkers managed to let a crate containing Bakst's original scenery for *Thamar* drop into the harbor.

On May 26, the company performed at Madrid's Teatro Real in the presence of King Alfonso, Queen Victoria Eugenia, their children, and Prime Minister Romanones.

When Diaghilev was invited to the palace, the king asked him his actual function in the company. "You do not dance, you do not play the piano, what *do* you do?" asked the king. "Your majesty," Diaghilev replied, "I'm like you. I don't do anything, but I am indispensable."

Present at every performance, the monarchs became the most faithful patrons of *Los Bailes Rusos*, and Madrid—which Diaghilev found surprisingly small—remained a wartime home base of last resort for *Los Bailes Rusos*. Stravinsky was summoned from Switzerland, Mik-

hail Larionov and Natalia Goncharova from Paris, and the three were told to think of a suitable ballet on a Spanish theme. They came up with a ballet to the music of Gabriel Fauré, which they named *Las Meninas*, after the famous Velázquez painting of the Infante at the Prado. It was really only a court dance for two couples, but a sinister spying dwarf was added to make it more topical.

Diaghilev himself traveled from Paris to Rome and convinced Erik Satie, Jean Cocteau, Pablo Picasso, and Léonide Massine, respectively, to compose, write the sketch, design the sets, and choreograph, a ballet they called *Parade*. To work on the project, Cocteau and Picasso came to Rome—where Pablo fell in love with Olga Khokhlova, one of Diaghilev's dancers. In May 1917 *Parade* premiered in Paris. In one of his program notes for the ballet, Apollinaire coined the word "surrealism."

In June, they were all back in Madrid—Nijinsky making his Spanish debut, Diaghilev, Massine, Stravinsky, Picasso, and Khokhlova going to the bullfights—before the company embarked on its first Latin American tour. Picasso persuaded his Olga not to go along but to marry him instead, and Stravinsky went back to Switzerland to finish the score for *Les Noces*. When the company returned to Madrid in October, the war seemed finally to have defeated the big man. Diaghilev assembled his troupe and told them that, beyond a few performances in Barcelona and Madrid and a side trip to Lisbon, he had no more engagements. Italy was in no state to receive them, in France the third battle of Ypres was raging, the Russian war effort was collapsing, and the Russians in the company, including himself, would cease to be citizens of an Allied country. Sokalova had been the first member of the company to come down with the Spanish flu, the epidemic which was to sweep Europe and cause more deaths than the war itself. Despite the tours of the United States, Brazil, and Argentina (where Bakst's original sets for *Cléopâtra* were burned in a fire), the company was foundering financially.

Diaghilev and Massine became friends with Spain's most famous living composer—Manuel de Falla. In Barcelona, de Falla took them to see a one-act farce for which he had written the incidental music. The play was based on Alarcon's nineteenth-century *El Sombrero de Tres Picos* (*The Three-Cornered Hat*) about the attempted seduction of a miller's wife by a local governor. Massine found the music (played

by eleven brass instruments) exciting, and both he and Diaghilev sensed the potential for a full-length Spanish ballet. De Falla was ready to go to work on the project.

The company spent December in Lisbon, dancing to less-than-full houses in unheated theaters that were so dirty that the dancers' shoes, tights, and costumes were almost ruined. Stubborn and generous, miserly and wasteful, Diaghilev might have been totally broke, his pants held up with safety pins, but he was still the lord of the manor. He telegraphed Misia Edwards, the Parisian lioness who had been his muse back in 1909 when the Ballets Russes first electrified Paris, for financial assistance. Misia wired back, GIVE IT UP, SERGE.

Instead, he put together a tour of provincial Spain—Salamanca, San Sebastian, Valencia, Cordova, Seville, Málaga, and Granada. His contracts with his dancers stipulated that they spend one month a year rehearsing at half pay. This clause was enforced during January 1918, when he accepted a music-hall engagement in London in which the ballet would share the playbill with an act of trained monkeys. On March 3, when Lenin signed a separate peace with Germany and Austria, giving up Finland, Estonia, Lithuania, and the Ukraine, Diaghilev and most of his dancers became stateless exiles.

It was this decimated and demoralized ghost of the Ballets Russes former self and its dauntless impresario that rescued the Delaunays.

Sonia and Robert were disinclined to lower their standards of living, but even Robert had to admit they could not count on the sale of their art to shelter, clothe, and feed them. After picking up their belongings in Valança, they moved to Madrid. Patronage of avant-garde painting might not be flourishing there, but it had to be better than in a frontier village.

Maria Oskarovna Terk arrived from Petrograd with an eyewitness account of how the soldiers had refused Czar Nicholas's orders to shoot on workers, how the Kronstadt sailors had revolted, the Red Guards factory hands had captured every strategic point in the city, and Lenin and Leon Trotsky had seized power.

"They won't last six weeks," she said.

Robert was not so sure.

Maria was. "The Germans will smash the Reds, and the Allies

will support and strengthen the antirevolutionary generals, the "Whites."

Maria had managed to smuggle some of Anna's jewelry out, but essentially she was as destitute as Sonia and Robert. Together they found a modest *pension*. Charlot was happy to see his great aunt arrive. She played with him as she had in Berlin during the *Herbstsalon*.

Diaghilev had put on weight since Sonia had first met him and seen him go through a box of Elizaveta Kruglova's chocolates in 1905. Though crushed by debt, he lived at the Madrid Ritz Hotel in a flurry of telegrams, champagne, gastronomy, promises of new heights, and threats of suicide, playing dancers and creditors against one another with ancien régime courtesy.

When Sonia met him at the Ritz, he put his arm around her and, in Russian, said, "Ruined?"

She nodded.

He smiled. "Like the rest of us."

With an imposing fur coat thrown over his shoulder, he looked more than ever like an Oriental prince.

"In any case," he added, "Robert and you are going to create a ballet for me."

Once assured that her husband and she wanted to work with him, he needed to know whether they were free and whether they were under contract to anybody. Sonia protested that they handled their own affairs and were not bound to anyone.

In his grand manner, he swept her off. He allowed someone to send a message to Robert to meet them at a flamenco night club. With Massine and Sergei Grigoriev, the company manager since 1909, and several other members of the Diaghilev entourage, the master took her to the night club. Robert joined them, and so did Nijinsky. Inspired by the guitars, the drinks, by this Russian woman painter who Diaghilev said would be joining them, this magical and puerile dancer, already grazed by madness, decided he loved her.

"We'll be a *ménage á trois*," Nijinsky shouted over the music.

He was another Cendrars, another Almada-Negreiros, a godly handsome man, an inspired, vulnerable Narcissus in need of her support.

Bakst, Léger, Derain, Laurencin, Goncharova, Matisse, Miró, Picasso. All had worked for Diaghilev. Robert talked—too much, as

usual. Spain's greatest composer was Manuel de Falla, Robert shouted. Diaghilev nodded. De Falla and Picasso were finishing *The Three-Cornered Hat* for him.

Robert could only think of doing Picasso one better.

The rituals of the guitars filled their souls.

"And if we did *Cléopâtra* again in London?" Diaghilev asked.

Sonia remembered the Paris premiere nine years earlier. "Ida Rubinstein was Cleopatra, and you were her slave," she told Nijinsky.

Robert could see the ballet in orphic splendor. Oblivious to the guitars' florid *cante jondo*, he told them about his apprentice days at Ronsin & Company, painting Vienna Woods backdrops for Offenbach operettas.

"We danced between huge pink gods that framed a glimpse of the Nile between columns in a purple dusk," Nijinsky reminisced,

For the entrance of Cleopatra and the Dance of the Slave Girls, they had picked the music from Rimsky-Korsakov's *Mlada*, and for the *divertissement* performed during the lovemaking of Cleopatra and Amun, the music was Mussorgsky's *Khovanshchina*.

Diaghilev remembered telling Bakst, "As for you, Levushka, you will have to paint us a lovely decor." Bakst had suggested a *salade russe* whipped together with sets of a temple on the Nile, columns, sultry twilight, the scent of the East, and a great many lovely women with beautiful bodies. That is, until Diaghilev took him into the other room, sat down at the piano and made him listen to the score.[1]

Leaning toward Sonia, Massine said, "You don't have much time, you realize. We open in London in August."

At dawn, Sonia and Robert returned to the *pension*. They were too excited to let Maria and Charlot sleep, and over breakfast told of their encounter and of the work ahead.

What Diaghilev and Massine had in mind for the less-than-choice engagement at the London Coliseum was perhaps nothing more than a touched-up replacement of the Bakst sets burned in Buenos Aires. What Robert and Sonia imagined was of course something totally new.

Since part of the ballet was ritualized ceremony, why not set it in a repetitive, angular precision typical of Egyptian painting? Diaghilev and Massine wanted to retain Cleopatra's entrance in which

she arrives on stage swatched as a mummy and the slaves lift her bandaged body from a sarcophagus. Sonia could envision herself making the veils in a riot of colors, and, at the end of the ritual unveiling, revealing the queen of the Nile in a bold frontal costume. Uncannily, it was something she had thought of for the stillborn Almada-Negreiros ballet project—disks of breasts, stomach, vying against diagonal radiations of hues in the headdress.

Robert and Sonia were soon running to the Ritz to submit stage models and costume designs to Massine, who loved their vivid colors. Charlot came along, and while his parents and Massine discussed details, Diaghilev invited him to afternoon tea on the hotel terrace. The big man laughed when the six-year-old stuffed his mouth with pastries.

The Delaunays traveled with the company to Barcelona for rehearsals. Diaghilev and Massine might reside at the Ritz and the Savoy, but the rest of the company lived more humbly. Mothers darned tights and fought among themselves for the supremacy of their children. Some spoke nothing but Russian and would stand in the wings throughout the rehearsals, cooing encouragements or hissing at fancied slights to their offspring. They had tales of adventures to tell, of giving birth in railway cars, of their own youth gilded by the attention of some grand duke.

Sonia met the stars she had to dress. Lubov Tchernicheva, who would dance Cleopatra, was a stunning ballerina with topaz eyes, who was also the wife of Grigoriev. She was the only female Diaghilev kept a jaundiced eye on. During their American tour, she and Massine had carried out a silent but ardent flirtation. Champagne glass in hand, Diaghilev had caught them during a reception in Washington. Since then any girl was threatened with expulsion if she interfered with the peace of the company by "disturbing" Massine. The erstwhile Hilda Munnings, alias Lydia Sokolova, would interpret Pavlova's old role, and Lydia Lopukhova, a quick-witted ballerina who was the first dancer to break an agreement with the Mariinsky Theater and to cut herself off from Russia, would dance the Bacchanal. Before joining Diaghilev, Lopukhova had danced in the United States and been engaged to Heywood Broun, the popular baseball and drama critic.

Sonia had not been so immersed in Russian since she married Willy. A mass emigration was under way. The exiles fled north to Finland, west to Poland, south to the Black Sea and Turkey, east to

Siberia, some to reach China and the outer world with their jewels, some reaching the frontiers with nothing, to become cab drivers, waiters, or just princes, bringing that rank to almost-professional status. There were 300,000 sick and destitute Russians flooding into Istanbul.

Diaghilev might joke about his art collection left behind in Petrograd and surely stolen by Lenin, and Robert might hail the Bolsheviks' triumph over privilege and lucre, but Sonia joined those who thought they might recuperate their assets. For the next fifty years the Terk heiress would be a member of an émigrés' Association of Victims of Spoliation, meet with lawyers, organize letter campaigns, and attend meetings. As for money from Robert's mother, the relentless devaluation of the wartime economy had reduced the Countess's means of existence to new lows.

For a short summer respite, Diaghilev took the Delaunays with him and his entourage to Sitges, a Mediterranean seaside resort south of Barcelona. There, Robert painted two portraits of Massine, capturing the dancer-choreographer's intense youthfulness, a charcoal drawing of Diaghilev's newest conquest, Boris Kochno, and one of Igor Stravinsky composing *L'Histoire du Soldat*. Massine and Robert planned a sports ballet. The inspiration was Robert's *Cardiff Team* and various watercolors he had made of soccer players.

A photo was taken of the group. Sonia, in gloves and a cloche, is next to Diaghilev, whose hand is on her shoulder. Robert stands at the end, next to Kochno and Stravinsky. On the other side of Diaghilev stands a smiling Manuel de Falla, and Randolfo Barocchi, the financier who had sailed to America with the ballet corps and had lured Lopukhova away from Heywood Broun and married her.

Always a man to obtain the highest patronage, Diaghilev got King Alfonso to obtain permission for the Ballets Russes to travel through France to England. The company members arrived August 5 in Paris, where they experienced their first blackout, and continued a few days later, crossing the mine-infested Channel to dock at Southampton.

The Delaunays did not go along to London, but Diaghilev sent them a telegram describing the ebullient reaction of the September 5 audience to their sets and costumes. Massine loved the colors of the

Delaunay setting. Charles Ricketts, a painter and stage designer and an old Ballets Russes devoté, thought Robert's sets were "hideous" with "pink and purple columns, a pea-green Hathor cow, and yellow Pyramids with a green shadow with a red spot."[2]

Was the theater their future, the way to earn a living? Nothing ever came of the sports ballet, and Robert would accuse Massine of having stolen his drawings. But Aga Lahovska, a Barcelona opera singer, wrote to Sonia, perhaps at Diaghilev's suggestion, that she would be singing Amneris in *Aida*. "The opera is so old and so well-known that, in order to see it on stage, it needs a new wardrobe."

Sonia immediately submitted an "Egyptian" costume design and received a commission from an opera company in Barcelona for costumes for the Verdi opera.

19

Transitions

While single and also while married to Willy Uhde, Sonia had been a young woman who could afford to treat money with airy insouciance. Her life with Robert, on the other hand, had seen a multiplication of financial difficulties. They were both impulsive spenders whose expenses always exceeded income. Fortunately, the monthly check from the Terks usually balanced the household account, and so the sale of a portrait could be converted into a summer villa rental, invitations, trips, or loans to friends.

Always full of ideas, Robert talked about getting into posters and advertising, but Sonia decided that she would have to be the one to take charge of earning a living. She had unlimited faith in her husband as a visionary and, for the time being, she gave up painting in order to concentrate on the income-producing decorative arts that would allow him to pursue his work.

The decision entailed no existential ruminations, no question of marriage and life; it was immediate and practical. How would they pay next month's rent? The fig leaf was "for the time being." It allowed

Sonia to keep her pride even though the temporary sacrifice was to last seventeen years.

Conceding that Robert's genius was superior, she smoothed away the obstacles he seemed to enjoy placing in his own way. Eclipsed by his verbosity, she submitted to his quicksilver moods and his know-it-all infallibility with serenity. She was the little Sarah Stern again, clenching her teeth without complaining. Her generosity and optimism helped her forge ahead, and she would claim she never felt unappreciated or diminished. Others saw them as a slightly eccentric couple, he the combustible and brilliant original, she the one at the wheel, the steadying influence. "Had it not been for my mother," Charles would say with terrible finality at the end of his life, his father "would have ended as tragically as Van Gogh."

The times were in Sonia's favor. Secure in her gifts, she was on the cusp of a new decade bursting with new art, literature, and music and offering a new place for women as innovators. If Robert was the outstanding figure before the war, if he was the painter who enlarged on the cubist theme and, for a few dazzling years, enriched painting with elements of dynamics, rhythm, and movements, the Roaring Twenties would belong to Sonia.

Typically, she would try to make light of it all. In her sketchy memoirs, she would never mention how she and Robert got back from Barcelona, how they found living accommodations in Madrid, who introduced her to the Madrilene aristocracy, who cosigned a bank loan that allowed her to open a fashion and interior design boutique.

The Delaunays had spent four years in the Portuguese provinces. If they were not quite refugees, since Robert's French citizenship covered his wife, they were destitute artists, and as such they belonged to a category of exiles that the fourth year of war was dredging up in profuse number in this neutral corner of Europe.

Sonia would talk of making raffia hats with stylized embroidery for the daughters of the Madrilene aristocracy. "For the fun of it, I agreed to do clothes for the aristocracy," she would write. "A tunic, a hat made of raffia, a parasol, everything in four copies, and dressed like that, you see the four daughters of the Marquis d'Urquijo. Gaby, a Madrid star, asked me to redo the interior design of the old Bonavent

theater which will be rechristened Petit Casino in order to convert it into a nightclub. I used contrasts sparingly. The entrance is all black, the main room red, white and yellow."

Diaghilev did not return to Madrid but spent a calm and happy year in London totally renewing himself and producing two of his greatest and most popular ballets. It was of course he, however, who introduced Sonia to eminent members of Spanish society and arranged for a British bank to put up the venture capital for La Casa Sonia.

Success came easily for her. Launched by the Urquijo daughters, clients were in no short supply. The House of Sonia in the chic Calle Columela prefigured modern interior design. The walls were painted white and the room furnished in raffia matting, folding screens, and round tables. Besides such interior decorating items as lampshades, chairs, sofas, and curtains, Sonia sold dresses, hats, coats, umbrellas, and handbags.

The press was quick to pick up on the novelty. *La Correspondancia de España* opened the rave reviews,[1] and before the end of the year *El Figaro* called Sonia "one of the most restless and marvelous artists of our time.[2]

High society fought over the stock available in Calle Columela. The Marquis de Valdeiglesias followed the Urquijo family's patronage, as did Juan Romero, the brother of the Spanish ambassador to Paris. The Madrid intelligentsia knew the Delaunays. Manuel de Falla brought the big writers, the aggressively bohemian Ramón del Valle-Inclan and the unclassifiable Ramón Gomez de la Serna, an eccentric exhibitionist with an acute awareness of modernism who would follow the Delaunays to Paris and be the future actor in many surrealist pranks and stunts.

De la Serna presided over the bohemian *"tertulia"* at the Café Pombo. A score of young writers receptive to "new poetry" gathered around him and eventually launched "ultraism," intended to be an "-ism" beyond all other -isms—expressionism, futurism, dadaism, simplicism, and so on. Sonia and Robert were introduced to the nineteen-year-old Guillermo de Torre, a poet and a critic, and the wealthy Chilean Vicente Huidobro, a vain, flamboyant, gifted, untruthful, and quarrelsome author of cubist poetry who would be a lifelong friend.

Sonia discovered the flattering pleasure of being a trendsetter, of catching the mood a little ahead of everybody else. To do fashion was to divine what people wanted, and to conceive it in ways they had

not yet conceived of wanting it. Fashion was a way of inspiring a need for beauty, and it was as illusory as the emperor's new clothes.

Sonia opened a branch in Barcelona and could have sold to the king and queen had she not run into an old nemesis at the royal palace—Marie Laurencin.

Since the epic Rousseau fête at Picasso's studio, when Apollinaire had been obliged to take Marie for a walk to sober her up, Laurencin had been persuaded that Sonia, "like all women, hates me," and Sonia had always found Marie evil-tongued, and the way she treated Apollinaire before she finally left him appalling.

Still married to the aristocratic Otto von Waetjen, Marie had found a ready audience at the Palace for her affected but personal portraits with their languid pale colors, allusive drawing, and gracious feminine subjects. She was not about to let a rival poach in her royal market, and the two women's enmity would spill over into their postwar careers in Paris.

What should have united them was the sad ending of Apollinaire. Life in the trenches, he had discovered, was both revolting and grandly barbaric, and his frontline poetry transcended violence. In March 1916, he was hit in the temple by a piece of shrapnel, evacuated to a hospital, and cited for valor. By the end of the year, he reappeared in Paris cafés and newsrooms, an eccentric figure in his too-small lieutenant's uniform and with his head wrapped in bandages. Still preaching the spirit of the new, he saw his reputation grow as he became the spearhead of the upcoming generation. In 1918, he published *Calligrammes*, "poems of war and peace" that astounded the public by the audacity of their inventiveness. On November 9, two days before the Armistice, he died, a victim of the Spanish flu.

Surrealists

With the end of the war Robert made a quick reconnoitering trip to Paris. His mother had paid the modest rent at 3, rue des Grands Augustins since 1914, and except for Sonia's success in Madrid, there was no reason not to return. He met Cendrars, cynical and wizened, looking more and more like an old salt. Blaise had opened his own small press, Les Éditions de la Sirène, and he described the enterprise to Robert while deftly rolling a cigarette with the one arm he had left.

Meeting friends was not always pleasant. To have sat out the war in Spain and Portugal seemed gutless to some, downright cowardly to others. The war had claimed over four million French casualties, of whom nearly a million had been killed in action, and Robert's mocking manner and burning sarcasm were not welcome.

Tristan Tzara was a new acquaintance, a Romanian who had spent the war years in Zurich, where he had been the spiritual father of what was to be the most raucous postwar movement. During the war the Cabaret Voltaire in Zurich had been, like Lisbon's La Brazileira, the natural home of exiles—a place to keep warm, work, argue,

and display oneself. Tristan, whose monocle gave him a sarcastic demeanor, was a lethally serious person. Together with fellow Romanian Marcel Janco, the German writer and psychiatrist Richard Hulsenbeck, and an artist from Alsace, Jean (or Hans) Arp, he had founded a movement that the foursome derisively called "dada." The babytalk *dada* meant "nothing," on purpose. It was just a violent cry against smugness, against the disillusions of the war. Dadaists, Tristan told Robert, emphasized the illogical, the absurd, the importance of chance, the freedom to experiment.

Tzara, who was sixteen years younger than Robert, had just arrived in Paris himself. He had been invited by André Breton and Louis Aragon, who shared the loathing of the dadaists and Robert for the paternal generation whose values had led to the insensate slaughter. Contrary to Robert, however, these new people, who would soon call themselves "surrealists," had no faith in modernity. Robert's pre-war notion that biplanes, turbines, and technology would usher in a Brave New World elicited hoots of derision from them, but Tzara welcomed Robert's collaboration and his theories on the dynamics of color and shapes.

So did Breton when they met.

"Be our guide," said the poet.

"I already have a hard time controlling myself; how can I guide anybody?"

At twenty-five, Breton was a natural, if touchy, clan leader himself. He inspired a doglike devotion, largely because he was very inventive, very perceptive, quick and definite in both approval and scorn, and gifted when it came to arguments. An army psychiatrist dealing with traumatized, shell-shocked victims of trench warfare during the war, he had become interested in the ideas of Freud. Like so many young survivors of the trenches, he had turned violently against everything that belonged to the crumbled order. If the fathers were patriotic and nationalistic believers in the myth of sacrifice, the sons were pacifists and internationalists.

Robert was the first French painter to renew with the Germans, and the first to learn how heavy the toll had been on the expressionist generation. Besides killing Macke and Marc, the war had brought Kirchner and Kokoschka to the edge of insanity. Kirchner's health was indeed permanently broken, and he was an invalid in Switzerland. By September 1919, Robert was corresponding with Harwarth Walden

in Berlin, and a month later Walden suggested that the pictures from Sonia's Stockholm exhibition travel back via Berlin and a show at the Sturm gallery.

Back in Madrid, Robert was convinced that Sonia, Charles, and he should return to Paris. He had met Tzara and Breton, the postwar generation. He had been accepted by them and, perhaps more important, had been asked to teach them a few things.

In June and again in December 1920, Sonia made trips to Paris to weigh the possibility of relocating her fashion activities. To be a big fish in the Madrid pond was one thing, to impose herself in the capital of fashion perhaps quite another.

The prewar world was fading fast. The disastrous attempt at a comeback by Paul Poiret showed how deep the chasm was between today and l'avant-guerre—now also called La Belle Epoque with a hint of bemused nostalgia for its rose-tinted naïveté. Poiret had let himself be inspired by the Ballets Russes before the war, and had dressed le tout Paris like Asian princesses, in the vivid colors of Bakst and the Fauves. In 1919, the impish little couturier had not quite been able to translate what was successful on the stage into clothes in which postwar women felt comfortable. A new element of fashion was sports, and the rising star was Gabrielle (Coco) Chanel.

Actually only four years younger than Poiret, Chanel seemed to belong to another period in fashion. She owed her first success to her intelligence and her pretty face, and to successive lovers with culture, influence, and money. From one of them she obtained the means to set up a small millinery shop in Deauville, the fashionable summer resort. She opened on Rue Cambon in 1914, and said she almost believed the war broke out to spite her, but the modest couture house soon acquired its owner's notoriety. One legend had it that she invented the short jersey dress, but what she really created was a new way of wearing clothes. Time and again, she came up with just what women wanted, and her name came to mean a total look, from sailor hat to beige-and-black sling-back shoes, even to the scent in the air. Her flair was instinctive, and by the time Sonia returned for the first time in six years to survey the Parisian scene, Chanel was turning sports clothes into everyday life and giving costume jewelry an intrinsic value of its own. As young designers would do after her, she adopted

men's styles for women, and at the height of her career Chanel controlled a fashion empire that employed 3,000 people.

Sonia was looking for business partners through the offices of a French aristocrat and Russian emigres who had managed to hold on to their fortunes. She knew the last czarist ambassador to Paris, and suggested she could perhaps employ Russian refugee women in her sewing rooms. She wrote to Diaghilev telling him she was available to execute costume and set orders. "We're ready to travel," she wrote, including Robert in the project. "We're ready for big jobs, big efforts."

She sensed her timing was right. What she needed first, however, was start-up money. She realized that the Rue des Grands Augustins studio would not do as a fashion and interior design boutique, that a Maison de Sonia would need a tonier address, with sufficient space for workrooms for quick execution of orders. Living space was getting scarce and expensive in postwar Paris. She made a side trip to Lyons to discuss commission from silk manufacturers and she reestablished contact with Anna Terk's sister, who was married to a doctor in Heidelberg. Throughout the 1920s, the Delaunays would have annual summer visits to the Zack family.

For a moment Sonia thought she might be better off catering to the vacation trade. Perhaps she should open her boutique in Cannes or Nice, or in an Atlantic Coast resort like Biarritz, with its large Spanish clientele. She went to southern France. Afraid of leaving Robert too long by himself, she wrote to him, "Tell me by return mail that you are all right. In Paris I worried that you might be down in the dumps or bored. Paris is marvelous. Kisses to both of you. Your Sonia. My letter is incoherent, but I'm tired."

21

Fashions

Practically everything of importance that was written, painted, or composed during the first dizzy years of peace was done in Paris, the city, where, as Gertrude Stein told the onrushing Americans, the twentieth century was. With Robert's verbose intelligence and Sonia's innovative sense of style, the returning Delaunays gravitated toward the new avant-garde. Some of the clever people with whom they associated—almost all younger than they—would be famous, others just footnotes to a momentous decade.

La Stein was in her glory with the footloose Americans who came to Paris, but with the young Parisian set she was increasingly out of date. Tristan Tzara called her a fraud, and Braque shrugged off claims of her artistic influence as nonsense: "Miss Stein understood nothing of what went on around her, but no superegotist does. She never knew French really well, she has entirely misunderstood cubism, which she saw simply in terms of personalities."[1]

Matisse had abandoned Paris for the Riviera, and Picasso was thinking about it. After designing costumes and scenery in London for Diaghilev's smash hit *Three-Cornered Hat*, Picasso spent the sum-

mer of 1919 on the Riviera with Olga and their newborn son. A year later he was back. Braque remained in his old studio in Rue Caulin-court next to the Montmartre cemetery. In bad health, he denounced Picasso's cheerful existence. This didn't prevent the two friends from meeting now and then, nor did it undermine their mutual admiration, but Braque's possessiveness made Picasso say, with cruel irony, "Braque was the woman who loved me most."

Studio space was becoming expensive in the burgeoning nightlife district of Montmartre, and the Montparnasse *cités* that had attracted Chagall, Soutine, Modigliani, and Brancusi before the war quickly filled up with new tenants.

Unlike Chagall and Cardoso, Robert and Sonia had never been close to Modigliani, but his tragic end touched them both. Jeanne Hebuterne had brought him a measure of stability in 1917, inspiring his most beautiful nudes and giving him a daughter a year later. To regain his health, Modigliani had spent a winter in Nice, only to die of tuberculosis in a charity hospital in January 1920. The next day, Jeanne committed suicide, leaving their baby orphaned.

Willy Uhde was back. Luck had been with him. He had spent the war doing guard duty at the main Frankfurt post office, and with undiminished optimism he was trying not only to recover his confis-cated work but to open a new gallery. Daniel-Henri Kahnweiler was doing the same, but the war had made the Rosenberg brothers Picasso's new art dealers. Pablo and Olga were living in bourgeois splendor at 23, rue de la Boetie, off the Champs Elysées, next door to the Paul and Léonce Rosenberg gallery. Rue de la Boetie was becoming the new street of modern art galleries.

Since neither Uhde nor Kahnweiler had abandoned German cit-izenship during the war—in Switzerland Kahnweiler could have done it—their property came within the scope of an Allied law ordering the sale of confiscated German properties. Willy's possessions were modest compared to Kahnweiler's, and the government auction of Kahnweiler's collection was the art world event of 1921. As a result of public indifference, and to the satisfaction of those who had wanted to settle old scores with cubism, seven-hundred canvases by Picasso, Braque, Derain, Vlaminck, and others were thrown onto the market

in five big sales. The bottom dropped out of the market, and no one profited except a few young amateurs, including twenty-year-old André Malraux, the future novelist, art historian, and Secretary of Cultural Affairs.

By no stretch of the imagination could Sonia and Robert be considered dadaist, or surrealist, painters. The movement rested upon belief in the higher reality of things, and one new aspect of surrealism was a renewed interest in the fantastic and grotesque aspects of such artists as Hieronymus Bosch; Guiseppe Arcimboldo, famous for his freakish figures composed of fruits or animals; Giovanni Piranesi with his fantastic, imaginary prisons; and such near contemporaries as Odilon Redon, who did lithographs of dreamlike scenes populated by weird amoeboid creatures; and Felicien Rops, who illustrated books with morbid, perverse, and erotic etchings.

If there was one contemporary painter in whose work the surrealists saw the essence of their disquieting poetry it was Giorgio de Chirico. This Italian of Greek descent painted haunting, melancholy cityscapes where tailors' dummies replaced people or humans were shrunk to tiny fetishist objects. De Chirico had been to Paris before the war and had known Apollinaire well enough to paint his portrait, but the main source of his inspiration was Arnold Boeklin, the Swiss romanticist whose *Isle of the Dead* had hung, in a reproduction, in Henri Terk's study in St. Petersburg. Until Max Ernst arrived in Paris in 1922 with a packet of dada collages and became the first resident surrealist artist, the group had been wholly literary.

Robert nevertheless was flattered to be considered a friend of a group of young people who believed an artist can create only if he lets his subconscious speak with such total freedom as to reach totally new knowledge. Sonia loved to be with young artists, to be an inspiration to them.

Tzara and Breton, who were giving dadaism a more positive spin by exploring the frontiers of experience, quickly became the Delaunays' friends. They were followed by writers like Louis Aragon and the jack-of-all-arts, Jean Cocteau.

Cocteau, who was to leave his elegant thumbprint on poetry, theater, illustration, novels, and filmmaking, didn't remain a card-carrying surrealist for long. He believed in renewal—in danger, liberty,

and the value of beauty for its own sake—and his interest was in the topical, in the cleverest possible exploitation of the very best fashion and the very best people. Homosexual, drug addict, and socialite, Cocteau needed to astonish, and he was a friend of everyone who mattered.

Tzara was soon sponging off the Delaunays' luncheon table, as had Cendrars and Apollinaire before the war. Other returnees who found their way to Robert and Sonia's ever-hospitable door included Marc Chagall, his bride, Bella, and their little daughter Ida.

Marc had continued his own work in Russia, largely impervious to the futurism and constructivism controversies, but he, too, had been swept up in the October Revolution. He was appointed commissar for the visual arts in his native city, Vitebsk, and he had persuaded Lazare Lissitzsky, a painter-architect who invented a tri-dimensional reality and had come up with some of the most original abstract perspectives, to help him. But Marc's life had been made impossible by the appointment to the local art school of people who despised everything he stood for.

At Lenin's suggestion, he had decorated the Moscow Jewish Theater—wickedly painting his own likeness in the arms of the drama director Abraham Efross. Anatoly Lunarcharsky was the Soviet Minister for Enlightenment, and although he was no great admirer of the avant-garde, the Lenin government loved the radicals for their anti-bourgeois fervor and used them to make propaganda theater and posters. For one tumultuous year, Kandinsky ran the Institute of Artistic Culture in Moscow, only to resign when his colleagues disapproved of his psychological approach to art.

The Chagalls had stopped over in chaotic, inflation-ridden Berlin to get some of the proceeds from Walden's 1914 one-man show. But money was one thing that Walden didn't have. Marc was furious, though he admitted to Robert and Sonia that Walden had taken great pains to maintain Chagall's place in the effervescence of the new German expressionism.

Sonia and Robert's first excursion was to the Salon d'Automne. What caught their eye in one room was a huge painting of disks that could have been one of their own. They dashed forward and looked at the signature. F. Léger, it said in the lower right corner.

"Asshole!" shouted Robert.

As Sonia would write in her memoirs, "This 'borrowing' didn't prevent us from being friends with Fernand later on."

The Delaunays were camping out in Countess de la Rose's apartment in Neuilly when ten-year-old Charles brought a lady to meet his mother. The woman apparently knew of the Delaunays, but more interestingly, Sonia found out, she had a huge apartment for rent.

The apartment was on the fifth floor at 19, Boulevard Malesherbes. There was no elevator, but it had five large rooms, and from the balcony there was a view of the Paris rooftops and the Eiffel Tower. Named after the lawyer who lost his life, and that of his client, Louis XVI, during the Revolution, Boulevard Malesherbes ran from the Madeleine Church through the 8th and 17th *arrondissements*, peopled by an eclectic mix of new poor, nouveaux riches, war profiteers, and persons ruined by inflation.

Sonia climbed the five flights and said yes. It was expensive, but big enough to be both living quarters and home base for her projected fashion empire. Robert was delighted; he could keep the Rue des Grands Augustins studio for painting only. The stairs were perhaps a bit much for some clients, but on the other hand, Sonia realized maliciously, the stairs might also deter clients from coming back for too many fittings.

The surrealists were interested in fashion. Its artifice appealed to them, its fleeting nature preferable to the would-be eternal values of the Louvre. Sonia's flair for adventuresome decorating, theater costume and book design, led her to adapt her bold color compositions, geometric designs, and swirling patterns to abstract dress designs. The result was a style that was different, a fashion that was decidedly avant-garde. This kind of haute couture could only be worn—and appreciated—by women who wanted to be noticed. Her clientele therefore included women who were known for their character and eccentricity, actresses and rich foreigners. To wear Sonia Delaunay was not, like wearing Chanel, to adopt a "look." It was to make a statement.

The quintessential 1920s person, the model of slender stylishness, social defiance, and sexual liberty, Nancy Cunard was a client. So was Vera Sudeikina, Ballets Russes star and the lasting Mrs. Igor Stravinsky. When Gloria Swanson, Hollywood's reigning screen god-

dess and prize clotheshorse of the day, came to Paris to make a film, the acquisition of a patchwork Sonia Delaunay coat was de rigueur.

The new apartment was transformed into an environmental collage of simultaneous colors and participatory art. Sonia and Robert might not have their prewar income, but still they resumed their "Sundays." Visitors were invited to take brush and paint in hand and to leave their marks. The entrance wall was soon covered with poems by Tzara and Breton. An Eiffel Tower painted by Robert on a door was inscribed by the signatures of Man Ray, Boris Kochno, Hans (now Jean) Arp, and his Swiss wife Sophie Taeuber. The elegant poet Paul Eluard, who lived in a surrealist *ménage à trois* with Max Ernst and Gala Diakonova (the future wife of Salvador Dali), inscribed his name under that of the art dealer Paul Guillaume. Ricciotto Canudo, who had lifted Sonia out of harm's way when Arthur Cravan swung at her at the Bal Bullier, painted his name next to Chagall's. Arthur Frost and Patrick Henry Bruce, Robert's American students from before the war, were back and stenciling their names; and the Latin friends joined in: Guillermo de Torre, Gomez de la Serna, and Huidobro. The home was a rare combination of invention, style, and fashion, and the enthusiasm with which the surrealists accepted the Delaunays made up for the loss of Robert and Sonia's prewar charmed circle.

"The walls were covered with multicolored poems," René Crevel, a young surrealist and follower of Breton, would remember. "Georges Auric, a pot of paint in one hand, was using the other to paint the notes of a marvelous treble clef. Beside him Pierre Massot was drawing a greeting. The master of the house invited every new guest to go to work and made them admire the gray crepe de Chine curtain on which Sonia Delaunay had through the miracle of inexpressible harmonies deftly embroidered in linen arabesque the impulsive creation of Philippe Soupault with all his humor and poetry."

Crevel was Sonia's newest admirer—a twenty-one-year-old poet, writer, and passionate surrealist, not quite sure how to express his homosexuality. She found his smoldering eyes, chestnut curls, and vulnerable pride touching. Like Cendrars and Almado-Negreiros, he wrote love poems to her.

Germans were not particularly welcome in postwar Paris, and the

Delaunays were practically the only ones to invite the new Bauhaus architects. Robert liked the rationalized, sharp-edged, machine-based design and Walter Gropius's idea of bringing architecture into a closer relationship with both social needs and industrial techniques. When the Delaunays entertained the Gropiuses there were sixty for dinner, and Mrs. Gropius ordered a dress from her.

The Chagalls brought a high-voltage couple to Boulevard Malesherbes. Claire and Ivan Goll were Alsatians who with the Versailles Treaty had become French, she a blonde Berlin poetess who at their own gatherings preferred to stretch out on a couch, he a Jewish poet and talent scout for a German publishing house. Claire and Ivan loved each other furiously, separated, tried to commit suicide, reconciled, separated again—all punctuated by public quarrels. Chagall had illustrated their *Poèmes d'Amour*.

The Golls' Sunday lunches rivaled the Delaunay soirees, and Sonia especially liked to be invited to their cosmopolitan open-house affairs, where the newest ideas from Berlin and Moscow were discussed. Here she met Clara and André Malraux, another mixed couple: she a German-Jewish heiress, he a pale and intense Parisian striking a proud and self-protective Nietzschean pose. Sonia also met Florent Fels, a vibrant war veteran who with his demobilization bonus had founded *Action*, a little magazine that, besides publishing Cendrars, Cocteau, Malraux, and Tzara, ran translations of the new Bolshevik authors and, even more daringly, the new German expressionists. Yet another guest at the Golls' was Kahnweiler, who was opening his new gallery in Rue d'Astorg with a French associate, André Simon, to protect him from any further "enemy alien" prosecution.

Gomez de la Serna's contribution to the Delaunay apartment decorating was a poem painted on a fan. The "fan poem" led Sonia to make a "dress-poem," sketches of women's clothes with geometric shapes, letters, and words. One dress poem called "The Eternally Feminine" played with the wearer's body and the poem, the "l" appearing at the bend of an arm, the "e" as fingers.

To a world used to T-shirts that advertise all and sundry in a profusion of lettering and colors, a dress-poem might not seem extraordinary, but to the world of 1923 the idea of wearing type on clothing, of clothes spelling out something was sensational. Sonia embroidered two short poems by Aragon on men's vests of her design.

Robert was painting huge, bold pictures of kissing heads and

calling the series *Les Amoureux de Paris*. The canvases imitated movie closeups—with Sergei Eisenstein's *Potemkin*, intellectual Paris was discovering the cinema. Robert also did portraits of Breton, Aragon, Soupault, Tzara, Cocteau, and the newest Russian émigré—Ilia Zdanevitch, a Georgian who called himself "Iliazd" and was quick to fall in with Robert, Sonia, and the surrealists. A born survivor, Iliazd would excel as poet, geographer, mountain climber, and publisher. More immediately, he became Sonia's first *nègre*, the Montparnasse argot for an artist working for another. Orders were rolling in, and besides seamstresses Sonia needed someone who could execute mockups and copy her originals.

For Iliazd Sonia created book covers, and, at the suggestion of Gomez de la Serna, she made "poem-fashions," elegant and expensive clothing for the jazz-age smart set. Her interior design of a Neuilly bookstore attracted press attention and led her to produce embroidered and appliqued "simultaneous" scarves, which she sold to the wives of artists and fashion designers.

The influx of money allowed Sonia to decorate her living room. The lighting was indirect, pointed toward the ceiling. The furniture was extremely modern—heavy, square chairs that latter-day Milano designers would call Mississippi, supplemented by huge Arabian hassocks and drapes of her own creation. There were never enough chairs, and guests were not shy about sitting on the floor with their sandwiches and snacks.

The centerpiece of the dining room was a sycamore table inlaid with geometric Sonia Delaunay incrustation. Henri Rousseau's *The Snake Charmer* graced the wall above the sideboard, flanked by two other Rousseau paintings: a self-portrait and a portrait of Henri's wife.

During meals, Robert was always ready to take the opposite side of anyone's argument just to capture attention. He had a strong opinion on everything. His views of other painters were full of nuances which, however, subject to swift revisions. With more than a grain of jealousy, he recognized Picasso's originality. He preferred Braque, however, calling Picasso an artful trickster.

Joseph Delteil was fast becoming the Delaunays' most trusted and faithful new friend. A small man who worked at the Ministry of Defense, Delteil was a best-selling author of lively, often bawdy, novels conjuring up such historical figures as Joan of Arc, La Fayette, Napoleon, and Don Juan. He was ten years younger than Robert, and

together the two men looked rather incongruous: Joseph was puny and his voice was thin and hesitant; Robert was husky and his perpetual verbalization sonorous. Still, they enjoyed each other's company, and the bureaucrat-author became not only the painter's attentive ear but his accomplice in various bizarre undertakings.

Since Sonia brought in the Delaunays' only income, they lived on a financial roller coaster. Bill collectors regularly climbed the five stories and on one occasion came with a court order to repossess the furniture. Charlot would remember his mother's dashing off one time and, by the time the dining room set was in the courtyard, returning with enough money to have the men carry everything back upstairs again.

In May 1922, money was so tight and creditors so persistent that *The Snake Charmer* had to be sold. André Breton was acting as the sometime secretary for the *Belle Epoque* couturier Jacques Doucet, an immensely wealthy, amateur collector. Paintings by Degas, Manet, Cézanne, Van Gogh, Matisse, and Picasso graced the walls of Doucet's townhouse, while his library included an original copy of Dante's *Divine Comedy*, first printings of Shakespeare and Racine, manuscripts by Lord Byron, Victor Hugo, and a handsome copy of the Blaise Cendrars–Sonia Delaunay *Prose du Transsibérien*. He had recently enlarged his collection considerably at the government auction of the expropriated Kahnweiler inventory. His acquisitions there included Picasso's seminal *Les Demoiselles d'Avignon*.

Doucet didn't haggle. When he came to Derain's studio to buy a canvas, the painter pulled a tape from his pocket, measured his canvas, and on a notepad began calculating. "It's pretty simple, Monsieur Doucet," said Derain. "It's so much per square centimeter, which comes to 40,000 francs."

Doucet pulled out his checkbook, and on the way downstairs told a friend, "They're fabulous, these modern artists. When I was young they were much less methodical."[2]

There are two versions of how *The Snake Charmer* was sold. According to Sonia and Charles, Robert gave in only after the elder couturier promised to will the Rousseau painting to the Louvre. Breton had it the other way around. "You will tell me, Monsieur Delaunay, how much you want for the painting," Breton quoted Doucet as saying. "You know what I've done for painters. Moreover, after my death, my entire collection goes to the Louvre. I'm the only

collector whose authority can force the Louvre to accept avant-garde painting."[3]

Nevertheless, Robert had Doucet sign a contract stipulating that "the purchaser pledges to will the painting to the Louvre museum." The price was 50,000 francs.[4]

With the *Snake Charmer* money, Robert acquired the Delaunays' first car and spent much of his time driving and tinkering with his new toy—a Talbot. For Robert, cars had tremendous romantic appeal, the appeal of speed, powerful machinery, and status symbol all rolled into one. Family excursions included visits to Blaise Cendrars and his new wife, the actress Raymonde. The poet lived in isolated splendor in Tremblay-sur-Mauldre, 50 kilometers from Paris. Whenever the Delaunays arrived, Charlot would remember, Blaise would call his dog Volga and would ask Raymonde to bring out a bottle.

When the Delaunays were flush with money—by 1924, Sonia was earning far more than a subsistence income—they invested in the newest consumer items. They were among the first artists to own a telephone and a radio. The Talbot was traded for an Overland, in which Chagall and Robert drove through France. Several photos exist of Delaunay, Chagall, and Delteil posing in front of the Overland: Robert expansive and superior, Marc with his frizzy hair, smiling to the camera, and Delteil, lank and serious with slicked-down hair.

Charles would remember Chagall as a rather doleful, sniveling personage, who spoke of little else but fatality, misery, and pogroms. His daughter Ida was just a few years younger than Charles, and the two adolescents had to suffer Robert's perpetual jokes about the two of them being made for each other. What Marc and Bella thought of the idea was not recorded.

Robert was anxious to get himself before the public, but he had no dealer, and the name Delaunay and the Rue des Grands Augustins studio were no longer one of the attractions of the Paris art world. Robert had not exhibited in Paris since the 1913 Salon des Indépendants, and he felt he had evolved tremendously in the intervening nine years. While Walden repeated Sonia's Stockholm show in Berlin, the Paul Guillaume Gallery gave Robert a one-man show at his Vieux Colombier gallery. The exhibition included both prewar paintings and canvases from Robert's Iberian years.

Guillaume was both collector and dealer. Eight years younger than Robert, he played a considerable role in the art world. Before the war, he had struck up a friendship with Apollinaire. Both had an interest in African sculpture—until then strictly the province of anthropologists—and Apollinaire had introduced his young friend to modern art. Marrying a wealthy and glamorous woman had allowed him to open a first small gallery, to show works of Cézanne, Picasso, Renoir, and Matisse, and to organize an exhibition of the Ballets Russes art.

Together with Apollinaire, Guillaume had published a first album of primitive art and, in a larger gallery in fashionable Faubourg St. Honoré, had dazzled Parisians with the first comprehensive show of African sculpture. Apollinaire had introduced him to Henri Rousseau, and the young dealer was behind Modigliani's early reputation. He was currently supplying Albert C. Barnes, an eccentric Philadelphia physician of enormous wealth, with more than a hundred paintings, from Cézannes to Matisses, Renoirs, and Picassos.

The Guillaume gallery was now on the Rue la Boetie. For the Robert Delaunay exhibition catalog, the dealer had Robert create his first lithograph. The show opened on schedule in 1922. The critics took cognizance of Robert Delaunay, but the show was, despite the supportive attendance of the surrealists, a fiasco.

Robert did not see the failure as any writing on the wall for him. He also did not sense the changes that Sonia's success imposed on their marriage.

But Charles did.

"Eclipsed by the verbosity and the work of my father, my mother nevertheless assumed the family responsibilities," he would say. "She never made waves. She was utter calm and tried to cut all discussions short. He was always right; she and I never contradicted him. I don't think she ever asked herself the question: Am I his equal? They both realized the potential of the other, and the question: Are we a happy couple? could have been a basis for an exchange between them, but I think they never had such a discussion."

Sonia could do the unexpected—and the contradictory. Her entourage included a lot of Russian émigrés, but she generally spoke only French to them. Sometimes, she showed off her origins, but she preferred to be seen as a French artist. She signed Delaunay-Terk until the 1930s and loved to speak Russian. She made the money, but she

hated feminists. She did not believe in politics, in revolution; if humanity would ever evolve, the evolution would be spiritual. She also did not believe in love as the redeeming impulse of human activities. She found love, as seen in movies and pop romances, mawkish and conventional.

"At a time when only a few excited suffragettes demanded the right to vote and access to areas so far reserved for men, the material well-being of the family rested exclusively on my mother," Charles would remember. "She therefore had little time for her son, who, from Madrid to Neuilly, to Boulevard Malesherbes, followed the peregrinations without having much to say while trying to get something out of a number of mediocre schools."

The boy was an easy target for Robert's moods and sarcasm. Growing into his early teens, Charlot, as they continued to call him, had a gift for drawing that Sonia encouraged. To Robert, however, the son was the incarnation of all evils—a bourgeois. Like his mother, Charlot learned never to have an opinion when confronted by his father. And the conformism that Robert detected in the boy's artistic compositions at least spared Charlot from being the butt of the sarcasm that Robert reserved for a special breed polluting the Parisian painters' milieu—the frauds, charlatans, impostors, and dupes.

"By love as much as by survival instinct, my mother tried to sweep from the path of her lord and master the obstacles that he strained his ingenuity to come up with," Charles would say. "To his mood changes, she offered a serene brow. When I was little, I rarely expressed myself and could not be considered a burden to their active social life. Everybody quickly got into the habit of considering me a prop, especially since, despite professions of hostility to anything that smacked of conformity and his avant-garde posturing, our lifestyle was sufficiently bourgeois to permit the addition of a maid to take care of my needs."

Art Deco

"By 1924 all the people had arrived, and the party was under full steam," British *Vogue* would write when it was all over. "It roared on until 1929, and expired with the Crash, leaving the guests bewildered and hung over." It was to be remembered as the Roaring Twenties, "but for the people who hadn't been asked to the party—nine-tenths of the population—it was a time of despair with hunger marches, dole queues, and war heroes reduced to selling matches."[1]

Sonia was not only invited to the party; she was one of the hosts. Whoever mentions the *Exposition Internationale des Arts Décoratifs et Industriels Modernes*, the 1925 show that gave a name to a style, also mentions Sonia Delaunay. Whoever utters the name of Cole Porter and the jazz age, Le Corbusier and auto racing, speaks also of Sonia Delaunay patchwork dressed in pure colors and kaleidoscoped together into vivid geometric and abstract designs, jumbled alphabets, and mosaics. They were made for golf and Bugattis, and Sonia had a car "personalized" in bold color striping to match her clothes.

The heart of the mid-1920s also palpitated to the rhythm of the surrealists. Despite André Breton's dead-serious 1924 *Surrealist Man-*

ifesto, which tried to give the movement a moral and esthetic doctrine, the surrealists were as much part of their day as Chanel's flappers, tennis, high society, sports cars, and charity balls.

Fancy-dress charity balls were popular in Paris and London throughout the decade. Guests wore extravagant and imaginative thematic costumes, frequently designed by couturiers. Sonia did the costumes for a February 1923 benefit for the Relief Fund of the Union of Russian Artists. Called Le Grand Bal Travesti-Transmental, the evening of dance, performance, and events was to be held at the Bal Bullier.

The program promised to be a vast fun fair. "Delaunay will be there with his transatlantic troupe of pickpockets, Goncharova with her boutique of masks, Larionov with his rayonism, Léger and his *orchestre-décor*, André Levinson and his all-star company, Marie Vassilieff and her babies, Tristan Tzara and his fat birds, Nina Peyne and her jazz band, Pascin and his original belly dancers, Codreano with her choreography, Iliazd and his bouts of fever reaching a temperature of 106 F, and many other attractions" read the newspaper advertisement. Robert decorated two stands, the Poets' Booth and The Booth for a Company of Transatlantic Pickpockets. Sonia designed a fashion booth which displayed her scarves, ballet costumes, and embroidered vests. She had girls model her newest line—"simultaneous" coats.

In the crowded dance hall, Robert ran into the couturier Jacques Heim, and brought him to the booth to meet Sonia.

"I know you're preparing a booth for the International Decorative Arts Exhibition," Robert told the designer. With an expansive gesture toward Sonia's display, he added, "This is what you'll need. With this you're sure to be noticed."

"That's an idea," Heim said. "I'll think about it."

"Listen, you sound as if you're selling me," Sonia told Robert after Heim left. "You're the husband; it looks tacky."

"Not at all. I'm your impresario. It's thoroughly modern."

Léger was in contact with a new abstract movement originating in Holland. *De Stijl* was both the name of a periodical founded by Mondrian, Theo van Doesburg, and the Belgian Georges Vantongerloo, and an architectural style. Mondrian, van Doesburg, and Vantongerloo believed that they were on the edge of a new, spiritualized

world order and that their severe abstraction would bring about the millennium of "universal language" and understanding. The trio were now in Paris and favored a cubist design which emphasized smooth surfaces and austere lines; they restricted themselves to primary colors and conceived enclosed spaces as opening out on all sides into the infinite space of the environment.

Doesburg had spent time with the Bauhaus group and influenced Walter Gropius and the new German architects. But the Bauhaus members' compromises with comfort, and even decor, were not acceptable to *de Stijl*. Doesburg, who with his wife Nellie was friendly with the Delaunays, was launching a new magazine with a name that would reverberate for decades, *Art Concret*, and he was also on the verge of accepting the commission that would be his masterpiece, the interior design of a Strasbourg brasserie.

Léger had become interested in movies. With Cendrars he collaborated with filmmaker Abel Gance on *La Roue*, and with Man Ray he was making his own avant-garde film, *Ballets Mécanique*. Léger was also opening a school for painters with two of Sonia's old student friends, Ozenfant and Alexandra Exter, and with Marie Laurencin, now divorced from her German husband. Elisabeth taught theatrical design at the Académie d'Art Moderne. She had spent the war years in Russia and had married George Nekrasov, an actor and the son of a wealthy Russian tea merchant. He managed the household, delivered her work to exhibitions, and in deference to his more famous wife, frequently introduced himself as George Exter.

The next major event on the Delaunay calendar came four months later when Sonia was asked to do the costumes for a grand surrealist evening. Besides Tzara's play *Coeur á Gaz*, the July 6, 1923, presentation at the Theatre Michel included music by Stravinsky, Auric, and Satie, films by Man Ray and Hans Richter, and poems and plays by Cocteau, Soupault, and the late Apollinaire, whom the surrealists were adopting as their patron saint.

Coeur à Gaz (The Gas-Operated Heart) was meant to be a provocation, an exchange of banalities among facial features (the characters are Eye, Nose, and Mouth) designed to offend bourgeois audiences. Tzara called it "a swindle in three acts," destined to "bring

luck to industrialized dummies foolish enough to believe geniuses exist." Sonia's costumes were renderings of stiff, formal bourgeois evening attire on cardboard encasement that parodied the clothes and the characters. Mouth was played by the novelist Jacqueline Chaumont; Nose by René Crevel. The performance was sold out.

The orchestra rows next to Robert and Sonia included Auric's musical friends Darius Milhaud, Stravinsky, and Satie. Also present were Cocteau and his chic friends from the Boeuf sur le Toit, the new "in" nightclub. The proceedings opened with the reading of works by Soupault and Apollinaire. Next, Pierre de Massot stood at the curtain and declared: "Gide and Picasso died on the field of honor."

André Breton bounced from the audience, jumped on stage and raised his cane at Massot. Somebody—the stage manager or Tzara, as Breton would charge—called the police. When they arrived, they expelled Breton and two of his followers. Someone announced an intermission.

Shortly after the curtain went up on *Coeur à Gaz*, two tuxedoed figures, Aragon and Eluard, jumped from the audience onto the stage. Sonia's cardboard costumes didn't allow the actors to move their arms, so when the two jumped on Tzara, there was little he could do to defend himself.

The evening ended at 19, Boulevard Malesherbes, with Sonia applying cold compresses to the scrapes on Tzara's chin, and Robert slowly pulling an explanation from the heroic author actor. First there was the paternity of *Coeur à Gaz*. Apparently, Tzara was not the only author of the tedious dialogue that passed for antibourgeois provocation. In fact, *Coeur à Gaz* had been part of a collective show at the Théâtre des Champs Elysées in June 1920, and Breton considered the play a common surrealist property.

Beyond personalities it seemed the surrealists were splitting along a new ideological faultline. Both Aragon and Breton believed surrealism should be more than a literary or artistic movement, and when the Communist International declared that a new revolutionary era was dawning, the two leaders declared themselves ready. Tzara was being excluded from the inner circle mainly because he was not interested in politics. As Sonia and Robert realized, that alone might very well have been the reason why he had embraced them so openly after their return from Spain.

* * *

Josephine Baker came to Paris, and Joseph Delteil fell in love—
not with the dancer but with Caroline Dudley, the peripatetic Amer-
ican lady who got the Revue Nègre to Europe in the first place.
Caroline was one of the celebrated Dudley sisters, a handsome trio
renowned for being bright, rich, and daffy. John dos Passos, one of
their many fans, wrote of them, "Somehow, out of the impact of
French novels read in their teens and of impressionist paintings de-
voured at the Art Institute, they had invented a certain style. Life
must be a *Déjeuner sur l'Herbe* painted by Renoir on the banks of the
Seine. They carried this special style into their conversations and their
cookery and their whole way of living."

When Joseph met Caroline she was the wife of a State Depart-
ment official transferred to the American Embassy in Paris. Her ardor
for her husband had cooled. Casting around for a fresh outlet for her
energies, she sensed the time was right for black entertainers in France.

And so it was. When Josephine Baker danced on the Théâtre
des Champs Elysées stage in nothing but a frill of bananas the audience
was gasping. The next day, black dancing and jazz were the talk of
the town.

La Baker soon defected from La Revue Nègre, leaving Caroline
Dudley $10,000 in debt. None of which deterred the smitten Delteil.

The textile industry was keeping a careful eye on images evolving
in the realm of the avant-garde, and Sonia was only the second artist
to be asked to create fabric designs. She followed Raoul Dufy, who
had already decorated fabrics for Poiret before the war. Her pure
geometry fabrics—squares, triangles, diamonds, and stripes—were dif-
ferent from the naturalistic designs.

"It's truly the rhythm of the modern city, its prisms, its illumi-
nation, the colors of its river," Robert told journalists. "The surface
of the fabric, intimate with the surroundings of everyday life, presents
something like visual movements comparable to chords in music, but
it gives the material a feeling of vitality."

The fabrics were a runaway success, and for good reasons. The
mid-1920s fashion had little structural detail, no waistline and a

straight neckline. The slim silhouette moved with pleats, bloused bodices, swaying fringes, flying scarves, and streamers. Designers went for the sleek, long-legged look; they cut the dresses on the bias, and made hemlines asymmetrical in printed crepes, alpaca, poplin, silk serge, and any fabric with a ribbed texture.

Robert's playing impresario at the Transmental Dance paid off. Jacques Heim stayed in contact and asked Sonia to work with him on "simultaneous" fur coats. He too liked mixed fabrics and interesting juxtapositions of shapes and colors.

Their collaboration led Sonia to form her own company. With start-up capital of 500,000 francs and Heim as a partner, The Ateliers Simultanés was both couture house and fabric design shop, and soon branched into fashion accessories and upholstery. Next came shoes, handbags, sports clothes, and hand-knitted bathing suits.

Delteil came for dinner. "My friends, I'm marrying Caroline." As soon as Dudley could obtain a divorce from her diplomat, she and Joseph would be married. In the meantime, Sonia and he collaborated on a fashion show at the new Claridge Hotel. He would declaim a poem about tomorrow's fashion; she would do a runway show. "I enjoyed not only creating a dress or a scarf, but a whole new person," she told the press.

It was the year of *Le Train Bleu*, a Diaghilev gamble that featured music by Milhaud, lyrics by Cocteau, choreography by Nijinsky's sister, Nijinska, costumes by Chanel, sets by Henri Laurens, and curtain by Picasso. Combining dance, acrobatics, pantomime, and satire, the ballet was set at a seashore resort and featured young men and women with tennis rackets in pursuit of Mediterranean pleasures.

Sonia moved swiftly into the new excitement. Cubists, expressionists, futurists, and surrealists were writing and making films, putting on plays, decorating, and philosophizing. Matisse designed for Stravinsky's new one-act ballet *Le Chant du Rossignol*, Joan Miró and Max Ernst designed a *Romeo and Juliet*, and Marie Laurencin did brief, modern costumes for Poulenc's *Les Biches*. But Sonia was running her own show, her own business. "I had every ability to be a woman executive," she would say, "but I also had other priorities. I never liked the business world, but there I was with corporate headquarters, letterhead, publicity budget, display windows. Yet I was leasing railroad cars to ship printed fabrics."

* * *

The *Exposition Internationale des Arts Décoratifs et Industriels Modernes* was meant to reaffirm France in the realm of taste and luxury trade. Anticipated for a dozen years, delayed by the war, the 1925 fair was meant to give an overview of new developments in the applied arts and to show the fusion of art and commercial enterprise. Pavilions from all the industrial countries straddled the Seine from the Eiffel Tower across the Esplanade des Invalides, and small boutiques, displaying the creations of luxury fashion houses, lined the Pont Alexandre III. Not all the exhibits could be described as "art deco." The U.S.S.R. pavilion, for example, displayed some fairly conformist groupings along with Vladimir Tatlin's sketches and mock-ups for a planned monument for the Third Communist International: a slanting tower, higher than the Eiffel Tower, that would give Moscow the world's highest building.

Yet as Yves Saint Laurent (the couturier who was not yet born but who was to consider the exhibition the high point of the century's tumultuous art) later pointed out, "It is not until 1925 that the look we think of as typical Twenties was achieved, and the exhibition gave its name to a style."[2]

The abstract design that Sonia, together with Kandinsky and Mondrian, had pioneered, was replacing the exuberance of Art Nouveau, the luxury style of 1900, and there was not a curve in sight. The pavilions were rectangular and the interiors austere. The art deco style, which was called modernist and functional, was defined as including Erte on the one hand and Le Corbusier's "architectural nudism" on the other. It was inspired by cubism, Bauhaus, and Aztec art, and the designs were intended for mass production.

Enormous fountains of glass played among life-sized cubist dolls, and music wafted down from four huge towers. Instead of display dummies, André Vigneau had made formalized wax or composition figures, Modigliani flappers with sculptured hair. The lines of Emile-Jacques Ruhlmann's furniture, Sue and Mare's interiors, René Lalique's all-glass dining room, and the quiet elegance of André Groult's designs were carried out in rare woods, covered with costly shagreen or executed in crystals. Other objects were in plastics and "ferro-concrete." The lamps, which had lost their metal curves and flounced shades,

were by Giacometti. Curtains hung straight and were of hand-woven fabrics and brocades designed by Dufy and Charles Martin.

Alfred Mallet-Stevens, the fashionable architect of the official pavilion, dedicated to the diffusion of French arts and crafts, ordered panels from Robert and Léger. Robert thought *The Woman and the Tower*—an elongated rendition of an erect Eiffel Tower, a broken-up Seine perspective, and a tall, semiabstract nude—would be appropriate for the Lounge of an Embassy room. Just before President Gaston Doumergue was to open the expo, Robert was told that the nude was perhaps too nude.

Furious, he painted a veil over the nude's less-than-graphic sex. When he was told that his thirteen-foot panel had nevertheless been taken down, he exploded. "I won't set foot at the goddamn expo." Sonia, who shared a stand in the middle of the Alexander III Bridge with Jacques Heim, asked Tzara, Soupault, and young Crevel to accompany her.

Poiret who had founded his textile and furnishing house on revolutionary lines in 1922, was naturally involved in the exhibition. He made a merry-go-round of Paris figures including an Apache dancer, a fashion model, and a fishwife, and had Dufy design three barges that he called "Loves," "Pleasures" and "Organs." Asked why, he answered, "Women, always women." "Orgues" housed his new collection with wall hangings by Dufy; "Delices" was a restaurant; and in "Amours" Poiret sat playing a perfume piano, which fanned scented breezes at visitors when he pressed the notes for different scents.

The right clothes to wear for the functional pavilion and machine-turned constructions of the expo were Sonia Delaunay's. Simplified design and striking colors stated the mood of the jazz age. Fashion was becoming a matter of personal style. The people who wore the clothes were overtaking the designers, who were obliged to conform to the uniform of short skirts, dropped waists, and simplicity demanded by the lives and tastes of society women. Sonia took advantage of the advent of sportswear—shawls, scarves, and flowing wraps that were in vogue for evening wear—and her line of clothes benefited from continuous surfaces and the modern cut.

Sonia's inventiveness, her feeling for fantasy, and the clarity and power of her colors gave her clothes an alluring visual vitality. The Sonia Delaunay woman is "radiantly reflected in her colorful dress,"

wrote Claire Goll. "The black, white and red stripe runs down her almost like a new meander, giving her movements her own rhythm. And when she goes out, she slips into the delightful mole-coat, which is covered with wool embroidery, so it looks almost woven, and its lines filled in nuances of brown, rusty red and violet. When she has friends visiting, she wears an afternoon gown, in which a gaudy triangle cheerfully recurs. But in the evening she wears the coat that is worthy of the moon and that was born of a poem."[3] Writing with the hindsight of sixty years, Diana Vreeland would say that the Sonia Delaunay success of 1925 was "a one-woman campaign of irresistible visual exuberance" that would reverberate in fashion decades later, in "the chromatic concussions of the 1960s, the outrageous shock of the punks and the lush fascinations of Oscar de la Renta, Yves Saint Laurent, Perry Ellis, and Stephen Sprouse. After all, it was she who gave the body permission to drape itself proudly in the incandescent and glorious rhythms of life."[4]

Every evening Sonia was at her stand to oversee her twenty models slip into her full line, or, on cool evenings, coats designed by Sonia and executed by Heim. Once dressed, the models paraded throughout the grounds. Sonia's high-heeled self wore ample dresses with floating sleeves, bias-cut from her own rectangular prints in violets and greens and framed in black. She was photographed at her stand in a wrap of zigzag design, and had photographers snap pictures of a nude draped in near see-through simultaneous silk, and a male model in a simultaneous bathrobe and pajamas. For an adventurous journalist, she "personalized" a Citroën B-12 roadster in simultaneous color striping. For a layout her models were photographed posing with the car.

Gropius showed her his inventions at the German pavilion— electric machines to do a household's wash, followed by an electric armoire where the clothes were tumble-dried. She asked who could afford such appliances.

"To begin with, royalty," he answered. "Later on, everybody."

Robert invited Gropius, Marcel Breuer, Erich Mendelsohn, their wives, and the rest of the Bauhaus group for dinner. When the Delaunays totaled the invitations, they figured he had invited sixty people. To Sonia, he said, "Make a gift of a dress to each of the women. That's publicity."

Sonia and Robert were turning forty. In a role reversal, there

were moments when she found the fashion business "disgusting" and he became the enthusiastic supporter of her triumph. "You're not to say no to success," he insisted. "People climb five floors to toss money at you."

"I'm doing it because I like the creative part; even to have limits to what I can do doesn't bother me," she answered. "It's the whole chi-chi side that I find less than funny, to invite people who are not our friends."

She feared the sellout. She didn't want to end up like van Dongen. "Kees was once an avant-garde artist; now he does fashion covers for *Vogue* and portraits of society women."

"So do I," Robert objected. To show he could still command commissions, he was doing sketches for a portrait of Heim's wife.

The commission took months. Robert did a total of twenty-three drawings before he painted the large (1.3 meters by 1 meter) portrait. "By midmorning, Robert drove up in his car," Simone Heim would remember. "We settled into the airy and light rotunda. He checked meticulously whether the chair was at its chalk mark, the posture of my feet, my hands and the position of the Sonia Delaunay scarf on my shoulder. He made drawings, interminably, sometimes talking a lot, sometimes not at all. As the sitting invariably lasted long, he stayed for lunch. It was a ritual."

When Dominique Desanti asked Simone Heim in 1986 whether the artist had been in love with his model, the octogenarian blushed and said, "You think so?"[5]

Twelve years earlier, when Robert painted his voluptuous *Nude at Her Dressing Table* in the Count Romanones' circular studio, Sonia had said her husband was too far removed from carnal temptations. Now she had little inclination—and less time—to wonder whether Robert was assailed by the demons of forty. She was the boss of a going business with thirty employees.

One day he tore her away for a crazy 900-kilometer round-trip to Strasbourg. There were no freeways in France in 1928 and the *routes nationales* were treacherous, two-lane highways, but Robert was aggressively pushing the car (driving "with open coffin," he liked to say).

As they lapped up the kilometers, he managed to tell her he had

had lunch with Maurice Raynal, the critic. But they had to see with their own eyes.

In Strasbourg, Robert parked in front of the Aubette brasserie and, with Sonia tailing him, tore into the restaurant. The newly redecorated interior was a symphony of slanting rectangles and squares in brazen colors.

"The sonofabitch," Robert shouted. "He has copied us, the traitor!"

The focus of his furor was Theo van Doesburg.[6]

Sonia became the comforter and the conciliator. Robert rather liked the erratic Theo, who had made himself a prophet of Mondrian, only to veer toward Delaunay.

When Robert wasn't painting or tinkering with the Overland, he tried to help his wife with inventions that had unpredictable results. Seeing Sonia prepare dress models, he imagined patterns printed directly on fabric and sold to women for quick home confection. Enabling women of modest means to accede to Ateliers Simultanés fashions appealed to his socialist posturing.

The idea of patterns and sewing instructions printed directly on the reverse side of fabrics was original enough to earn him a patent. He met a Lebanese engineer who held out bright-enough prospects for industrial production to bilk him out of a hefty sum of Sonia's earnings.

Swindle apart, Robert was of course both ahead of his time and slightly off. The future was not ready-to-sew, but ready-to-wear, and yet it would be another forty years before Pierre Cardin led a very reluctant Parisian haute couture industry into ready-to-wear.

The Sonia Delaunay clothes were one-of-a-kind couture. When Sonia explained Robert's printed patterns, a journalist immediately asked if she didn't fear her clients would take offense. She would be knocking off and mass producing her own line. The question was vexing. Sonia thought it over and decided the answer was that Ateliers Simultanés would not get into jewelry. The way for rich women to remain elegantly different, she decided, was to add jewelry of their own choice.

23

All in the Family

"It seems to me that in those days intellectuals weren't exactly home-bodies," Charles would say. "They spent the better part of their lives on the run, partying, going to shows, sitting in cafés."

Turning fifteen in 1926, he won first prizes in art classes, but the rest of the *lycée* curriculum bored him. His parents' parties, too. The guests might all be creative people, but to Charles they were all conventional. His father demanded that he attend, and his only pleasure was during the dancing: He became the disk jockey for the evening, winding up the gramophone and choosing the records. The party they gave for Joseph Delteil's marriage to Caroline Dudley was especially memorable, because he could play jazz records. That Caroline had brought La Revue Nègre and jazz to France made her more than special in the eyes of the adolescent because jazz was becoming his passion.

Still, he liked to draw. His sketching talents almost had him thrown out of the Carnot *lycée* when he was discovered showing two nudes he had painted to his classmates. Hauled before the principal, he was given a note for his parents. Robert blew his top—not at

Charles, for a change, but at the school. With his son in his wake, Robert stormed in to see the principal, who, in self-defense, appealed to the boy's art teacher. The latter was a painter himself and rather sympathized with the irate father. Negotiations led to Charles' readmission—on the condition, however, that he henceforth refrain from showing risqué works of art in class.

Sonia encouraged her son's interests by enticing him to help her with the fabric designs. Painting patterns might be repetitive, but he had the opportunity to benefit from his mother's expertise: She showed him that a line had to be drawn quickly, almost by instinct, to feel alive. She told him to try his own patterns, and he produced several hundred. Sonia sent several of them off to the textile manufacturers, thinking—or pretending—they were her own. When her son pointed out the mistake, she laughed.

But Charles knew that he would not be a painter. "I didn't have what it takes to be a genius, and I had no intention of sacrificing my life for delusions," he would remember. "I told myself, 'I'll be a painter for the fun of it, as others go fishing or work in their garden. Maybe when I'm old I'll devote my entire life to painting."

As a child he had wanted to be a bus or tramway conductor. What had impressed him was the uniform, the money-changer, multicolored tickets and the right to pull the chain when everybody was on board. "My college years were laborious but they veered me away from this first career choice without revealing a new vocation, that is, with the exception of sketching, or to be more precise, advertising."

Joseph Delteil married his American Caroline and received the prestigious Goncourt literary prize. He resigned from the Ministry of Defense and took his bride to live with him in his native region near Montpellier. If literature couldn't feed them, there was a vineyard he had inherited. Within a few years, Joseph and Caroline were producing a prized Languedoc. Montpellier was nearly 800 kilometers from Paris, and a new challenge for Robert and the Overland.

The corporate Sonia Delaunay expanded abroad. A London wholesale office opened at 20 Berkeley Street, and a Rio de Janeiro boutique at 52, rue 13 de Maio. The movies were next.

Two film directors asked Sonia to create costumes, fabrics, and set designs for their upcoming projects, and she in turn made sure Robert's stage set apprenticeship at Ronsin & Co. and his work for Diaghilev were not only recognized but led to employment. Unlike Fernand Léger, whose own film, the experimental *Ballet Mécanique*, had led the painter to do "close-up" paintings, the Delaunays kept their film experiment within the parameters of craftswork on routine commercial movies.

Marcel L'Herbier was the paragon of a polished, avant-garde "impressionism" in French film, a director who stressed elaborate images, bizarre costumes, and sets in *L'Inhumaine, Don Juan*, and *Faust*. Mallet-Stevens the architect, Milhaud the composer, and Léger had already worked for him when he asked Sonia to do the costumes for *Le Vertige*, a film adaptation of Maxim Gorky's 1907 novel *Mat'* *(Mother)*. This was a story of revolutionaries in a Russian industrial town. Sonia's costumes were in stark contrast to the seriousness of the drama, and although the film was a success, she was not invited to collaborate on L'Herbier's big adaptation of Emile Zola's *L'Argent*.

René Le Somptier was a director whose last smash hit dated from 1918 and whose career would come to an end with the talkies. In his *Le P'tit Parigot*, Sonia's patterns and abstractions and Robert's sets accentuated the comedy, but the film was a flop.

There were other bread-and-butter commissions. Sonia designed the stage wardrobe for Gabrielle Dorziat, a leading lady of the theater, created the drop curtain for Ernst Krenek's jazz opera *Johnny Spielt auf*, and fashioned costumes for Lucienne Bogaert, the star of Bernard Zimmer's play *Le Coup du 2 Décembre*, and another actress. Robert did the illustrations for a reprint of Henry de Montherland's first novel, *La Relève du Matin*, and a Joseph Delteil edition. In 1928, he exhibited a new version of a 1913 painting at the Salon des Indépendants, and found an amateur of his art.

Jean Delhumeau was a shipowner from Normandy, a former captain and rather an extraordinary personage. His mother had founded the Banque de l'Ouest, and he had spent half a century building and sailing ships, only to discover painting in his wealthy, if eccentric, retirement. He took lessons from André Lhote and in Robert's work discovered an echo of his deepest aspirations. Preceding dealers and museums by decades, Delhumeau bought many of the most important Delaunay paintings—*Sun, Moon and the Eiffel Tower*, which Sonia

thought was her husband's masterpiece, and, eventually, *Homage to Blériot*—and became the only true collector of his art that Robert would ever know.

Picasso, Gris, and Pedro Pruna all importuned Diaghilev to let them make portraits of him, but Diaghilev hated to acknowledge he was aging and resisted. He was spending more time in Venice, but in May 1927 he was in Paris. His newest discovery was a sculptor friend of the Delaunays—Naum Gabo. Naum, whose real surname was Pevsner, had experienced all the ferment of revolutionary art, having known Tatlin, Lissitzsky, and Malevitch before leaving Russia in 1922. His brother was the painter-sculptor Antoine Pevsner, a timid little man who had been in Paris before the war and recently returned with a wife whose charms had Robert in ecstasy. Diaghilev's eye was unerring, and for *La Chatte* (music by Henri Sauguet), Gabo came up with a gleaming construction of transparent planes and curves against a shining black curtain.

Sonia would have loved to work with Diaghilev again, but it was Massine who suggested they collaborate on a ballet together. Since their Spanish exile, Massine had been dismissed from the Ballets Russes once, commissioned by Diaghilev to create two new ballets, rejoined, and left the company once more. At the end of the 1927 season, Massine and Diaghilev parted company, quite amicably.

The ballet Massine and Sonia had in mind was an adaptation of Vivaldi's *The Seasons*. The production would incorporate some of the Milhaud-Cocteau-Chanel-Laurens-Picasso outdoor breeziness of *Le Train Bleu*. Sonia's sketches included a beach scene with balloons and dancers in multicolored bathing suits. The ballet was never produced, but her sketches for sets and costumes survived, showing a unified look surpassing any of her previous theatrical endeavors.

There were other disappointments: commercial poster art that was never sold, Robert's sets for *Le Triomphe de Paris*, their joint sets and costumes for *Parce que Je T'Aime*, a movie cancelled in preproduction.

The idea of a fashion inspired by modern painting led to the publication of the first book on Sonia Delaunay, a selection of her fashions, designs, and paintings. The album of twenty plates of Sonia's work was prefaced by André Lhote and included texts by Cendrars,

Delteil, Tzara, and Soupault.[1] The album was reviewed by Cocteau. "When are you going to give the male these colors?" he wrote in a burst of enthusiasm. "Thanks to you, women travel covered by marvelous postage stamps."

Despite its resonant name, the central activity of The Philosophical and Scientific Study Group was to organize lectures at the Sorbonne University. In 1927, the group asked Sonia to speak on "The influence of painting on the art of dressmaking."

Sonia accepted. Robert had her recite her speech to him. She didn't like to speak in public, but on January 27 she was on the podium, flanked by the Philosophical and Scientific Study Group members, and facing her audience and the traditional water pitcher from which she didn't dare pour a drink.

"Fashion is entering a critical period, a period as crucial as the revolutionary epoch," she began. There were a few familiar faces— Willy Uhde and his sister. She summed up the periods of liberation —the end of the girdle for women, the detachable collar for men, the end of "couturier academism." What was new was the fashion for active women, a constructive fashion, inspired by modern painting. "The construction and cut of the dress is henceforth to be conceived at the same time as its decoration."

What was next, besides a new collaboration between couturier and fabric designer, was an inevitable standardization.

During the question-and-answer period, Sonia was asked if she wasn't afraid clothes copied by the thousands wouldn't scare off her couture clients. The point was not the value of a garment, but imagination, she answered. With a whiff of Robert's socialism, she added, "Elegant women, whose role is to recirculate money, will always know what to wear to make a difference. They will find whatever will complement an evening's dress, create a harmony of colors between their jewelry and their clothes."

She believed the current, linear fashion lent itself perfectly to the art of precious stone cutting. "I'd like to see jewelers stick to simple geometric lines. People who think the current movement is a passing fad make me smile. Each season they tell us that geometric designs will soon be out of fashion."

The assertion led to a tricky question: Was she against sheer impulse?

"Not at all, but I like the idea that those we feel act on whims

are usually propelled by the most rational of logic. Have you seen how [the jeweler] Fouquet manages to create effects with a stone, to stimulate without making it heavy? I believe precious stones are in and of themselves decorative, and that the cutter's work is merely to extract their beauty. I compare raw gems with colors smeared out on a painter's palette—amorphous masses without any precise quality which spring to life when the artist arranges them on the canvas."

To the question of her favorite stone, she answered that she liked them all. What she hated was women showing off pearls to show off their fortunes. "But if pearls go well with such and such a dress, with such a such a skin color, a woman should of course wear them."

Sonia was getting far away from painting, from the all-consuming passion of art for its own sake. And Robert was there to remind her.

"To produce is great, but we must also promote our ideas," he told her. "Fashion, interior design add up to a kind of speaker's platform."

Weekend motoring saw him plunge into his next imaginative project.

On gorgeous spring Saturdays and on crisp fall weekends, Robert liked to motor to Nesles-la-Vallée, 100 kilometers north of Paris. Wife and teenage son came along, and the trio spent the night at the Golden Pheasant Inn.

Robert fell in love with the arid beauty of the hills above the Sommes River, a limestone landscape with gnarled forests and abandoned quarries, and conceived the idea of an artists' colony.

He plunged quickly into this new adventure. The site seemed ideal. Painters and sculptors could use local materials to build their own houses. Damming up one of the quarries could turn it into a swimming pool. He imagined a museum where resident artists could exhibit their work, a museum built on the principle of the snail's house, infinitely expandable—Frank Lloyd Wright would use the techniques when he built New York's Guggenheim Museum. Robert's faith in modernity was unabated, and Charles Lindbergh's transatlantic triumph in May 1927—Robert hauled Charles off to Le Bourget airport to watch the famous landing—sent his imagination soaring. A landing strip would put Nesles-la-Vallée at a half-hour's flying time from Paris.

Negotiations with the local owners, who were happy to get rid of land serving only as hunting grounds, proceeded with unaccustomed

speed. Robert got architects to survey the quarries and the woods and draw up plans for the development.

The Chagalls and Gleizes bought lots, as did Fredo Sides, and Robert and Sonia put up a hefty sum to buy the rest. Sides (pronounced *See*-dess) was an elderly rake married to an American vetegarian whom he prided himself on betraying. The son of an insolvent Italian banker and a blue-blooded mother, he had followed Raquel Meller, a music-hall queen, to America and made his fortune in antiques.

Sonia was a great fan of the libertine, who with his clubfoot and sartorial elegance was a cultivated charmer. She liked to hear him say, "I'd never leave a woman! That's vulgar; it is so easy to make the woman leave first."

The redoubtable womanizer was quick to size up the Delaunays' relationship. He could see that Sonia needed to be controlled by Robert and that both played the game, that she needed both to dominate and to be the submissive wife.

Robert and Sonia spent all their savings to pay for the nine-tenths of the property that their friends didn't buy.

To skeptics, Robert pointed to Le Corbusier. Wasn't the architect planning *The City of Tomorrow* and his *Radiant City*? Not to mention his Voisin Plan, underwritten by the car manufacturing brothers, Charles and Gabriel Voisin, which would see a good hunk of the Right Bank from the Halles to the Madeleine razed and replaced by glassy skyscrapers and right-angled giant avenues.

Like the idea of the sewing instructions printed on fabric, the dream of an artists' colony would remain a utopia. The plans sank into oblivion and, for Sonia and Charles, became a subject never to bring up in Robert's presence.

As an artist, however, Robert remained interested in quarries, stone and composite materials—sand, casein, mosaics, cement work, and plastics. He applied a veneer, made primarily from casein emulsions, both to cardboard and to canvas that allowed him to paint with watercolors, and he mixed his casein with a paste of cork sawdust that gave him a surface coat resistant to temperature changes. He also came up with a lacquered stone that could be used to make colored walls, a material with the density of marble and the resistance of cement.

A young American couple appeared in their lives. Alexander Calder lived in nonchalant misery in the Rue Daguerre on Montparnasse, and was a friend of Tsuguharu Foujita and Piet Mondrian. Alexander—everybody called him Sandy—was from Philadelphia. His mother was a painter and his father and grandfather sculptors, but he had started as an engineer only to become the leading figure in the school of sculpture in welded metal.

Both Sonia and Robert loved his "fils de fer," the whimsical portraits, circus figures and animals Sandy made out of chicken wire with a pair of pliers. He had just met Louisa James, a grandniece of the author Henry James, and when they came back from America in 1930 they were married.

Together with Mondrian and Pevsner, Robert opened Calder's eyes to abstractions. Sandy would remember Robert's getting furious when, to cover the expenses of an abstract group show, someone suggested they invite Picasso to join. Instead, Brancusi was invited. He sent a photo but no funds, but the group show went on at the Porte de Versailles.

"Have you noticed how driving calms Dad's nerves?" Charles once asked his mother. She had indeed, but there were moments when her own nerves were tied in knots. Fashion was concerned with inspired assertion and sensuous allure, but the corporate Sonia Delaunay was both carrying and devouring her. To advance was to impose new forms and new patterns, but social pressures imposed a code of clothing that constituted the current fashion. New forms didn't obey any logic of taste, any precepts of harmony or laws of contrast and similarity. New forms didn't follow rules; they set themselves. Yet to be successful, such rules had to please the individual woman's temperament and character and try to tell her something.

There were moments Sonia wished she were Robert, tooling off in the morning to the Rue des Grands Augustins studio, then over to paint Simone Heim before an exquisite lunch. But there were theatrical wardrobes to complete, costumes for the Rio carnival that the Brazilian branch was ordering. If she wanted to paint it would have to be from 11 p.m. to midnight, when she had an hour to herself.

In early 1929, she was close to a nervous breakdown. The doctors

ordered her to take a complete rest, to take the cure at the Bourboule spa in the Mont Dore mountains of Auvergne.

"I'll drive you," said the solicitous Robert.

Chagall was coming along. As long as there are moments of separation, married life is perfect, he liked to say, and a week's absence from Bela and Ida, their daughter, would be nice. Robert decided that while Sonia was taking her rest cure at Bourboule, the two of them could shoot on down to Montpellier and see Joseph and Caroline Delteil.

Sonia explained to Marc that an early spring excursion in the Overland was a trip to Siberia, that the wind leaked under the canvas top and froze you to death. Fortunately, she'd be able to bring woolen sweaters for all three, workmen's cardigans that she had embellished with simultaneous strips.

La Bourboule was 450 kilometers from Paris, and by the time Robert and Marc were off for Montpellier, Marc was wearing four of Sonia's sweaters. The receptionist at a country inn asked the muffled-up Chagall with his luxuriant hair and red cheeks, "Would Madame prefer a room with two beds or a single?"

Marc and Robert couldn't wait to get up to the room and call Sonia. A Dr. Géraud, a friend of Delteil in Carcasonne, invited the two painters for lunch and, to their delight, bought a picture from each. The next day, they got a flat on a railway crossing. The little local managed to wheeze to a halt a few meters from the Overland.

Joseph and Caroline were delightful. "Like George Washington," he said, "I want to be a simple citizen in the shadow of my vineyard." Caroline was sarcastic. "I married a writer; now look at me, I'm a vinegrower's wife!"

In Paris, Sonia and Robert liked to sip an *apéritif* on Boulevard du Montparnasse before dinner. They knew everybody and had no real preference for where they sat, especially if Robert could strike up a conversation with interesting people at the next table. The venerable Le Dome was reputed to have been depicted in at least fifty novels. La Rotonde, established in 1911, had been headquarters to the Russian revolutionaries Lenin and Trotsky before the war and was now frequented by Mediterraneans and Slavs and such painters as Diego

Rivera and Haïm Soutine. The new Coupole, neon-lit and enormous, with pillars decorated by Kisling and Léger, was the symbol of a new and gaudier Montparnasse, while Le Select with its somewhat raunchy reputation, at least after 2 a.m., played host to Americans and central Europeans and such French poets and playwrights as Sonia's old flame René Crevel, Jacques Prévert, and the Russian-born playwright Arthur Adamov, and the composers Virgil Thompson, Darius Milhaud, and Cole Porter (who had bought a townhouse in Rue Monsieur). Almost any night the Delaunays would see Derain, massive and aloof, with Madeleine Ansprach, his longtime lover. Kisling and Foujita were there, usually with Kiki de Montparnasse, Modigliani's and Man Ray's one-time model and mistress, now corpulent, noisy, and décolleté. Fernande Olivier, Picasso's love from the days in Rue Ravignan, showed up. The epicenter of the American colony was the Vails: young, handsome, and glamorous Laurence Vail and his wife, the heiress Peggy Guggenheim. They loved the company of writers and painters and people of all sorts and would buy anybody a drink. The Russian colony gathered around the white-maned Ilya Ehrenbourg, the Paris correspondent for *Izvestia*, and included Brancusi and Ossip Zadkine, and the card-carrying surrealists around Breton.

The summer of 1929 gave Sonia her first real vacation. Together with Jean Arp and his wife Sophia Taeuber-Arp, the Delaunays drove out to Normandy to visit Delhumeau. Sonia and Robert had met Arp at Harwarth Walden's in Berlin just before the war. Since the Alsatian painter-sculptor had been a founding member of the Zurich dadaists, his frugal cubism, his painted wood reliefs, and big geometric collages had inspired the surrealists and the *de Stijl* abstracts. Sophie was Swiss, born at the Davos ski resort, and she and Jean had met in 1915 in Zurich where she was teaching weaving and textile design at the School of Arts and Crafts. They married six years later. For the last three years Sophia and Jean had lived in Meudon just outside Paris and become fast friends with the Delaunays.

Jean and Robert looked astonishingly alike. They had the same skin and eye colors, the same pointed nose and straight lips, and Jean was only a few months younger than Robert. People often mistook them for brothers. What attracted Robert, however, was that Jean laughed a lot and articulated whatever passed through his mind. Sophie

was more self-effacing, but her husband credited his success to her inspiration and tried to push her work on buyers. "It was Sophie who showed me the right way, the way of beauty, the limpid serenity that emanated from the vertical and horizontal compositions." The Arps were childless, and lived in a modern house Jean had built himself. Each had a whole studio floor, and there was a garden full of his work.

The foursome were off to Nantes, where Robert's "fan" lived. Captain Delhumeau, they discovered, spent the summer on the Isle of Yeu, the speck of an island off the south Britanny coast where 3,000 people lived in the summer. No cars were allowed, so Robert parked the Overland on the mainland and bought tickets on the little steamship going to the island.

Delhumeau lived in lordly splendor and, at home, proved to be a somewhat-trying host. Robert was glad he had brought the Arps along; that way they could take turns listening to Delhumeau's interminable stories of Cape Horn.

After a week, Robert had had enough, and the vacationing quartet took the steamer back to the mainland. Sonia managed to phone Tzara, who was vacationing at Quibéron. Vacationing in nearby Carnac was Vincente Huidobro, the Chilean novelist, poet, and political activist who had just been through a lurid, if lucrative, Hollywood episode, writing a cubist movie that earned him $10,000 but was never produced. Everybody rendezvoused at the Carnac beach resort.

The boys had a great time. They donned beards made of seaweed and had themselves photographed in their bathing costumes, Robert a little taller and stouter that Tzara, Arp, and the crew-cut Huidobro. They rented a boat and had themselves transported to l'Île aux Moines, where in a subterranean grotto they found engraved stones they all agreed were prehistoric. Together, Robert and Jean came up with insane theories on the origins of humanity and art.

Charles found his vocation that summer, inspired by a twenty-six-year-old Ukrainian who, under the name "Cassandre," was becoming the leading poster artist. Like Sonia, Adolphe Mouron was a former student of André Simon, and his sense of layout and graphics saw his bold advertisements for Pathé, Pernod, and Wagons-Lits Cook and steamship lines imitated all over Europe and the Americas. To Charles, Cassandre was the master.

Poster artists had their own star names—Carlu, Charles Loupot, Paul Colin, and Leonetto Cappiello—and if eighteen-year-old Charles

didn't get to see Parisian walls covered with his posters, he managed to free-lance as a mock-up, insert, and newspaper ad designer. He liked the advertising milieu, but jazz remained his passion, and whenever he met record company publicists his ears pricked up. He hoped someday to combine the two pursuits.

24

Recessions

In October 1929, Wall Street crashed, and the depression hit Europe a year later. Sonia was in the luxury trade, and by 1931 it was considered bad taste to even look rich. The women who were still wealthy wore plain black dresses, furless wool coats, sweaters, and slacks. Said British *Vogue:* "It is no longer chic to be smart."

Sonia Delaunay-Simultanés was even more vulnerable than couture houses that could add ready-to-wear lines. Coco Chanel cut her prices in half in 1931 and went to Hollywood to work for Samuel Goldwyn. Fabric manufacturers tried to stimulate the market by supplying their materials on credit. Sonia had no orders, clients neglected outstanding bills, and banks threatened action on overdrafts.

"I was brooding," she would remember, "wondering what work I could give my staff, how I was going to pay the overhead when all we were doing was spinning wheels."

On one of the first days of spring, she and Robert were sitting down at a table at the Select when, across Boulevard du Montparnasse, they saw the Belgian painter Georges Vantongerloo sitting at the Dome. Vantongerloo, whose abstractions were, unlike Mondrian's,

the result of mathematical calculus, sat with his face turned toward the sun, his eyes closed, oblivious to the bustle around him.

In a flash Sonia saw the solution to her crisis. "Let's do like Georges who is dreaming in the sun," she told Robert. "Let's drop everything and go back to painting."

In her short, tape-recorded autobiography, she would give the lines to Robert: "Look!" Robert shouted. "Look how happy he is. Do like him. The business is eating you up. Stop everything. You'll paint and we'll live like before."[1]

The truth was less breezy.

Sonia would call the early and mid-1930s "my freedom years," but dropping everything did not only mean quietly closing the Ateliers Simultanés and letting thirty people go; it meant giving up the Boulevard Malesherbes apartment and even the Rue des Grands Augustins studio they had rented since 1911. The diary she resumed in 1933 after twenty-seven years would belie her cavalier dismissal of the fashion world. Constant entries would tell of a trip to Amsterdam that she knew would result in a purchase, of private orders received and executed, of a dinner with a banker to whom she complained about her bookkeeping chores. She might have legally dissolved her corporation, but she continued as a one-woman artisan shop.

The mid-1930s were difficult years of obscurity. Robert was only vaguely remembered, if at all, for his Eiffel Tower paintings. He returned to abstract painting and began a series of works entitled *Rhythms*, using circular forms that had none of the power of his 1912–1914 abstractions. In fact, he painted in a style that approached anonymity and often didn't finish his canvases. His contempt for the art business kept dealers away (Paul Guillaume, the only one who had given him a one-man show in a gallery, died in 1934).

His intellect made him forever float above most people's heads, and he saw their daily preoccupations as shabby and dull. A lawyer friend suggested to Sonia that Robert register for unemployment. It was important for their tax status and for an application for a subsidized apartment. Robert wouldn't hear of it. He'd rather sell another painting to Delhumeau. Sonia filled out the papers. A person receiving unemployment benefits could not own an automobile, however. The lawyer managed to transfer the registry of the Overland

to Sonia's company, a move that would complicate the final liquidation.

The reason for Robert's abrupt return to abstraction was the claim of his friend Albert Gleizes that the uncompromising abstractionism that flourished in the works of Mondrian, the Arps, Vantongerloo, Kupka, Gleizes himself, and Theo van Doesburg had been anticipated by Robert twenty years earlier. This notion made Robert decide that his portraits, his towers, and the rest of his representational work of the twenties, were a kind of self-betrayal.

With Sonia, he joined Abstraction-Creation, an association that tried to group together abstract painters from all over the world—including among its most influential members the Arps, Calder, Duchamp, Gleizes, Kupka, the Pevsner brothers, and Vantongerloo—and which organized an annual show. It was at the 1932 show that Calder exhibited his first freestanding and hanging contraptions that, at Marcel Duchamp's suggestion, he called "mobiles."

And it was Marie Cuttoli, Sonia's longtime gallery owner friend, who gave Calder his first one-man show in her Galerie Vignon near the Madeleines. Here, he exhibited fifteen objects moved by little motors, and fifteen nonmotorized mobiles that all had moving elements.

Charles was drafted for the eighteen months of compulsory military service in 1932. In a basement on Boulevard Raspail, he listened to his first jazz concert. On stage were two black Americans, the pianist Freddy Johnson and Arthur Briggs, a trumpet player, two white saxophone players, Russell Goudie and Andy Foster, plus a drummer whose name no one would remember. "I'd be hard pressed to describe the performance," he would write fifty-three years later. "It was uncanny. I was overcome by emotions; no longer quite on this earth. Never had a fullness of a trumpet hit my eardrum like this one. It was beautiful! Afterwards came the great Garland Wilson, who seemed merely to caress the piano, and Louis Cole, a tiny guy who hummed a few refrains although with a brilliant rhythm."[2]

Out of uniform, Charles became a cofounder of Le Jazz Hot. Louis Armstrong became his first American friend in 1934, and Ben Carter the one who polished his schoolbook English. Sonia wasn't sure his love of jazz could earn him a living. However, as Charles Delaunay

became a name and an authority in European jazz circles, she not only became immensely proud of him, but learned to love jazz and to attend the big-band concerts he organized. Over the years, he would become the foremost proselytizer of jazz in France. He would be an associate of magazines, record companies, clubs, and radio stations as producer, writer, disk jockey, concert promoter, and ceaseless traveler between New Orleans, Harlem, Hollywood, and Paris.

Sonia kept her unswerving faith in Robert. She stored his canvases, took notes, and gathered information for a catalog in anticipation of future exhibits and sales.

"My life was very complex, torn apart," she would say in retrospect. "I was fragmented between the private orders I still received from couturiers, some projects for shop windows and posters, album editing, magazine articles, and appointments with architects, engineers and possible underwriters."

Robert's ideas and research were fascinating, even though the end result looked like the classroom exercises of high school art students. By painting colors in a spiral motion, he created a succession of *Rhythms* that might be called the closest abstract painting has come to visualizing music. After that he created a series of *Rythmes sans Fins* (*Endless Rhythms*), both in watercolors and in oils, in which half circles repeat each other on both sides of a median line, followed by *Rythmes-Hélices*, in which the rhythms take on twisted drill forms. His experiments with stone, he believed, would lead him to tridimensional *Rhythms in Relief*.

Jean Cassou was a poet, essayist, sociologist, and art historian who worked for the Department of Education and in his spare time did a lot of free-lance writing. He had written on Robert's experiments with stone, and now he wanted to do an article on Sonia. The piece appeared in *Marianne*, a new weekly financed by the Gallimard publishing house. Sonia was pleased, but Cassou was too busy to become a friend.

But there were others. As Charles would say, his parents constantly needed new people, new impressions, and new surprises, and the newer the acquaintances the more Robert and Sonia liked them: "Newcomers to their circle had all the charms; old friends were suddenly less interesting. Then they spun the wheel again."

Alberto and Suzi Magnelli were a new couple. Alberto was a wholly abstract artist of interweaving geometric shapes painted in flat primary colors that pleased Sonia by their purity. There was, in fact, no imagery and no echo of figurative inspiration in this native Florentine who had come to Paris in 1934. Suzanne Gersohn—everybody called her Suzi—was the daughter of a wealthy Jewish family from Berlin. It was out of the question that she marry an Italian, and so the two of them lived together.

Three years younger than the Delaunays, Magnelli was self-taught. In impassioned talks with Robert he showed his personal magic, his ability to manipulate plastic fantasy, his brilliant grasp of the fundamentals of composition rules. Alberto and Suzi spent part of the year in a house they owned in Grasse, the "perfume capital of the world," situated in the lavender-covered hills above Cannes.

Besides the work that Jacques Heim still managed to subcontract to Sonia, advertising allowed her to make some money. She experimented with neon and created posters for Mica-Tube, a light bulb and neon tube manufacturer. Annette Coutrot, the wife of a paint manufacturer, proposed that the Delaunays decorate her apartment. The job, which they enjoyed, led to the decoration of Simone Heim's private rooms and the apartment of Georges Ullmann, a young diamond merchant who would remain a family friend.

Sonia took a trip to Holland to meet Henk de Leeuw, a wholesaler who was still buying her fabrics. A widower with a grown daughter studying in Paris, de Leeuw was a small, handsome man with a lively intelligence. Traveling with de Leeuw's daughter Kitty to Amsterdam, Sonia was overwhelmed by the father's reception. Her merest wish to see the Vermeers in the Rijkmuseum was transformed into commands to the family chauffeur. The host himself took charge of the rest of her stay, escorting her to the nearby Kroeller-Mueller Museum, to see early Van Goghs and works of her friends Léger, Severini, Gleizes, and Chirico. There were no paintings by Robert or Sonia. To comfort herself, she noted in her diary that all the works on the Kroeller-Mueller walls had been chosen "before the abstract period" of their authors.

She liked what she saw of Holland—the manicured farms, the modern architecture of Hilversum, the comfort of low-income housing, old Amsterdam. She called it a country with a human face. The

excursions had a different effect on her host. The widower fell hopelessly in love with Sonia.

"Divorce him," he begged.

She protested, but de Lueew's arguments hurt. "Is that a life, to give fabric design lessons at 25 francs an hour?" he asked. "To take in couture repair work, to borrow in order to pay the few seamstresses you still have, workers who complain you exploit them because they are émigrés? Is that a life, to have to beg for extensions at the tax office? Divorce him. I can give you the life of your dreams."

The little widower was not the man who'd make her lose her head. After four days, she took the first express train back to Paris. In her diary she noted that Robert and she had a drink with André Lhote that same evening.

Arnold Schoenberg, Sonia's old acquaintance from Karlsruhe, was the first victim of the new Nazi regime's move against prominent Jews in the arts. Schoenberg, who had abandoned his Jewish faith in 1898, had taught in Berlin since 1926. He had never taken part in politics. He was still a Jew by birth, however, and when on March 1, 1933, the president of the Berlin Academy stated that Jewish influence in the national life had to be suppressed, he offered his resignation. He asked only for an equitable settlement of his contract, which had two more years to run, and permission to take money out of the Reich to the country to his birth—Austria. He hung around for three weeks waiting for an answer, but then, in response to warnings from all kinds of friends, left for Paris with his wife and year-old daughter. The Schoenbergs' Paris stay was brief. A private music school in Boston offered Arnold a teaching job, and so the Schoenbergs went to America, to end up in Los Angeles a year later.

Meanwhile Vassily Kandinsky settled in Neuilly, the swank western suburb of Paris, with his wife Nina, and renewed acquaintance with the Delaunays. No artist looked more like a banker than Vassily, who had become a German national in 1928. Nina was some thirty years his junior; and everybody adored him and detested her. On a professional level, Robert loathed the whole spiritual side of Kandinsky's work, but recognized his prodigious invention, technical mastery,

and knack for revitalizing himself. Robert had done representational work throughout the 1920s; Kandinsky had never deviated from abstraction.

Sonia's diary made no mention of the rise of antisemitism and right-wing sentiments in France. Serge (Sasha) Stavisky was the immediate focus of whipped-up antisemitism in 1934, and a painful reminder for someone born Sarah Stern. Sonia's diary would only make an indirect allusion to Stavisky, although Robert took part in a February 12, 1934, protest march.

Born in Kiev a year after Sonia of Jewish parents of modest circumstances, the slick, little Stavisky had come to Paris at the turn of the century. He rose in the crime world from drug peddling, confidence games, robbery, and white slavery to stock market manipulation, which finally landed him in jail in 1927. Thanks to his friends in the Justice Department and the courts, among the police, and in certain ministries, he managed to have the trial postponed while he made more money in a string of fraudulent enterprises. L'Action Française, the organ of the die-hard royalists, was the first overheated Paris newspaper to scent from how high a level Stavisky was protected, but when it blew the lid of the Stavisky Affair, the central figure disappeared. Police for whom he had sometimes informed were unable, or unwilling, to arrest him. The press speculated that police hoped he would flee the country, but on February 8, newspapers reported that Stavisky had committed suicide just as police were breaking into the villa where he was hiding. Few people believed the suicide story. Most were sure police had murdered the well-connected crook to prevent him from exposing them. The next day L'Action Française issued a ringing appeal for Parisians to gather after work and march on the Chamber of Deputies.

Rancorous and intolerant, French conservatives generally resented the antics in parliament and demanded a forceful leadership. Obsessed by decadence and driven toward authoritarian solutions, the conservatives were making progress, especially in university and intellectual circles, by repeating again and again that the Germans, the Jews, and the Communists were the enemies of France. A splinter group cast admiring glances across the Alps at Benito Mussolini's regime and created a French fascist party.

Led by a war veteran, 40,000 conservatives, "ultras" and royalists massed at the Place de la Concorde on February 9, shouting "Down

with the Republic, down with the Jews, the robbers, the deputies."
When they tried to cross the Concorde Bridge to invade the Chamber
of Deputies, police blocked them. In the resulting riots, sixteen dem-
onstrators and one policeman were killed, and hospitals counted 1,664
injured. The confrontation had started with hysterical news stories in
the right-wing press claiming the government had secretly brought
tank squadrons and regiments of black Senegalese troops into the
capital.

Three days later, Robert was one of many who responded to the
Communist party's call for a massive rally on the Place de la République
to "protest against fascism." He was not one of the 1,200 demonstrators
arrested. Four rioters were shot dead and twenty-four wounded. The
popular press, which had castigated police for their "brutality" on
February 6, congratulated the authorities for their firmness in putting
down the communists.

Led by the adventurous steelworker Jacques Doriot, the French
Communist party was trying to regain its losses—its membership had
fallen from 130,000 to 55,000 since 1923, and most disillusioned
leftists had joined the Socialist party. But what Doriot's Communists
lacked in numbers they made up for in ingenuity and militancy. A
remarkable feat in 1926 had been their drawing the surrealists and a
good part of the intelligentsia into their ranks. *La Révolution Surréaliste*
had announced that "vast areas of agreement exist between the Com-
munists' and our aspirations." In 1932, however, Joseph Stalin's crack-
down on dissidents and his proclamation that "socialist realism" was
the only permissible art had the surrealists—with Louis Aragon
abstaining—voting to walk out of the party.

Constructivism, which had exalted the Soviet triumphs in the
1920s, was denounced as "formalist." Vladimir Tatlin, Alexander
Rodchenko, and Varvara Stepanova continued to work, but lost faith
in communism and in the theoretical ideals of their art.

The advent of nazism had made an old friend seek refuge in the
Soviet Union. Harwarth Walden had managed to revive *Der Sturm*
in 1924, and, although the monthly didn't regain its prewar authority,
he had continued to publish it until 1932. In Moscow, he would be
a collaborator on *Das Wort*, the organ of the German émigrés, only
to disappear in the Siberian camps in 1941.

The surrealists' break with the party was more traumatic for

some than for others. Breton still hoped to be able to explain the group's stand at a party-sponsored Writers Congress for the Defense of Culture to be held in June, and all the surrealists, including newcomers Salvador Dalí and Luis Bunuel, hoped an accommodation was possible. But after Breton ran into Ilya Ehrenburg, *Izvestia's* fashionable Paris correspondent, and slapped the Russian over an article that castigated the surrealists, he was told he would not be invited to the upcoming writers gathering. Crevel, who had fallen in love with the Delaunays' apartment and with Sonia twelve years earlier, worked ceaselessly behind the scenes, and seemed to have elicited the promise that Paul Eluard could read a prepared text when his effort ran into a stone wall.

Besides the virile Max Ernst, whose cool, Germanic looks were irresistible to women, Crevel was the only good-looking surrealist. He had become the author of droll novels, virulent pamphlets, and haunting poetry, but he was also burdened by recurrent tuberculosis, drugs, depressions, and a homosexuality he could not accept. The lacerating conflict between his communist convictions and his passionate adherence to surrealism drove the thirty-four-year-old Crevel to commit suicide.

Sonia and Robert found a modern studio apartment at 16, rue Saint-Simon, a quiet street off Boulevard Saint Germain. Sonia hesitated at the thought that neither of them would have a private work space. The studio itself with its two-story windows came with a platform outside the upstairs room that would be their bedroom. Sonia decided that since she was a "neat painter" who cleaned her brushes after using them and stuck them in a pitcher, she could work here. Robert would have the downstairs work space, next to the kitchen and eating area. The only inconvenience was that Charles's room would be behind Robert's, meaning that Charles would have to cross his father's work space and be subjected to sarcastic remarks, to which the twenty-four-year-old still reacted with offended sulks.

The Nesles-la-Vallée real estate disaster was forgotten, and Sonia agreed with Robert's suggestion that, in order not to get on each other's nerves, they could perhaps look for a modest country house,

maybe even an abandoned farm house within driving distance of Paris that he could fix up. They decided to take the studio and, with forty packing cases, moved to the new home.

It took them months to settle in.

Berthe de la Rose came to visit. Forever the enchanting countess and profligate—and totally lacking in common sense—Robert's mother often had to ask her son to help her make shopkeepers exercise patience with their bills, and occasionally when Sonia wasn't looking, Robert would slip Sonia one of his mother's bills. Whenever Sonia found out, she would mark down the amount in her diary as "loan to B."

Berthe lived in a small house near Versailles, always knitting or embroidering—sometimes for her daughter-in-law, despite their edgy relationship. The countess adored only her son and grandson.

Robert's research with sand, which he now shot onto casein coatings with an air gun, provoked the ever-patient Sonia to revolt. This was not something he could do in an apartment. He'd have to find another place to do his "filthy experiments."

She found it for both of them. Felix Aublet was a young architect working for Mica-Tube, the company for which she made neon advertising. He was interested in her work, and urged her to submit a poster for the annual *Electricité de France* power company competition.

"Why don't we do it together?" she suggested.

Their Zig-Zag neon sculpture won the 1936 first prize.

Aublet was a bachelor who lived with an adoring mother and a effusive sister in the family townhouse in Neuilly. The residence included a somewhat neglected garden and a vast glass-enclosed hangar that had once served as garden shed and greenhouse.

Sonia, Robert, and Felix established themselves in the Aublet garden shed, Robert doing his filthy experiments, Sonia and Felix working on neon sculpture. Robert loved the place and, by a kind of artistic *droit de seigneur* was quick to consider it, if not his own, certainly not exclusively the Aublets' space.

When Felix was in the shed he was fascinating to his new friends. He was talented and articulate, and his ambition as an architect was to integrate electricity and architecture. He counted himself among the new interior designers who thought of electric light

as a material to work with. He was too young, however, to breathe art twenty-four hours a day. He liked to go out, to spend nights dancing in clubs or enjoying the company of agreeable women of his own milieu. For Sonia he was yet another gifted young man to guide and direct.

25

World's Fair

Sonia and Robert turned fifty. They painted and kept up with friends and the times. When the bills became too pressing, they sold another of Robert's canvases to Captain Delhumeau. They were in the Aublet garden shed one day in the late spring of 1936, when a physician friend popped in to tell them Mallet-Steven was trying to locate them.

"What does he want?" Robert asked.

"He wants you to decorate a couple of pavilions," the doctor said.

On April 26, 1936, France had gone to the polls in heavy rain and returned—with a record eighty-five percent of registered voters casting their ballots—a leftist coalition. The advent of the *Front Populaire* had been welcomed by the masses as a thrilling victory promising long-overdue social and economic reforms, while a dismayed Right saw France at the brink of red revolution. The head of the coalition government was socialist Léon Blum, a man prey to self-doubt and self-criticism and given to airing his soul searching in public. Blum was a Jew—a fact the Right never failed to underscore—and

he and his party had spent their entire lives in the opposition. Just turned sixty-four and without any cabinet experience, the Socialist leader, with the support of the Communists, formed a government, and the experiment of the Popular Front was launched.

The new government's modest, if long overdue, "social reforms" could not have come at a worse time. With the bourgeoisie tense with fear, capital fleeing the country, and the Treasury in difficulties, the Blum administration passed laws that gave everybody two weeks paid vacation, extended family support, instituted unemployment insurance, and limited the work week to forty hours.

Organized by the Blum government six years after the major financial crisis, the 1937 *Exposition Internationale des Arts et Techniques* would rise in the midst of widespread unemployment, economic uncertainty, consolidation of fascist power in Germany and Italy, and civil war in Spain. In contrast to the 1925 art deco fair, the expo would emphasize public works and technology.

Robert put on his best suit and went to see Mallet-Stevens, for whom he had created the too-risqué *Woman and the Tower* panel in 1925, and was quickly introduced to the administrators. Yes, the idea was to have Delaunay decorate two government pavilions. One would be the aeronautics building, the other the railway exhibition hall.

Robert returned in ecstasy. "Can you imagine, 2,500 square meters of wall to paint," he told Sonia and Felix. "The task is enormous."

"But you accepted?" Sonia asked.

"Of course."

There were still details to iron out, but the expo was less than a year away. And like the First Hundred Days of the Roosevelt administration three years earlier, when idealistic young people flocked to Washington to be part of the New Deal and everything seemed possible, the Blum government signed up people with unaccustomed speed. Jean Cassou, who two years earlier had supplemented his Department of Education income with free-lance journalism, suddenly was the director of the Musée de l'Art Moderne, which, at the end of the 1937 expo, would be housed in the building under construction on Avenue du Président Wilson. One of Cassou's first acquisitions was Robert's *City of Paris*, which had been at the New York Armory Show in 1913.

Others were given assignments. Raoul Dufy was selected to ex-

ecute murals celebrating electricity, Fernand Léger to illustrate phys-
ics. Besides Mallet-Stevens, Le Corbusier would design a theme
building, to be called *Modern Times*.

The commission was a shot in the arm for both Robert and Sonia.
They grew taller by the minute, their son would say. They began going
out again. Sonia noted in her diary that they went to the opening of
a Matisse, Braque, and Picasso show January 20, 1937, and that on
leaving, "I just caught Picasso taking off in his car, but he said hello
to me."

Art and politics were a heady mix. At Léger's insistence Robert
and Sonia, together with Felix Aublet, appeared at a huge meeting
of artists organized by the Communist party. The May 14 encounter
was held at the Maison de la Culture, a party assembly hall the
Delaunays had never seen before, and from the moment they entered
the auditorium, the murals had Robert's teeth on the edge. As they
sat down, they were aware that huge replicas of Goya, Daumier, and
Courbet, executed by militant painters who claimed they were "bring-
ing art to the people," were mixed with wall paintings by Léger, Jean
Lurçat, and Marcel Gromaire. As the proceedings began, Léger and
Le Corbusier filed onto the dias. Edouard Goerg was the first speaker.
The engraver who would go to Spain and do Breughel-like engravings
on the horrors of the civil war, talked of art and its historical context
and emphasized the need for artists and writers to turn to realism.
Louis Aragon was next. Sonia listened, thinking of the portrait Robert
had made of the cofounder of surrealism. But Aragon, who was living
with the Russian poet Elsa Brik, who nowadays called herself "Elsa
Triolet," also wanted the artistic world to rally around realism. He
ended his speech by underlining one more time the need for "realism."
In the middle of the applause, Léger and Le Corbusier tried not to let
the Communists impose any Stalinist socialist realism. Robert blew
his top.

From his seat, he shouted, "So what the party wants is that we
all return to the uninspired old crap!"

At the stadium, Aragon tore into his allies of yesterday, calling
surrealists and cubists left-behinds in a new evolution. In derision,
Robert's supporters chanted, "Rem-brandt!" "Rubens!"

At the door, Sonia ran into Cassou. He, too, was troubled. As the curator of the yet-to-be museum, he was for the Popular Front but was appalled that the Communists' support was giving weight to conventional, uninspired traditionalists. Le Corbusier came up, excited and angry, but trying to have it both ways.

"What a misapprehension of words, to call our art abstract," he said. "Our art is concrete. What we're trying to find is the art of the second industrial age."

Robert had voted socialist and had applauded three weeks later when workers, so long submissive, began a series of strikes that swelled beyond anything the country had ever seen. Actors, painters, and pop artists, including the famous Mistinguett, offered their support.

Sonia's friends in the fashion industry were shocked. Coco Chanel's two thousand seamstresses went on strike. Chanel was dumbfounded. What did the girls have against her? What would they *be* without her? The world was going mad. She offered to give her employees the company on condition she alone would manage it. The women turned the offer down as a ruse. She gave in, but didn't forgive and three years later closed her house.

Robert assigned to Sonia 230 square meters of murals at the railway pavilion and the creation of fabrics. Besides his wall compositions featuring fantasy machines, complete with dials, propellers, engine parts, and cockpit instruments, he proposed a major assemblage of enormous concentric loops and a full-sized plane soaring under the pavilion skylights. The architecture of the railway building was designed to resemble a train station, complete with ticket counter, restaurant-cafeteria, and newsstand. Entitled *Portugal* and *Distant Voyages*, Sonia's murals would loom above all that and celebrate the romance of railway travel.

Robert had always wanted to do mural decorations, to escape the convention of easel painting. He had done stage and movie sets and, with Sonia, decorated apartments. Now, he felt he was ready for the truly monumental. His experiments with glazes, mosaics, and lacquered stone would allow him to achieve outdoor murals that were impervious to wind and rain. These public works fulfilled an essential need in the development of his art.

Felix Aublet cosigned some of the contracts with the government. Sonia's demanding friendship and hovering affection, not to mention

Robert's exactingness and short temper, made for conflicts. The collaboration was not without sudden blowups, and the Delaunays soon regretted being contractually linked to the young architect.

But Felix was not alone. Like the Roosevelt administration's Federal Theater and Writers projects that put actors and authors to work in America, the Blum government wanted to create jobs for out-of-work artists on government-funded projects. Fifty unemployed *artistes-peintres* were assigned to the Robert Delaunay venture.

Robert rented a huge garage in suburban Levallois, which Sonia immediately outfitted for the collective work. They hired a Russian friend six years their senior as a kind of foreman and floor manager. Leopold Sturzwagen had been in France since 1908 and, at the outbreak of the war in 1914, changed his name to Survage. He, too, had created sets of a Diaghilev ballet and knew how to work on very large surfaces.

Robert and Sonia did the miniature models and the full-sized mock-ups. Albert Gleizes helped them. It was not easy to remain a friend of Robert's, but over the years this son of artists was the sincere if solemn friend with whom Robert shared artistic convictions and signed innumerable pictorial manifestoes. With his wealthy and somewhat intimidating wife, Juliette, Albert lived a secure existence devoted to art and meditation on art. His mature paintings were thoughtful, toned-down exercises in cubism, huge geometric "picture objects." Albert also wrote books in which he interpreted the laws of art in terms of religion. Juliette and he spent part of the year in Serrières, a village south of Lyon, where he sought to let Celtic and Roman ruins inspire him, and they owned a farm in Saint-Rémy de Provence, another town steeped in Roman vestiges.

Once the Delaunays—and Gleizes—had finished the mock-ups, the fifty painters were divided into teams. Then, under Survage, they executed the final panels on the garage floor. One person was assigned the job of taking color photos every day. "We lived like monks," Sonia would remember. "From our mock-ups, we painted with the fervor of the born-again."

The work went on seven days a week and, when the crew got a day off, continued at home. Sonia's sketches were so numerous she gave them numbers, so in her journal she merely wrote, "After lunch I went home and worked on drawing 1415," or "Colored drawing 1417." Fortunately the commission allowed her to hire Galina Kulin-

sky, a White Russian widow with a knack for making *pirozhki*, to take care of the house and prepare lunch every day.

After an inspection tour, Minister of Communications Raoul Dautry pronounced himself enthused. He especially like Sonia's joyous disks, frenetic circles, shimmering spokes, and perspectives of squares. He imagined she had let herself be inspired by railway signals, and he provoked collective hysterics when a crate of actual railway signals, courtesy of the ministry, arrived at the Levallois garage.

Through her gallery-owner friend Marie Cuttoli, Sonia was in on the innermost government gossip. Henri Laugier, Marie's boyfriend, was climbing fast in political and scientific circles and knew everybody in the government, and Marie was giving power lunches where Léon Blum was a habitué.

Robert would not allow the use of industrial paints, and so he ordered by the bucket oils that were usually sold in tubes. Meanwhile the great depression deepened, and the flight of the franc continued. Blum, despite his suspicion of the Communists and distrust of the Soviet Union, tried to forge a military alliance with Moscow to check Adolf Hitler's ambitions. Inflation wiped out the substantial wage increase won in June. For the Delaunay team this translated into a forty percent increase in the cost of paint, canvas, and supplies. Robert was obliged to ask for both supplementary funds and advances.

Inevitably perhaps, he got into budgetary fights with the architectural overseer and with jealous "social realist" artists. With Sonia, Felix, and the fifty floor painters, Robert wrote the grievances down and took the letter to the prime minister's office. Blum was too busy to see the deputation, but he assigned a socialist from his entourage to straighten out the financial impasse and smooth their relations with painters opposed to their concepts. Through Marie Cuttoli, Sonia learned that the prime minister was in their corner and, as she wrote in her diary, "determined to support us to the end."

Whatever else might be said of the Delaunay crew and its loquacious, boisterous, and opinionated project director, they didn't fall behind schedule. As they approached the May 1937 deadline, tempers often flared. Sonia's warm friendship with Felix waned ("I don't understand how anyone can go out and have a marvelous time before finishing urgent work," she scolded). The work progressed, and journalists arrived.

In the May 1937 issue of *Le Petit Parisien*, Jean Maréchal wrote

sympathetically of discovering "in an immense garage and amid make-shift arrangements, an outburst of enthusiasm, of light, of springtime.

"A group of young painters, men and women, work feverishly to finish," he wrote. "Wearing bright yellow pants and a russet sweater, Robert Delaunay, the energizer of the whole enterprise, was putting the last touches on a folded up canvas, ready to be shipped to the expo. . . . For the railway pavilion Sonia Delaunay was finishing a composition rich in stylized, yet both picturesque and evocative, characters." A photograph showed Sonia and her crew surrounding part of the *Distant Voyages* mural: The painting is still on the floor, and Sonia and her seven painters stand, hands locked and arms lifted, along the upper edge.

Léon Blum opened the expo on Labor Day, May 1. Through no fault of the Delaunays and their crew, however, the air and railway pavilions were not ready. The foreign exhibits were open, and the crowds admired the Soviet Union's pavilion with its entrance statue of a forward-thrust couple whose hands were joined in holding a hammer and sickle aloft. The facade of the German pavilion was also upswept toward the huge neoclassical eagle and swastika. The fair's sensation, however, was *Guernica*, Picasso's invective against war, hanging in the pavilion of the Spanish Republic.

Ten of thousands of visitors missed the air and railway pavilions, but when they finally did open the response was overwhelmingly positive. Robert's architectural-sculptural decoration under the domed skylight of the aeronautic pavilion resembled a prescient model of the 1974 Terminal One building at Paris's Charles de Gaulle airport; Sonia's developing spirals, spheres, and interlocking circles looked like a blueprint for Calder's 1973 decorations of Braniff Airlines planes.

"Robert Delaunay offers us a synthesis of Paris," the critic Louis Cheronnet wrote, "Paris as glorious central station. Sonia Delaunay takes us along on memories of trips in sunny lands full of the burst, glare, sparkle [of poet Arthur] Rimbeau. Her magical space leads us into the optical and invisible space of telecommunications."

Overseas visitors, in particular, were impressed by the two pavilions, by the variety of the severely modern architecture and savant mix of engineering, painting, and sculpture. American officials invited the Delaunays to participate in the upcoming American World's Fair, to be held in New York during 1939 and 1940, and an Argentine architect talked to them about taking part in a Buenos Aires expo.

In December, there was talk of their participation in decorating a U.S. airlines building going up on New York's Forty-Second Street.

Charles was interested only in the American pavilion. Performing there was the Teddy Hill orchestra from Harlem's Cotton Club, including its nineteen-year-old third trumpet player, John Birks Gillespie. Charles was producing a weekly one-hour jazz radio show, and taking the Quintette du Hot Club de France on its first foreign tour —to Zurich for a university campus engagement. He had never heard anybody do a solo like Dizzy Gillespie.

Sonia was proud of Robert's and her achievement and deeply gratified. At the Closerie des Lilas one night she let someone read her palm. She would still have a lot of success, the palm reader said. What he added so astonished her that she wrote it down in her diary: "If I hadn't worked a lot all my life, I would have committed suicide. My inner being will remain young thanks to a little continuous flame which is my escape from boredom."

When they didn't go out, she spent evenings pasting newspaper clippings into an album, proof of the revived interest in the name Delaunay. Modern art was full of forgotten cul-de-sacs, and so many of their talented friends had slipped into oblivion. Synchronism had become a footnote and Morgan Russell and Stanton MacDonald-Wright had sunk into obscurity, even in America. Larionov and Goncharova, Mondrian, Kupka, and Kandinsky were living in obscurity in Paris. Typically, Marie Vassilieff, Sonia's roommate at Madame de Bouvet's *pension* who had once dazzled Apollinaire, was someone everybody at the Coupole knew without knowing who she was. Francis Picabia was living an increasingly detached and eccentric existence in the south of France; he had a racing car attached by a rotating arm to the top of a tower on his estate, a customized fairground attraction in which he whiled away the time by whizzing round and round in midair. Chagall made money repeating his fiddler-on-the-roof themes—Robert upbraided Marc for his obsession with making money, and the friendship was cooling again. Cendrars was a journalist in Hollywood, and Gertrude Stein had finally made herself famous in America with her *Autobiography*.

The expo had put Robert and Sonia up there with Léger and Dufy, even if they all labored in the eternal shadow of Picasso. Not

that there hadn't been costs. The end of the relationship with Felix Aublet was more than strained. The young architect—who would remember Sonia as peculiarly naive for a fifty-year-old woman yet confident in herself, rigid in her judgments and fearful of all lies and intrigues—had become an adversary to handle with caution as the contracts they had signed in the first flush of enthusiasm were still in force.

Robert was not always in the best of health. He had difficulty urinating at times. At a dinner at the Gleizes, Sonia got to talk about the problem with two physicians who had "very modern ideas." Robert, however, would hear nothing of it. He was just overworked, he said.

It had been a heady twelve months, yet monetarily they had not come out that well. After all the expenses were paid, all the overruns covered—it took another deputation to government departments to extract the final payroll—Sonia calculated that for the eleven months of nearly round-the-clock work, the two of them came away with 400,000 francs.[1]

26

In Demand

A month after Léon Blum inaugurated the expo, his coalition government was no more. Trying to win the confidence and support of bankers and industrialists by "exercising power within the framework of capitalism," the prime minister failed not only to stop the flight of capital but also to realize that the economic and financial power structure was out to destroy his government—at whatever cost to the country.

In June 1937 the Senate defeated the quarreling leftist alliance. Blum handed the prime minister's office to fellow coalition member Camille Chautemps, and the Chamber of Deputies gave this centrist politician plenary powers to deal with the financial situation. The franc was taken off the gold standard and devalued. A rise in prices and wages, an increase in defense spending, a decline in production, and a trade deficit all conspired to create yet another financial crisis.

The demise of the Popular Front and the economic crisis further polarized politics. The parliamentary maneuvering that made Chautemps prime minister made the masses bitter and disillusioned. Many flocked to the Communists, convinced that a bloodier revolution was

necessary to curb the power of the powers that be. The Right, ever fearful of communism, turned more and more to the belief that a savior would have to be someone like Hitler or Mussolini. A remark circulating in upper-class circles became almost a chant; "Better Hitler than Blum."

In October André Breton asked Sonia to sign a petition protesting "the execution of old Russian revolutionaries." Stalin's purges were exterminating "Lenin's old companions," charging them with treason, terrorism, and espionage and bringing them to "confess" guilt. The Moscow show trials were an acute embarrassment to western party intellectuals and, as Crevel's suicide had shown, tore progressive sympathizers apart on the existential issue of whether *any* end can justify unjust means, and the Marxists' ruthless insistence that anyone who was not *for* them was by definition *against* them.

"Even though I sympathize with your gesture," Sonia answered in turning down the surrealist leader's request, "I don't want to cramp the *Front Populaire*'s action."

For a person as uninterested in politics as she, the refusal was surprisingly precise. In communist parlance, to be a "sympathizer" meant being a fellow traveler, and Dominique Desanti, Sonia's French biographer, could only speculate that members of the Delaunays' painters' collective inspired Sonia's refusal to endorse Breton's petition. There was another, and perhaps deeper motivation. Sonia still believed—or wanted to believe—that Stalin would pay for the 1917 confiscation of the Terk property. She was still a member of the Association of Victims of Spoliation, and through émigré lawyers' grapevine she had heard rumors that the association was on the verge of final settlement and compensation from the Soviets. Also, for her and for many of her generation, the one year of the Popular Front was a privileged period, a moment of optimism and can-do spirit when a popular government had given the lower classes a sense of participation and shared aspirations in the national life.

The family was together for a Christmas luncheon, prepared by Galina. Maria Oskarovna Terk, by marriage Sonia's last link to her own Russian family, joined them, and there was a card from the Zacks. Charles' Christmas present to his mother was an assortment of color crayons.

In January 1938, Chautemps remodeled his cabinet as a purely middle-of-the-road administration, but it was not supported by the

socialists and communists and lasted only two months. Its resignation coincided with Hitler's *Anschluss* of Austria. Blum attempted to establish another Popular Front coalition, but it lasted less than a month.

The new prime minister was Edouard Daladier, a tough, intelligent and straightforward middle-of-the-road politician who had led his party into the Popular Front coalition and had been one of its staunchest supporters. After receiving unprecedented votes of confidence in the Chamber and the Senate and the power to govern temporarily by decree—something the Senate had refused to Blum—Daladier moved quickly to the Right and took two moderate conservatives into his cabinet.

The Delaunays were in demand. Sonia exhibited in Amsterdam with a group of abstract painters, executed a monumental entryway for an Art Mural show, and, with Robert, exhibited at the Fifteenth Salon des Tuileries and at the Petit Palais. Picasso hung next to Pevsner in one room at the June mural art exhibition; Sonia and Robert shared another with Gleizes, André Lhote, and their former overseer Survage. Louis Chevronnet and Waldemar George, two important critics, reviewed the Delaunay works with enthusiasm. The Petit Palais show allowed each painter to show his evolution. Robert chose to start with his first abstract works, Sonia with the two-meter-long *Prose du Transsibérien*. For the Museum of Modern Art, Cassou bought *Woman with Vegetables* from Sonia's Portuguese years.

They were both active in the Abstraction-Creation movement. The question as to who was first riled Sonia. And whenever abstract painters designated Kandinsky as the founding father, she would snap, "Robert."

Kandinsky might have painted the first of his *Improvisations* in 1909 and his first abstract watercolor in 1910—irrefutably, London's Tate Gallery had a purely abstract Kandinsky dated 1910, the year Robert was painting his *Saint-Severin* and *Eiffel Tower* series—but Sonia would insist that Robert "invented" nonfigurative, nongeometric, and noncubist painting before 1912. She would also forget that Robert had painted a series of portraits and that she, too, had had a representative period.

Working with a crew on the expo commissions had given Robert a taste for collaborative accomplishments, and he took on students

once more. Every Thursday he brought together young artists and architects to whom he expounded enthusiastically his ideas. Each was assigned abstract sketches on a given theme and had to show them the following weeks.

Serge Poliakoff was a Russian-born émigré, fifteen years younger than Robert and Sonia, who earned a living playing the guitar in cabarets and nightclubs. A longtime admirer of Klee and Kandinsky, Poliakoff would remember listening to Robert as to a prophet and doing the weekly exercises: " 'Two greens and one blue' was one week's assignment, then, more difficult, 'The dissonance between two blues and one green.' Delaunay thought less to influence us than to make us discover for ourselves."

Denise Centore was a musician, the daughter of friends of Sonia, who used to come to Robert's lectures. One Thursday, she suddenly spoke up. "You do with color what Bach did with music," she said. "To paint is to let oneself be guided by the affinity of colors, without any story, any anecdotal impurity."

Sonia, who was present, was struck by the idea of counterpoint. Robert wanted to publish a book, perhaps with Gleizes writing the analytical part. Nothing would come of the project.

Robert had a commanding view of art. He was the first to grasp the notion that to paint on walls allowed a kind of overlap of painting and architecture. As he told one of his little Thursday groups, "I believe you can go from one painting to another, to a third, and that the whole constitutes an entirety, and I believe this brings us to architecture. Painting on walls doesn't destroy architecture, because you can make play with volume in new ways."

When they were alone at Rue Saint-Simon and both were painting, Sonia and Robert had their own little endearments.

"What do you think," Robert would say, stepping back from a canvas.

"Why do you ask? You know I don't like the orange."

"You say that, but you've used orange."

She would smile. "You use my blues now."

They went to "The Exhibition of Popular Masters of Reality," a show of Wilhelm Uhde's collection. Willy had continued as a dealer and as a writer, concentrating on his first love—the primitives. His taste had lost some of its unerring assurance, but since uncovering Séraphine Louis, he had found and backed Camille Bombois, Louis

Vivin, and André Bouchant—"naifs" who after Uhde's 1937 show would not be rediscovered until the 1960s.

Willy lived with a Frenchman near his Galérie des 4 Saisons, and was to be found every afternoon at the Smith's Tearoom on the Rue de Rivoli. He was now in his early sixties and, although Sonia thought her former husband had turned "shallow" with age, and he felt she had become disdainful and "domineering," they rather liked each other.

Two weeks before Christmas, Berthe de la Rose died.

The rituals of funeral and internment brought the families together. Charles had loved his grandmother and spent an hour by the open coffin. Sonia, who had hated her mother-in-law, found herself bequeathed an extravagant housecoat. She gave it to Maria Oskarovna Terk.

At the funeral, Robert met for the first time since 1910 his aunt, Marie Damour. As they tearfully embraced, the woman who brought him up told him she would reconcile him with his uncle Charles.

The new year began with more upsetting news. The January 28, 1938, newspapers announced that the air pavilion was being torn down. Sonia phoned Felix Aublet, who managed to save all the huge canvases. She would later accuse him, wrongfully, of "losing" two of Robert's canvases.

Francis and Adelina Picabia came for dinner. Francis had sold his residence in Mougins, a village above Cannes, and was painting again, mostly tossed-off gestures of contempt for the modernist mainstream. Surrealism was at its last breath, he claimed. "A scandal that lasts too long is no longer a scandal; the ear and the eye get used to it." Still extremely rich, Francis irritated most painters by leading a dual existence as an artistic anarchist and big-spending socialite, but Robert loved his occasional visits. More down to earth, Sonia had Francis advise her on how to deal with Americans. Robert and she still wanted to do the World's Fair and had sent a proposal and a portfolio of their sketches to New York. Theresa Bonney, a resident American photographer who had been Sonia's client, helped her compose a follow-up telegram. So far, however, Sonia had received no answer.

* * *

In early spring, Sonia's doctor advised her to take a short rest in the country. Robert had bought a new car, an Amilcar convertible, and happily consented to play chauffeur. Near Gambais, a stony village off *Route Nationale 12* less than 60 kilometers west of Paris, Robert fell in love with an eighteenth century farm. The property was partially in ruins, but the proportions of two viable buildings charmed him. They were big enough for painting in grand dimensions. The price for the uncultivated farm was 150,000 francs. They paid 50,000 francs down and took a ten-year mortgage for the rest.

With students and friends, Robert began to fix up the living quarters and to restore the main stone barn. He would spend the winter 1938–1939 in Gambais, he decided.

Back in Paris, however, he got caught up in the ideological fight that posed him and the other abstract painters against the social realists. The confrontation broke out when a member of the Paris city council chided Jean Cassou's purchases for the new Museum of Modern Art.

To castigate the municipal critic, Robert invoked both the *Intourist Art Guide*, which rejected abstract art as "the last expression of the decomposing bourgeoisie," and Hitler and Mussolini showing off "degenerate" art to the abomination of their hypnotized crowds.

The fate that met the modernists and their central achievement in abstract art in the Soviet Union was a tragedy. Even before Stalin's terror, Lenin had withdrawn his support from the avant-garde and handed their hard-won authority to their enemies, the academicians and ideologues who established socialist realism as the only permissible style. Malevitch died in disgrace in 1935. Tatlin, Rodchenko, and other modernists were now systematically hounded.

In Germany, the Nazi government confiscated 639 paintings by Kirchner in 1937, a move that played a big role in the suicide of the fifty-seven-year-old founder of *Die Brücke* a few months later. With the Law on the Withdrawal of Products of Decadent Art of May 31, 1938, the Nazis destroyed the artistry of an entire epoch. The almost-endless list of works despoiled in Germany ranged from Van Gogh and Picasso to Chagall, Klee, Kokoschka, Kandinsky, and the Bauhaus architects Gropius and Mies van der Rohe. In Frankfurt, the *Kun-*

stinstitut put the works of Max Liebermann, the Berlin impressionist who had given Sonia her first box of colors when she was fifteen (and had died in Berlin in 1935), into storage.

Uhde knew terrible jokes about Hitler's art appreciation. Honoring the memory of the man who brought her up, Sonia couldn't laugh when Willy told how the Führer loved Boecklin. With their evocation of nostalgia and melancholy, Boecklin's mood pieces were considered kitsch now, but Sonia never forgot that a copy of *The Isle of Death* had once decorated Henri's St. Petersburg study and that on her first visit to Italy, Henri Terk had almost taken her to meet the artist.

Uhde got into trouble with the Nazis when a Swiss publisher brought out his commentary on history and art.[1] The artistic avant-garde cannot live in totalitarian regimes, whether of the Left or the Right, he wrote, elaborating on his old notion that what destroyed Germany was Luther, Goethe, and Bismarck. A year after the publication, the German embassy in Paris notified him that he had lost his German nationality.

"Something of an annoyance," he told the Delaunays, "since I haven't got my French naturalization yet."

Robert's irascibility increased as honors were bestowed on him, and through it all Sonia was his first line of defense, his ever-enthusiastic supporter and guardian. He exploded when a gallery in Rue de Beaune omitted him in an exhibition of paintings of which Apollinaire had spoken. Sonia had to phone and mobilize friends to have one of Robert's works included.

Floor plans arrived from the New York architects as the interest in the Delaunays spread to California. The proposal to create murals for the New York World's Fair would be stillborn—a fleeting mention in Sonia's diary mentions that an agent named Hartwig was told the plan was "a folly." But another international expo was being prepared for San Francisco. The *Front Populaire* might be out of power, but Henri Laugier and Marie Cuttoli were as plugged into the power structure as ever. Henri's command of English had made him a kind of roving emissary in London and Washington. During one of his trips to America, he had come up with the idea that France should have

a Palace of Discoveries at the Golden Gate International Exhibition, celebrating the opening of the Oakland and Golden Gate bridges, to be held during the same period as the New York World's Fair.

California officials coming to Paris were impressed with Sonia's English and proposed she teach a course at the University of California at Berkeley. Robert would accompany her. The dates were set. They would arrive in San Francisco December 15, 1939.

It would be their first overseas voyage. Neither of them had ever been outside Europe. The proposal was serious enough for Sonia to begin making lists of what they would bring along and and for Robert to wax his mother's handsome luggage, the toilet case bought at Hermès, and the Vuitton suitcases.

Just as money started to be a problem again, a very moneyed American art lover, followed by his no less acquisitive niece, came calling.

As a patron of the arts, Solomon R. Guggenheim had collected old masters for years. Since 1926, he and his beautiful wife, Irene Rothschild, had directed their attention to the acquisition of avant-garde and modern art, with dire consequences to their marriage. That year, the sixty-five year-old "S. R.," as he was called, met Baroness Hilla Rebay von Ehrenweisen, a painter thirty years his junior. The indomitable daughter of a German army officer, Hilla Rebay had first painted in the expressionist style until she became converted to Kandinsky's notion of reducing art to its essential of color, form, and line. Under her spell, S.R. had started to buy the works of the artists she admired, and in 1937 he announced he was creating the Solomon Guggenheim Foundation. Within two years, the Museum of Non-Objective Art would open in a rented townhouse at 24 East Fifty-Fourth Street in New York, around the corner from the Museum of Modern Art. Hilla would be its director.

Solomon and his niece Peggy—now divorced from the dashing Laurence Vail—had been exposed from an early age to the German-Jewish emphasis on culture. The Segilman family on Peggy's mother's side were bankers who had been in America for over a century and who for the past forty years had set the tone of the "Our Crowd" society in New York. The Guggenheims had been rich but parvenus, a mining and smelting dynasty, but their name was becoming synonymous with enlightened philanthropy, the arts, dentistry, metallurgy, and aeronautics.

For appearance's sake, S. R. was staying at the Meurice while Hilla had an apartment at the George V. On Bastille Day 1938, Sonia and Robert were S. R.'s guests and stood on their balcony watching the fireworks.

A week later, Solomon paid a visit to Rue Saint-Simon. Sonia had cleaned up the studio apartment. Paintings were hung over the upstairs balcony and along the stairs, making it all look like the bridge of a yacht, she noted in her diary. S. R. bought Robert's *The City* from 1910 for 60,000 francs.

After S. R. had made arrangements to have the painting shipped to New York and had chosen several sketches to take along, Robert offered to drive him to the Place de Tertre, high up on the Montmartre hill next to the Sacré Coeur, which Guggenheim somehow believed was the center of Paris. Sonia came along, and at an outdoor restaurant where they all had lunch, S. R. suggested the Delaunays move to New York.

"Look at your son with his jazz, he's a real American."

Leaning forward, Robert lowered his voice. "You really think the Right will triumph?"

"Here, in France?" the millionaire smiled. "God no, France is the biggest democracy in the world."

Two weeks later, Robert and Sonia were dinner guests at Hilla's George V apartment. Sonia went to the hairdresser, Robert bought a tuxedo half paid for with a painting—and joined the Gleizes and the critic Yves Rambosson. Never one to be left with the ladies after dinner, Sonia joined the men with their cigars on the balcony. The conversation was all about painting. Guggenheim believed Delacroix could be said to have been the first painter to imagine abstract art. Next, he would place Seurat. Rambosson suggested a watercolor Kandinsky painted in 1910 was the first to deliberately suppress all references to the objective world, while Sonia suggested her husband's chromatic theories and the use of pure colors were at the origin of abstract art. Hilla suggested Sonia send photos of one of Robert's *Saint-Severin* paintings, and Guggenheim eventually bought *Saint-Severin No. 3* from 1909.

Robert was not well, though by temperament he refused to acknowledge anything but moments of lassitude and fatigue. As always,

Sonia had to deal with the doctors, if not with the truth. In her diary she would dutifully write down the name of his prescription medicines, note the appointments for daily shots that a Dr. Viard gave Robert, and cite the different treatments that the physician tried, but she would never dwell on the diagnosis or on her fear.

27

Incidental Events

If there was one thing that relaxed Robert it was driving. Escorting foreign visitors like Solomon Guggenheim and Hilla Rebay around Paris, shouting obscenities at other motorists, and exchanging coarse jokes with cabdrivers loosened him up. And now that money was rolling in again, Sonia and Robert decided to splurge, to drive to the Riviera for a summer vacation.

On the way down, they stopped in Lyon, where Sonia conferred with her former fabric manufacturers regarding her designs for San Francisco. The Coutrots, whose apartment they had decorated, invited them to use their apartment in Cannes, and Kitty de Leeuw, the daughter of Sonia's Dutch gallant, was in Saint-Tropez, a fishing village that the author Colette was making fashionable. To Robert's horror, Kitty counted among her friends André Dunoyer de Segonzac, Sonia's classmate from back at the Académie de la Palette. Segonzac had remained serenely traditionalist, painting landscapes along the Marne, nudes, and still lifes.

"Conventionalist!" shuddered Robert in mock horror.

More to his liking was a visit with that other Saint Tropez summer resident—Le Corbusier.

On the way back in September, Sonia and Robert stopped at Grenoble to meet one of Willy Uhde's museum director friends, Andry Farcy. A fat little man in his fifties who had once been a *Tour de France* cyclist and was forever lecturing all over France, Farcy bought judiciously for the Musée de Peinture et Sculpture, from Signac and Matisse up through Picasso, Modigliani, and Léger.

The director and his adoring wife invited the Delaunays to stay a few days with them. Meanwhile the prime ministers of Britain and France, Neville Chamberlain and Edouard Daladier, were returning from their meeting in Munich with Hitler and Mussolini. In thirteen hours of talks, with no Czech representative present, Hitler, Daladier, Mussolini, and Chamberlain agreed to the Führer's annexation of the Sudetenland—the richest part of Czechoslovakia. In London, Chamberlain told Parliament that the agreement had brought "peace in our time." In Paris, the press, with few exceptions, praised Daladier, and even Léon Blum wrote in a *Populaire* news commentary that "war is spared us; the calamity recedes."

Sonia's diary makes no mention of the Munich agreement, but notes that the Farcys were nervous, "expecting war to break out any moment." Farcy had helped Uhde put together his Popular Masters of Reality show. Sonia wanted to talk about a possible abstract exhibition, but the museum director was too distracted by the current events.

The war jitters hit closer to home when Charles was called up in the September 23–24 mobilization of one million men in response to Hitler's ultimatum to Czechoslovakia and a general mobilization of Czech armed forces. On October 4, however, the chamber approved the Munich accord by a vote of 535 to 75. Across the Channel, Winston Churchill spoke out in the House of Commons. "We have sustained a total, unmitigated defeat," he began, but he was forced to pause until a storm of protest subsided.

Charles was assigned to antiaircraft gunnery duty in Carnetin, on the eastern approaches to Paris. By November, fears of war subsided as suddenly as they had arisen. At two meetings in London, Daladier had shown he understood that Hitler no longer intended to stop with the Sudetenland but wanted to dominate Europe. But Daladier lacked

the will and the persuasive powers to prevail either with the British government or within his own.

Charles came home for Christmas on a furlough. With members of his antiaircraft unit he had thought of forming a jazz orchestra or perhaps of trying to get promoted to the general staff as an interpreter. On New Year's Eve, they went out, and made a toast to the waning year that had not seen Europe go up in flames.

The year 1939 began quiet enough, but on March 15, Hitler invaded Czechoslovakia. Two days later he rode into Prague. The shattering of the six-month-old Munich accord suddenly and unexpectedly shook up Chamberlain and Daladier. A week later, Britain and France issued a formal declaration that they would intervene militarily in case of aggression against Holland, Belgium, and Switzerland. On April 13, after Mussolini invaded and occupied Albania, a joint Anglo-French declaration promised armed support of Greece and Romania, and the same day the French government publicly confirmed its alliance with Poland.

Fascism triumphed in Spain. In May, General Francisco Franco celebrated his civil war victory over the legitimate government. While Britain, France, and the United States had dithered over whether to help the Republic, Italy and Germany had sent military support to Franco and his revolting army. In his victory parade in Madrid marched 10,000 Italian troops and 5,000 of the German Condor Legion.

Together with Jean Gorin, a painter friend of Mondrian; Fredo Sides, the rakish antique dealer; Nellie van Doesburg, the widow of Theo van Doesburg; and the art critic Yves Rambosson, the Delaunays planned a first all-abstract art show.

Sides came up to the opening of the *Salon des Réalités Nouvelles* at the Charpentier Gallery in scarlet-lined cape and cane. The group exhibition—which besides the Delaunays and Gorin featured works of Jean Arp, Marcel Duchamp, his brother Jacques Villon, Auguste Herbin, Georges Valmier, and Albert Gleizes—was a major success. The sales of the catalog alone covered the expenses, and several sales were made during the first few days.

Robert was delighted. "The success is proof that the surrealist

con game is over, that the surrealists, slaves of literature, of the anecdote, of the subject are finished," he told journalists. What is finally victorious is the art that belongs to the age of radio, airplanes, the new materials. Art delivered from illustration!"

Robert was slipping. Marie Cuttoli suggested to Sonia that she take her husband to the south, to one of the tonic spas in the Auvergne region. Dr. Viard had no objection, but Robert protested he'd rather push on to Grasse, where at least he'd be able to talk with Arp and Magnelli.

Whether premonition of war or a word from Dr. Viard were behind her decision, Sonia prepared the trip with singular gravity. She sorted out the family papers—Maria Oskarovna's will, the deeds to the properties in Nesles-la-Vallée and Gambais—and went through her jewel box. Before they could leave, however, the other collecting Guggenheim wanted to visit.

The forty-year-old Peggy Guggenheim had hurled herself into a life of adventure in 1920, sailing to Europe to marry Laurence Vail. After indulging in a career of scandalous love affairs, of giving parties and collecting pictures and people, Peggy had opened an art gallery in London. She began buying paintings from each artist she showed or slept with—her latest conquest was Max Ernst. Now she was in Paris enjoying a buying spree and overseeing Vantongerloo's cheerful decorating of her apartment on Place Vendôme.

Like her uncle, she had a scout who knew everybody.

Nellie van Doesburg had walked into Peggy's London gallery a few months earlier and lectured the gallery owner on who her husband had been and who she was herself. The way Nellie worshiped her husband's memory touched Peggy. Nellie's chic and marvelous vitality soon had Peggy call her "the most adorable, dearest friend."

Nellie set up a meeting with Sonia. Like her uncle, Peggy wanted to buy a classic Delaunay. She had no high opinion of Robert's current work—he had not painted anything since 1938—and in her auto-biography would describe the bargaining over a purchase in less than flattering terms.

"He had been an important and good painter about thirty years before," she would write. "I wanted to buy one of his paintings of that period, as his contemporary ones were horrible. But he had been

foolish enough to ask me 80,000 francs for it, so of course the deal did not come off."[1]

Robert had not sold many paintings in his life and he refused to haggle. What Peggy Guggenheim knew, and he didn't, was that one of his "classics" was on sale at Picasso's dealer, Léonce Rosenberg's, for 10,000 francs.

Sonia and Robert were still in Paris September 3 when, after Hitler's blitzkrieg on Poland, Britain and France declared war. In the evening they went to dinner in a small restaurant on Rue Mazarine, which they knew from their days in nearby Rue des Grands Augustins.

Without lowering his voice, Robert said, "War is an incidental event. The only event that makes an imprint on its era is its art."

From another table, a man's voice shouted, "Deserter!"

Robert got up. "Repeat that!"

Pierre Brasseur, an actor who had reached stardom the year before in Marcel Carné's film *Quai des Brumes*, was at a table between the Delaunays and the patriot. The actor got up and walked toward the visibly drunk heckler. A friend of the heckler, who turned out to be a student of Dunoyer de Segonzac, got up and apologized for him.

"God, a figurative!" Robert bellowed.

Robert and Sonia paid and rose with dignity, inviting Brasseur and his party to a drink at the Deux Magots café on Boulevard Saint-Germain. The confrontation turned into a farce, as the painter friend ran after them, trying to defend figurative art.

Poland was crushed by the mighty German army in one week, but France, with eighty-five divisions facing an enemy with little more than a covering force, did little to keep its commitment to Warsaw. Britain did no more. Its small contingent of two divisions didn't reach the "front" until September 26. After a perfunctory "Saar offensive" by nine French divisions, all was quiet on the western front.

Robert shared the general opinion that there would be little fighting and that, in any case, France was safe behind the Maginot Line, which stretched along the German border from Belgium to Switzerland. The joke was that after the war France would get back

the immense cost of the Maginot fortification because the Maginot would become the biggest tourist attraction in Europe. Stories reached Paris telling how the Germans, with loudspeakers and large signs, chided the frontline French about the absurdity of "dying for Danzig" and blamed the English for the whole thing. "Don't shoot. We won't if you won't." Often French troops would hoist a crude sign of their own signifying their agreement. Sometimes *Wehrmacht* troops across the Rhine would cheer soccer games played by Frenchmen on their riverbank.

It was the loveliest autumn Paris had known in decades, as the capital settled uneasily into the "phony war." Robert was out in Gambais overseeing the continued rehabiliation of the farm.

Sonia's diary makes no comments on the war. It is as if she had decided once and for all that the follies of men could not be rationalized, that in the face of history's twisting trial it was useless to try to gauge events and the future, that to adapt as she had always done was enough.

She noted the comments of others, however. At a dinner at Marie Cuttoli's, Le Corbusier showed a gnawing pessimism. "I have a feeling that our milieu is shattered in its foundations," he said, "our avant-garde environment of tolerance and creative freedom." They ran into Piet Mondrian on Montparnasse in early 1940. He had felt the war coming and in 1938 had moved to London, but now the war was in London, too. He was in Paris to liquidate his Rue du Départ studio, and she noted his comment: "I'm sixty-eight. I've got a lot of projects. I won't allow the war to distract me." She also wrote down Robert's answer: "It's not because I'm thirteen years younger that I'll let myself be diverted."

The next day, Robert had forgotten everything. With Marie Cuttoli, he and Sonia spent the afternoon at the Saint-Ouen flea market, wandering aimlessly and finding silly objects. In one alley they saw Picasso and Dora Maar, his tall Yugoslav mistress, walking their equally tall dog. Sonia's journal made no mention of their reaction to seeing the one painter whose life seemed blessed. It was thirty-one years ago that Willy and she had entertained Pablo and Fernande at their apartment, that at Gertrude Stein's place Robert had bragged about being sure he'd achieve as much as Picasso when he reached his age. Since then they—and the rest of the art world—had labored in the shadow of the fiery Catalan. Robert had

always railed against Picasso, calling him a charlatan, Sonia cuing
in by calling his influence destructive. Yet he was the most influ-
ential and successful artist of the century, with painting, sculpture,
graphic art, and ceramics all profoundly and irrevocably affected
by him.

Sonia sent food packages, including Galina's *pirozjki*, to Charles.
He wrote home that when the first squadron of German Dornier
bombers had appeared in perfect parade formation, he realized that
the antiaircraft was a joke, that the enemy planes seemed out of reach
of his 75-mm cannons. Sonia was afraid of censorship, and wrote back
to tell him not to give any details. So little could be accomplished in
antiaircraft that he was writing a book about jazz.

Meanwhile, Robert had his own diversions. With the wartime
rationing of gasoline, why not be the first to have his car converted
to run on wood alcohol? Since he was always ready with new
schemes, Robert could see himself as the owner-operator of one of
Paris's only gypsy taxis. The wood-burning sedan would be a gold
mine. And Sonia could get into the rag trade again. They'd make
it. But, the advancing illness prevented him from having the car
converted.

Nellie van Doesburg called one day in November to tell Sonia
that Peggy wanted to buy one of her oils. Guggenheim was trying to
persuade the government to back a huge showing of modern French
art in the United States. It would be a kind of propaganda effort. The
idea was not without self-serving motives, of course. It would help
consecrate Peggy's collection—now called Guggenheim Jeune, to dis-
tinguish it from her uncle's. Peggy was living in the Rue Halle apart-
ment of Giorgio Joyce, James's son. When she had the Delaunays for
dinner November 15, they brought her fresh fruit from Gambais.

On November 30, Sonia confided to her diary the first indication
of the severity of Robert's illness. With Dr. Viard unavailable, they
managed to get their local pharmacist to give Robert his needed shot.

Meanwhile, Peggy Guggenheim was everybody's hope of a sale.
On January 3, 1940, the Delaunays met Vassily and Nina Kandinsky,
and the seventy-four-year-old Kandinsky was saying how difficult it
was to sell a painting to a French person. Peggy, however, was leaving
for the winter sports resort of Mégève.

In February 1940, France offered itself the luxury of a government crisis. Three-hundred representatives abstained when Daladier asked for a vote of confidence on the way he conducted the war. His unexpected loss of a parliamentary majority brought Paul Reynaud, Daladier's energetic finance minister, to power. Reynaud, who lived with the slightly mad, excitable, and meddlesome Hélène de Portes, agreed with his friend Colonel Charles de Gaulle that the war should be prosecuted more vigorously. He established close contacts with Britain's Admiralty chief Winston Churchill, whose ideas he shared and whose energies and imagination he admired. Reynaud was thought to be too "Anglophile" by many. Now was his chance to fight the war with vigor. Members of Charles's antiaircraft unit soon found that their leaves were abruptly shortened.

Suddenly in April the lull was over. After Hitler's surprise attack and occupation of Denmark and Norway, the *Luftwaffe* struck airfields in northern France. At Dr. Viard's that afternoon, Sonia and Robert talked over the situation, and in the evening she wrote in her diary that the Allies had provoked the attack on the two Scandinavian countries. "I'm optimistic and convinced that it was provoked by the Allies so as to force the Germans to confront them somewhere."

The next day Sonia and Robert were at the Gallery Reveillon for the opening of a French Artisans show, which included Sonia's fabrics. "Picasso and Dora Maar made an appearance, with Nellie and Peggy," she noted in her journals. Two days later, Robert got Marie Cuttoli to show one of his big paintings to Peggy.

German armor outflanked the Maginot line by crossing the borders of Holland and Belgium. In two days the German panzer division pierced the "impenetrable" Ardennes and began rolling toward the Meuse and Sedan rivers. The outskirts of Paris were bombed May 11. Sonia and Robert could not go back to sleep once the air raid was over. Five days later, the Allies suffered their first disaster, causing panic in the high command and consternation in Paris.

Marie Cuttoli phoned Sonia that afternoon. "The Germans are in Laon!"

Sonia's French geography was shaky, but Robert could tell her Laon was only 140 kilometers northeast of Paris.

Three weeks later as General Erwin Rommel's armor swept across northern France to the Channel, the outskirts of Paris were bombed and the Exodus—the fleeing of the civilian population from the German army—began. At his antiaircraft installation, Charles saw the beginning of *l'éxode*. First heavily packed limousines came down the highway, heading south, then buses, trucks, people on bicycles with their belongings stacked on little trailers, horse-drawn farm wagons loaded with grandparents and babies on top of piles of furniture.

The Luftwaffe hammered the ragged remnants of Allied armies standing at Dunkirk. In London, Chamberlain resigned, and Churchill, promising "nothing but blood, toil, tears and sweat" became prime minister. Desperately, more than 300,000 men were ferried across to England from the beaches of Dunkirk. On June 10, the day Italy declared war on France, the Reynaud government abandoned Paris and in a convoy of ministerial limousines fled south to Tours on the Loire River.

Thanks to an affidavit by Fredo Sides testifying that he would house the Delaunays in his Riviera villa at Mougins, a village between Cannes and Grasse, Robert managed to obtain the precious coupons allowing him to buy rationed gasoline.

Sonia's packing was methodical. She had already sorted out vital papers and jewels, and on June 1 she went to the *mairie* to get a copy of their 1910 marriage license. Together, they took care of their art. Each canvas was removed from its frame and rolled up. Robert's health was deteriorating. He had to lie down two, three times a day, and the big job was ahead of him. Sonia had never learned to drive; it would have to be Robert behind the wheel for the thousand kilometers on clogged highways, bombarded at times by Italian fighter planes.

They left messages everywhere for Charles, whose unit was supposed to be retreating toward the Loire, and started out. The trip was a nightmare. Millions were fleeing homes, jobs, friends, and neighbors, all heading south and spreading disorder and depleting stores. Robert held up behind the wheel, and Sonia would run into scores of hotels in Étampes and the other stopover points and, if a room was available, help Robert to bed. On June 16, they were in Vichy, the cheerless resort west of Lyons where part of the retreating government was camping out. It was in Vichy, of all places, that she learned the Soviet

Union did not consider her eligible for restitution of the Terk assets. The Association of Victims of Spoliation had been told that compensation would be limited to people residing in Russia in 1917. In Clermont-Ferrand, they managed to buy a tire at the Michelin factory.

Robert wanted to avoid Marseilles and swung east toward Grenoble. The old Route Napoléon down the flank of the French Alps was probably safer than the coastal highway. Besides, Grenoble no doubt offered the hospitality of the Farcys.

Peggy Guggenheim was also on the road and heading for Andry Farcy's museum, where she hoped to store her hoard until the war was over. In Paris, Fernand Léger had told her the Louvre would give her a couple of square meters somewhere secret, and she had her pictures taken off their stretchers and packed. To her dismay, the Louvre decided her pictures were too modern and not worth saving, and so she rolled up her Kandinsky, several Klees and Picabias, a cubist Braque, a Léger, a Gleizes, a Marcoussis, a Delaunay, two Italian futurists, a van Doesburg, and her collection of surrealists, from Ernst to de Chirico, Tanguy, Dali, Magritte, plus sculptures of Lipschitz, Laurens, Pevsner, Giacometti, Moore, and Arp, and tooled south. In the barn of a woman friend's bilingual school near Vichy, she found a temporary haven for her boxes. After Farcy agreed to shelter her paintings, she and Nellie van Doesburg continued to Grenoble with her art. Farcy gave her a room where she unpacked her paintings and had them photographed.

When Sonia and Robert rolled into town, Farcy told them of his American visitor stacking her pictures against a basement wall. Robert wondered if he couldn't sell her the canvas she had found too expensive in Paris a year ago. Sonia kept phoning Nellie. In exasperation, Peggy offered 40,000 francs for the "classic" he had wanted 80,000 for a year earlier.[2]

On June 17, a hastily formed government headed by Marshal Henri Philippe Pétain accepted Hitler's terms for an armistice.

Six days later Hitler paid his only visit to Paris, arriving at dawn. His staff car whipped through empty streets. He paused to contemplate the staircase and foyer of the Opéra. He stood briefly on the flowing

steps of the Trocadéro and looked across the Seine at the Eiffel Tower. The convoy was glimpsed by very few Parisians.

Later, Hitler confided to Arno Breker, his court sculptor, "I could have entered Paris at the head of my victorious army, but I didn't want to harm the soul of the population, to damage their national pride." In his table talk, in conversations with Speer, the Führer told of the singular radiance Paris had shed on his imagination. As a young student of art and architecture, he had pondered reproductions of its great buildings and treasures; it's unique "aura" had long preoccupied his will and fantasies.

Robert went to see Peggy Guggenheim alone. "I think most artists are better without their wives," Peggy would write in her memoirs. "He brought his painting with him. He very kindly restored for me a Gleizes I had bought in Paris, from the widow of Raymond Duchamp-Villon, Marcel's brother who had died in World War I. When Delaunay left, I gave him my darling cat Anthony as I could no longer endure living in one room with these foul-smelling creatures. Delaunay loved cats, and this one took to him at once. Soon after this, Delaunay got very sick and wrote me many letters about his own illness and about the cat."[3]

With Peggy's cat but not her 40,000 francs—the money would come in installments—Robert and Sonia rolled into Cannes. Alberto Magnelli was sitting at the terrace of a café, waiting for Suzi to go back to Grasse, when he looked up and saw a big automobile, loaded down with enormous rolled-up canvases, swing into view.

His memory would remain vivid. "And who did I see inside? The Delaunays. We made reciprocal gestures of wonderment. They stopped, and came over to the café, to celebrate their arrival and our chance meeting."

Robert and Sonia moved into Fredo Sides's house in Mougins. Alberto and Suzi were the first visitors. Robert had literally covered all the walls and the floor with the unpacked canvases. "In order to pass from one room to the next there was no way but to walk over the paintings," Magnelli would write. "We were somewhat abashed, but Delaunay assured us that it did the canvases no harm to be walked on. The effect was surprising, and we took advantage of this extraordinary Delaunay museum."

On August 4, they received the first news from Charles. He was in Montauban, between Bordeaux and Toulouse. His unit was never captured, merely demobilized, after their commander distributed medals, in a hamlet southwest of Bordeaux. The same night Sonia noted in her journal that she listened to both German and British radio broadcasts.

Three weeks later Charles showed up. Mougins was full of refugees, including jazz musicians he knew, but he didn't want to stay. While stopping over in Marseilles, he told his mother, he had tried to get a visa to the United States. Chagall, he had found out, was waiting to get a visa because he had an invitation from the director of the Museum of Modern Art in New York.

The armistice divided France in two. The northern half, including Paris, was occupied by the Germans; the southern, or Vichy France, ruled by the eighty-four-year-old Pétain and his Premier, Pierre Laval. Only German authorities in Paris could issue travel permits between the two zones, but like thousands of others, Charles found a way of sneaking over the "border." He was sure the Germans had banned a weekly jazz show he produced on national radio, and he wanted to get back and hide the thousands of jazz records before the occupiers could confiscate them.

At Vichy, Pétain and Laval not only knuckled under, but by emulating Hitler's regime tried to curry enough favor with the dictator to have him go easy on a defeated nation. In an atmosphere of fear, defeatism, and confusion, they abolished the Republic and instituted L'État français. Pétain became Chief of the French State, Laval vice-president; they assumed all powers.

Governing by proclamation, they deprived anyone who had left the country between May 10 and June 13—such as de Gaulle and his tiny band of followers—of citizenship. They ordered the creation of a special High Court to try the ex-ministers who had "betrayed their responsibilities"—meaning Daladier and Blum—instituted a review of all naturalizations and closed all public offices to anyone born of a foreign father. The first anti-Jewish law went into effect September 10 and was extended October 3 to exclude Jews from public office, press, radio, and the cinema. In her diary, Sonia wrote

this without comment, and noted who among her Jewish friends would be affected.

Robert was getting worse. In early November he collapsed. Put to bed with 102°F fever, local doctors made several wrong diagnoses. Sonia insisted that he see a specialist in Cannes. After a series of tests and x-rays, Sonia was told that Robert had a "small polyp with bleeding lesions."

28

"What a Lovely Trip"

Not to tell a patient he or she was suffering a terminal illness was routine medical practice in Europe in the 1940s. In her memoirs, Sonia would write that Robert didn't want to know—without adding whether *she* knew. If she had been told, she didn't want to believe it, and she "reduced" his illness to symptoms. There were days when he was better, days when he was convinced he was on his way back to health. "Robert didn't realize he was dying," she would write thirty-seven years later. "He said he still had a lot to say, a lot to do. All the time, he was thinking of his painting." The diary, increasingly a daily refuge, a focus of sanity and order in a confused world, would make no mention of death for another six months.

What preoccupied Sonia—and Robert, on his good days—was making a living. Cannes and Nice, the resorts in between and the hills above, sheltered a strange fauna of people. There were refugees running out of territory—German and Austrian socialists, Russian revolutionaries out of favor with Stalin, Spanish Republicans, some on their fourth exile, stateless persons and Jews of all nationalities,

rich Jews selling, buying and selling back documents, visas, currency, and tidbits of information, and poor Jews running through daily routines of glimmers of hope. There were the notorious antifascists and intellectuals, André Malraux and André Gide, living cautiously in magnificent villas belonging to very absent British friends, and those who treated the disasters of war with a studied indifference.

Marseilles, the largest city in Vichy France, was the focal point of those trying to escape. The United States was not at war, and the Reich still respected American citizens. Varian Fry, a young classics scholar from Harvard, arrived in Marseilles, in August 1940. He was the envoy of the quickly formed Emergency Rescue Committee, whose sole purpose was to get out of France those artists, intellectuals, and political activists in greatest danger. As a one-man rescue committee, Fry soon realized there were far more people at risk than anyone in New York suspected. Eleanor Roosevelt was a backer of the Emergency Rescue Committee, but more difficult than securing American entry visas was getting Vichy police exit papers. And worst off were German nationals like Max Ernst, already on the Nazis' list of "degenerate" artists, who needed exit visas approved by the Paris *Kommandantur*. The Vichy regime was no friend of such notorious antiestablishment figures as the surrealists, and André Breton and Marcel Duchamp were on Fry's list.

For some, life returned to a semblance of tolerable routine. Matisse was back in the old-fashioned Hotel Regina in Nice after giving up on the idea of escaping to Brazil. Picasso and Dora Maar were fearlessly back in Paris after being surprised by the Germans in Royon, on the Atlantic coast. But most important for the Delaunays, Jean and Sophie Arp, Alberto and Suzi Magnelli, and Simone Heim and her children were nearby.

During October 1940, Sonia tried to open a fashion boutique. She took the bus down to Cannes, continued to Antibes, Biot, Cros de Cagnes and on to Nice to look for that rarest of specimens, someone willing to buy art, to get addresses and try to line up 10,000 francs in start-up financing. From Felix Aublet came some money, a portion of what he apparently owed them from the 1937 expo. The saleslady at the local Jacques Heim boutique had orders to take Sonia's garments

on commission. Sonia proposed herself as an artisan. She bought color paper and yarns: Robert wanted to make Christmas cards they could sell. She knitted scarves and wanted to try hats.

On days when he was better, Robert talked grandly about art to visiting Jean and Sophie. They proposed to help. Sophie Taeuber-Arp possessed that most envied of neutral nationalities. She was Swiss, and planned to take her husband back with her to Zurich. They could take a number of Delaunay paintings with them. Robert wanted 5,000 Swiss francs for each, which came to 50,000 French francs at the official exchange rate and twice as much on the black market. In her diary, Sonia noted that Jean wanted a high-enough commission for himself so he wouldn't have to sell his own works in the depressed wartime market.

Robert and Sonia were down to the point where they were borrowing 100 francs at a time when a letter from Hilla Rebay announced they would be receiving $150 a month on account on a future Delaunay acquisition by the Solomon Guggenheim Foundation. Hilla also wrote that she was working on their affidavit, that crucial proof of support from an American citizen and political bona fide status which would secure an American visa. The United States was not at war, and although communications were slow, it was possible to send letters and money orders via Portugal. The Delaunays themselves corresponded with Henri Laugier, Marie Cuttoli's one-time lover and Blum administration insider, in New York.

In December, a money order for 7,000 francs arrived from Peggy Guggenheim, which allowed Sonia to pay the electricity bill and the credit she had run up at the local bakery.

Peggy was in Marseilles, trying to think of how to send her collection ahead to New York. In Grenoble, Andry Farcy made her understand that it was risky for him to keep her pictures. A forwarder, who had consigned paintings to her from Paris to London before the war, however, told her that getting the art to America was easy enough. She was moving, wasn't she? It would be easy to pack all the paintings and sculptures in with the blankets, pots, and pans, and send the whole lot off as "household goods."

When winter arrived, rationing began in earnest. On April 12, 1941, Sonia gave a little party for Robert's fifty-sixth birthday. The

Arps and Simone Heim were the guests, and Simone had made arrangements for a luncheon at a restaurant.

Robert suddenly decided he wanted to get to Paris for treatment he thought could cure him. He could no longer drive, let alone sneak over the demarcation line into German-occupied France, so he had Sonia apply at the Préfecture of the Alpes-Maritimes *département* for a travel permit. Instead of presenting their *cartes d'identité*, they submitted the copy of their 1910 marriage certificate. The police headquarters answered with a questionnaire, where only one question demanded a reply: Are (were) the parents of Robert Delaunay French? They chewed over this enigmatic question with their friends. The consensus was that someone at the Préfecture was trying to warn them of something. The friends told Sonia not to go.

The Chagalls, the Bretons, and Ernst slipped out via fascist Spain—Max without an exit visa—followed by Peggy and her paintings. She left for Madrid and Lisbon as the Vichy government forced Fry to close down his Emergency Rescue Committee during the summer of 1941.

By early June, the specialist in Cannes suggested Robert be seen by one of his colleagues, a surgeon in Châtelguyon, a spa near Clermont-Ferrand. If this confrere should suggest an operation, the hospital in Clermont-Ferrand would offer surgeons and the right facilities.

The 500-kilometer railway journey was long and painful. The trains were overcrowded and only once did Sonia find a compartment where Robert could lie down for a while. Sensing that he could not make the trip in one day, Sonia managed a hotel reservation in Nîmes, the halfway point. In the lobby Sonia ran into Theresa Bonney. Their American photographer friend was on her way home, with exit visas and railway tickets to Lisbon. "Not that I'm across the ocean yet," she smiled. "Visas don't protect anyone from mines."

The three of them convinced the surly hotel management to serve a small meal in the Delaunays' room. Robert sat up in bed as they talked about the dresses Sonia had made and Theresa photographed, and the old days at the Closerie des Lilas and the Dome, the impassioned arguments over abstract art. They'd see each other soon, they agreed as Theresa left. Peace could not be far away. Five days later, Germany invaded the Soviet Union.

With Sonia in the consulting room, the referral specialist slipped on surgical gloves and examined Robert's rectum. After sending Robert

to the toilet, the surgeon told her, "The tumor is the size of tangerine. It's malignant. It's too late to operate."

She objected; she told him that the specialist in Cannes had taken x-rays and repeated the specialist's opinion. The surgeon winced as if to disparage all previous diagnoses.

Sonia kept up her mask when Robert returned, and they left the office.

An operation was performed at Châtelguyon in early July. Charles came down from Paris—having sneaked across the demarcation line with the help of professional smugglers—and was astonished to see his father in his hospital bed, thin but relaxed. Charles had turned thirty, and for the first time in his life, his father spoke gently to him.

"There was no indication that his attitude was faked," Charles would write. "In fact, I have since wondered whether he wasn't trying, at the end, to have himself forgiven for a half-century of dirty tricks."[1]

Charles was a success in Paris. He had brought with him a copy of his first book, *De la Vie et du Jazz.*[2] Jazz was for the young, it was a way of denying the occupation. Jazz was subversive.

With American titles discreetly gallicized (*Saint Louis Blues* was changed to *La Tristesse de Saint-Louis*; *Honeysuckle Rose* became *Chèvrefeuille*), he had organized a concert that was so successful it had to be repeated. Django Reinhardt, the gypsy jazz guitarist Charles had promoted for years, was suddenly as famous as Maurice Chevalier. While Sonia wrote letters for him to take back to Paris, they talked about the garden in Gambais. When he left, she told him to try to convince Dr. Viard to come.

Sonia, who was allowed to share Robert's hospital room and took part in his personal hygiene, braced herself to cling to the doctors' evasions, to what they didn't quite say. On August 7, a sudden spiking of fever surprised the doctors. For the first time, a new specialist told Sonia that her husband's case was hopeless. Another doctor offered the cliché reserved for families of the terminally ill: "Be strong."

The continent in flames intruded on the little world of the hospital room. Within a month, the Nazis advanced into Russia along a front that extended from Finland to the Ukraine, putting Leningrad on the northern flank and Odessa in the south under German siege. In September, Kiev fell, and all of the industrial area of the central

Ukraine was in German hands. Gradizhsk was too small to show on the front-page newspaper maps. Sonia made no mention of her birthplace in her journal, but it was overrun when the Germans took Kharkov and continued east toward the Don River. Together with a Mrs. Reichenbach, Sonia listened to the British Broadcasting Corporation news every evening.

Closer history also crowded in. At the hotel where Sonia sometimes took a room for a night to get some sleep, lived the wife of the former education minister Jean Zay, and among the patients was a daughter of Léon Blum, visited by her mother. Sonia was surprised that these wives and a daughter of leading politicians knew her. "Since the art deco expo in '25," she quoted them as telling her. "The '37 fair. Your photo was everywhere."

From America came a document of stinging irony. Now that Robert could not be moved came the Solomon Guggenheim Foundation affidavit, engineered by Hilla Rebay, that practically guaranteed U.S. visas for both of them.

Robert was moved, one last time. On October 2, Dr. Viard arrived. He was on an official trip to Vichy, and could only stay a few hours. Robert was happy and reassured, and he tried to sit up in bed.

"Get him to Montpellier, to my father-in-law's clinic," Viard told Sonia. "By ambulance. He'll get attention there."

Sonia walked the doctor back to the bus depot. Everything she feared, everything she felt, the meanness of the people, poured out of her.

"Yes, France is behind," he said, "that's why we lost the war."

He took her in his arms. "Robert leaves behind a body of work, and a son who's a good man."

Montpellier was nearly 300 kilometers south of Clermont-Ferrand. Sonia made the arrangements, calculated the price of an accompanying nurse. She left for Vichy, standing up all the way in a crammed train, to get the permissions and prescriptions, and on October 19, 1941, they set out.

October 20 was a gorgeous Sunday. They stopped for lunch at Tournon, and on the Rhône River. Robert sat with them at the table—the driver, the nurse, and Sonia—and ate the fish the nurse prepared for him. The landscape charmed him, the glittering river, the autumnal colors.

"What a lovely trip," he sighed.

Back in the ambulance, he talked through the frosted window to the chauffeur, about driving. His temperature was over 100°F when they arrived that evening. The doctors insisted that Sonia take a sedative.

Montpellier meant Joseph and Caroline Delteil, still cultivating their vineyard, and a refugee couple they vaguely knew from Paris, the psychiatrist René Allendy and his wife Colette. Dr. Allendy was a celebrity among intellectuals, a psychiatrist who believed in oriental religions, occult sciences, astrology, and homeopathy. A big man in his early fifties, he had treated Author Anaïs Nin, who thought of him more as a magician than a psychiatrist, and would remember sessions where he sat behind her, constantly interrupting her analysand's monologue to conjure up vast syntheses of her life and personality. When his wife Yvonne had died in 1935, he immediately married her younger painter sister, Colette. Joseph came to the hospital on his bicycle, bringing freshly picked grapes and agreeing to run errands. A telegram must be sent to Charles, but it took one hour at the post office to have it pass censorship.

Sonia insisted on staying with Robert. "It doesn't look good at all," said a doctor the next day.

When Robert woke up from his sedation, he would not let her leave the room.

"You're too far away. Why do you leave me alone?" he asked.

She moved her chair next to the bed. When he let go of her hand, she picked up a newspaper.

"You keep everything to yourself."

He had always used that phrase when he wanted her to read to him. She began with the headlines, the front-page story of German advances in Russia. After a while, he slipped away again.

René Allendy came to the hospital. There was nothing he could do but comfort them both.

There were moments when Robert was totally lucid. "Life is a bitch," he suddenly launched. "It is full of lies."

"I hate lies," she answered, knowing full well that for months she had lied to him, to herself, too.

After a while, he added, "Money . . . put it away. Don't spend what comes in right away on books, flowers, clothes."

In the evening, a doctor came in and suggested Robert try to

sleep a little. Sonia was surprised. "He doesn't sleep much," she told the physician.

But when she asked Robert if he wanted to sleep, he nodded. She helped him lie on his side.

Exhausted, Sonia let herself collapse on her bed. At 2 a.m., she was suddenly awake. A nurse was in the room. Together, they counted the intervals between Robert's last breaths.

PART THREE

29

Alone

To fill the void in herself, Sonia clung to the routines that would get her through this October 24, 1941, her first day alone in thirty-two years. She had not slept, but spent the long hours before dawn at the nurses' station, drinking ersatz coffee and showing them photographs of Robert and her when Charles was little and photos of paintings. At 7:30, she took a streetcar to the center of Montpellier and found dahlias—deep-red, fluted flowers. They were 100 francs the bunch, she dutifully noted, along with the car fare. When she got back to the clinic, they had removed Robert's body to the morgue. Slowly, she arranged the flowers around her husband, thinking he looked serene and handsome, like Charles. The coffin was lead-lined so that after the war Robert could be easily transferred to Gambais, for a final resting place in the garden. Caroline came to get her, and together they took the little local out to the Delteil farm. Joseph was taking care of the funeral arrangements.

René and Colette Allendy came to comfort her. Joseph and Caroline took her home with them. Sonia wanted to talk about the future. She wanted Joseph to promise he'd write a book about Robert.

"Believe me, Joseph, I know all the contemporary painters, no one else has what he had—life. Henceforth, my only purpose is to show his talent to its fullest advantage. No one has appreciated his true importance."

"It's because he disturbed too many people."

"You're the only one who has his gift for life. You must promise me to write a book on Robert."

She decided to dedicate herself to securing Robert's place in history, to somehow gaining for his work the recognition his exuberant and difficult personality prevented while he was alive.

They showed her to her room. For the first time in months she slept seven hours at a stretch.

It took Charles forty hours to get there from Paris (a railway employee charitably told him where to crouch and hide behind a freight train's locomotive while crossing the demarcation line). His mother could only talk about the mundane, the role she had given herself. She was touched, however, when Charles gave her 2,000 francs. He was doing all right, he said.

Despite his objections that a lack of ink and paper made it impossible to publish a book right then, she insisted that he collect and send her Robert's manuscripts. "I want to consolidate all the documents, to prepare everything while I remember everything, while I'm alive. Joseph will write the human portrait, the life, the poetry, and I'll do the technical side. Caroline suggests we keep the apartment on Rue Saint-Simon in order to show the paintings in a handsome environment."

The weather turned cold the day of the funeral. After the brief ceremony at the Saint-Lazare Cemetery, Sonia and Charles found refuge from the freezing rain in a tea room. She gave her son instructions to buy a cemetery plot for two at Gambais. She could envision Brancusi doing a gravesite sculpture. She was not going to live long, she was sure. In her diary she made several notes about her heart, about the aches and weariness that assailed her.

She had made a momentous decision. Charles was, with her, the heir to Robert's estate, and she wanted her son to agree with her resolution.

"We will not sell your father's art, except to museums," she began. If the name Robert Delaunay was to mean something, if Robert's

inventiveness, independence, and experimentation were to be an in-
spiration to new generations, his work would have to be accessible,
to be visible in public museums. It could not be locked away in the
homes of the rich.

Robert Delaunay might have been the creator and master of a
dazzling color vocabulary and pioneered the field of abstract painting,
but that was thirty years ago. It was absurd to talk about his place in
history, the value of his paintings at a time of war when a sack of
potatoes or a kilo of butter caught the attention of people's minds a
lot faster than the quality of a painting. Charles talked about the
humidity in Gambais that ruined everything including paintings and
about life in Paris, the black market, the collaborators who call them-
selves realists, but Sonia remained adamant. They would sell no paint-
ings now.

They had just buried their husband and father. They were both
overwrought. Charles was doing all right, as he said, and, except for
Delhumeau and the Guggenheims he was hard-pressed to remember
anyone paying money for his father's art. Sonia easily obtained his
consent. For his return, she packed one of his father's suits and several
mementos.

Joseph and Caroline suggested Sonia stay with them. They dis-
cussed anything, even the Delteils' marriage, to avoid talking about
the pain. Joseph was not happy. Caroline's temperament, he con-
fided, had a way of breaking his élan. Sonia could only draw a com-
parison with Robert and herself. "The life you have created here
together would have enchanted Robert. To live as you do with the
vineyard, domesticated animals and at the same time to have the
freedom to work on your art, that's ideal when two people do things
together."

They talked about Charles and his jazz, which Joseph compared
to surrealism. Sonia said jazz was a mixture of the made-up and a
constructive foundation. To combine improvisation and technique
was the most difficult challenge in art. Johann Sebastian Bach had
achieved it; the works of the geniuses proved it could be done.

Joseph wrote a moving tribute to Robert that was published in
Le Figaro in Paris[1] and in several provincial newspapers. One night
he told Sonia, "You must start painting again. Now, perhaps you will
find the fullness of your power."

* * *

Sonia decided to return to the Riviera. Her first task was to find places to store Robert's paintings until the end of the war. In the frozen wastes around Leningrad, a Russian offensive for the relief of the city was under way, while in the Ukraine, the Germans were being driven back from the oil of the Caucasus. On November 16, Hitler flung his armored divisions against Moscow for a second time. By December 6, the cold of winter hit his soldiers and the Russians counterattacked. The next day, the Japanese attacked Pearl Harbor. With the Americans in the conflict, it became a whole new war. In the meantime, as she noted in her journal December 19, the dollar went down.

At home, the official antisemitism of the Vichy government was being tightened. Jewish deputies to the National Assembly were being dismissed. Not that Sonia felt threatened, at least not in the immediate future. She would have liked to go back to the apartment in Paris, but she was not foolhardy enough to tempt fate in German-occupied France. In Vichy, she was safer.

A telegram arrived from Jean and Sophie Arp suggesting that she come and stay with them in Grasse. She wasn't sure she was ready to be sociable, and in any case she wanted to get to Mougins first and sort out her affairs.

Andry Farcy and his wife came to Montpellier. They were staying at the Hôtel de l'Europe and invited Sonia to dinner. It was the first time she'd gone out, and to talk to a museum director who knew Robert and his art was just what she had needed.

They chatted about friends. Ossip Zadkine was in America, his wife hiding in the black hills of Perigord in south-central France. Leaning forward, Farcy whispered a question. "As an 'Israelite,' aren't you afraid?"

She never confided to her diary what her answer was. Instead she noted their conversation about Robert's paintings. Farcy asked for prices. He was interested in one of Robert's 1912 *Windows*, and asked how much she wanted for it. She would have to consult Robert's own notes, she said, and then talked about the book Delteil and she were planning. That night, she woke up with a new intuition about the conversation with Farcy: the preliminary aside about her Jewishness and the request for a price list. "The danger," she would write, "is

that under the pretext of religion and getting canvases for nothing, I let myself be plundered."

After a last visit to the cemetery, she left Montpellier with a trunk full of Robert's last earthly belongings. In the bus from Cannes up to Mougins, a young woman journalist she vaguely knew turned to her and introduced Paul Poiret. The megalomaniac and dazzling fashion designer of the delirious decade when Diaghilev bewitched the western world was earning a living as a painter and a sometime stage and movie decorator, exhibiting his poverty as he had once vaunted his wealth.

"Are you a relative of the late painter Delaunay?" Poiret asked, showing he was up on the news. As the bus climbed into the hills, they talked about Spain and Portugal, Sonia telling the designer how much she and her late husband had loved Iberia.

Sonia was packing boxes in Mougins December 12 when Jean and Sophie Arp came to hug her and to reiterate their invitation. Their conversation was subdued, philosophical. They talked about all the painters who had ended up in the United States—Léger, Chagall, Breton, Duchamp, Ernst, Lipchitz, Mondrian, Ozenfant, Benjamin Péret, and André Masson.

"And Zadkine, although his wife is in Perigord," Sonia added.

Jean sighed. "France is finished."

Sonia became prophetic and optimistic. "After all upheavals, we will have an extraordinary renaissance, a renewal based on everything we love. I don't think we will live to see it, because the sea changes we're experiencing are very big and very long. But for me the point is absolutely clear. What we must do is to work so as to leave behind a life's work, to make sure the work survives so that it can be communicated and serve as a basis."

The Arps told her about the house they rented in Grasse, 10 kilometers further up in the hills. They called it "Château Folie." It was nestled among olive trees with one huge palm behind a natural spring and a cemetery. From the windows, they had a view of the lavender fields that supplied Grasse's perfume industry, and, on the southern horizon, the blue Mediterranean.

"When the palm leaves rustle, we know it's going to rain."

She would be with friends, Sophie said. The Magnellis were there, and Ferdinand and Irène Springer, François Stahly, and his wife. Sonia didn't know Springer and Stahly, but accepted the Arps' hospitality

on condition it be temporary. She was thankful for the opportunity to share a house with artists she respected and for the pleasure of the countryside that, Sophie promised, offered the beauty that healed, but she would prefer to be on her own, perhaps to sublet from somebody.

It would be more difficult to get down to Cannes from Grasse than from near-suburban Mougins. Before she moved, she decided to go shopping for necessities in Cannes. It was New Year's Eve, and there was a line of people waiting at the depot.

When the ticket office finally opened, the man behind the counter called out for those who had priority. In the Paris subway this usually meant disabled servicemen and pregnant women. But here there were no paraplegics or obviously expectant mothers waiting. The people in line started to protest when a gentleman stepped forward and went behind the counter.

"He didn't even show his ID," Sonia shouted.

The man wheeled around. "I don't have an ID, but I can show you my passport," he sneered in impeccable French. With that he whipped out his passport. *Deutsches Reich.*

Sonia turned her back.

With her ticket she got on the bus. The German was laughingly explaining to an elderly lady how Sonia, when he showed his passport, had suddenly become very small. Sonia sat down across from them and stared them down. A woman from the ticket queue took the seat next to Sonia.

As they started to roll, Sonia looked with insolence and a sarcastic smile at the German and, with a poke at the woman next to her, said as loud as she could, "Don't you mind, Madam. There is justice in this world. Each gets his turn. Some of us just have to shut up, be patient and know how to wait!"

30

Les Six de Grasse

"In the chaos of the defeat, six human beings who dedicated their lives not to violence but to creativity, find themselves in Grasse, a refuge where they try to put down new roots," a future catalog of their joint exhibition would say. "From those years of uncertainty, anxiety and infinite restrictions come a small number of modest works, often made with chance material, works that, beyond problems of esthetics and expression, are memories of a deep friendship which brought together and comforted the six and those close to them."[1]

The postwar years would give a place to Jean Arp, Sophie Taeuber Arp, Sonia Delaunay, Alberto Magnelli, Ferdinand Springer, and François Stahly. Younger artists would rhapsodize about this wartime community of artists, but Sonia would in turn puncture some of their reverence: "It wasn't idyllic. We quarreled, and each of us put away his or her sugar cubes so the others wouldn't pinch them."

In the overview of her life's work, the two and a half years she spent in Grasse would remain significant. If the years 1910 to 1913 were her most productive, if Portugal was a key period, and the 1937

expo made her try very big dimensions, Grasse was a time of meditation before a radiant postwar burst.

History would retain only Jean Arp and Sonia Delaunay, yet Magnelli began a large series of collage canvases and, when he ran out of oils, a number of important gouaches; Sophie, who was slowly dying of cancer, painted her most lucid canvases; Stahly began to sculpt; and Springer, who would survive them all, solved inner contradictions in his art.

They were all refugees with complicated nationalities. Stahly was the youngest and most at risk because both the Italian and German armies were looking for him. Born in 1911 in Constance, in Baden-Württemberg, he was Italian by his father and German by birthplace. Because he had joined the French army in 1939, he was also a naturalized French citizen, except that the Vichy government had nullified his naturalization.

Of the group, Stahly worked the hardest. He and his wife had two small children, and they rented a small farm in Saint-Jean-de-Malbosc, owing half the olive and hay crop in annual rent. Up at dawn, the Stahlys toiled till sunset tending goats and rabbits, pruning olive trees, haying, and working in their "victory garden." François had only the evenings to fabricate the belt buckles and accessories he made for a Cannes couture house.

Ferdinand Springer was born in Berlin, the son of a German scientific editor and a Swiss mother. He had been in France since 1928, and had married Irène. After being helped by Wilhelm Uhde, he had traveled and exhibited in New York and London. At thirty-four, he was just out of the Vichy government's so-called assembling and screening camp at Milles, near Aix-en-Provence, after having been called up and trained in a French army unit for foreigners. The Milles camp was a converted brick factory full of Austrians, Czechs, foreign legionnaires, Jews, and *apatrides*—stateless individuals. The internees slept on brick, breathed bricks. Springer ran into Max Ernst and Hans Bellmer, a surrealist famous for his life-size dolls. As a souvenir, Bellmer had done a portrait of Ernst, outlined entirely in trompe-l'oeil bricks.

The chubby Alberto was Italian and Suzi the daughter of a prominent Jewish family from Berlin. They were still not married, and Alberto was trying to find a very discreet mayor who would turn Miss

Gersohn into Mrs. Magnelli without looking too hard at their papers. They had owned a house in Grasse since before the war. Jean Arp had been born in Strasbourg when it was German and, like all other Alsatians, had become a French citizen with the 1919 Versailles Treaty.

It was Sophie, who was Swiss, who had fallen in love with the uplands of the Côte d'Azur. Every morning she visited her flowers. She spoke to flowers and, at night, to stars, and she rescued butterflies which flew too close to the kerosene lamp. When they went for walks, she beamed with happiness. As her husband would say, "Her eyes couldn't get enough of the silver-green of the olive groves, the meditating silhouettes of shepherds amidst their herds, the clumps of villages on the mountains, the sparkling shield of the Alps, dazzling with snow. Her inner translucence struck the people who met her. She opened up like a flower whose decline is approaching. The glow within her brought protection and solace to those in distress."

Sonia did not stay long with Jean and Sophie, but found separate accommodations in a big house belonging to a Monsieur Chonet. She knew she was difficult to live with, and preferred two rented rooms to the disaster of outstaying a friendly welcome.

They were a cautious group, trying to stay out of any possible limelight. Sonia never talked about her Russian origins; no one knew that Alberto and Suzi were not married or that Irene was Belgian. They met almost daily at the Arps' or the Magnellis'; these get-togethers distracted them from their individual anxieties and made them forget they were sometimes hungry. The atmosphere was conducive to quiet work, and Sonia began to paint.

Oils were hard to come by, and by necessity she began work with gouaches. She had not used gouache since 1913 and liked the flatness of the opaque watercolors because the effect resembled the fresco technique of painting on moist, lime plaster surfaces. She used thin coats, preferably on smooth surfaces and even when she used oils shunned pasty effects. Critics would see a change in her technique. Her oils and her affection for gouaches, they would say, confirmed her longing for huge surfaces. Nobody gave her any walls to paint in Grasse—it was during the other war, twenty-six years earlier that the father-in-law of the mayor of Valanca had let her decorate a chapel —so she made small-scale murals on paper and canvas.

Wartime living favored improvisations, the short view of things, getting by, finding a bicycle tire, tomorrow's dinner. There was no purchasing public for art in Grasse, and for the six to advertise their presence would have been reckless. So the members of the little colony exchanged their works as gifts. "We were our only customers and collectors," Sonia would say. Jean Arp would remember the solidarity of the little group. "Never was there a trace of vanity, arrogance, rivalry," he would write.[2]

There was a deep need in Sonia to believe that no one disappeared totally, that something intangible remained. She bought three copies of the New Testament, one in Russian for herself, two in French— for Jean and Sophie and for Charles. She attended Bible readings, but after two months, felt disappointed and stopped going. For Christmas, she forced herself to go to Montpellier by herself, fourteen hours standing in crowded trains, so she could be at Robert's grave on New Year's.

Caroline came to get her at the station. New Year's 1942 dawned cold but sunny. Sonia was the only person at the cemetery that morning. In her diary she wrote, "I stayed quite a while. I've done what I wanted; I've come to spend the holidays next to him, to take care of him as if he were alive. She could see his gaze, his smile, so ironic and so sad. He could only feel less lonely like that. The grave was handsome, alive with the spirit I breathed."

Charles came down, bringing with him art supplies and firsthand news. The winter 1941–1942 was one of the coldest on record in Europe. Food and fuel shortages were hitting millions, and Charles told of strange meats served at restaurants at exorbitant prices. Much of people's time was spent rummaging behind scummy window displays for unrationed foodstuffs—to stumble on a beet or a cabbage was a windfall.

Not that all their acquaintances were suffering. Picasso, whom the Nazis considered the principal representative of "degenerate and negroid art," was selling briskly to German officers, who appreciated his work and looked him up in his studio in Rue des Grands Augustins. Other *Wehrmacht* brass frequented Louis Carré's gallery in Avenue de Messine, and, more discreetly, the gallery owner's apartment in Rue

Louis-Murat. The forty-five-year-old Carré was a consummate art dealer, an authority with an eye for excellence and innovation, who had started out by becoming an expert on ancient silver and had graduated to modern art. He counted among his friends Bonnard, Léger, Villon, and Dufy.

Gerhard Heller, the *Propagandastaffel* chief, would remember seeing his first Delaunays at the Carré apartment. "I can still see, on the dining room walls, the somewhat brutal exaltation of colors and movement expressed by the Delaunays, in contrast to the genteel contemplations that [Jean] Bazaine elicited," he would write. "Louis Carré's activity was not disinterested of course, and he continued his prolific transactions throughout the war, both with German and French amateurs of modern painting."[3]

Arno Breker, Hitler's favorite sculptor, came to Paris for the opening of his exhibition at the Orangerie, to look up his old haunts on Montparnasse, and to meet his old master, Aristide Maillol. The eighty-three-year-old Maillol, whose works were devoted almost exclusively to the female nude, came to Breker's show. Dina Vierny, a Russian Jew, former model for Maillol and friend of Sonia, was introduced to Breker, who saved her from the concentration camps toward the end of the war.

To show Heller real art, Marcel Jouhandeau, the author of comic and cruelly bitter novels and a genuine eccentric, took him to meet Jean Fautrier. The painter had abandoned oil on canvas in favor of paper, presoaked in color and frame-mounted, which allowed him to trace thin graphics in ink and pastels. Heller saw Fautrier paint his famous *Hostages* in this technique. Carried along by Jouhandeau's enthusiasm, Heller managed to overcome his own shock and surprise. "In the face of this magic and dramatic world, he made me discover, beyond the motive of the image, the subtle nuances of color, the primal matter worked over like a plowed field, in order to reach a transfigured reality and to show it to us," the *Sonderfuehrer* would write. "And thanks to Jouhandeau, I discovered and learned to appreciate—even touch with hand and eye—the horror and ridicule of the Nazi ideas on decadent art."

The uncanny flowering of the arts in occupied Paris was everywhere. Braque was also at work in his studio, Giacometti was sculpting, and the Galérie Braun exhibited such young talents as Jean Bazaine,

Edouard Pignon, Maurice Estève, and Gustave Singier. Jean-Paul Sartre produced his fundamental treatise on *Being and Nothingness* and his best plays, Paul Valery wrote his autumnal *Mon Faust*, and Jean Cocteau turned adroit cartwheels, acting as impresario, master of ceremonies, and ambassador between the native talent and the imperious guests. Heller and his bureaucracy permitted Marcel Carné to film *Les Enfants du Paradis* and *Les Visiteurs du Soir*, and two-hundred other features were produced, allowing such stars as Jean Marais, Martine Carol, Danielle Darrieux, and Gérard Philippe to come into their own. Madame Grès and Balenciaga and ten other couture houses managed to show abbreviated collections in 1941 and 1942 and to sell their creations, mostly to recently moneyed black marketeers, German wives, and those French mistresses of *Wehrmacht* officers who dared to wear them.

Together with Marie Laurencin and Coco Chanel, Heller, who was responsible for all book censorship, was a frequent guest at the lunches given by occupied Paris's leading American, Florence Gould, the wife of the youngest of financier Jay Gould's children. Dunoyer de Segonzac, Vlaminck, and van Dongen came to the opening of Breker's show.

What Charles didn't tell his mother was that he was involved in the nascent resistance movement. The winter had brought the first real armed opposition to the German occupation, even though the retaliation was merciless. In German-occupied France, the Gestapo shot fifty French hostages for each member of the *Reichwehr* killed. Charles's group was code-named Cart—after Benny Carter. They had just received their first parachute drop of arms from the British.

Sonia felt that her son was pulling away from her. Although he was thirty years old, she was offended when he slipped down to Cannes to meet a woman friend. Also, he didn't like the promise Sonia had wrested from him the day of the funeral: He wanted to sell some of his father's paintings so he could have money for his own passions—his jazz club, jazz magazine, and record collection. "He doesn't understand us," she wrote in her diary as if Robert were still alive. "We have had only one goal, to create."

There was something moving about the group members' studied effort to pursue their calling in the midst of one of the bloodiest

conflicts in Europe's history. Although in occupied Paris Fautrier was painting *Hostages*, the canvases in Grasse were devoid of any reference to war. Postwar critics would wonder about Sophie's self-willed innocence and Arp and Magnelli's dogged concentration. For Sonia it was the second time she had felt aloof and detached from the follies of war. Yet, as Hilton Kramer would write forty years later à propos Sophie, "there is a sense in which they, too, constituted an antiwar gesture, an avowal in innocence in the face of worldly evil and catastrophe."[4]

Who among the six got the idea of doing collective paintings? Apparently, it was Arp who dreamed up the idea that one of them should come up with an initial motif that the rest could take turns developing. Although the style of each is not hard to recognize, the unity of color and construction of these picture puzzles would surprise later critics.

Sonia particularly liked to work with Jean. To see him impose his organic forms, which suggested growth without being actual plant or animal shapes, on her rhythms of color and circles within circles gave her profound pleasure.

Looking for a lithographer who could transfer the ten collective gouaches to zinc plates so they could eventually be printed, Sonia came into contact with Céline Weiss, a former director of a school for secretaries, who also rented rooms at Chonet's. Although Céline's comings and goings were mysterious, she became a fast friend. She was the same age as Sonia, and her husband, René, was usually absent.

René was the owner, or had been the owner—Céline was always a bit vague regarding the details—of a printing shop in Cannes specializing in art work and lithos. André Kalin was a lithographer, a friend of theirs who had sometimes worked at the Imbert printing plant in Grasse.

René and Céline were in the Resistance, and so was Kalin.

Forty years later, Céline would remember a little differently the reason Sonia contacted her: "When she came to see me the first time it was to see about false papers, a *laisser-passer*. She said, 'My name is in the dictionaries.' "

Sonia apparently believed the Weisses were Jewish, and her flippant reference to dictionaries was meant to signal that to have Stern as a maiden name on one's ID flagged the authorities' attention. René

Weiss was Alsatian, however, not Jewish, and Céline didn't like the inference.

Céline took her to meet her husband, and the couple became fast friends with Sonia. Like Robert's, René's politics were progressive, and Sonia immediately found him sympathetic. "It was Sonia's blackest period, a moment when she needed people," Céline would remember. "She had just lost Robert Delaunay and told me all kinds of things about him, how she used to sharpen his pencils. She had loved him very, very much, and when she talked about Robert Delaunay— she never said Robert, always Robert Delaunay—you knew how terribly afflicted she was."

By the spring of 1942 the hills above the Riviera sheltered a number of partisan groups. They all wanted the defeat of Nazi Germany, but their ideas for the future were not all the same. The Communists, who were the first to really fight, wanted if not an outright Marxist France at least a Popular Front after the war. From London, Charles de Gaulle called on his compatriots to continue the struggle, reminding them that "overseas France"—nearly half of Africa, Syria, the Caribbean islands—was not in enemy hands, that most of the navy was safe in Algerian and Moroccan ports, that whole divisions had made it across the Strait of Dover after Dunkirk.

René was the head of the de Gaulle underground formation, counting among his partisans the wife of the Free French ambassador to London, André Vienot. If he and Céline moved around a lot, it was because they had just suffered their first casualty, a former L'Humanité editor caught and executed by the Germans.

The Axis powers held the initiative during much of the year. After the devastating attack on Pearl Harbor, the Japanese moved on to attack the Philippines, the Dutch East Indies, Malaya, Singapore, Indochina, and Burma. In the Atlantic, German submarines were doing their best to cut off Allied shipping to Britain. On the eastern front, the German army was steamrolling into the Ukraine, while the Luftwaffe subjected England to the relentless blitz.

In Vichy, Pierre Laval became the Pétain regime's "chief of government." The much-delayed trial of Daladier, Blum, and General Maurice Gamelin, the joint chief of staff at the Fall of France, was a disaster for the puppet regime. Daladier succeeded not only in dis-

crediting the trials as political, but also in flaying the generals who had been called to testify to the lack of preparations for war. In April, the trial was suspended "for further inquiry."

For Jews the worst news came from the German-occupied zone. After May 29, Jews there were ordered to wear yellow stars. Three weeks later, on the first anniversary of the German attack on the Soviet Union, Laval told the nation in a radio broadcast that he wished for a German victory. To spare French Jews, he allowed French police to collaborate with the Germans in a July roundup of 17,000 foreign Jews, 5,000 of them *apatride* Jews from the Vichy zone.

"It's normal," the woman behind the counter at the Grand Hôtel de Grasse told Sonia. "They're foreigners. There's already not enough to eat for the rest of us."

The Préfecture had advised the hotel not to rent to foreigners who had entered France after 1936 and people who had been admitted as refugees by the Popular Front and were therefore suspect as anti-fascists. "Last night, the police were making arrests in places where furnished rooms are let," the woman added.

The book about Robert's art remained Sonia's obsession. Robert had wanted Albert Gleizes to write about his work. She did not agree with Albert's assessment that Robert and she belonged to cubism, but she wanted to honor her late husband's wish. She got together the poems Apollinaire, Cendrars, Aragon, and Delteil had written about Robert's *Towers*, and traveled to Saint-Rémy de Provence to deliver the documents.

Albert was waiting for her at the bus depot. Albert's wife Juliette would be along any minute to take them to the farm, he said.

They waited and talked. Sonia discovered that the old friend was a Pétainist. Whatever else anyone said, he argued, Hitler was trying to stop the Bolshevik hordes.

"Hitler is Napoleon, what can I say?"

Answered Sonia, "Napoleon left a legacy."

Juliette arrived, holding high the reins of her little horse. On the way to the farm, the Gleizes boasted about their harvest, the fact that they had eight hams of their own curing in the larder. The

luncheon, Sonia noted, was "an epic of moderation." Afterward, Juliette asked her to leave a rationing coupon for the bread.

Everything bothered Sonia, including Albert's current work. His paintings, she decided, lacked focus.

She was happy to leave.

She went to Lyon to sell fabric designs. Robert Perrier, a textile manufacturer who had once produced fabrics for her and now bought a dozen for old times' sake, took her to lunch. They were joined by Perrier's cousin, a high official in the Vichy government, who was openly for de Gaulle. Sonia left all cheered up.

In June, Sonia was suddenly without a penny. She had lost the black marketeer who had exchanged dollars for her, but worse, a hefty sum was waiting in Switzerland. Allianz Verlag in Zurich had published an album of works by the Arps, Kandinsky, Magnelli, Vantongerloo, and Sonia, and the Museum of Basel had bought one of Robert's paintings.

The Swiss consulate in Cannes would issue a six-day visa, she was told, but would she get a French exit visa? She made another trip to Montpellier to get Joseph Delteil's advice. He knew someone at the local préfecture. Sonia screwed up her courage and early in the morning went to the police headquarters where ten months ago she had brought Robert's death certificate.

She filled out the exit authorization request and was told to leave all her papers and come back in the afternoon. To while away the day, she went to the grave, cleaned up the plot, and put down new flowers. When she returned to the préfecture, the exit authorization and all her papers were ready.

She left September 9, 1942, on a ticket paid for by the Basel Museum. Geneva was less than 400 kilometers from Montpellier, but the moment she changed in Valence and boarded the Swiss train she sank back into a prewar world of upholstered splendor. At Bellegarde, however, the present was back. A woman customs agent had her strip to her underwear, and she thought it was all over, when the German frontier police went through the compartments.

"If anyone carries a letter, everybody gets off!"

They rolled again, on to the actual border. On the left were the Jura Mountains and Nantua Lake where she had followed Robert

through the fields of snowdrops and had come down with scarlet fever thirty-two years ago. Then suddenly they were on Swiss soil.

An even-dimmer past greeted her at the Geneva railway station. Elisabeth Epstein was there, sent by the Basel Museum. The two friends from the days of Madame de Bouvet's, of the Académie de la Palette, flew into each other's arms.

It was a world of wonder. Elisabeth took her into shops overflowing with goods and showed her stationery store racks with *Time* magazine and London newspapers. Sonia wanted to pick up things for Charles, for the friends in Grasse. And they talked. Sonia had seen Marie Vassilieff on Boulevard du Montparnasse shortly before the exodus. Alexandra Exter was also living in Paris.

In Basel, Sonia was met by the Kunstmuseum staff. Raoul La Roche of the city's premier pharmaceutical company was making a major donation of cubist art, and besides handing her a check for 1,000 Swiss francs and discussing possible acquisitions—2,500 to 5,000 Swiss francs for Robert's paintings and 1,000 for her own—the curators were interested in what she thought of the museum's modern art section.

"Your selection of Matisse and Klee is superb, but a lot of gaps, too," she said after a tour. "It looks like the personal choices of a collector. You need an overview. You see, Robert's *The Windows* is the basis for constructivism."

The Kunstmuseum bought Robert's 1913 *View of Paris, Notre Dame* and a 1911 *Eiffel Tower* and, with the understanding that the paintings could perhaps not be delivered until after the war, trusted her with a hefty advance.

In her diary, Sonia never mentioned whether she thought of outstaying her six-day visa and seeking refugee status in Switzerland. Did she think of the possible repercussions on Charles, Joseph Delteil, the friends in Grasse if she defected? Of being separated from Robert's grave? She had always been prudent, and if she went back it was because she somehow didn't believe any harm could come to her. She was the widow of a French citizen. She had papers, including a *certificat de domicile* showing her legal residence to be in Mougins. Besides, she had lived in France since 1905, felt utterly French, and believed she was protected by her married name and her grief.

Loaded with Guerlain soap, Suchard chocolate, and 10,000 francs cleverly concealed in her sewing kit and under luggage labels, she returned to Grasse.

Five weeks later, Germany put an end to the fiction of the two "zones" and occupied all of France.

31

Trial of Strength

The first occupation troops in Grasse were not German but Italian. Sonia saw their motorized columns drive up from Cannes and take up position in front of the Grand Hotel. The SS *Reich* division occupied the Saint-Mandrier peninsula overlooking Toulon. In the harbor, the disarmed French fleet scuttled itself to escape German takeover. On the radio, Sonia heard that the Americans had landed in North Africa and that the Russians were counterattacking at Stalingrad.

The Arps were the first to leave Grasse. Despite her serenity, Sophie's health was deteriorating, and Jean convinced her to go to Zurich for treatment. She was Swiss and, as her husband, Jean, had no difficulty obtaining a visa. Alberto and Suzi disappeared in such a hurry that Sonia had to pack their belongings. "I had only one obsession, to protect the crates of paintings belonging to the four of us from the bombing raids." Next, Ferdinand and Irène Springer left. Because his mother was Swiss, Ferdinand managed to get a Swiss visa. It carried an odd condition: he was not to exhibit or sell his works.

The Italian occupation was no great threat. A large part of the

native population was of Italian descent and the troops fraternized openly.

Like most people in occupied Europe, Sonia followed the events on the much-jammed BBC radio. Though the decisive battles were still a year or more away, 1943 was a turning point for the Allies. The "arsenal of democracy" was at last in full production in the United States; tanks, planes, and ships were coming off U.S. assembly lines in constantly increasing numbers. With Germany's defeat at Stalingrad, the Allied invasion of Sicily, and Japan's losses at Guadalcanal, the Axis tide that had been running for three years appeared finally to be slowing.

Sonia tried to focus on her art and her mission. The entries in her journal told of a deliberate concentration on the small things in life, on the personal. She wrote of finishing a drawing, taking out the cat, going to Imbert's printing shop to okay engraving proofs, completing an inventory of everything Robert had ever painted, reading Balzac and listening to the news. The July 24 downfall of Mussolini warranted one line, while a book by a young curator rated an enthusiastic paragraph. In his book, Bernard Dorival predicted the coming of "inobjective" painting. "If Robert could have read this!" she commented.

Robert was constantly in her thoughts, and in her notes. "I started working and began a gouache," reads the August 8 entry. "I would like to link the principle of fabric design to painting as Robert always advised me to do." She began a letter to Charles to explain, perhaps excuse, his father's and her awkwardness when it came to money. Their burning ambition had been to paint without compromise, without surrender. The reverence for money, even among people with artistic pretensions, revolted her. Robert's death had left her existentially adrift. "One thing is of comfort. In fact, the only thing that gives me the courage to live—and I love life but not people—is art."

Charles was arrested in Paris September 7. Two days later, the Germans rolled into Grasse. Sonia heard a rifle shot at 6:45 a.m. and ran to the window. Below, the Germans were taking the Italians prisoner, gesturing with their machine guns. At 9 she went downstairs. The Grand Hotel entrance was full of German soldiers. Out on the square stood a disarmed Italian truck.

Charles was taken to the Fresnes prison, the infamous penitentiary outside Paris that was the transfer point of the thousands deported to concentration camps.

In Grasse, the Stahlys managed to disappear—with fake papers that a friend had traveled halfway to Bordeaux to obtain—a few days before the Gestapo raided Imbert's printing plant. Looking for evidence of illegal printing of flyers and underground newssheets, they tore through everything. André Kalin, the lithographer, was arrested.

When Sonia got there, many of the collective originals had been destroyed. She had proof sheets of some of the work Kalin had already done and managed to save some of the gouaches.

From Zurich came the news of Sophie's death. Jean's letter spoke of accidental gas poisoning in the home of the sculptor Max Bill. Sonia was convinced Sophie had taken her own life, that she had opened the oven because life was too beautiful to be lived with ever-diminishing capacities.

Through the efficient Morse system tapped out on plumbing pipes, everybody in Fresnes was informed of everything. After two weeks, Charles learned that the only other member of his underground network who could have talked under torture had fled the country. This meant the Gestapo had very little on him. When it was his turn to be taken away for interrogation, he had memorized a plausible story, repeated it to himself until he had expurgated all variations, and eliminated all risks of incriminating others. After repeated cross-examinations—one lasting seven hours with a sinister scar-faced colonel—he became one of the very few to be set free.

Convinced he was under surveillance, he and his girlfriend decided to get out of Paris. They bicycled out to Gambais only to find his parents' farm had been turned into the communications center for the German antiaircraft unit.

The mayor of Gambais put up the young couple.

Sonia knew nothing of all this.

The inventory of Robert's *oeuvre* led Sonia deeper into the examination of her own existence, her own talent. The dating of his paintings for the book with Joseph Delteil evoked thoughts of Robert's progression, and of her own evolution. She planned to leave herself out of the book, but as she dated the paintings, she remembered things

that Robert had told her about her work, things that made her want to know whether there had been times when she was the leader, when she was ahead of him.

It was the first time she allowed herself such musings on paper, the first time she wrote down such reflections on her place in the turbulent history of modern art. As if she were afraid of the question, however, she added that if on occasion she had been the precursor, it could only have happened "unconsciously."

Joseph was not getting anywhere with his part of the book. He kept promising. In December he and Sonia had a long talk. Without mentioning the Robert Delaunay project, he said he had a writer's block, that he had a hard time inventing the truculence, panache, and imagination of his early works. The day he would be able to recapture his earlier verve, he'd write again.

Sonia had an idea that might help. She liked to read in English, she told him, because when she got to words she didn't know she used her imagination. "When I read in a language where I know everything, I'm bored. It's the same thing in painting. I know exactly how to express things, but I'd like to have a little more feeling in what I depict."

She liked Joseph and felt they understood life the same way. She would be patient. Their book probably wouldn't be published until after the war, whenever that was.

As 1944 began, the Allies were making progress. In the Pacific, U.S. ships dealt a series of crippling blows to the Japanese fleet. Soviet armies were launching massive counterattacks and were gathering momentum all along the front, while the western Allies conquered the skies and were devastating the Rhineland and Hamburg. In France, the Resistance was blowing up German trucks and sabotaging rail lines, while British and American planes were systematically bombing railway yards around Paris.

The occupation weighed ever heavier. In January, the Vichy government created justice by militia court-martial, and a month later the Germans made all Frenchmen aged sixteen to sixty subject to forced labor duty in Germany.

While René and Céline Weiss managed to escape, Kalin was deported to Germany, ultimately to disappear in the concentration camps. Sonia knew she could be picked up at any time, and concentrated on finding a sanctuary for the art in her care.

She had practically the entire life work of Robert, along with her own, neatly rolled up, plus the paintings and belongings of the Arps and the Magnellis. In March 1944 she discovered that one of Robert's 1915 paintings, *L'Espagnole*, was deteriorating. The protective wax was flaking. In her diary she noted that in repairing the damage, she did "what Robert would have told me to do, what he used to do himself."

Everybody speculated that the liberation of Europe could not be far away. Not that die-hard Vichyites believed so. At the end of April, when the now eighty-eight-year-old Marshal Pétain visited Paris, he called liberation a "mirage."

Five weeks later it happened. On a 120-kilometer stretch of the Normandy coast, wave after wave of British and American soldiers waded through the surf and the German bullets to scramble up the beaches on June 6. By nightfall in one sector alone, they held 15 kilometers of the once-fashionable beaches from Trouville to Deauville, but it took the Allies three weeks to capture Cherbourg.

Sonia found a hiding place for the art. Some people with a garage that was halfway underground agreed to let her store three trunks of rolled-up canvases in the back of the garage, and in the end had to help her carry everything. To conceal the trunks and their contents, they put bags of plaster in front. It was the best Sonia could do, and on July 8 she left Grasse for Saint-Gaudens, Tarbes, or one of the other Pyrenees villages nestled against the Spanish border. She had spent the last two years of the other world war in Spain; perhaps it would be her refuge one more time.

The chance meeting with Wilhelm Uhde during the Gestapo check in the Toulouse café altered her plans. The stay in the château near Grisolles was improvised and, if she had any say about it, would be of short duration. Willy was turning seventy and, with his white beard, showed his age. At forty-eight, Tristan Tzara was livelier, but Sonia resented his heavy flirtation. When he asked, "Why don't you and I grow old together? We have the same ardent and disillusioned appetite for life," she could only smile.

"I've given the biggest part of my life to Robert, and some to Charles. What's left I intend to keep for myself."

If she had been starved for intellectual stimulus in Grasse, she

found the highbrow patter at the château exasperating. "Intelligent people are just as stupid as everybody else," she wrote in her journal, "only they try to make you look foolish."

Jean Cassou was one of the local resistance commanders, the representative of the de Gaulle government-in-exile, and he was rarely there. Toulouse was full of rumors, fears, and hopes. Field Marshal Gerd von Rundstedt had ordered the crack SS *Das Reich* division to move up the Normandy front, and the entire resistance movement had gone into action. Bridges had been blown up, railway track torn up, and tanks harassed with that newest and deadliest of Allied weapons—the bazooka. The German reaction had been reprisals against the civilian population, notably the rounding-up and execution of fifteen-hundred men, women, and children in Tulle and Oradour.

On July 14—Bastille Day—Sonia was in a village with some of Cassou's men while fifty miles to the north two-hundred U.S. and Royal Air Force planes relayed each other for six hours dropping supplies in a 15-square-mile zone marked off in the middle by all the region's sheets spread out in one gigantic Z. Dodging German road-blocks and intersection "hot points," fifteen-hundred men and women surrounded the site and carried the supplies to safety as fast as they were dropped.

The weapons were for the upcoming battle for Toulouse. Since the *Reich* division had left, the German defenders were a demoralized rear guard of old men and boys, plus French collaborators fearful of popular revenge.

No battle took place. While insurrection broke out in Paris, French and American troops opened a second front by landing on the Riviera. Paris was being liberated. The capital was without gas, electricity, and public transportation. The Americans were in Chartres, an hour's drive from the capital, when General Philippe Leclerc's Second Armored Division rolled into Paris, via Porte d'Orléans and down Boulevard Raspail to Montparnasse.

The Germans began to retreat from Toulouse on the 19th after setting off explosions. During the night when Cassou returned from a meeting, his driver refused to stop at a German checkpoint. The Germans opened fire and killed the driver. They then attacked Cassou with rifle butts and left him for dead. Sonia saw the retreating Germans and their French militia diehards on the highway—loaded with bun-

dles "like street bums," she noted in her diary. Next, she heard Cassou was in the Hôtel-Dieu hospital in a coma.

She dashed to Toulouse. When she saw him lying lifeless in the hospital bed and his wife holding and kissing him, she burst into tears.

Sonia had been through long hospital routines with Robert. The two women talked, and when Cassou's wife asked what Sonia would do, she answered, "Go back to the arts and crafts, to earn a living. I wouldn't mind teaching either."

In Paris, the last pockets of German resistance were broken and the city was proclaimed liberated on August 22. In Vichy, Pétain, claiming he was a prisoner, was driven away under armed guard. The destination of Pétain, Laval, and the remnants of Vichy, was a former Hohenzollern castle near Stuttgart. The surreal fiction of a French government-in-exile in Nazi Germany fighting de Gaulle and his foreign "paymasters" was maintained until the end of the war.

Where was Charles?

Safe and sound in Gambais, and back in the parental house as soon as the last Germans had left. Two days later, he couldn't help noticing how almost everybody in town sported Free French armbands and raced around in Citroëns with huge FFI (Forces Françaises de l'Intérieur) painted on hoods and doors and *tricolors* fanions flapping smartly from fenders. "It was the phenomenon that the natural sciences call 'spontaneous propagation,' " he would say.

Charles rode into Paris on a bicycle and at dawn saw the first GIs in their jeeps.

Sonia was still in Grisolles at the end of September when Grasse was liberated by U.S. forces. Cassou was brought to the château to recuperate. Half of France was liberated, General George Patton's famous Third Army was rolling east toward Lorraine, and Cassou was in the best of moods. When Sonia visited his room, he talked about the future, and she mused on Robert's place in the scheme of things. She mentioned how she had managed to hide her treasures in a garage in Grasse. He laughed and told her that until recently the treasures of the Louvre, including the *Mona Lisa*, were close by, having been hidden from bombings and Germans' lust in Montauban, twenty kilometers up the road. Now, Lucie Mazauric and her crew had moved them to the even more isolated Château de Latreyne up in the Black Perigord region.

All kinds of people showed up. Sonia liked the philosopher Vladimir Jankelevich, a man who knew the art of scores of countries and played the piano like Arthur Rubinstein. She got into a fight with him when he said he'd never play a German composer again—How could Beethoven and Schubert be responsible for Hitler?

On October 24, Sonia was at Robert's grave in Montpellier. Already three years had passed since he died. Next year she would be sixty. There were days when she felt she would not live long. She told Cassou that if he wanted to write a book on Robert, he shouldn't wait too long to interview her. "I have no intention of becoming ancient," she told him. There were other days, however, when she felt her age as nothing more than a passing fatigue.

32

Artbiz

Robert Delaunay, the visionary of light, structure, and dynamics, who for a few heady years before the "other" war had outdistanced Picasso, Braque, and the cubist mainstream, was, in 1945, an unknown.

Sonia returned to Paris and to the apartment on Rue Saint-Simon on January 1, 1945, ready to be part of another postwar era. She was prepared to live in the present, to concentrate on the future. Ferdinand and Irène Springer came to Paris and found Sonia uninterested in lingering on the memory of the war years. "You must come to see me, come and talk to the young who have a future," she told Ferdinand. She had always liked talented young men around her, and in the revived Abstraction-Creation she found several young painters she thought worthy of perhaps one day continuing Robert's research.

The selling of Robert Delaunay was not easy. Sonia's journal is filled with references to time spent talking to gallery owners and potential buyers, to feisty repartee in defense of Robert at social gatherings, and to hurtful discussions with Charles, who wanted to marry his wartime girlfriend and come into his inheritance.

In early 1946, Sonia met Denise René, a small, elegant woman

who owned a gallery on the Rue de la Boetie off the Champs Elysées. Denise was an enthusiastic supporter of nonfigurative art, and she was more interested in including Sonia's work in a "Tendencies in Abstract Art" exhibition than in organizing a Robert Delaunay retrospective. Sonia was happy to join the group show—Denise billed her as "a young woman of sixty"—especially since the others were Jean Arp, Alexander Calder, Hans Hartung (a German who, like Ferdinand Springer, had joined the French army at the beginning of the war), Antoine Pevsner, and Robert's enthusiastic student from 1939, Serge Poliakoff. The show would also include works of Sophie Taeuber-Arp and Kandinsky, who had died in his Neuilly apartment in 1944.

There were other happy surprises. Colette Allendy, who with her psychiatrist husband had been of comfort during Robert's last days in Montpellier, had opened a gallery in the exclusive Auteuil district. She too was a widow now, and, in the small gallery in her townhouse on Rue de l'Assomption, she was already very effective in promoting avant-garde artists. To balance her support of younger painters like Camille Bryen and Frank Malina, she exhibited the works of Sonia, Arp, and Magnelli. Dina Vierny, who had escaped the camps thanks to Arno Breker but was careful never to mention that she owned her life to Hitler's favorite sculptor, opened a small gallery on Rue Jacob.

In April, Sonia found a dealer who agreed to do a Robert Delaunay show: gallery owner Louis Carré.

Sonia liked Carré's enthusiasm and his authority. He might have supplied enlightened *Wehrmacht* officers with choice art works during the Occupation, a task that, as *Propagandastaffel* Chief Gerhard Heller had said, had not been without self-interest, but on the positive side, he had also supported Maillol, Vuillard, Matisse, Roualt, Laurens, and Picasso. More important, he was emerging as one of the leading international dealers. He believed in the old maxim that art dealers made a living buying and selling, but a fortune from *not* selling. In other words, the longer a dealer can afford to keep a desirable object, the more money it will eventually bring.

He encouraged Sonia's conviction that she should give or sell as much of Robert's art as she could to museums. Four groups of people dominated the art world: museums, dealers, auction houses, and collectors. Museums hoarded treasures, thus taking them off the market. This made the high-quality works that museums did not own even rarer and hence more valuable.

Carré's price was steep. Since Robert's paintings had little commercial value and Sonia had no means of paying for an exhibition, she had no choice but to accept his terms: In exchange for putting on the show, the gallery would deduct thirty oils of its choice from the collection. Considering the numerical limits of Robert's work—all in all about a hundred paintings—and the choice pieces Carré would select, it was a heavy tribute. A few more exhibitions like that, Charles angrily told his mother, and the work of a lifetime would be little more than a memory to the artist's family.

Still, Sonia prevailed. Her need to believe in Robert as a pioneer whose very innovations made him difficult to place and therefore difficult to value and recognize, swayed Charles and his live-in girlfriend, Denise. In her diary Sonia did not mention whether she appealed to her son's filial instincts or used Carré's crassest calculations. Charles was not insensitive to his father's work as an artist or to his mother's ascendancy. He was also not immune to the art dealer's logic: *Each* canvas of a famous Robert Delaunay would be worth more than the life work of a forgotten Robert Delaunay.

Carré was more than a shrewd merchant. What impressed Sonia was his sense of the times, his flair for divining artistic moods and trends. Change, he believed, was accelerating. The reasons were several. For one, yet another postwar rush of artists to Paris was taking place. The result was a proliferation of galleries and artistic manifestations, increased international contacts, especially between Europe and the United States—he opened his first subsidiary gallery in New York in 1949—and, more profoundly, an erosion of "isms," schools, and groups of artists.

Sonia didn't want to agree to the latter proposition. She saw herself as the upholder of the sacred flame of abstraction, especially the art of simultaneity as practiced by Robert and herself.

The scene was confusing, she had to admit. On one hand, figurative art was back. On the other, abstract art was finally conquering Paris.

Peace and its emotional solace brought a return to an interest in the subject of abstraction. The horror of what human beings could do to do one another, from the destruction of the atom bombs dropped on Japan in August—which Sonia deplored in her diary—to the

ignominy of the concentration camp, had cried out for the painter's direct presence in the drama. In Paris, it led to the creation of the "Man as Witness" circle with twenty-year-old Bernard Buffet in the center. A painter of extreme precocity, Buffet continued Francis Gruber's dejected *miserabilisme* of the sufferings of war with his own sad grays, thin spiky forms, and obstrusively angular signature. The group included Bernard Lorjou, Jean-Paul Rebeyrolle, and Alfred Wols, a German deserter and painter of bitter, mocking realism whom Springer took Sonia to meet. Jean Dubuffet, who before the war had twice abandoned painting, proposed a new source of inspiration—"raw art." Encouraged by the notions of alienation and by graffiti, this self-taught forty-five-year-old displayed ferocious, destructive candor, and his portraits and nudes scandalized critics and amateurs.

And there were the committed leftists. Intellectual Paris was existentialist—with Jean-Paul Sartre and Albert Camus—and sharply leftist. Stalin was one of the Big Three, and the Communists extolled social realism. After his war years in New York, Fernand Léger felt a need to give his work a social and political dimension and to deal with "big subjects" in which the human figure held sway. He was the leading "name" to join the party and to rally to the cause of edifying art, "understandable by everybody, without subtlety." With him, a number of young painters refused on principle all nonfigurative art.

Yet abstraction triumphed, and not just in the Denise René Gallery. Nonfigurative painting might be fuzzily divided into geometric and lyrical abstraction, but it nevertheless gained acceptance. A new May salon and a "New Realities" show in 1945 and 1946 laid the groundwork. The geometric abstraction that hailed back to the prewar period and late Mondrian (he died in New York in 1944) was continued by Jean Gorin, cofounder with Fredo Sides, Nellie van Doesburg, and the Delaunays of *Realités Nouvelles* in 1939.

Supported by Denise René's gallery and the critic Léon Degand, the joint winners of the first Kandinsky Prize, Jean Dewasne and Jean Deyrolles, along with the Dane Richard Mortensen, the Canadian Jean-Paul Riopelle, and Hungarian-born Viktor Vasarely expressed themselves in a freer abstract language, while Henry Valensi and Charchoune developed musical cadences on their canvases. Gallery owner René Drouin exhibited the works of Wols—who was also the illustrator of books by Kafka and Sartre—Hartung, Dubuffet, Poliakoff, and Fautrier.

Sonia was terribly moved when, on the eve of the Robert De-launay retrospective opening, Fernand Léger paid tribute to her hus-band. "It was with Robert Delaunay on our side that we joined the battle," Léger wrote in *Arts de France*. "Before us, green was a tree, blue the sky. After us, a color became its own object. Today, anybody can use a blue square, a red square, a green square." The piece, adapted from a series of conferences Léger gave, did not mention Sonia, al-though what she had contributed was singled out: "I think there is quite an important revolution that happened slowly in publicity, in window decoration and through which we got to influence the dec-orative arts of our time."[1]

To the critic Degand, she quoted Apollinaire's *mot* to Robert: "They say time is money; you go further. To you time is light." Over tea with Antoine Pevsner, his brother Naum Gabo, René Massat, and Poliakoff, she discussed passionately the fate of innovators, from Gal-ileo to Delaunay. Why were they always misunderstood at first? Must an artist starve to death in order to become famous posthumously?

"No!" Sonia and Poliakoff shouted in unison.

"Yes!" cried Massat, to be different.

Pevsner, who was only a year younger than Sonia, grinned. "Only the first sixty years are tough."

Said Sonia, "It can be longer than that!"

The Robert Delaunay show at Louis Carré's Avenue de Messine gallery was not a commercial success, although it did establish Robert as one of the artists of the prolific generation of the beginning of the century, and a lot of young artists called Delaunay a revelation.

Carré was not happy with the result, however. He had printed a very handsome catalog, and the exhibition did not break even. He wanted to lower the prices he and Sonia had agreed on, and sell whatever he could to foreign collectors.

Jean Cassou, however, was back running the Musée de l'Art Moderne and, in desperation, Sonia convinced him to buy one of Robert's *Towers*. Again, she had to make promises. In return for the purchase, she agreed to a generous donation to the museum later on.

Charles was furious. At thirty-six he was about to become a father. Denise and he were expecting their first child in June 1947, and their situation was an echo of his parents' charade in 1910. Denise needed a quickie divorce so that she and Charles could marry before the child was born.

Sonia had never been able to tolerate the women who were close to her, whether her own mother, Anna Terk, or the Countess de la Rose, and now again she was projecting her hostility toward her daughter-in-law. Conveniently forgetting how Willy Uhde's gracious consent had facilitated her divorce, she told Charles and Denise that *she* had turned her own dilemma into a lark while theirs amounted to nothing but problems.

"They make mountains out of molehills, and gossip like apartment superintendents no longer do," she wrote. Yet, she tried not to be totally critical.

Friends of Charles thought Denise beautiful; friends of his mother found her insignificant. As the moment approached when Sonia would be a grandmother, she noted that she was getting along with her daughter-in-law, although "without intimacy."

Charles needed money and proposed that Sonia and he sell a good portion of Robert's work. Charles had made his first trip to the United States to bring Dizzy Gillespie and bebop to France, and during his absence a palace revolution in the Hot Club de France had almost eliminated him from the presidency. Hugues Parnassie was beaten back, but to totally reestablish his control, Charles needed to buy out his rival's magazine *Revue du Jazz*.

On June 27, before anything could be sold, Denise delivered. Sonia rushed to the American Hospital in Neuilly, and once she was allowed to see the newborn through the nursery window, she rushed to a telephone.

"It's a boy, three kilos," she told Charles, who had stayed home. "He's got black hair, and he doesn't cry, well—almost. He looks like your father. Come quick!"

The boy was named Jean-Louis.

The summer that brought the birth of a grandson also brought the death of Willy. "What struck me," Sonia noted in her diary, "is that I had received a note from him a few days earlier." Willy's last years had not been easy. He had been a genius collector during the years 1905 to 1910, but had lost his touch for discovering what was the significant new in art.

Marc Chagall and Max Ernst returned from the United States, both with new wives and both claiming they hated America. Marc

was coming back, he told Sonia, because "when I work in America, it's like shouting in a forest; there's no echo." Of course the sad thing about the Parisian art scene, he added, was that the same names were still on everybody's lips, "Picasso and Matisse, Picasso and Braque, Picasso and Picasso."

Picasso was living on the Riviera with Françoise Gilou, an art student less than half his age, and reaching new heights of self-renewal and fame. A sunny, idyllic paganism marked his expansion into engravings, lithography, pottery, ceramics, and sculpture while the world's museums fought over his work.

If Picasso floated in the stratosphere above them all—critics now claimed no other artist since Michelangelo had changed more radically the nature of art—Sonia couldn't help admiring the facility of a mere mortal like Chagall for selling himself.

"He is much better at talking about himself; he doesn't talk too much about him, just enough," she noted in her diary. "Just enough of a ham, he knows how to do business, but he's in good health, both physically and mentally."

With Virginia Haggard and their little son David, Chagall moved back into his house in suburban Orgeval. At the Museum of Modern Art, Cassou gave a big Chagall retrospective that permanently established the painter.

Ernst and his new wife, the painter Dorothea Tanning, also chose to live in a little village outside Paris. Ernst found the exhausted surrealist movement too depressing. André Breton might not want to face the fact that surrealism was dying out and try to recruit young painters still interested in the movement, but Ernst was in the midst of a period of fertile meditation, executing obscure and poetic compositions.

Sonia, too, had a place in the country. The farm in Gambais, where Robert had planned to work and had begun restoration, was still hers. But she rarely went.

There were days when she told herself she had had enough of the *vernissage* cocktail parties. "I went to Colette Allendy's," she wrote in her journal December 10. "The Magnellis came, too. All these people seemed to form a united group, and I just don't feel I belong. They're always together, apart from us, and will remain so. Later, Arp arrived. He told me he no longer wanted to give away his sculptures to museums, that others are getting commissions, etc. I told him you've

got to start somewhere, that people like Matisse and Braque made donations. The more I think about it, the more I realize that all these people are awful petty bourgeois with whom I have nothing in common. I leave these affairs depressed. What a difference from the generosity, the splendor of our generation."

Coming home late two days later, she felt a need for a life of fecund contemplation. "How do I eliminate from my life all the people who prevent me from living exclusively for my work?" she asked her diary. "I need to catch up. I have not conserved the strength I used to have for the only thing I love: painting. Robert was right when he said I had too much talent but didn't work enough."

Still, she kept accepting invitations to new openings. She needed the bustle of the gallery scene, the art gossip, the new people, and the respectful, if sometimes flirtatious, admiration of talented young men.

Michel Seuphor was a propitious new voice on the art scene. Sonia didn't remember him, but they had met in 1925 when he arrived in Paris from his native Antwerp, a twenty-four-year-old editor of his own little art-and-poetry magazine. In 1934, he and his wife had left Paris for a solitary existence in remotest south-central France, writing poetry and autobiographical novels and translating Flemish and German poets. The reclusion had lasted fourteen years, and Seuphor was fast becoming the most forceful advocate of abstract art.

Sonia thrived on artistic debate and volunteered her opinion on everybody. She, who had designed fashion fabrics and applauded her husband for trying new materials, reproached Vasarely for his multifaceted talent when he designed the mural "Homage to Malevitch" for the University of Caracas and experimented with ceramics that included aluminum. She called Hartung, who, along with Poliakoff, had been an attentive listener at Robert's "Thursdays," too cerebral. She couldn't stand Dubuffet and called him an "antilight" painter. Wols and old friends like Stahly and Picabia were dismissed.

She spoke like Robert, even adapted his jingoist taunts. Incongruously, she reviled the "dirty foreigners"—usually no less French than she—Arp, Magnelli, Miró, and—always—Picasso, who, she wrote in her diary, "closed ranks" and left no place for the real French: Delaunay, Léger, or Gleizes. There were moments when she admitted that she, too, was foreign-born, but in the next breath she would add that she at least wasn't speaking out against her adopted country, a

realization that didn't prevent her from calling grasping or miserly women—especially her daughter-in-law—"real money-grubbing Frenchwomen." Only Russian women had any style, when it really came down to it. Nadia Léger's devolution to Fernand was an example. "Only a Russian woman is like that."

To make Robert fit the place in history she wanted assigned to him as pioneer of abstract painting, she was not above rearranging his past. As repository of Robert's thoughts, she invented a new prescience for him. To make him more "modern," she deleted his ardent embrace of orientalism in 1918 when they worked together for Diaghilev and Massine. In her fear that Kandinsky and Mondrian might outshine him, she conveniently forgot that Robert had been a portrait painter, that he had done an astounding number of portraits of Cendrars, Tzara, Stravinsky, Cocteau, and Breton, that he had done nudes and still lifes, and that he had boldly introduced the Eiffel Tower, sports, aviation, and railroads into modern painting.

Sonia's attitude toward the postwar talent was ambiguous. She resented the gallery owners' eager boosting of new painters. The Bing Gallery—Louis Carré's big rival—made Jean-Michel Atlan, a North African Jew, into a triumph; Louis Carré was behind the success of Hartung and of Jean Bazaine and Maurice Estève, a pair of young abstract painters. Her two women-friend gallery owners, Denise René and Colette Allendy, took on artists in their twenties. When the Americans arrived—Jackson Pollock to declaim Breton's poetry in an alcoholic stupor and Mark Rothko to parade his knowledge of Russian by shouting "Down with surrealism; up with aquatic worlds"—Sonia was happy when at least two of them, Willem de Kooning and Arshile Gorky, knew the name Delaunay. Gorky, who had just lost twenty-seven canvases in a fire and would commit suicide in 1948, told her he was really an Armenian. She thought of them all as the most dangerous "dirty foreigners," and warned Cassou not to buy any of their works for the Musée de l'Art Moderne. They were out to dethrone Paris and make New York the new capital of the arts.

But she also liked the young. Although her favorite companions remained the friends of her younger years, clever young people delighted in her company, and she in theirs.

She had her hair done and she dressed to the teeth to attend the

wine and cheese openings. Her escort was often Tristan Tzara, who liked the attention, smiled to everybody and glanced at the new art with his dainty monocle. Sometimes, the two of them went to his apartment on the Rue de Lille to have tea under his African masks and to playfully talk deals. Would he consider an exchange of proof sheets with Apollinaire's handwritten corrections? What would she swap for a first edition of Rimbaud's poetry?

They had known each other since the end of the first war, when Robert and she returned from Spain and Tristan brought dadaism from Zurich. He was fifteen years her junior, and had she been so inclined, they would have become lovers. At the Château Grisolles he tried to woo her, and her diary contained two references to his ardor. "Like Arp, he's looking for a woman and if I wanted to be his mistress . . ." she had noted right after the war. "But I have to finish our work and therefore do not consider myself free. Also, I like the way I live right now."

Arp had lost Sophie, she Robert, and their intimacy was limited to deep talks about the difficulty of loving again after losses such as theirs. "I understand him so well," she wrote. "Spiritual unions cannot be replaced. Jean's belief in the unknown has turned him into an infinitely better person."

The cold war cast a pall over the land of Sonia's birth. The Stalinist coup in Czechoslovakia and the Berlin blockade, which sent the iron curtain clanging down in the middle of Europe, polarized France—and its intellectuals. To the right of Sartre and Camus, André Malraux believed Europe was living its final Wagnerian twilight before monstrous empires would carve it up. On the communist left, Louis Aragon and his wife, Elsa Triolet, called Malraux a turncoat and false prophet who had betrayed his past.

Sartre and Camus had their differences, but they both believed existentialism could be a rational third choice between the poles of anticommunism and Marxism. Before the war, Robert Delaunay had fulminated against the artistic straightjacket the party wanted to impose. Now, in the deepening chill of the cold war, the Communists ruthlessly hammered home the point, "If you are not one of us, you are against us." The postwar era had revealed the existence of the Siberian death camps, and Camus cried out against the gulags and

their justification. In the crunch, Sartre, like so many fellow travelers, felt he couldn't allow himself to be against the proletariat.

The existentialist craze reached high fashion in the fall of 1947. For men the correct attire for an evening of pub crawling in Saint-Germain des Prés included the black turtleneck; the feminine dress de rigueur was a black *fourreau*, which Christian Dior called "le sack look." The Tabou on the Rue Dauphine was the most fashionable existentialist boîte. There the high priestess was young Juliette Greco, a raven-haired singer with kohl eyes and a throaty voice, who belted out black humor composed by Boris Vian, the premier name of the Saint-Germain des Prés subculture and a friend of Charles.

Vian had abandoned engineering to play jazz, and his activities included pornography, singing, acting, translating, and writing a libretto for Darius Milhaud.

Sonia knew Vian through Charles. Despite their tiffs over money and inheritance, Charles sent his mother tickets to the jazz concerts he organized—huge festivals at the Palais des Sports that mixed Dizzy Gillespie and Boris Vian, Charles Parker and Claude Luter, solo concerts with Duke Ellington at Salle Wagram, and intimate gigs at the Edouard VII theater with Charles's favorite, Bill Coleman.

What the postwar *yéyé* youths, who rocked with the amplified beat, thought of the elegant sixty-year-old in the choice orchestra seat remains unrecorded. She, however, confided to her journal that when she listened, "It's so beautiful I don't know where I am."

The creation of Israel in 1948 was, for most French Jews, the happy end result of a new self-assertion, but Sonia's attitude toward the new Jewish state was ambiguous. The death camps had horrified her, but she never identified with the victims. She gave gouaches to a charity sale for "unhappy and abandoned children" without mentioning that the children were orphans of deportees. To Israel's first ambassador to Paris she would say that it was normal for the new country to invite her to exhibit, but when Fernand Léger told her an Israeli museum was reticent about buying and in fact expected donations, she snapped, "Sure, they'll pay Chagall; and want our stuff for free."

Andry Farcy was still the director of the Grenoble Museum, and in 1949 he agreed to do a "Homage to Robert Delaunay" retrospective.

Sonia was tireless, and the Grenoble show led to a big, important exhibition organized by a powerful new name in the art business— Maeght. André and Marguerite Maeght (pronounced man-yeh) had started a lithography business in Cannes—Sonia's wartime friends in Grasse, René and Céline Weiss, had sold out to them at the Liberation. A true friendship had developed between the young artisan couple and their aging neighbor, Matisse, who did a number of portraits of Marguerite. After the war, the Maeghts opened a gallery on Rue de Téhéran in Paris and immediately struck paydirt with a series of commanding exhibitions organized around novel themes: "Black Is a color," "Dazzling Hands," and "Behind the Mirror." Familiar with publishing, André and Marguerite branched into coffee table editions of their shows, including their biggest success, "The Sixth International Surrealist Exhibition" in 1947. The following year they published Seuphor's *L'Art Abstrait, ses Origines, ses premiers Maîtres*, the first major study of abstract art.

If shows could be turned into *éditions de luxe*, why not turn books into exhibitions? For 1949, the Maeghts planned a "First Masters of Abstract Art" and agreed to include the names Robert and Sonia Delaunay. Sonia got to design the invitations.

"For today's young painters, the passage from figurative to abstract art is no doubt inevitable," wrote Seuphor in the catalog.

Sonia was at the December opening, recognized and appreciated. But her pleasure was short-lived. She heard someone in the crowd say that Seuphor was preparing a book on Mondrian.

Sonia froze. When she spotted the author, she cornered him and asked him point-blank, "What about Delaunay?"

Seuphor was not against the idea. She persisted. She had all the research. He suggested that she might consider writing the book herself.

"I consider abstract painting a logical development of modern art, starting with the impressionists, the *Fauves*, the cubists, and that is what we have to prove," she said.

Seuphor nodded.

She pressed on. "If we place the Delaunay *oeuvre* in this perspective, two things happen. One, it becomes much more difficult to attack us. Second, it becomes possible to ask for official patronage."

"I agree," the critic said. "Just, let's not fight over this."

"As long as things are done right, I'm not out to fight with anybody."

She had a second shock when the art historian and critic Rene Huyghe reviewed the show in *Arts*. "I talked to Farcy about the article," she wrote in her diary December 11. "The article is very nice, but you can see he doesn't understand our development. Maybe it's high time to explain it to people. I've decided to write to him, to make him understand that there was only Delaunay and, then, Mondrian, abstract painters on whom a future in the arts can be built. The rest of the abstracts can be dismissed in one sweep, along with all the current painters' U-turns and their literary embellishments."

Kandinsky was another threat. In an echo of the tragic destinies of Cézanne and Van Gogh, who never sold a painting during their lifetime, Kandinsky's prestige was posthumous. The full scope of his work was finally understood and appreciated, and the breadth of his influence discernable throughout the new abstraction. Sonia had never liked his widow, but she had to admit Nina Kandinsky was effective in organizing shows everywhere. When friends told Sonia she should do the same thing, she said Vassily and Robert could not be compared, that Kandinsky had left hundreds of paintings, all nicely ticketed and ready to be sold.

"I don't have many canvases," she said. "I have to start with a Robert Delaunay retrospective, because each of his paintings is an evolution."

Louis and Olga Carré invited her to an intimate dinner at their townhouse in Rue Louis-Murat. There was someone they wanted her to meet, someone who was also eager to meet her.

Sidney and Harriet Janis were the Carrés' guests of honor. Janis, who had started his art dealer career in 1927 by buying a Matisse, was a big name in the New York avant-garde world. Without opening a gallery, he had bought and sold for twenty years Picasso, Léger, Rousseau, Dubuffet, and Giacommetti, along with the surrealists from Duchamp to Klee, de Chirico, and Dali. That was all changing, however. He had just opened a gallery at 15 East 57th Street and had come to Paris to stock up. He had seen the Maeght show, and, he told Sonia as Jean Arp arrived, he had loved the Delaunays.

The dinner was exquisite, the conversation animated. As always when the talk was about art, Sonia was in top form.

"Abstract art is a dead end, really," Arp said at one point.

"Not at all," Sonia cried. "Abstract art is a passage, a transition to something else."

"To what?" Janis wanted to know.

She smiled and said her intuition told her that once art managed to surpass its old concepts, painters who understood color would have a vast new country ahead of them. "It's a realm where everything will be possible, even a return—why not?—to figurative, to representational art."

Janis, who was about to become Jackson Pollock's dealer, talked about the American art scene and told naughty stories about the Peggy Guggenheim–Max Ernst marriage when Dorothea Tanning showed up, about Léger, Mondrian, and the other exiles getting around to parties during the war. Of course Peggy had closed her gallery in 1947, and Solomon had just died.

Sonia wanted to know what had happened to the *Disks* Peggy had bought from Robert in Grenoble during the war. Janis explained that to keep her gallery going, Peggy had dipped into her capital or sacrificed pieces of her personal collection. Each time she sold something, she knew it was a mistake. Humiliatingly, the paintings invariably turned up either at her uncle's museum or the Museum of Modern Art. She had sold a 1936 Kandinsky for $2,000 to a dealer who then resold it to Uncle Solomon. Yes, as far as Janis knew, Peggy had also sold a 1913 Delaunay, together with a 1921 Picasso.

The death of S.R. had meant the dismissal of the formidable Hilla Rebay and the appointment of a "professional" director, James Johnson Sweeney. Sonia should write to Sweeney.

After dinner, Carré told Janis about Sonia's studio and the paintings she had. The American said he would like to do a Robert Delaunay exhibition in New York, to generate some sales. Could he come and have a look?

"There aren't too many," she said with a nod toward Carré.

"What about the private market?"

It occurred to her that Jean Delhumeau might have died, that the heirs to the eccentric shipowner might indeed want to sell *Sun, Moon and the Eiffel Tower* or some of the other paintings sold to the only collector Robert had known during his lifetime.

"There's someone in Normandy I might try," she said.

She agreed with Janis on a date and time for him to come to Rue Saint-Simon for a visit.

On the appointed day, the dealer showed up at Rue Saint-Simon. What he saw took his breath away.

He walked around the studio and stood on the staircase to the upstairs. "And that?" he said, pointing.

"That one is by me," she smiled.

Janis stood quiet for a moment. Finally, he said, "You know, you're a great artist."

33

Her Turn

Sonia was sixty-seven when she broke out of her late husband's orbit. In the footsteps of Titian, Rubens, and Rembrandt, who painted their most luminous works in their twilight years, she challenged herself and, as she entered her seventies and eighties developed her most personal expressions. The year she turned ninety, the United Nations commissioned her to design the poster for the International Women's Year. If the scintillating "orphic" years 1910 to 1913 were to remain her prime, Portugal an important phase, and the 1937 Expo her monumental period—she never considered the art-deco twenties as capital—the 1950s, 1960s, and 1970s were decades of brilliant, personal triumphs.

Sonia never stopped working, and what she made gave pleasure to an ever-larger number of people. She returned to oils and to large formats and employed a varied palette of subtle colors that adjusted and readjusted the geometrics of broken and interlocking disks. She began new experiments in color and form, and for the first time allowed black to dominate *Colored Rhythms No. 616*, a breakthrough composition for her.

She executed a series of *Colored Rhythms* and huge compositions.

On her canvases, checkerboards break into circles, angles into squares, dark greens play against brilliant yellows, blues and reds against whites and blacks. She turned out exuberant gouaches, tapestries, and illustrations.

She worked with mosaics, designed monumental doors for an auto show, resumed fabric and furniture designs as well as lithography, designed a deck of cards and illustrated new editions of Blaise Cendrars and Tristan Tzara. Her love of poetry deepened.

Finishing a painting was a time full of trauma for Sonia and demanded her deepest concentration. She meditated for hours, sometimes days, before finding the solution that, after the fact, seemed logical but that only she could have discovered.

The pivotal year was 1953, two years after Sidney Janis had surprised her by calling his New York exhibition *Delaunay—Man and Wife*. In that year the Bing Gallery in Paris gave her her first one-woman show since the solo exhibition Willy Uhde had given her in 1907. Her protectors were there for the opening—Jean Cassou and Bernard Dorival from the Musée de l'Art Moderne, Janis, and a new American dealer Rose Fried. Michel Seuphor, Léon Degand, and the rest of the critics, and her friends. Serge Poliakoff stormed forward to kiss her. She was touched and invited him, his wife, and child to Rue Saint-Simon afterward. At the party, Serge pulled out his guitar, and together he and Sonia sang Russian ballads. Everything about Robert's old student pleased her. In her diary she forgave his raspberry-colored shirt. She needed to feel nestled, accepted.

Symbolically, 1953 was the year Robert's remains were laid to rest in the little cemetery in Gambais, with space for her own burial at his side arranged. Brancusi had sculpted the tombstone at war's end, but was too ill himself to attend. So was Arp. After the little ceremony, Sonia went to see Jean in Meudon. They talked about death, about Sophie and Robert. Jean got the idea that the big barn in Gambais should be turned into a museum.

Jean got well again, but Brancusi, suffering from phlebitis, remained increasingly Sonia's burden. In 1951, she had discovered him living in misery, sharing his dusty living space cum toolshed-studio with Istrati, a fellow Rumanian, and this man's wife. Horrified, she alerted Jean Cassou and his new curator, Bernard Dorival. At her instigation the Musée de l'Art Moderne agreed to accept a Brancusi donation in exchange for a modest pension.

The Group from Grasse captivated the public twice in the 1950s, when ten of the Jean and Sophie Arp, Sonia and Magnelli engravings were printed—young painters were fascinated by the collective works—and when the Galerie Bing exhibited the group together.

Sonia was generous to the young. The Istratis, the Poliakoffs, Georges Pillet, and many others were not only invited for Christmas parties, where thoughtful gifts awaited them under the tree, but she also bought their works. She wanted them to learn and understand the Robert Delaunay manner. Ironically, none of them had much talent.

She was also magnanimous toward old rivals. When she learned that Goncharova and Larionov were living in abject poverty in suburban Fontenay aux Roses, she convinced Jean Cassou to buy one of Natalia's paintings. The gesture demanded that Sonia phone the couple. Natalia was overwhelmed. "But that is an act of true friendship," she gasped.

Sonia had never been a "woman's woman," comfortable in feminine collusion, and Goncharova was the only woman artist she respected and, at the time of the Ballets Russes, feared.

Sonia had always refused to exhibit at shows reserved for women. She considered her painting to be anything but feminine. In her view, few women had been out front in the century's forward thrust. Apollinaire had once called Marie Laurencin a "scientific cubist," but to Sonia, Marie was more muse than colleague to Picasso's crowd on the Rue Ravignan. The *Fauves* had no female members, and as far as Sonia could tell, Marianne von Werefkin and Gabrielle Muenter had been part of the Munich avant-garde because their men—Jawlensky and Kandinsky—had been members of the movement. She had never met Paula Modersohn-Becker and the other German expressionists who had worked in isolation, and it was only through Elisabeth Epstein that she knew of the women painters of the short-lived Soviet avant-garde. She never met Dorothea Tanning, Lee Krasner, and Elaine Fried, the painter wives that Max Ernst, Jackson Pollock, and de Kooning brought with them from America, and among the younger generation she had little sympathy for Anna-Eva Bergman, the woman in Hartung's life.

Sonia felt somewhat cheapened when she found out that Sidney

Janis's homage to Robert and her was part of an "Artists: Man and Wife" series, that the New York gallery followed up with Sophie Taeuber and Jean Arp, Dorothea Tanning and Max Ernst, Lee Krasner and Jackson Pollock, Helen Philipps and William Stanley Hayer, and—horrors of horrors—Françoise Gilot and Pablo Picasso.

If there was one younger woman painter Sonia considered a rival it was Maria Viera da Silva, the Portuguese-born abstractionist who had been in Paris since 1927 and studied painting with Léger. Twenty-three years younger than Sonia, Viera da Silva had evolved into an abstract painter who created elaborate linear patterns that seemed based on intricate town plans or the intersecting wires of a suspension bridge. Arpad Szenes, her Hungarian-born painter husband, however, considered Sonia a better painter than his wife, and at gallery openings he never hesitated to tell her so.

When *Combat*, the newspaper founded by Albert Camus, asked Sonia what she thought of women painters, she said, "I don't see any difference. There are good and bad painters, like among the men." She mellowed sufficiently in 1955, however, to agree to be represented in the Delius Gallery's "Great Women Artists" show in New York. When an association of French women painters asked her to take part in a roundtable broadcast, she agreed, saying, "If my name can be of any help." Social conditions might govern the opportunities open to women artists, but wasn't that also true for men?

She believed creativity sprang from deeper, more mysterious sources. Nearly all artists grew in the same manner. Very young, they were more responsive to the world of art than to the world they shared with others. They felt a compelling impulse to paint, though aware that their first works would no doubt be bad. After a period of copying masters, they became aware of the discrepancy between what they were imitating and what would one day be their art. They had glimpses of a new approach, and as they mastered color, drawing, and means of execution, they began to interpret what they painted in new ways. As they aged, they modified and intensified this interpretation. Greatness was not just the result of favorable circumstances. It was an unending self-questioning, an incessant challenging of oneself and one's creation.

The work on the Robert Delaunay inventory took longer than Sonia had imagined. The journal was a continuous notation of her

progress. On Tuesday, November 1, 1949, for example, she wrote: "I've classified the *Disks* until the last ones of 1938. After that I finished off with photos that I assembled the other day. All I've got left to do now is (1) illustrations, (2) theater and film sets, (3) the 1937 Expo. I have classified paintings with paintings so that this catalogue can be used as a basis for Charles or whoever else wants one day to work on [Robert's] *oeuvre*. Little by little I will make fiches this winter and after that it will all be more or less ready, and each time I find a painting or when I have the money to do it, I'll have photographs taken to supplement the catalogue.

"This way one realizes how important and logical the life work is, despite such pranks as *The Kiss* series. Working on all this has restored my balance, relaxed me, and given me back my good mood."

She could congratulate herself on the launching of Robert Delaunay—while Charles and Denise, who made her a grandmother a second time in 1953 when their son Eric was born, hung their heads in shame; they had wanted to sell Robert's art at any price.

From New York, James Sweeney wrote that Robert's *Disks*, the 1913 work, was hanging at the Museum of Modern Art and that Peggy Guggenheim considered her having to sell it one of the tragedies of her life as a collector. As the Galerie Bing closed its Sonia Delaunay show, the Musée de l'Art Moderne opened a "Cubism 1907–1919" exhibition featuring both Robert and Sonia Delaunay. In 1955, the Guggenheim Museum did a Robert Delaunay retrospective, followed by shows in Rome, Milan, Houston, Munich, and, in 1959, a joint Robert and Sonia Delaunay exhibition of 160 works at the Musée de Lyon.

Yet in the face of Nina Kandinsky's success at selling *her* late husband, Sonia faulted herself for not doing better. The Kandinsky Prize galled her. Friends of hers, Antoine Pevsner, G. San Lazarro, the editor of the *XXème Siècle* magazine, were on the jury. Seeing Nina Kandinsky at a Paris gallery opening, dressed like a czarina and floating from group to group, Sonia murmured, "Going out like that with anybody, dressed to the teeth like an icon, she'll end up strangled by some gigolo with her own pearls."

A few years later, Nina was robbed and murdered by a stranger.

* * *

The books came along, too. The biographies planned with Joseph Delteil, Albert Gleizes, and Jean Cassou never happened—Gleizes died in 1953—and the Michel Seuphor project also remained stillborn. The curator Gilles de la Tourette agreed to write a monograph, however, and although the author died before publication, the book did appear.[1] Sonia assembled and classified Robert's often rambling and disjointed writings, and convinced Pierre Francastel, a university professor in aesthetics, to edit and preface the work. Seeing what it entailed for Sonia, Francastel suggested she hire a secretary. She agreed, as long as the secretary was a young man. The first was one of his students, Boris Fraenkel, who would remember his boss serving tea, Russian style, every day when he arrived, and having to walk grandsons Jean-Louis and Eric home, if they came for a visit.

The relationship with her son and her daughter-in-law deteriorated precipitously when Charles demanded those of his father's paintings that belonged to him. Sonia was convinced Denise was behind the requisition, and when Charles asked his mother if she had made a will herself, she became incensed. She would leave nothing to "that woman."

Tristan Tzara introduced Sonia to Leo Matarasso, a stocky lawyer friend of Charles's generation. At their first meeting, Sonia was furious, Matarasso pacifying. She loved to give, she said, but hated to be forced to give.

"I refuse to see our life's work fall into mercenary hands," she said. Telling him of the arrangement she had made for Brancusi, she added, "I'd rather give it all to the state!"

The lawyer tried to make her admit there were laws of inheritance that would come into play. Perhaps he should talk to the son. Sonia asked if she couldn't skip a generation and leave whatever the law required her to leave to the grandsons.

The family drama would last another twenty years.

Jean-Louis was eleven, Eric eight in 1958 when Sonia decided they should spend the month of August every year in her company. Charles and Denise acquiesced, perhaps thinking it would soften a grandmother's heart.

309

The boys' vacation began at Old England, a haberdasher on Boulevard Haussmann where Robert once had outfitted himself. Jean-Louis would recall trying on blazers with silver buttons, flannel shorts, and wincing when the salesman called him his "little model." Eric would remember it was all "très British," and that he and his brother were never asked what they thought.

Traveling with Anne-Marie Mayer, Sonia's more recent secretary, and a tutor for Eric, grandmother and grandsons took the plane to Zurich. There Monsieur Voegeli, the director of the Park-Hotel in Brunnen on the Vierwaldstaetter Lake, waited with his Oldsmobile, a car with a two-toned horn.

Voegeli took the boys to see an enactment of the William Tell legend while Sonia worked on the hotel terrace.

"I've done two engravings," she announced when they returned.

Jean-Louis preferred the tennis lessons, Eric the antique wooden streetcar and lake excursions aboard a paddle boat. The vacations included shopping trips to Lucerne and excursions to Italy.

The summer ritual ended, as Dominique Desanti would write, "when a refusal by Jean-Louis led his kid brother to say he also 'preferred' to spend the holidays with his parents, acts which in Sonia triggered a Russian drama halfway between Chekhov and Dostoevsky."[2]

Charles was going on fifty, and after twenty-five years of concerts, road tour management, broadcasting, amateur competition, magazine writing, and publishing, he had found his niche in the record business. The label was Vogue and its bestselling star Sidney Bechet, the trumpet player Charles brought over in 1949 to headline the Second Paris Jazz Festival with Charlie Parker. Bechet stayed in France and, with Charles as his manager, made a recording of *Petite Fleur* that cast a spell of jukebox melancholy on a European postwar generation. Cities from Cannes to Knokke-le-Zoute in Belgium asked Charles to organize jazz festivals. For his 1958 Cannes jamboree, he brought to Europe John Lewis's Modern Jazz Quartet (Lewis thanked him with a composition entitled *Delaunay's Dilemma*), Coleman Hawkins, Bill Coleman, Roy Eldridge, Dizzy Gillespie, Ella Fitzgerald, and Sarah Vaughan.

By the late-1950s Sonia totally loathed her daughter-in-law and called her a liar in her diary. When Jean-Louis was sent to a boarding

school, Sonia imagined it her duty to save Eric from parental turmoil. The twelve-year-old came to live with her.

It didn't last long, but Eric would remember it as a time of comfort and boredom. His grandmother had him taken to and from school in a taxi, and forced him to eat copious slices of veal liver. Grooming him to be a painter, she took him to her gallery openings, exhibitions, had him "absorb" whatever he could of her art talks. She asked René Massat to be the boy's tutor.

Eric thought his grandmother's friends were phonies. Some of them thought he was an obstinate brat. Jacques Damase, who met Sonia in 1964 when he was a free-lance magazine art director for the Conde Nast group, would remember Sonia telling him about her grandchildren pointing to paintings in Rue Saint-Simon and crying, "I want that!" and "That's gonna be mine, mine, mine."

The inability of French politicians either to wage war or to make peace in colonial Algeria brought Charles de Gaulle to power in 1958, and with him, as minister of information, André Malraux.

The fifty-six-year-old intense, pale, and electric Malraux was the most dazzling star in the new government. His department was soon enlarged and given the more sonorous title Ministry of Cultural Affairs, a name more in tune with the Gaullian concept of France's grandeur and civilizing mission. For the next decade, this revolutionary activist, novelist, essayist, editor, and art philosopher, whom Sonia had first met at one of Clair and Ivan Goll's "Sundays" in 1921, tasted what few intellectuals ever come to enjoy—the power to experiment with culture.

Malraux sent the Louvre treasures on globetrotting tours and scraped centuries of grime off Paris landmarks. He initiated an unprecedented inventory of France's artistic legacy, started new archeological reserves, commissioned Marc Chagall to paint the Opéra ceiling and Coco Chanel to decorate a wing of the Louvre, and flew off himself to be the darling of the arts-conscious Jacqueline and John Kennedy in the Washington White House. He celebrated Picasso's eighty-fifth birthday with a huge one-man show at the Grand Palais, tried to make the Bateau Lavoir where Picasso and Fernande had lived and loved and celebrated Douanier Rousseau's birthday an historic

landmark, and gave Braque a state funeral in the inner court of the Louvre.

The accomplishment he himself put above all others was the founding of the *maisons de culture*, on which he spent a good part of his budget every year. These multimedia art centers, erected in Grenoble and seven other provincial cities, were inspired by ideals from the years of the *Front Populaire* and revolutionary Spain. At these centers, Malraux invited people to create themselves. Here, he wanted not only to extend Parisian standards of excellence, but to foster a cross-pollination of the arts by combining facilities for drama, music, film, and exhibitions. Convinced that modern consumer society was profoundly anticultural, that an intellectual elite had ample access to the highest quality of art while the masses were flooded with trash, he wanted people's rights to public education extended to include a fundamental right to access to theaters and museums.

Sonia turned seventy-five in 1960, and her awareness and dread of aging made her decide to donate most of Robert's and her art to the government. She had been going to too many funerals—for Brancusi and Colette Allendy, and for Cendrars who, when she saw him the last time in his bed, called her "Sonnichka." There were moments when she resented the survivors in their eighties. She found it depressing to run into Max Ernst and Leopold Survage at gallery functions. Even people younger than she could fill her with foreboding. Seeing Felix Aublet, the young collaborator from the 1937 Expo, walk with a cane horrified her. After seeing Charles and Denise in Gambais she noted that she had found them "terribly old." To friends she called Charles "my grandpa."

In preparation for the donation, Sonia pulled out all her paintings that were still in her possession. Her self-scrutiny was merciless. "Nothing satisfies me," she noted in the diary. "I find the last canvases incomplete. One should be able to work like in Portugal, melt into the canvas, but waking up is tough. I've decided to redo on canvas an old gouache and to flank it with two gouaches. That will make a wall holding up with the rest."

A German playing-card museum provided a happy distraction—a proposal that she design a deck of cards. If the result was interesting, the Deutsche Spielkarten Museum in Bielefeld would commercialize the deck. Sonia had toyed with the idea in her youth and threw herself into the project with enthusiasm. Her numbered cards were tradi-

tional, hand-painted hearts, clubs, spades, and diamonds, but her face cards were joyously colorful quasi-abstractions. Her kings were squares with hints of crowned heads, her queens S-shaped diagonals topped by diamond-shaped heads, and the jacks mixtures of disks and angles.

Together with Le Corbusier, Hartung, and Pierre Soulages, Sonia got the idea of proposing a new museum of modern art. Malraux agreed to see them.

The Ministry of Culture was on the Rue de Valois on the site of a palace once occupied by Cardinal Richelieu. Visitors were greeted by mirrors, tapestries, gold-and-white paneling, and an air of religious decorum.

Malraux listened to their plans, raised an eyebrow at Le Corbusier's idea that the Victorian Grand Palais off the Champs Elysées be demolished. The minister knew how to deal with volatile artistic temperaments and mercurial egos and stalled for time. He preferred to talk about Cendrars, he said, agreeing with Sonia that Blaise was perhaps more remarkable than Apollinaire.

"I quote you a lot," he told her.

She came away convinced that when it came to writing about her and Robert's "poetic years," only Malraux could do justice. She decided to approach Malraux about writing the long-desired book about Robert's work. She wrote a letter to him, saying she had collected and collated all the necessary documents. Politely, he refused. "All I get to write now are speeches and signatures."

Sonia acquired new friends. Pierre and Annick Beres were a wealthy young couple with an apartment on Avenue Foch and a country home in Adamville, a few hours from Paris. A week after meeting Sonia, the art editor and collector drove her to the country to meet his wife and teenage daughters, whom Sonia found adorable. The ride through a gorgeous September landscape included a stopover at the Gambais cemetery. Sonia found Robert's grave handsomely maintained, and found her hostility toward her son melt a little. "Charles takes care of the grave," she noted in the journal. "That way you have a feeling Robert is a bit with us." Over the next years, she would make other trips to Adamville and become a familiar figure at Bereses' townhouse-museum.

She spent Christmas in Holland with Henck and Gina de Leeuw,

the son and daughter-in-law of her one-time admirer and fabric buyer. Gina was convinced the only reason Sonia liked her was because she worked. Their daughter Josephine was a student in Paris, and whenever she visited Rue Saint-Simon was asked, "And how's work?"

Work and competence were the only qualities Sonia respected. She was politely indifferent to VIPs and beautiful people. Whether a person was an ambassador or a cleaning woman made no difference to her as long as he or she did the job right. What she found shocking in this world was injustice and mediocrity.

What she loved in abstract art was its clear feelings, its exacting sensibility. The Denise René Gallery showed forty-three recent Sonia Delaunay gouaches in 1962. The compositions were variations on a theme, swirls and undulations, squares and diamonds, disks, triangles and rectangles, and half-moons in rhythms of color. The paintings, which barely had titles—*Colored Rhythms No. 698* (1958), *Rhythm-Color No. 894* (1959–60), *Rhythm-Color No. 959* (1962)—summed up her artistic vital pulse. To coincide with the show, the gallery published a selection of poems by Rimbaud, Mallarmé, Cendrars, Delteil, Soupault, and Tzara illustrated by Sonia. During the summer, Sonia was in Germany and Austria, for the opening of shows representing the "generation" of 1912 in Cologne, contemporary painters in Essen, and "Art from 1900 to Today" in Vienna.

Without capitulating to his mother, Charles agreed in 1963 that they should give the bulk of Robert's and her art to the Musée de l'Art Moderne. He still wanted a number of his father's paintings and still asked his mother about her will—a question she continued to find offensive and refused to answer, and Matarasso tried to convince her she had no choice but to comply with her son's wishes.

"It's the law," the lawyer sighed. "You cannot disinherit him, Sonia."

The legacy was enormous. In all, 117 pieces by Robert and Sonia Delaunay were given to the state. Jean Cassou had little difficulty convincing his boss, Malraux, to exhibit the donation in the Louvre. Cassou wrote the catalog text, Malraux gave the inaugural address, and Sonia felt she had finally achieved recognition for Robert. Newspaper accounts chose to highlight the fact that she was the first living woman painter to be exhibited at the Louvre.

On January 12, 1965, she was invited to the Elysée Palace. Charles and Yvonne De Gaulle greeted the guests together with Malraux. The head of state thanked her for the donation; Malraux smiled.

Inside, Sonia met Alexander Calder and embraced him, calling his mobiles "color, dynamics, life!" Ida Chagall, Marc's daughter, was also there. At a buffet Sonia came upon Arp and Soulages. Dina Vierny, once immortalized in bronze by Maillol, was there, and together the two hefty émigrés from St. Petersburg tasted the presidential cuisine. The two friends agreed that only art was more important than delicious food, and took each other to lunch on occasion.

In her diary that night Sonia noted the emotions she experienced when de Gaulle thanked her. "I mumbled something," she wrote. "I was struck by the serenity and handsomeness of the man. She, too, had a pretty smile. Not pretentious at all."

For her eightieth birthday the following November 15, Alberto and Suzi Magnelli and Nellie van Doesburg insisted on giving her a party at her favorite restaurant. Birthdays were better forgotten at her age, she said; she wasn't in the mood for celebrations. But when they persisted, she agreed to come. Over the champagne, Alberto managed to make her laugh, but she forgot to open her present.

34

Midnight Sunrise

Catherine of Russia had Prince Grigori Potemkin as her *éminence grise*, lover, favorite, and escort for seventeen years; Sonia Delaunay had Jacques Damase for sixteen. Catherine the Great bestowed on Potemkin the highest honors and allowed him to become the most powerful man in the empire. Sonia made Damase her spiritual son and, in return for the sixteen years of servitude, he became the wealthy executor of her will and guardian of her artistic afterlife.

Sonia was, at eighty, an arresting presence. Under her rinse-tinted and perfectly coiffed gray hair, her forceful face was dominated by her prominent nose. There were rings under her eyes and lumps under her chin, but her gaze was direct, without excuse or self-pity. Her much-freckled hands were chubby, but in the presence of a paint brush they became as agile as those of a woman half her age. There was something imperial about her, something forbidding that she would catch others reacting to with smiles that soon froze, a liveliness that turned to reserve—something she wished wasn't there.

The infirmities of age were limited to rheumatoid arthritis that caused a sometimes painful swelling of hands and feet. She was spared

the gout and gallstones that weakened the eighty-nine-year-old Michelangelo, the loss of eyesight that assailed the aging Degas and Mary Cassatt, the trembling hands with which the octogenarian Goya drew his last torture scenes, and the bitter despair that made the ninety-year-old Titian paint himself as an ancient goblin.

She was not easy to deal with. Her mistrust of people became more pronounced, and Charles found her increasingly tyrannical. She had asked him on several occasions to help her manage her affairs. Convinced it would never work, he begged off. His new job at Vogue Records made him move himself and his family to Villetaneuse, a distant and dreary new suburb where the record company had relocated its administrative and production activities.

When Damase first met Sonia, he was a thirty-five-year-old journalist, publisher of art books, and habitué in the world of interior decorating, fashion, and jewelry, who believed in renewal, surprise, danger, liberty, and beauty for its own sake. A native of Brittany, he was a man of multiple characters and of many worlds: an intimate of Paris's jet set and a friend of Yves Saint Laurent, Rudolf Nureyev, their "queen bee" Helen de Rothschild, and the Proustian coterie of elegant and bright young men and women whose charm combined elegant despair with attractive self-mockery.

The occasion for their meeting was an interview for *House and Garden* magazine regarding her fashion years. In the course of their conversation, Damase discovered that not even a monograph existed on her. He also felt that she was rather lonely in her world of art.

After the piece appeared, Sonia sent him a thank-you note and invited him for tea. It was at the inauguration of the Chagall ceiling at the Opéra, however, that they met again. She was not impressed by the lofty mural. She thought Chagall was repeating himself, and she was beginning to admire Picasso because he at least continued to renew himself. Instead of tea at Rue Saint-Simon, Damase took Sonia to see friends who had an apartment on one of the Left Bank quays, people who had known Robert and Sonia on the Riviera in 1940. On a wall in the living room, Sonia discovered one of her gouaches, elegantly mounted and hung for exquisite effect. Driving her home later, Damase told her how he had published his first book when he was eighteen with money sent to him by his American godmother.

He had a knack for choosing type and paper and for doing layouts, and over the last ten years had brought out *éditions de luxe* and art books on folk songs, the Ballets Russes, and Braque, and had published texts by Sartre, illustrated by Wols, and music by Joe Bousquet with sketches by Ernst.

At her door, he asked her bluntly if she would like to do the lithos on a book that he would write and publish. She said yes. It would be fun to do big gouaches and see them united with handsome type. It was a throwback to the time of *La Prose du Transsibérien*.

Sonia asked Damase to come travel with her.

Their first trip was to London in January 1966 for the opening of a "Sonia Delaunay" exhibition from the Gimpel & Hanover Galerie in Zurich. The suite reserved for her at the Grosvenor Hotel was beautiful; the flowers from Pierre Gimpel, the Anglo-French gallery director, rivaled those from Damase. The Tate was showing Peggy Guggenheim's entire collection, and Norman Reed, the Tate director, and Peggy came for tea together with the Gimpel people.

The weather was wintry and foggy, and the next day Damase insisted on taking Sonia to the docklands to see a purple Turneresque sun set over the misty Thames. She had not been in London since Willy and she had married at the Holborn registrar's office sixty years ago. Here she was again with a man who, all age differences aside, would never desire her in the flesh either. Yet she felt her escort was a kindred spirit and confided to her diary, "It is curious how Damase's sensitivity is close to mine, that in this area he understands me like no one else. We are on an equal footing, and he interprets me very well."

The trip and her new companion made her want to paint. "Jacques' great sensitivity fits in with mine," she noted in her diary February 27, 1965. "I have never before found this feeling and compassion in anyone else, and I missed it all my life. This somewhat cerebral hypersensitivity translates, in my case, into painting. I told him that it was this that brought me close to him, that there was in all this an ethereal enjoyment which propels toward creativity and everything else toward void and destruction."

They had terrible rows and tender reconciliations, moments when no epithet was too coarse, moments when she called him her third grandson. Her journal traced the ups and downs of the relationship. She admitted that the private life of a thirty-five-year-old man was

none of the business of an octogenarian woman, yet she tried to make him live his life according to her cadence. Over the decade, the Parisian art world would witness the svengali kowtowing to his lady, but also her tearfully begging him not to go away.

When it was all over, he would say he had been there for her—at her disposal "day and night, for sixteen years."

Charles was less than thrilled with the appearance of Damase, and with his mother's infatuation with this knight-servant. Sonia reminded Charles that she had asked Damase to help with her affairs, and now accused him of wanting her ruin. As if to spite the son, Damase encouraged Sonia to spend money on herself. She became a client of the Chanel and Patou couture houses and had her hair done by Carita. She chose her gloves at Hermès and shopped for her food at Fauchon's.

"Age made it difficult for her to move around and, finding taxis too uncomfortable, she rented limousines for morning rides through the Bois de Boulogne," Charles would remember.

Denise found the soft spot in her mother-in-law's armor and refused to let Eric visit her. Sonia cried that they were taking away her grandson. Leo Matarasso was called in to intercede. The result was that Eric could visit again, but that Sonia would have to pay for his transportation. Turning eighteen, Jean-Louis had had enough of the family quarrels and, for a few years, disappeared into the Left Bank subculture, to reappear as a sound engineer.

The Damase-Delaunay book, *Rythmes-Couleurs*, appeared in March 1966, a selection of poems by Damase illustrated with eleven of Sonia's *pochoir* prints, presented in a dazzling layout of fonts and colors. Malraux had just received the copy she had sent to him when she saw him at the ministry. The new museum of modern art project was the reason for the meeting and Malraux could report that he had talked to the city council about eventually locating the museum in the Bois de Boulogne. Soon, they were talking art and poetry—when she mentioned Tzara, he again said only Cendrars was worth considering. Malraux showed her a collection of Chinese engravings he had just brought back from his secret mission to Mao Ze-dong on behalf of President Lyndon Johnson and American peace overtures in Vietnam. Before she left, he gave her the three engravings she liked most.

Malraux, who considered Picasso the greatest living artist and the audacities of Picasso, Braque, Léger, and Gris the high point of the century's vanguard, suggested a major Sonia Delaunay retrospective. The idea almost backfired when she was asked to submit to a television profile. The TV director asked her to stand on an apple box next to a photo while her interviewer started asking her what she thought of Picasso. Angry at being cornered and feeling unprepared, she said Picasso represented a destructive period and that he was responsible for all the horrors that young painters were doing nowadays. Robert and she represented intelligibility, and what she and her husband painted was experiences they had lived. She had not made "simultaneous" dresses in order to be a center of attraction. "I did it to please *us*," she said.

Sonia got a commission to decorate a church—and to trim a sports car. In his late eighties, Matisse had decorated a chapel in Vence, the small hill town above Cannes where he lived for most of his last years, and at seventy-five Chagall did stained-glass windows for the Metz Cathedral. Sonia's church was in Montpézat en Quercy, a hamlet 50 kilometers north of Grisolles where she had spent the last months of the war. The car was a racy Matra B530, decorated as part of a benefit exhibition for medical research. Her color squares, less dense than in her 1925 Citroën B12, were in hues of blue, with red rectangles covering the retractable headlights.

Damase was more than a cheap con worming himself into a dowager's confidence with flattery and pretense. He not only worked doggedly to expand her renown, he made suggestions in the area that interested her most—her art. His fine-tuned ear and eye recognized the contemporary chord in her style. His vantage point was the intersection of avant-garde publishing, advertising, and trendy journalism, his milieu the cutting edge of fashion, and his friends the big names who didn't so much invent novelty as launch it.

Youth was openly displaying its strength, allure, and power. Society was becoming kinetic and impermanent; pop art was the great way of being new. Courrèges introduced the new space age to fashion, Mary Quant the miniskirt, and Saint Laurent made a worldwide hit with his Mondrian Look. Damase saw that the pop- and op-art clothes the young women were wearing were subjective playbacks of Sonia's

"simultaneous" radiance, her sharp geometric shapes, and electrified color surfaces of forty years ago. His choice of one of her 1929 textiles for the poster art for a 1973 New York showing of her tapestry designs, for example, made him suggest that she take up her late 1920s black-and-white designs. He found several of these motifs to be "optical art" before its time, early versions of the graphics that were now making Vasarely's reputation.

Throughout the decade, Damase actively promoted Sonia Delaunay. Together they traveled to Milan and Lisbon, Cologne and Brussels, Geneva and Zurich. They went with Philip Johnson to Bielefeld for the laying of the first brick of the American architect's first museum—but he had nothing to do with the big Sonia Delaunay retrospective that the Musée de l'Art Moderne accorded her in 1967.

The apotheosis came November 28, 1967, two weeks after Sonia's eighty-second birthday. Bernard Dorival had supervised the installation by Michel Hoog, curator of the Louvre's Orangerie and Jeu de Paume divisions, and finally the author of Robert's *catalogue raisonné*. To coincide with the exhibition, Hoog published a book on the Delaunays.[1]

Sonia had designed her own poster and invitations, and on the eve of the inauguration she was still painting her last contribution. Edgar Pillet and his girlfriend found her in Rue Saint-Simon finishing a big gouache.

"But Sonia, if you fall?" the girlfriend cried out when she spotted Sonia atop a stepladder.

"And why should I fall?" asked the painter.

Employees from the museum came to pick up the still wet gouache.

The exhibition featured her paintings in chronological order, starting with her *Fauves* signed Sonia Terk, *Philomène*, the portraits of the poet Chuiko. They were followed by the *Transsibérien*, the *Electric Prisms*, and the huge *Bal Bullier*. Walking through the exhibition just before Malraux arrived for the official opening, Sonia found the Portuguese years "strong and human," the group from the Grasse period and postwar work "less well defined." And her general impression?

"It's warm, human, very much 'today,' " was her verdict.

Malraux took his time looking at the mock-up of the Matra automobile at the entrance. Dorival conducted the ministerial tour. Old friends and rivals followed: Henck and Gina de Leeuw, Pierre Gimpel from London, the Seuphors, Denise René, Dina Vierny, the Hartungs, the Soulages, Istrati and his wife, and Viera da Silva and her husband. The press coverage included television and a correspondent from Tass, a man she found to be no ideologue, simply "very Russian and sympathetic."

Half mockingly, she was called the czarina, and she sensed a need to sum herself up. "I have had three lives," she wrote in the diary. "One for Robert, one for my son and grandsons, and one, all too short, for myself."

She hated pretense, and had little tolerance for women who affected to be younger than they were. Seeing Nina Kandinsky and Claire Goll, her friend from the early 1920s, show off with men young enough to be their grandsons, she told herself in the diary, "Make sure you don't come out looking ridiculous yourself, at your age." She was perspicacious enough to see the damper her presence tended to put on younger people. At the Venice Biennale one night she happened upon Denise René and a tableful of artists on a café terrace. Seeing her heading in their direction, the boisterous group stopped laughing and made an effort to regain a serious composure. In the journal that night she wrote, "For someone who likes a laugh, I guess I'm not very funny."

True art was a living thing, something new that its maker expressed almost organically. Artistic freedom was just that—freedom from whatever constraints might detour an artist from a personal goal. "Among sculptors as among painters there are people who start out artists and end up businessmen."

Yes, abstract art *is* difficult. It demands that both artist and spectator use their heads. It is so much easier to refer to the appearances of reality than to make up a new world in one fell swoop. And since the art world has so few experienced and strict connoisseurs, a lot of people imagine that nonfigurative art is devoid of reference points, without checks. Craftsmanship is replaced by effects, and what you are looking at is more or less successful publicity displays. Abstract art also has its learned clerks, borrowers of the personal means of others, dispensers of prefab formulas.

"I'm not sure I can define my painting, and that's all right, too,

because I distrust classifications and systems. How can you—and why should you—explain and interpret what came out of your guts. In most recent research I have the feeling that I'm getting very close to what Robert had a foreboding of, what was the solar source of his work. I still come up against black details, but I'm sure that, beyond it, lies something fundamental which will one day be the basis of the painting of tomorrow. The sun rises at midnight."

35

Endgames

Sonia lived nearly another decade, and was celebrated for her visual exuberance, inventiveness and feeling for fantasy, quarreling and reconciling with Damase, fighting over the inheritance with Charles, and traveling to be discovered—and rediscovered. Her work was widely admired, and she became an object of wonder and pilgrimage. She knew how to bring people and events of a now-legendary era to life in a vivid and unsentimental way. As a friend, and as a source of ideas, she never went out of style, and until she broke a thighbone at the age of ninety-two, she displayed an inexhaustible vitality. Fame allowed her to experiment with tapestry, achieving something nearly comparable to Matisse's cut-paper compositions of his last years—to break down the distinction between fine and applied art.

The diary was quietly abandoned, and only Charles, the grandsons, Damase, and a handful of faithful friends were allowed to visit Rue Saint-Simon, where arthritis and the strains of nearly a century weighed down the irreducible Sonia.

Eric wanted to become a painter, and when he brought his grand-

mother his first painting, she cried with joy. "My grandson is a painter."

When he began painting expressionist canvases, his grandmother was perplexed. "Expressionism was a passage," she told him, "before the First World War."

He persisted in believing that the true goal of art was to render emotions and feelings directly. In 1978, they confronted a new point of contention—the name Delaunay. If he wanted to become a professional painter, she told him, he'd have to use a pseudonym.

"Why?" he asked. "It's my name."

"In the art world, it's Robert and I who gave the name a meaning."

"Still, it's my name," he insisted.

She never doubted that the name Delaunay belonged to the very first ranks of the century's artists. Others might consider the Delaunays—along with Albert Gleizes, Jean Metzinger, Francis Picabia, and André Lhote—the lesser talents of the heady and contentious years before the First World War. She, however, was certain that Robert, if not herself, had tackled with originality such key questions of cubism as the conflict of volume and color.

Robert had been influenced by the neoimpressionists and absorbed Cézanne's lesson; the twin powers of Gauguin and Van Gogh had carried her toward a fierce and color-saturated fauvism. Her unswerving passion for pure colors swayed her husband during the pivotal pre-World War I years when he was a pioneer in abstract painting, and their friend Apollinaire attempted to create labels for him: "orphic painter" and "heretic of cubism." Although Sonia didn't hesitate to extend "simultaneity" to fabrics, embroidery, bookbinding, and fashion, she, too, painted her masterpieces, *Le Bal Bullier* and the *Electric Prisms* series, during those years while at the same time attempting a passionate synthesis of poetry and painting with her illustrations of Cendrar's *Transsiberian Prose*.

She would never admit that Robert was an artist who peaked early, that he suffered a burnout after their Iberian period, that, with the exception of such admirable compositions as the *Cardiff Team* and *Coureurs* series, the 1920s were for him a decade of hesitation during which he perfected his vocabulary without making any progress. The decade made her famous as a fashion leader. Perhaps to "match" her

husband's evolutionary deadlock, she later dismissed her roaring twenties as a time of "doing scales." Posterity would see her decade of versatility as prime, as a time when she applied the principles of abstraction to functional objects, to the life around her.

Robert's second burst of creativity began in 1930 with his total conversion to abstract art, his amateurish-looking research into *Rhythms*, and it continued until the monumental 1937 Expo murals. Very precocious, but dead prematurely, Robert never lived to experience the self-assurance and mastery that gave Matisse a fresh flowering in old age. Sonia did. After Robert's death in 1941, she emerged—not "better" but "different"—in tune with the times. She continued Robert's and her joint quest for the holy grail of color as the absolute of painting, the supreme referee that allows a new positive interpretation of space and the dynamics of matter in accordance with contemporary science.

Critics saw her as a "shaper" of modern life, although perhaps not of the stature and power of the Bauhaus architects, Kandinsky and Klee. Yet her influence was totally absorbed. Young women in multicolored clothing at the wheels of yellow and vermillion cars thought they had rejected their mother's fashions—unaware that they dressed in a fashion launched by a woman for whom, in 1913, color was already the fabric of the world, who from that fabric fashioned her own piece of happiness.

When Henri Terk raised investment capital in London for the forest and oil explorations in the czar's farflung empire, he had known Calouste Gulbenkian. Now, the millions that the extraordinary Armenian had left his last adopted country helped make Henri's adopted daughter famous in Portugal and brought her back to Lisbon and Vila do Condo. The famous "Mr. Five Percent" of the Middle East oil riches had put together the greatest accumulation of Chinese art outside China, and started a western collection with the acquisition of Ruben's fantastic painting of a black servant holding an umbrella over a woman's head, and portraits by Gainsborough, Manet, Monet, and Renoir. When he died in Lisbon in 1955, he left the bulk of his vast fortune and art collection to a charitable foundation.

His son Nubar brought Sonia to Lisbon in April 1972 for a show that the Gulbenkian Foundation gallantly called "Robert, Sonia De-

launay and their Portuguese Friends." The friends were of course Eduardo Vianna, Amadeu de Souza-Cardoso, José Pacheco, and José de
Almada-Negreiros—all of them long since dead—but new Portuguese
friends took her back to the places Robert and she had once known.
In Vila do Conde they showed her the plaque commemorating the
Delaunays' sojourn in the house in Rua dos Banhos, the aqueduct
with its 999 arches, and the square where market women still disappeared behind mountains of pumpkins and vegetables.

Sonia loved the attention and the Gulbenkian Foundation exhibition. She gave an oral history of the period, and donated and
authorized the publication of her correspondence with Vianna, Souza-
Cardoso, Pacheco, and Almada-Negreiros. The correspondence included Souza-Cardoso's telegrams and letters when Robert was immobilized at the French consulate in the Spanish frontier town of
Vigo, when Portuguese counterintelligence suspected her of being
another Mata Hari.

After Portugal, German art lovers and scholars rediscovered a
rich lode of the glory days of expressionism, with her memories of
Schoenberg in Karlsruhe, Kandinsky and Macke in Munich and Paris,
and Liebermann in Berlin. She was in Berlin for a Nationalgalerie
homage to Schoenberg and in Cologne for the inauguration of the
Wallraf-Richartz Museum, suffering a thousand arthritic tortures but
walking like a queen to the podium to receive a medal.

She loved Italy and its humanity, the great Renaissance painters
Tintoretto, Titian, Carpaccio, and the people in the street. She exhibited in Rome, in Milan, in Genoa, and, in her favorite city, Venice.
She had been Signorina Terk the first time she saw the Piazza San
Marco and the canals. Now she came to be feted as an octogenarian,
to stay at the Gritti, and to have pigeons and balloons released in her
honor from the square. Damase would remember how a Milanese
collector and race horse owner named a filly after Sonia, and the
painter, the eternal young woman from St. Petersburg smiled and
acquiesced.

Sonia never got to America, but her art did. Occasions were
missed as far back as an invitation to New York World's Fair in 1939,
the Guggenheim Foundation's wartime efforts, and, more recently,
Sidney Janis' entreaties that she come for a Sonia Delaunay show.
When President Georges Pompidou visited Richard Nixon in Washington in 1970, he gave him, in the name of France, a painting by

Sonia. The painting, *Rhythm-Color No. 1633*, ended up in the National Gallery in Washington. Four years later, the Guggenheim begged her to come to its big summer exhibition of modern masters —Picasso, Léger, Brancusi, Chagall, Mondrian, Klee, Kandinsky, Delaunay, and Franz Marc.

Sonia's ninetieth birthday, in 1975, was marked by a French Legion of Honor, a poster for UNESCO's Year of the Woman, a homage at the Musée National d'Art Moderne, a private showing at the gallery of her old friend Denise René, a French television special, and a number of foreign TV interviews.

Was she touched by the acclaim?

"Everything I've done, I've had fun doing."

The celebrations of the International Year of the Woman in 1975 brought questions of her "liberation." She refused to be interviewed by feminist magazines and wanted to hear no talk of "women painters." "I know only painters—and they may be either men or women," she said. "The only liberation I ever took an interest in was the liberation of color."

Françoise Giroud, the secretary of state for women's affairs, paid tribute, calling Sonia "a dazzling creative force, rediscovered and found to be in vibrant harmony with our times." Damase published Giroud's text, together with words of praise from Calder, Kijno, and Viera da Silva, and called it *Sonia Delaunay, the 90th Birthday*.[1]

Although Sonia no longer liked to show her face on the screen, Damase persuaded her to sit still for a filmed interview with his filmmaker friend Patrick Raynaud. The result was a surprisingly candid and droll first-person retelling of her life. Damase turned transcripts from the soundtrack into *Nous Irons jusqu'au Soleil*, a slapped-together Sonia Delaunay "autobiography" that he would admit was less than satisfactory.[2]

At ninety-four, she stood aside to let Robert Delaunay shine alone. André Malraux was no longer minister of cultural affairs, and his successor suggested first the Petit Palais and then the Grand Palais for a big Robert Delaunay retrospective. She refused and was finally granted the Orangerie, in the Tuilerie Garden, which was, until the opening of the Centre National d'Art et de Cultures Georges Pompidou in 1977, the government's most hallowed exhibition site.

Sonia lived to see her permanent place in the Beaubourg, or Pompidou Center, the striking machinelike structure on the fringe of the historic Marais area of Paris.

There she was in history, embodied in the most powerful painting of her youth, *The Young Finnish Girl*. The pubescent maid from Sonia's adolescence and early womanhood illuminated the wall with her riot of primate yellows and reds, greens and aquamarine. She was flanked by Alberto Magnelli's intense, Braque-like 1914 *Workman on His Cart*, and Frantisek Kupka's evanescent female silhouette from 1910 simply called *Color Planes*. Across from them hung Mikhail Larionov's 1911 *Autumn*, Ernst Ludwig Kirchner's 1913 *Couples*, and Emil Nolde's 1914 *Still Life with Dancers*.

The Musée de l'Art Moderne, somewhat neglected by successive French governments since the opening of the Pompidou and the still newer Musée d'Orsay, housed but did not display the ensemble of its Robert and Sonia Delaunay collection. The huge murals from the 1937 Expo, however, hung at the entrance.

For a king's ransom, the Tokyo Museum of Modern Art bought Robert's *Helix* from 1923. Sonia handled the sale and agreed to an important Robert-Sonia Delaunay show in Tokyo in 1979. In the meantime, the Gallery Artcurial launched a "simultané" revival, and at ninety-two Sonia started working in ceramics. As she had done with Robert's and her art, she donated her diary, scrapbooks, letters, memorabilia, and documents to the French government, in this case the Bibliothèque Nationale. Florence Callu, the conservator, allowed Charles, who said he had never read his mother's journal, to take part of the journal home for his perusal. To the National Library's acute embarrassment, parts were never returned, apparently misplaced by Eric. "He is hard to communicate with," Callu would say.

The fracture of her femur was serious. The accident happened at home January 13, 1978, and as paramedics lowered her to the street in the narrow elevator, she asked, "But will the hairdresser come to the hospital?"

The doctors did not like what they saw on the x-rays. Because of her age, they decided not to operate. Henceforth, they told her, she would have to live with a wheelchair and hire a daytime nurse. Not that it slowed her down mentally. In the spring, she created,

with the filmmaker Raynaud, the costumes for a Comédie Française production of Pirandello's *Six Characters in Search of an Author*. For a summer festival in Basel, she painted a series of gouaches that stunned critics with their youthful character. She designed Christmas cards for former First Lady Claude Pompidou.

She contributed works and documents to the Pompidou Center's huge Paris-Berlin show, and impertinent comments when Albert Speer, Hitler's architect and later his minister of armaments, was included and Arnold Breker banned. Film of Hitler addressing his hypnotic rallies in Speer's Nuremberg Stadium, drawings of Speer's Berlin Dome, and a Doric wedding cake meant to serve 130,000 Nazi party members for ceremonies, went on display as examples of "the faces of power," whereas Breker's 1930s sculptures, hidden since the war in museum warehouses in Cologne as "involuntary acquisitions," were considered too embarrassing to show. Sonia called Dina Vierny and asked her friend to speak up for the sculptor who had saved Dina from the concentration camps. Vierny answered that she didn't have the courage.

Damase published *Noirs et Blancs*, an album of Sonia's drawings, stretching from her studies in Karlsruhe in 1905 to her latest essays seventy years later, and including her 1925 fabric designs. Artcurial organized a show of a number of these drawings, and in the early fall Sonia had herself wheeled to the opening.

The Tokyo museum sent her a copy of the catalog for the upcoming exhibition. She leafed through it with tender admiration. The reproductions were so beautiful, she told Damase. She thought of Robert and his premonition of fame to come. "You will see," he had always said. Thirty-seven years had passed since he died, and every year on the anniversary she visited the grave in Gambais. Would she make it this October 24?

She did.

Three weeks later she inaugurated a Pompidou Center homage to Damase and his thirty years in art book publishing. She designed the poster for the show, and Louis Aragon wrote the homage to the forty-eight-year-old editor and publisher. Albert Skira might be more famous and the house of Rizzoli a greater commercial success, but Damase's passion for the printed page was unequaled. He had written sixteen art books, published another sixty, and branched into litho-

graph printing. He had become a gallery owner, a talent scout, and an organizer of exhibitions.

When he was eighteen, fate, he believed, had allowed him to spend his American godmother's money on publishing a book. He considered meeting Sonia fourteen years later a second stroke of luck, and called their relationship an uncommon love affair. To him, she was a woman who dominated the contemporary art scene in France.

To anyone who would listen he said that a mistaken perspective had put her in the shadow of her husband when in reality her life offered the most extraordinary artistic crossing of the century. She was a bridge between Apollinaire and today's world, a force of nature above the confusing parade of vanguards.

The big check from Tokyo arrived in the mail December 4. An hour later Damase came by with a contract from the Deutsche Spielkarten for a reissue of her deck of cards. To celebrate, she gave him a gouache she had just finished. The next morning when the nurse arrived, she called her to help her get dressed.

"Hurry up," Sonia said.

The nurse came into the bedroom and helped Sonia get up. As Sonia stood there, she suffered a stroke, slumped back onto the bed, and died.

When the Paint
Was Fresh

She was buried next to Robert in Gambais December 7, 1979. After the parish priest said a prayer, only family and intimate friends accompanied the coffin to the grave. Her death had been merciful. Anyone into his or her ninety-fifth year could not ask for a sweeter death than the massive stroke that ended her life in one fell swoop. At the tomb, Charles, who would survive her by only half a dozen years, said a few words.

With her death, said *The New York Times*, passed one of the last survivors of the Parisian art world before 1914, a painter of exceptional gifts, an artist whose versatility was almost without parallel, and a source of ideas that never went out of style.[1]

The Tokyo exhibition went on as scheduled, followed by the first American museum show: the Albright-Knox Art Gallery exhibition that traveled from Buffalo, New York, to Pittsburgh, Houston, Atlanta, New York City, Chicago, and Montreal. Six years later the land of her birth celebrated her.

Jacques Damase was relentless in pushing Soviet authorities in

general and the Leningrad House of Artists in particular to show her work, and a few months after Mikhail Gorbachev became secretary general, a modest exhibition of her engravings opened. Damase was at the Leningrad House of Artists next to the Fabergé Palace for the 1986 inauguration. "She would have loved it," he remembered. "The reception was fantastic, when you think that she was a woman, a Jew and an émigré."

He stood in the street outside and watched people looking at the Sonia Delaunay poster. "The posters were all over the city, announcing in Cyrillic lettering, the return of a Petersbourgeoise."

Sonia Delaunay was an artist who believed the modern world—and her own attitude toward modern life—could be expressed through the primacy of color and the dynamic interplay of dissonance and harmonies. She was a painter who made her own rules, an individual more complex than her most riveting creations. She was considerably more than a wife, a mother, and an artist. She was a feminist in her own right—if not in word and posture, then in the independence of her intellectual life and in her ability to support her husband, herself, and their son for more than twenty years. Her story was a fairy tale that lasted ninety-four years, the story of a remarkable marriage of opposite temperaments and similar aspirations. Robert was a gifted pedant, a spoiled, egocentric, and fascinating promoter of ideas; Sonia a "practical" woman of all seasons who four years after they met matched his creativity and at the end of her life believed she was touching the fundamentals of what will be the painting of the future. The surrealists fell in love with her, the abstractionists saw her as a peer. She cut up brightly colored paper years before Matisse; Klee, the key to nonfigurative art, acknowledged he was inspired by her; Robert admitted that his colors were hers.

Art, said André Malraux, is a display of what people cannot see—the sacred, the supernatural, the imaginary that only the artist can show us. Sonia Delaunay made us discover that there is no such thing as high art and low, decorative, pop, greeting-card material. Art—she preferred the earthier words painting, etching, engraving, dry-point, etc.—should not be confined to the studio and the show-rooms, but should be part of everyday life. She trespassed freely across

the border of fine and applied arts, and for nearly two-thirds of the century made dresses and fabrics, theatrical costumes and movie sets, book design and stained-glass windows, auto styling and scarves, tapestry, engravings, and posters. With Coco Chanel, she marked the jazz age, draping the body in incandescent and vibrant colors and sharply patterned geometric collages. Her visual exuberance has been reinterpreted in the chromatic quakes of the 1960s, and has given us the colors we, with the whole range from Benetton and Esprit to Yves Saint Laurent, take for granted.

The world was gray and black before Sonia Delaunay and her contemporaries colored it. As Robert Hughes would say in *The Shock of the New*, "You have to pinch yourself to remember that when the paint was fresh on the Delaunays and cubist Picassos, women wore hobble skirts and rode around in Panhards and Bedelias."[2]

The aims were lofty, the aspiration towering, the stakes thrilling when the paint was fresh on *The Young Finnish Girl, Philomena*, the *Bal Bullier*, and *Market at Minho*. Sonia and her generation *were* the next great idea.

Seventy years have flattened the ambitions, trivialized the spiritual dimension and thrown a deadening pall of commercialism over the deep passions of modern art.

For Sonia, however, the need to express herself was an immortal impulse. She invited us to move, to change our outlook, and she was sure new painters would come along to surprise us. Discoveries are still ahead, she believed, because, in the search for beauty, art is its own end.

Like Matisse, she loved patterns and self-sufficiency in painting, abstractions that didn't have to tell a story. She lived through Europe's worst wars, through nazism in occupied France, but nothing of the Apocalypse enraged her painting. Her art, like Matisse's, exalted the best in our collective coloring books. She was in the end perhaps too old and too wise to believe that art can change the world, that art can interpose itself between history and its victims. There is scarcely a reference to a political event—let alone a political opinion—to be found in her work. She found her emotional creed, she once said, in the sky—in the light and the movement of colors. There was nothing of Robert's obsessional and pained character in her art. For her, art

—or the play of colors—was a normal function, like eating and sleeping.

"Do nothing by chance, do it all for love," was her motto. Her gift is her self-assurance, her optimism, and her faith in work and excellence. Her sense of design, which today we demand of everything from steak knives to sailboats, is her lasting legacy.

NOTES

Chapter 7. Boulevard du Montparnasse

1. Sonia Delaunay, *Nous Irons jusqu'au Soleil*, with Jacques Damase and Patrick Reynaud. Paris: Robert Laffont, 1978.

Chapter 8. Les Demoiselles d'Avignon

1. Fernande Olivier, *Souvenirs Intimes*. Paris: Calmann-Levy, 1988.
2. Gertrude Stein, *The Autobiography of Alice B. Toklas*. New York: Harcourt Brace & Co., 1933.
3. Daniel-Henry Kahnweiler, *Mes Galeries et Mes Peintres*. Paris: Gallimard, 1961.

Chapter 10. Willy

1. Wilhelm Uhde, *Von Bismarck bis Picasso*. Zurich: Oprecht, 1938.
2. Dominique Desanti, *Sonia Delaunay: Magique Magicienne*. Paris: Ramsay, 1988.
3. Gertrude Stein, The Autobiography of Alice B. Toklas, op. cit.
4. This would be about $170 in 1989 U.S. money.
5. Gertrude Stein, *The Autobiography of Alice B. Toklas*, op. cit.
6. Alexander Benois, *Reminiscences of the Russian Ballet*, translated by Mary Britnieva. London: Putnam, 1941.

7. Paul Morand, *L'Allure de Chanel*. Paris: Hermann, 1976.
8. Sonia Delaunay, *Nous Irons jusqu'au Soleil*, op. cit.
9. Michel-Eugene Chevreuil, *Of the Laws of Simultaneous Color Contrasts*, 1839.

Chapter 11. Robert

1. Wilhelm Uhde, *Henri Rousseau*. Paris: Eugène Figuière, 1911.
2. Robert Hughes, *The Shock of the New*. New York: Alfred A. Knopf, 1980.
3. Wilhelm Uhde, *Von Bismarck bis Picasso*, op. cit.

Chapter 12. Fireworks

1. Dominique Desanti, *Sonia Delaunay*, op. cit.
2. Josef Rufer, *Das Werk Arnold Schoenbergs*. Kassel: Baerenreiter, 1959.
3. Guillaume Apollinaire, *L'Hérésiarque & Cie*. Paris: Stock, 1910.
4. Letter quoted in James R. Mellow, *Charmed Circle: Gertrude Stein and Company*. Paris: Avon Books, 1982.
5. Letter dated November 5, 1911, quoted Michel Hoog, *R. Delaunay*. New York: Crown Publishers, 1976.

Chapter 13. La Vie de Bohème

1. *L'Intransigeant*, March 19, 1913.
2. Quoted in Michel Hoog, *R. Delaunay*; translated from the French by Alice Sachs. New York: Crown Publishers, 1976.
3. André Warnod, in *Comoedia*. Paris, March 18, 1913.
4. Guillaume Apollinaire, *Oeuvres Poétiques*. Paris, Gallimard, 1956
5. Blaise Cendrars, *La Prose du Transsibérien et de la Petite Jeanne de France*. Paris: Hommes Nouveaux, 1913; translated by Walter Albert, *Selected Writings of Blaise Cendrars*. New York: New Directions, 1962.
6. Sonia Delaunay, *Nous Irons jusqu'au Soleil*, op. cit.
7. Guillaume Apollinaire, *Die Moderne Malerei. Der Sturm*, no. 148–149, February 1913.

Chapter 14. Syntheses

1. Guillaume Apollinaire, in *Mercure de France*, January 1, 1914.
2. *Les Soirées de Paris*, June 15, 1914.
3. Approximately $200,000 in 1989 U.S. currency.
4. Sonia Delaunay, *Nous Irons jusqu'au Soleil*, op. cit.

Chapter 15. Distant Drums

1. Quoted in Pierre Daix, *Picasso*. New York: Praeger, 1965.
2. Sonia Delaunay, *Nous Irons jusqu'au Soleil*, op. cit.

Chapter 16. To Be Thirty

1. Charles Delaunay, *Delaunay's Dilemma: De la Peinture au Jazz*. Mâcon, France, Éditions W, 1985.
2. Letter dated October 29, 1915; quoted in Paulo Ferreira, *Correspondance de Quatre Artistes Portuguais: Almada José de Negreiros, José Pacheco, Souza-Cardoso, Eduardo Vianna avec Robert et Sonia Delaunay*. Paris: Presse Universitaire de France, 1981.
3. In letter dated February-March, 1916; quoted in Paulo Ferreira, *Correspondance de Quatre Artistes Portuguais: Almada-Negreiros, José Pacheco, Souza-Cardoso, Eduardo Vianna avec Robert et Sonia Delaunay*, op. cit.

Chapter 17. Disks and Circles

1. A photograph of the untitled newspaper column is reproduced in Paulo Ferreira, *Correspondance de Quatre Artistes Portugais: Almada-Negreiros, José Pacheco, Souza-Cardoso, Eduardo Vianna, avec Robert et Sonia Delaunay*, op. cit.

Chapter 18. Diaghilev

1. Sergei L. Grigoriev, *The Diaghilev Ballet, 1909–1929*. London: Constable 1953.
2. Quoted in Richard Buckle, *Diaghilev*. New York: Atheneum, 1984.

Chapter 19. Transitions

1. *La Correspondancia de España*, June 18, 1918.
2. *El Figaro*, November 20, 1918.

Chapter 21. Fashions

1. Quoted by Stephen Longstreet, *We All Went to Paris*. New York: Macmillan, 1972.
2. François Chapon, *Mystère et Splendeurs de Jacques Doucet, 1853–1929*. Paris: J.C. Lattes, 1984.
3. Quoted by Jean-François Revel in "Jacques Doucet Couturier et Collectionneur," in *L'Oeil*, no. 84, December 1961.
4. Approximately $11,500 in 1989 U.S. currency.

Chapter 22. Art Deco

1. Georgina Howell, *In Vogue: 60 Years of International Celebrities and Fashion from British Vogue*. New York: Schocken Books, 1975.
2. Axel Madsen, *Living for Design: The Yves Saint Laurent Story*. New York: Delacorte Press, 1979.
3. In *Surrealisme*, October 1925.
4. In foreword to *Sonia Delaunay: Art into Fashion*, Introduction by Elizabeth Morano. New York: George Braziller, 1986.

5. Dominique Desanti, *Sonia Delaunay: Magique Magicienne*, op. cit.
6. Executed with the collaboration of Jean Arp and Sophia Taeuber-Arp, the Brasserie Aubette interior, demolished since, was an exemplary prototype of the height of art deco.

Chapter 23. All in the Family

1. *Sonia Delaunay, ses Peintures, ses Objects, ses Tissus Simultanes, ses modes.* Paris: Éditions Chretien, 1925.

Chapter 24. Recessions

1. Sonia Delaunay, *Nous Irons jusqu'au Soleil*, op. cit.
2. Charles Delaunay, *Delaunay's Dilemma*, op. cit.

Chapter 25. World's Fair

1. Approximately $16,000 in 1989 U.S. currency.

Chapter 26. In Demand

1. Wilhelm Uhde, *Von Bismarck bis Picasso: Erinnerungen und Bekenntnisse.* Zurich: Oprecht, 1938.

Chapter 27. Incidental Events

1. Peggy Guggenheim, *Out of This Century: Confessions of an Art Addict.* New York: Universe Books, 1987.
2. The exchange rate for dollars on the black market was 85 francs to $1, making the purchase worth $4,700 in 1940 U.S. money.
3. Peggy Guggenheim, *Out of This Century: Confessions of an Art Addict*, op. cit.

Chapter 28. "What a Lovely Trip"

1. Charles Delaunay, *Delaunay's Dilemma*, op. cit.
2. Charles Delaunay, *De la Vie et du Jazz.* Paris: Hot Jazz, 1940; Lausanne: L'Echiquier, 1945.

Chapter 29. Alone

1. *Le Figaro*, November 1, 1941.

Chapter 30. Les Six de Grasse

1. Introduction to *Les Six Artistes de Grasse*, by Georges Vindry, curator, Société du Musée Fragonard, 1967.
2. James Thrall (ed.), *Arp.* New York: Museum of Modern Art, 1958.
3. Gerhard Heller, *Un Allemand à Paris, 1940–1944.* Paris: Éditions du Seuil, 1981.
4. Hilton Kramer, "MOMA Presents a Neglected Abstractionist." *New York Times,* October 4, 1981.

Chapter 32. Artbiz

1. Fernand Léger, in *Arts de France.* no. 6, 1946.

Chapter 33. Her Turn

1. Gilles de la Tourette, *Robert Delaunay.* Paris: Charles Massin, 1950.
2. Dominique Desanti, *Sonia Delaunay,* op. cit.

Chapter 34. Midnight Sunrise

1. Michel Hoog, *Robert et Sonia Delaunay.* Paris: Musée National d'Art Moderne, 1967.

Chapter 35. Endgames

1. *Sonia Delaunay, 90ème Anniversaire,* edited by Jacques Damase. Paris: Agotado, 1976.
2. Sonia Delaunay, *Nous Irons jusqu'au Soleil,* op. cit.

Chapter 36. When the Paint Was Fresh

1. John Russell in *The New York Times,* December 6, 1979.
2. Robert Hughes, *The Shock of the New,* op. cit.

BIBLIOGRAPHY

Almeras, Philippe, *Les Idées de Céline*. Paris: Bibliotheque de la Litterature Française Contemporaire, Université de Paris, 1987.

Anscombe, Isabelle, *A Woman's Touch: Women in Design from 1960 to the Present Day*. New York: Viking-Penguin, 1985.

Apollinaire, Guillaume, *The Cubist Painters*. New York: Wittenborn, 1944.

Buckberrough, Sherry A., *Sonia Delaunay: A Retrospective*. Buffalo, New York: Albright Knox Art Gallery, 1980.

Buckle, Richard, *Diaghilev*. New York: Atheneum, 1984.

Calder, Alexander, *Calder: An Autobiography with Pictures*. New York: Pantheon, 1978.

Cassou, Jean, *Chagall*. New York: Praeger, 1965.

Chapon, Francois, *Jacques Doucet*. Paris: J. C. Lattes, 1984.

Cohen, Arthur, *Sonia Delaunay*. New York: Harry Abrams, 1974.

Crankshaw, Edward, *The Shadow of the Winter Palace*. New York: Viking Press, 1976.

Damase, Jacques, *Rhythmes et Couleurs de Sonia Delaunay*. London: Thames and Hudson, 1972.

————, *Sonia Delaunay: Dessins Noirs et Blancs*. Paris: Artcurial, 1978.

Delaunay, Charles, *Delaunay's Dilemma: De la Peinture au Jazz*. Macon, France: Editions W, 1985.

Robert Delaunay. Cologne, West Germany: Gallerie Gmurzynska, 1983.

Sonia Delaunay, Ses Objets, Ses Tissus Simultanés, Ses Modes, Andre Lhote (ed.). Paris: Editions Chuetieu, 1925.

Sonia Delaunay: Art into Fashion, introduction by Elizabeth Morano, foreword by Diana Vreeland. New York: George Braziller, 1986.

Sonia Delaunay, 90ème Anniversaire, text by Françoise Giraud. Brussels: Agotado, 1976.

Delaunay, Sonia, *Nous Irons jusqu'au Soleil* with Jacques Damase and Patrick Raynaud. Paris: Robert Laffont, 1978.

de la Tourette, Giles, *Robert Delaunay*. Paris, Charles Massin, 1950.

Desanti, Dominique, *Sonia Delaunay: Magique Magicienne*. Paris: Éditions Ramsay, 1988.

Dorival, Bernard, *Sonia Delaunay*. Paris: Éditions Jacques Damase, 1980.

———, *Robert Delaunay, 1885–1941*. Brussels: Agotado, 1975.

Everling, Germaine, *L'Anneau de Saturne: Picabia*. Paris: Fayard, 1970.

Ferreira, Paulo, *Correspondance de Quatre Artistes Portugais: Almada-Negreiros, José Pacheco, Souza-Cardoso, Eduardo Vianna, avec Robert et Sonia Delaunay*. Paris: Presses Universitaires de France, 1981.

Guggenheim, Peggy, *Out of This Century: Confessions of an Art Addict*. New York: Universe Books, 1987.

Hartwig, Julia, *Apollinaire*. Paris: Mercure de France, 1972.

Hoog, Michel, *R. Delaunay*. New York: Crown Publishers, 1976.

Hughes, Robert, *The Shock of the New*. New York: Alfred A. Knopf, 1980.

Kahnweiler, Daniel-Henry, *Mes Galeries et Mes Peintres*. Paris, Gallimard, 1961.

Madsen, Axel, *Malraux: A Biography*. New York: Morrow, 1976.

Pleynet, Marcelin, *Henri Matisse*. Lyon: La Manufacture, 1988.

Rich, Daniel Catton, *Henri Rousseau*. New York: Museum of Modern Art, 1942.

Sickel, Pierre, *Mondrian*. New York: E. P. Dutton, 1967.

Solomon, Flora, *A Woman's Way*. New York: Simon and Schuster, 1984.

Stein, Gertrude; *The Autobiography of Alice B. Toklas*. New York: Harcourt Brace & Co., 1933.

Stravinsky, Vera, and Robert Craft, *Stravinsky*. New York: Simon and Schuster, 1978.

Tzara, Tristan, *Morceaux Choisis*. Paris: Bordas, 1947.

Uhde, Wilhelm, *Henri Rousseau*. Paris: Figuière, 1911.

———, *Picasso and the French Tradition*. New York: Weyhe, 1929.

———, *Von Bismarck bis Picasso*. Zurich: Oprecht, 1938.

Warnod, Jeanine, *Suzanne Valadon*. Naefels, Switzerland: Bonfini Press, 1981.

Weld, Jacqueline Bograd, *Peggy: The Wayward Guggenheim*. New York: E. P. Dutton, 1986.

White, Palmer, *Poiret le Magnifique*. Paris: Payot, 1986.

BOOKS ILLUSTRATED BY SONIA DELAUNAY

Cendrars, Blaise, *La Prose du Transsibérien et de la Petite Jeanne de France.* Paris: Éditions des Hommes Nouveaux, 1913.

Damase, Jacques, *Rythmes-Couleurs* (poems), (Geneva: Editions Motte, 1966).

Rimbaud, Arthur, *Illuminations* (nine poems), design and typography by Jacques Damase, (Paris: Galerie de Varennes, 1973).

10 Origin (album of 10 original lithographs by Arp, Bill, Delaunay, Domela, Kandinsky, Leuppi, Lohse, Magnelli, Taeuber-Arp, and Vantongerloo). Zurich: Allianz Verlag, 1942.

Tzara, Tristan, *Juste Present.* Milan: Paganini, 1961.
———, *Coeur à Gaz;* (reprint of 1923 costume sketches). Paris: Éditions Jacques Damase, 1977.

Album with Six Prints. Paris: Galerie Denise René, 1962.

A.B.C. *Alphabet de Sonia Delaunay.* Text by Jacques Damase. New York: Thomas Y Crowell, 1972.

Robes-Poèmes de Sonia Delaunay, avec extraits de textes de Guillaume Apollinaire, Blaise Cendrars; introduction by Jacques Damase. Milan: Edizione del Naviglio, 1969.

INDEX